Jasper Johns *An Allegory of Painting, 1955–1965*

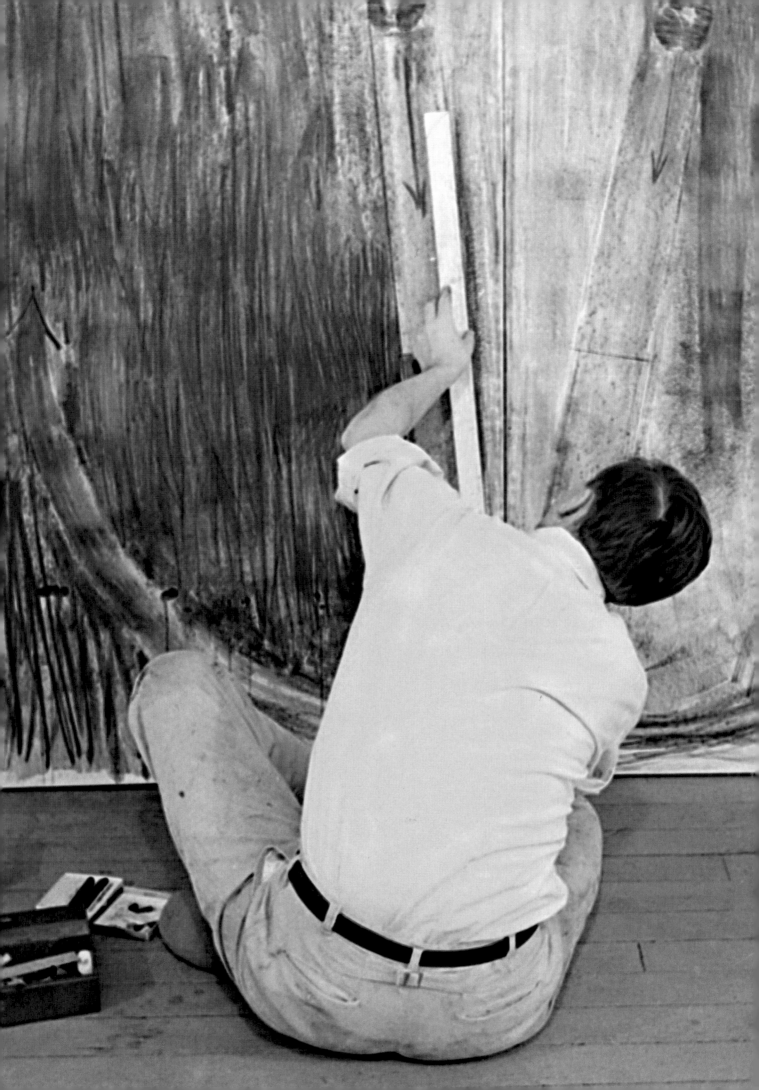

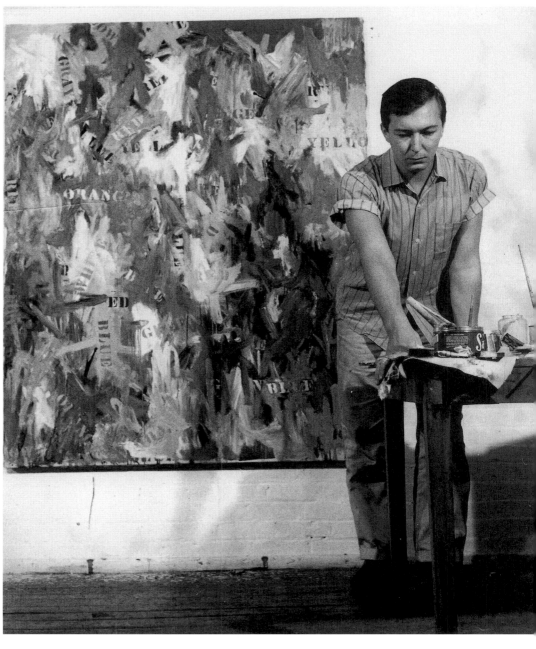

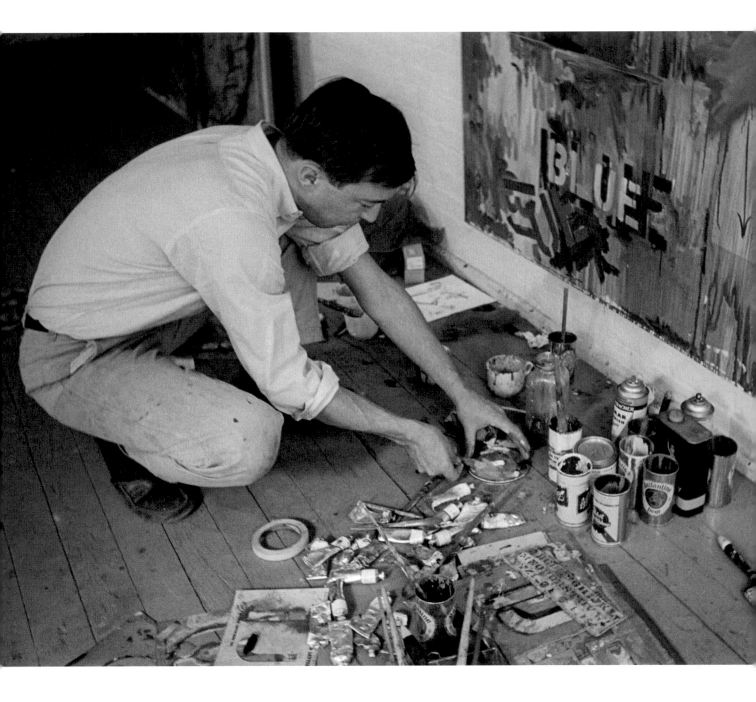

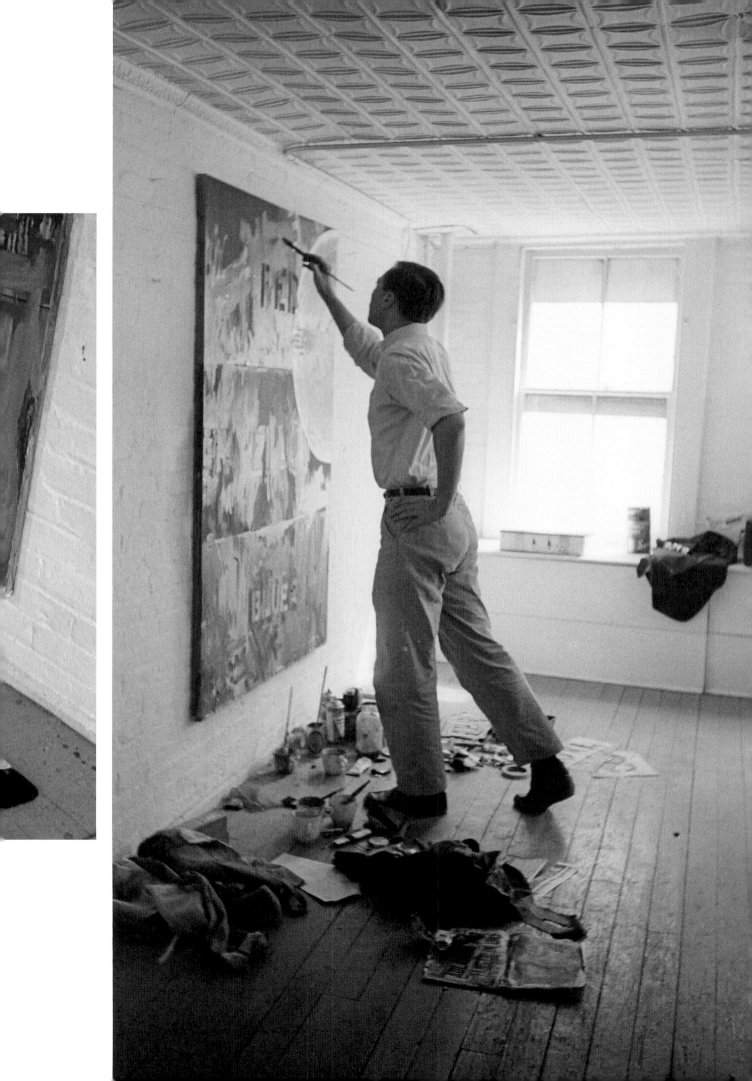

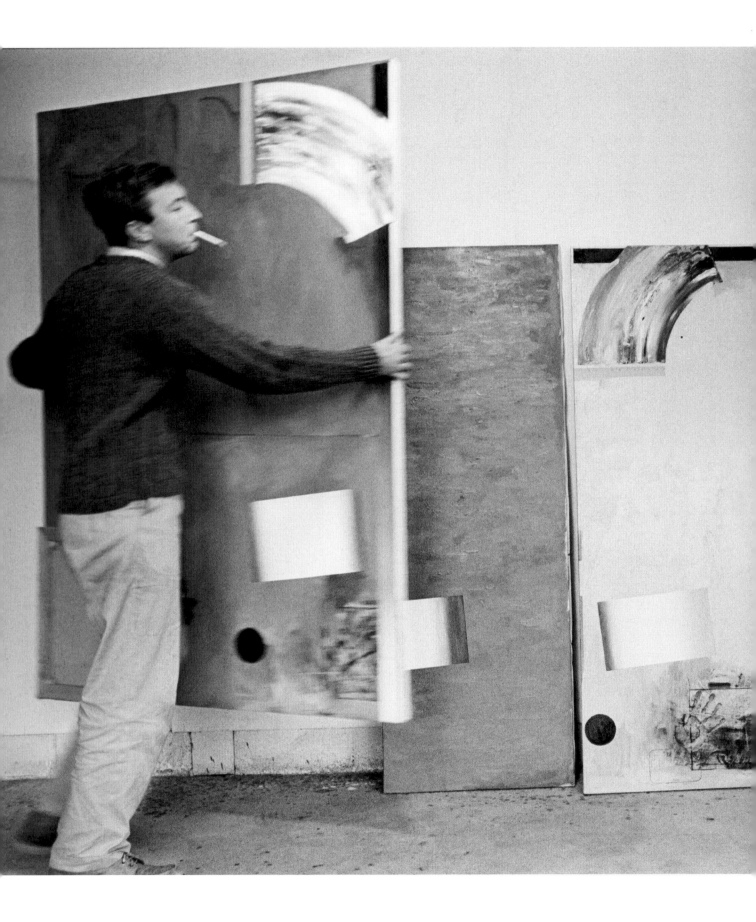

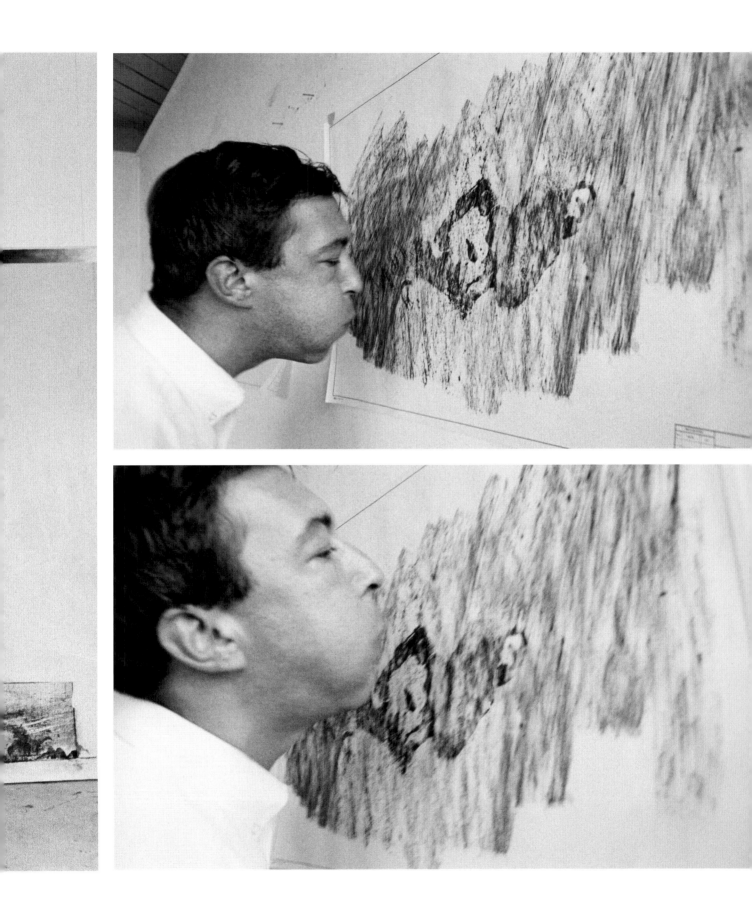

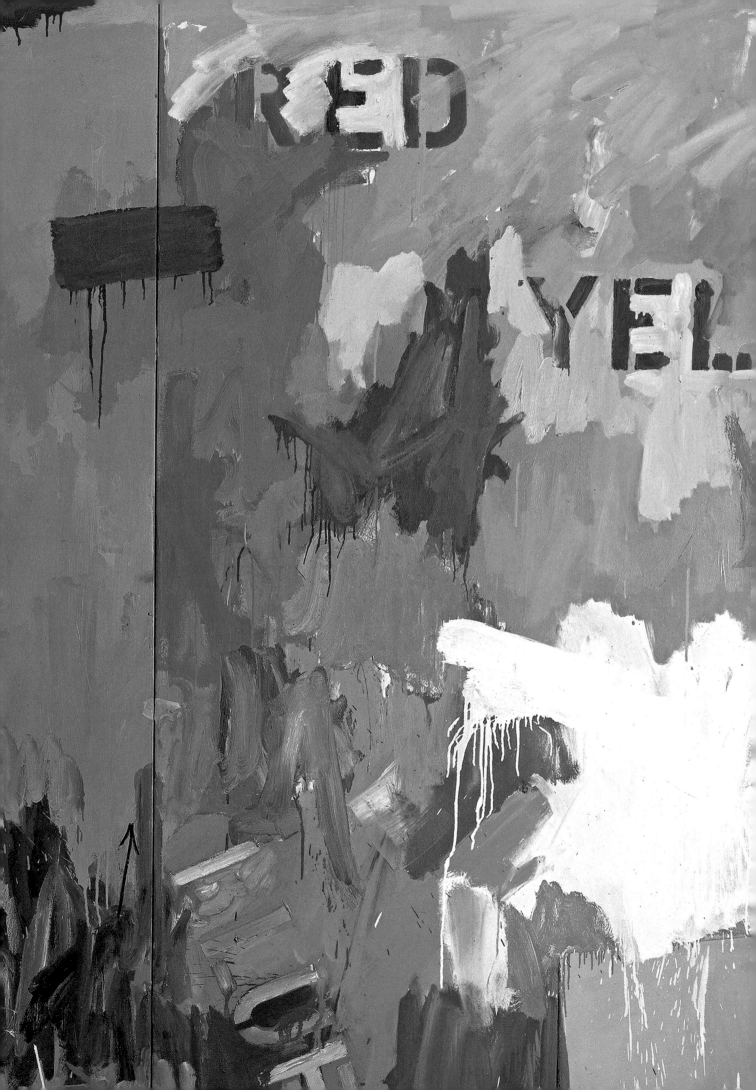

JEFFREY WEISS

with JOHN ELDERFIELD, CAROL MANCUSI-UNGARO,
ROBERT MORRIS, *and* KATHRYN A. TUMA

NATIONAL GALLERY OF ART, WASHINGTON *in association with*
YALE UNIVERSITY PRESS, NEW HAVEN AND LONDON

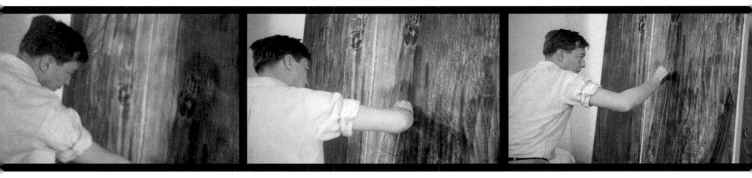

Jasper Johns *An Allegory of Painting, 1955–1965*

This exhibition is proudly sponsored by Target as part of its commitment to arts and education.

The exhibition was organized by the National Gallery of Art, Washington.

Exhibition dates:

National Gallery of Art
January 28–April 29, 2007

Kunstmuseum Basel
June 2–September 9, 2007

Library of Congress Cataloging-in-Publication Data

Jasper Johns: an allegory of painting, 1955–1965 / Jeffrey Weiss; with John Elderfield . . . [et al.].

 p. cm.

Catalog of an exhibition at the National Gallery of Art, Washington, Jan. 28– Apr. 29, 2007; and at the Kunstmuseum, Basel, June 2–Sept. 9, 2007.

Includes bibliographical references and index.

ISBN-13: 978-0-300-12141-4 (hardcover: alk. paper)

ISBN-13: 978-0-89468-341-1 (pbk.: alk. paper)

1. Johns, Jasper, 1930—Exhibitions. 2. Johns, Jasper, 1930—Criticism and interpretation. I. Weiss, Jeffrey S. II. Elderfield, John. III. Johns, Jasper, 1930– IV. National Gallery of Art (U.S.) V. Öffentliche Kunstsammlung Basel. VI. Title: Allegory of painting, 1955–1965.

ND237.J66A4 2007
759.13—dc22

2006029832

Produced by the Publishing Office, National Gallery of Art, Washington, *www.nga.gov*

Judy Metro, *Editor in chief*
Chris Vogel, *Production manager*
Margaret Bauer, *Design manager*
Julie Warnement, *Senior editor*
Evanthia Mantzavinos Granville, *Editorial assistant*

Designed by Margaret Bauer and edited by Julie Warnement

Typeset in Helvetica Neue and Whitman by Duke & Company, Devon, Pennsylvania

Printed on Scheufelen Phoenix Motion Xantur by Grafisches Zentrum Drucktechnik in Ditzingen-Heimerdingen, Germany

Hardcover edition published in 2007 by the National Gallery of Art, Washington, in association with Yale University Press, New Haven and London

Yale University Press
302 Temple Street
P.O. Box 209040
New Haven, CT 06520-9040
www.yalebooks.com

10 9 8 7 6 5 4 3 2 1

Contents

Director's Foreword

Earl A. Powell III

The National Gallery's relationship with Jasper Johns and his work is a longstanding one. Works on paper by this artist are represented in our collection in great depth, and thanks to both past and promised gifts from Robert and Jane Meyerhoff, paintings are also joining our holdings. Further, for a number of years now, we have shown in our galleries a group of paintings on loan from the artist from various periods of his career. In 1990, the Gallery was also home to a remarkable retrospective exhibition of Johns' drawings, a show that traveled to London and Basel — indeed, to the Kunstmuseum Basel, which will also graciously host the present exhibition.

Our commitment to Johns' work draws from its historical significance, which is profound. It might be said that one true measure of the importance of a given artist's oeuvre is the impact of the work on artists of his own and subsequent generations. Despite the fact that Johns' career is still thriving, his work can clearly be described as remarkably generative, having signified for many artists a watershed — a new, skeptical, but deeply engaged investigation of painting, drawing, and object-making in the era after abstract expressionism.

We are pleased, then, to be mounting an exhibition that offers an unusually focused examination of the critical role this great artist's work has served in the history of art since midcentury. The time is right for new perspectives on objects that have become perhaps almost too familiar, given the startling breakthrough they represented to the world of art during the first decade of the artist's career — the period that is our specific concern in the present exhibition.

First and foremost, we wish to thank Jasper Johns, who has been extremely gracious in his counsel and typically generous in his support, lending numerous works from his own holdings that are indispensable to our project. It is with pride that we strive to show his work in a context that emphasizes its historic importance. The many other lenders to the exhibition also deserve our deepest thanks. The exhibition obviously depends on such willingness to share these precious works of art.

Jasper Johns: An Allegory of Painting, 1955–1965 is sponsored by Target. We are enormously grateful for this sponsorship — Target's fourth at the National Gallery of Art — and for Target's continuing commitment to the Gallery.

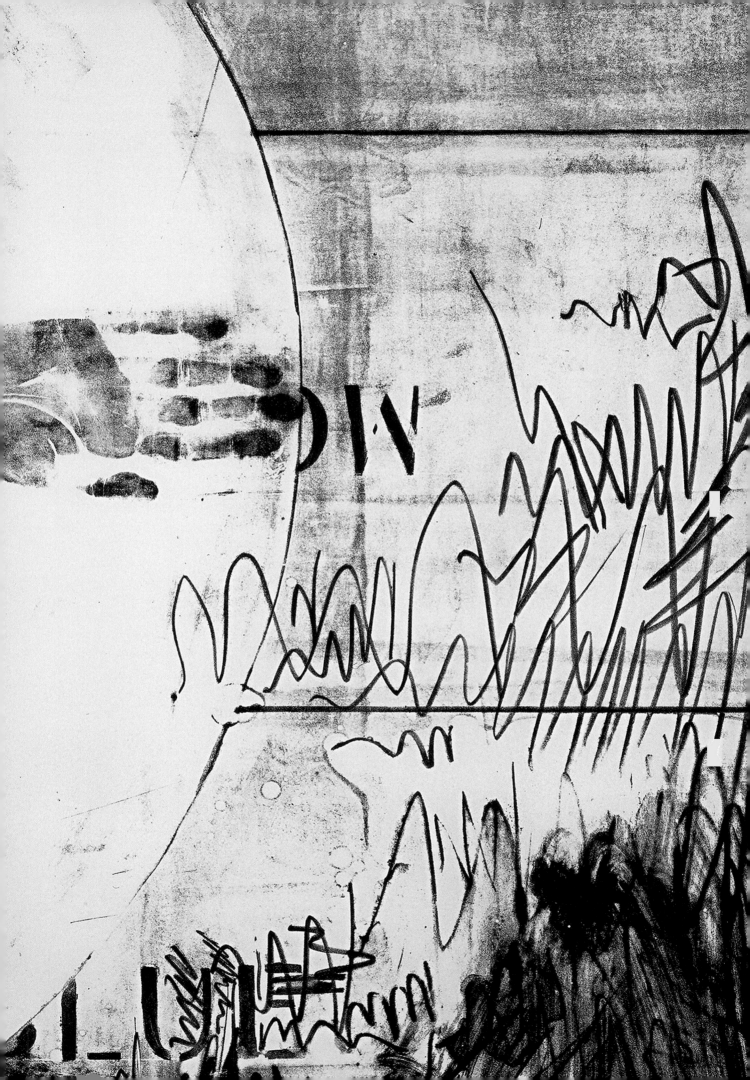

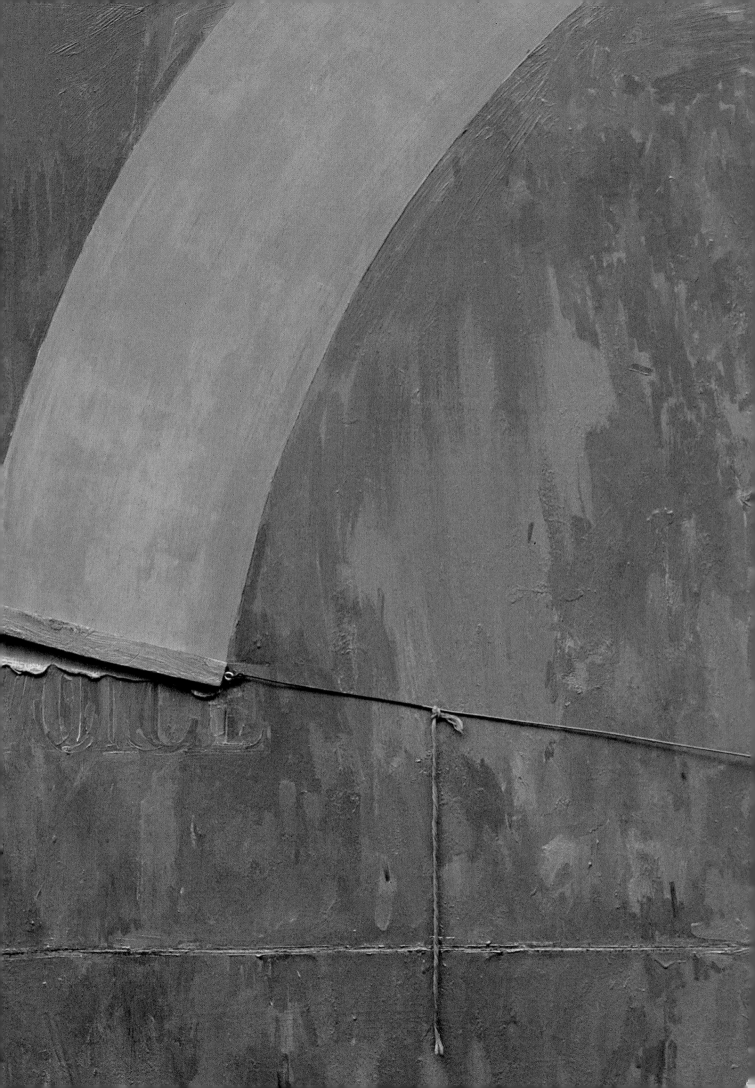

Preface

Jeffrey Weiss

This exhibition concerns the first decade of the work of Jasper Johns, from 1955 to 1965. It is not, however, a survey of the period. Indeed, the exhibition is partly motivated by the fact that Johns' career is so familiar that the character of the work has been obscured by habits of seeing and thinking about it as a whole. The deep significance of Johns' work to the history and philosophy of art since midcentury suggests that an effort at de-familiarization might be useful.

In this case, the effort takes the form of exclusion. The premise of the exhibition is that within the first decade of work lies an explicit narrative concerning the fate of painting after the apotheosis of large-scale abstraction — in the hands of New York School artists — and the ostensible demise of figuration. (Writ large, the issue of a future for painting pertains, of course, to a broader, world-historical crisis of means in art and language following the great divide of the war.) This "narrative" is openly plotted by cues within the work. Specifically, it takes the form of an unfolding relationship of four motifs: the target; the "device" (the pivoted slat used to scrape paint); the stenciled naming of colors; and the trace or imprint of the body.

It would be false to claim that this development within the work is self-conscious and programmatic. Nonetheless, the relationship of motifs remains quite clear: that is, over the course of ten years, the four motifs appear alone or together in various combinations — to the exclusion of almost all other images (most notably, the flag and the number) — forming a quasi-linear progression of themes. The target, a banded image drawn with a compass, *becomes* the compasslike "device"; the mechanical device is joined in a number of works to the stenciled names of colors — RED YELLOW BLUE; the imprint of the body is incorporated into works with the device and the name; and by 1962, the artist's handprint is joined to the device, creating the image of an extended arm. Each motif represents a quasi-mechanical procedure: rotation; the appending of an object; stenciling; the impression or trace. Together they comprise an inventory of operations through which Johns managed to invoke yet shun both abstraction and representation. The inventory describes something like a thematics of process; more, Johns can be said to have addressed the work of art, radically, as a kind of self-describing, functional (or instrumentalized) object. From this position, one that Johns spoke of in almost ethical terms, the artist sought to draw meaning almost strictly from means. The exhibition attempts, then, to show Johns narrating his own philosophy of painting through an internal logic of form.

Inclusiveness frames the methodology of exclusion. In order to represent the intensity and depth of the ten-year progression, the exhibition includes almost all of the works relevant to the narrative from target to trace. Johns continued to pursue these and other motifs after 1965, but a meaningful arc can be drawn across the first decade (ending with the painting *Voice*), after which the artist's application of the images becomes broader and less strict. This approach, which is uncommon in exhibitions of Johns' work, portrays the artist's process as having been attended by a certain quality of fixation. The number of works solely devoted to the target, for example — some two-dozen images on canvas and paper through 1960, most of them painstakingly worked in collage and paint or graphite — asks us to acknowledge a form of almost nondevelopmental (certainly nonserial) repetition that is crucial to any characterization of the psychic

underpinnings of Johns' art. Indeed, the repeating target allegorizes this issue, both through the focused distraction that the target as image solicits and through the very action of rotation that is required to draw the target's concentric bands. So too does Johns' practice of drawing after painting — of producing replicas of his painted work in graphite and ink or wash, or both (and, after 1960, in the lithographic medium); these repetitions, of course, conjure a spectrum of differences across the proliferation of the single image.

Procedures of repetition, in turn, create and signify a peculiar density or depth in Johns' work. The objects themselves, shown here in great number, reveal conceptual gravity deriving from material presence (rather than the insubstantiality that we normally associate with reproduction or facsimile), even as the conceptual realm of the copy — implicating notions such as archetype, prototype, and counterfeit — is also invoked. Within this realm, Johns addressed the premises of image- and object-making in a fashion that manages to be both highly skeptical and fully engaged. That last duality represents a primary tension of Johns' works from the first decade: they are deeply palpable yet deadpan, often seemingly inscrutable. Likewise, the motifs that constitute this exhibition represent distinct modes of knowing — seeing, naming, touching — that are objectified by the works, but that remain subject to interrogation by Johns and therefore also remain abstract.

What is a painting? What can it be? What is pictorial space and what is the place of the figure — of the body — in an era of esthetic doubt? Johns' answers — better, his speculations — lie solely within the realm of the procedural and the concrete; from target to trace, such is the work's primary theme. That is, even as it seeks extrinsic meaning, the work always brings us back to itself. Perhaps in its tautological circularity and in its arcing reach, the rotation of the compass-device figures this condition: of meaning and skepticism drawn from the mechanics of process alone.

Allen Memorial Art Museum,
Oberlin College

The Baltimore Museum of Art

Bayerische Staats-
gemäldesammlungen,
Pinakothek der Moderne,
Munich

Barbara Bluhm-Kaul &
Don Kaul

Irma and Norman Braman

The Eli and Edythe L.
Broad Collection, Los
Angeles

Barbara Bertozzi Castelli

Jean-Christophe Castelli

The Cleveland Museum
of Art

Steven A. Cohen

Dallas Museum of Art

Victoria Ganz DeFelice

Stefan T. Edlis

Frederick R. Weisman
Art Foundation, Los Angeles

Tony and Gail Ganz

David Geffen

Jasper Johns

Werner H. and Sarah-Ann
Kramarsky

Kunsthaus Zürich

Kunstmuseum Basel

Mark Lancaster

Barbara and Richard S. Lane

Louisiana Museum
of Modern Art, Humlebaek

The Menil Collection,
Houston

The Metropolitan Museum
of Art

Modern Art Museum of
Fort Worth

Moderna Museet, Stockholm

Museum Ludwig, Cologne

The Museum of
Contemporary Art,
Los Angeles

The Museum of Modern
Art, New York

Jane & Marc Nathanson,
Los Angeles

National Gallery of Art

Kimiko Powers

San Francisco Museum
of Modern Art

Andrew and Denise Saul

Sonnabend Collection,
New York

Whitney Museum of
American Art, New York

And other lenders who wish
to remain anonymous

Lenders to the Exhibition

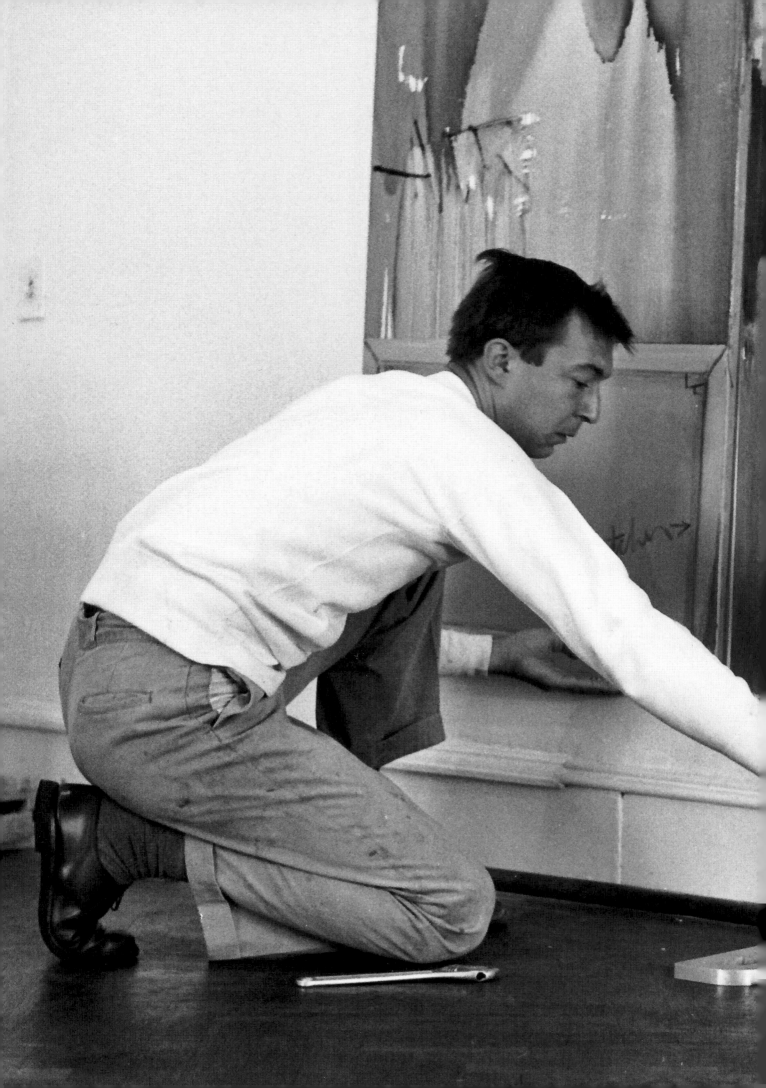

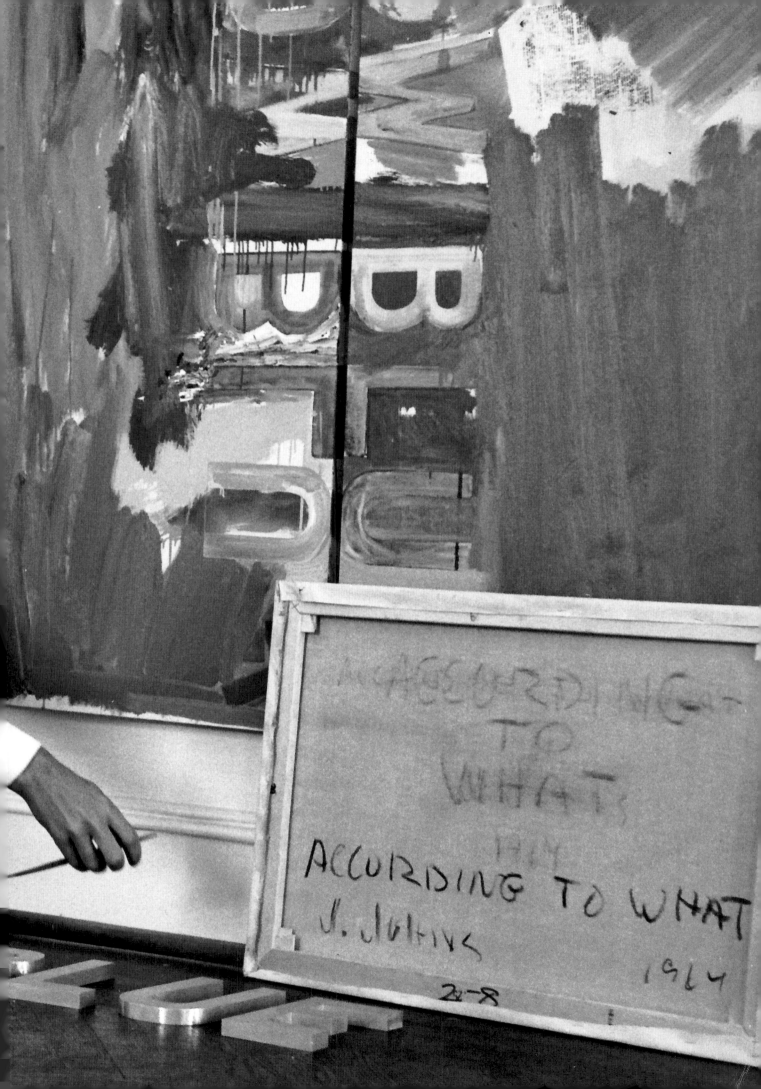

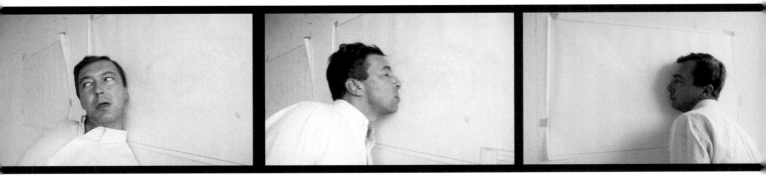

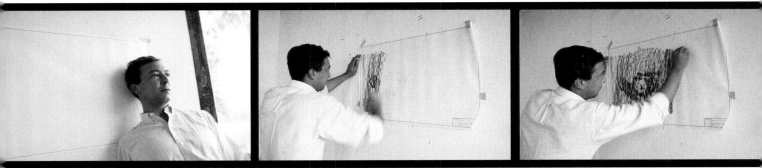

Painting Bitten by a Man

Jeffrey Weiss

Find ways to apply / make paint / with simple movements / of objects — the hand / a board, feather, string, sponge, rag, shaped tools, comb / (and move the canvas against paint-smeared objects) How / (What) / can this be used to mean if it / were language? / In what ways can one / intend to use them. *Jasper Johns*

And even my sense of identity was wrapped in a namelessness often hard to penetrate … when already all was fading, waves and particles, there could be no things but nameless things, no names but thingless names. *Samuel Beckett*

NO. The word is presented in two ways (cat. 47). Cut from a lead plate, the letters — uppercase roman type — are suspended several inches away from the canvas by a long, stiff, crooked wire attached to an eyehook (the hook is screwed through the upper edge of the painting into the stretcher bar, and the wire is also fixed to the canvas by a small piece of overpainted fabric or tape). "NO" was also imprinted into the paint surface (and thereafter inpainted with Sculp-metal), thus implying the dangling letters had been mechanically deployed to leave a trace. There is a third way to read the word NO, but it is contingent: the installed painting can be lit such that the letters, which are objects, cast a shadow on the canvas surface.

A painting cannot *mean* "NO" simply by enunciating the word. Even during the period of its emergence, Johns' work from the 1950s and early 1960s — the beginning of his career — was positioned by critics and observers in acute critical relation to recent art and, more broadly, to language and other conventionalized systems and modes of signification, such as the image as emblem or sign. In other words, the work presented itself from the start as a fully formed antisystem of its own, utterly certain of its uncertainty and its entitlement to philosophical doubt. Soon to be vaunted for their irony, the paintings — images of targets, numbers, and flags in encaustic or wax and collage — were unequivocal, minutely crafted, and commanding in their visual and material presence. It is still difficult to imagine a first solo exhibition as heart-stoppingly open-and-shut as Johns' show at the Leo Castelli Gallery in January 1958.[1]

By the time it was suspended from a wire dangling across the surface of a painted canvas in 1961, Johns' "NO" was in its philosophical credibility thoroughly secure, grounded as utterance in the closed antisystem of his early work. Painted in monochromatic gray, *No*'s nuances of dark and light prevent the painting from achieving the optical flatness normally associated with monochromy (recently demonstrated in a series of Black and Aluminum "stripe" paintings from 1959–1960 by Frank Stella, which are, in fact, indebted to Johns' targets and flags). Those nuances — deployed through vertical brushstrokes and drips, each fixed in its autonomy by the fast-drying, preservative nature of encaustic — do not accomplish anything like shadowy pictorial depth. This negation (of the color gray as a conventional tool for the illusion of volume or depth) is heightened by the unpainted lower edge of the canvas, a literal "reveal" — occurring often in Johns' work since roughly the beginning of his career — where the strokes and rivulets are exposed

against a narrow expanse of bare canvas; this strip is where we are reminded that painting is a material operation, a laying of one surface across or atop another, with no metaphorical conjuring of light and dark. (In a notebook from 1967, Johns would refer to the procedure of "exposing layers" as a "recognition.")[2] Neither flat nor representational (a double negative), the runny, encaustic paint layer is a kind of bodied surface, possessed of palpable density, like wax or fat. As such, the stretched canvas as physical support (patchily exposed throughout the painting, not just at the lower edge) can visually sustain (stand up to) the appended objects — the hook, the wire, the heavy metal "NO." And the paint surface receives, like a scar, the imprint of the object-word. If, as Fred Orton suggests, "NO" can be read as a pun — "KNOW"[3] — then the negations of *No* eschew the lying contrivances of the pictorial and ask us to recognize paint as substance and the painting as an embodied thing.

My own language — embodiment, bodied surface, fat, scar — is, of course, loaded. In fact, in a notebook from 1964, Johns sanctions such a train of thought in a list: "encaustic / (flesh?) / linen / celastic" ("celastic," a commercial product, is resin-treated fabric).[4] Indeed, the inference of embodiment first appears in an account from the early sixties by the sole contemporary observer who sought to come to terms with the affect of Johns' work. In 1962, Leo Steinberg attempted to classify the work by identifying formal properties shared by the Target, Flag, and Number paintings: the way in which Johns' flat, conventional, or ritual "subjects" establish a series of a priori conditions according to which the works function or perform; these subjects, "which prescribe the picture's shape and dimensions," therefore establish a "single image-meaning" — the painting and the subject are one and the same. By extension, the literal-mindedness of his work includes the ontological identity of "painting" itself. Steinberg describes Johns' oeuvre as a meditation "on the nature of painting pursued as if in dialogue with a questioner of ideal innocence and congenital blindness." "Innocence" is a classic empirical device, but "blindness" pertains to Steinberg's appreciation of a Johns painting as a tangible entity. The painting *No*, in Steinberg's estimation, "writes a new role for the picture plane: not a window, nor an uprighted tray, nor yet an object with active projections in actual space; but a surface observed during impregnation, as it receives a message or imprint from real space."[5] It is a curious formulation: the surface is not, after all, observed to *be* receiving an imprint, but to *have* received one, although Steinberg's suggestion of beholder as witness and the temporality that imparts to one's encounter with the painting as object is significant. In Europe, the painted canvas had been similarly addressed for some years — in the punctured or slashed canvases of Lucio Fontana, for example, probably unknown to Steinberg. One key difference, however, is that Johns includes the agent of imprinting: the painting and the instrument that presumably "impregnates" it are a single construction, hence the conceit of a continual present tense. And, of course, that instrument stands apart for being a manifestation of language, an object-word.

Steinberg's essay was composed during the first wave of committed critical debate about Johns' work, much of it concerned with terms derived from the formal analysis of abstract expressionist painting. The chief critics include Clement Greenberg and his respondents, Max Kozloff, Sidney Tillim, and Michael

Fried, as well as William Rubin, a Greenbergian writer whose observations on Johns preceded Greenberg's and were cited by him.[6] Steinberg, an outsider, was a young scholar of Renaissance and Baroque painting and an occasional writer on modern and contemporary art. His Johns text, composed in the first person, takes the form of a series of speculations and reasonings-through, a list of observations followed by the empirical deductions according to which they were formulated. But the essay was unique at the time for drawing existential conclusions, above all concerning what Steinberg identifies as a certain quality of "deceleration": in the careful process of producing the work, the commonplace, standardized subjects — the flag and the target as image / object — are "slowed down," obviating the implied presence of "human users." Ultimately, Johns' paintings are unsettling because, processed in this way, these banal images "acknowledge no living presence; they imply human absence from a man-made environment." Elsewhere, even worse: "they insinuate our own absence, not from a scene of romantic desolation, nor from a universe of abstract energies, but from our bedroom and kitchen."

That Steinberg's essay possesses a personal, almost confessional, tone can be partly explained by a later admission: writing it was motivated by his recognition — in confronting Johns' work at several exhibitions — of irrevocable generational change, and this sensation was internalized by the critic as a "portent" of his own approaching middle age.[7] It should be said, then, that Steinberg's formalism was projected. That is, he found — and therefore probably sought — in Johns' work inflated intimations of his own mortality. But this is the source of the strength of his text, for in so doing, he de-familiarized a body of work that was already being assimilated by familiar, confining critical debates.

Steinberg does, however, sharply contradict himself, and the contradiction is useful. Early in the essay, as he wrestles with the identity of Johns' targets and flags, he describes the paintings as virtually co-equivalent with their subjects — which are, tautologically, flat objects. Whether or not one puts the targets and numbers to "use" in the conventional sense, he argues, is a matter of choice; but "the posture of aiming at a Johns target is no less sane than was genuflection before an icon. Because the subject in Johns' art has regained real presence." The point, he stresses, is an ethical one: according to Johns' terms, "a painting must be what it represents." So much for "deceleration" through craft whereby the flag or target "no longer submits" to use; so much for the insinuated absence of the beholder.

In portraying the surface of *No* as a newly functioning picture plane, Steinberg raised the stakes on the notion of a haunting absence in Johns' work, for the imprint — or "impregnation" — received from "real space" delivers painting to actuality (this phrase was used by Donald Judd in 1960 to describe the appearance of stenciled words in the painting *False Start*, cat. 30, where the letters "are as they would be on a box"[8]). In the case of *No*, the imprint also renders the painting self-sufficient. Not only an object (the blindman's painting) or a surrogate (encaustic as flesh, here impregnated or scarred), *No* is reflexive: it performs an operation on itself. A second imprint, at the upper left, which was made from heating the base of a bronze object-sculpture by Marcel Duchamp called *Female Fig Leaf* and pressing it into the paint, italicizes the metaphor of the body — of flesh or skin. The identity of *Female Fig Leaf*, which is a negative cast of female genitalia (probably taken from the mannequin in Duchamp's *Etant Donnés* installation at the Philadelphia Museum of Art), while unapparent in the imprint,[9] is certainly relevant to any such association.

The embodiedness of a painting such as *No* draws from Johns' earlier works, in which painting as object (or image as object, depending on one's epistemological vantage) is built up with layers of pasted newspaper and encaustic paint. In *No*, the object nature of the painting is established by the thick, runny monochromatic encaustic surface as well as by the role of the stretched canvas as a support for more than paint (including a fabric collage patch at the top left). Perhaps taking cues from Steinberg, Kozloff would soon describe this procedure — in which painting becomes object — as one of "transubstantiation." Johns'

subjects and techniques, like those of Marcel Duchamp, he writes, work to "efface any outward manifestation of temperament"; finally (the metaphor shifts slightly here), "only in figuratively eradicating themselves" can "their operations pretend to the magic timelessness of icons."[10]

Steinberg's contradiction — more a paradox — is of interest because it places Johns apart. Embodiment (impregnation, transubstantiation) and use-value versus self-sufficiency (the target and the icon): these terms are ill suited to work by any other artist that Steinberg and Kozloff might have encountered circa 1960. (This is true even for Johns' closest contemporaries, Cy Twombly and Robert Rauschenberg, neither of whom shared Johns' literal, declarative mode). More, in the era of the waning of abstract expressionist painting, these terms identify a separate paradigm for the practice of art-making. Not just deducible from Johns' work during the first ten years, their meaning was *narrated* by the progress of the work and structured, as narrative, by specific cues. Grounded in process — in painting (and drawing, which is almost wholly neglected by Johns' early critics) as a process self-consciously concerned with medium as matter — the terms are the condition of the work. Ultimately, they describe an extended series less of inventions than of interventions.[11]

Between 1955 and 1965, Johns' work passed through several phases. Most close observers then and now draw the lines of demarcation in 1959 and 1961. In 1959, the emblematic motifs that had governed the work began to lose their priority. Johns also abandoned the kind of methodical brushwork and monochromatic or restricted palette that he had applied exclusively since 1955 (or 1954, since the first Flag painting was begun that year), with areas of color delineated by the edges of a motif, and turned to a broader application of paint (eventually oil paint alone rather than oil and encaustic) in which colors often change from stroke to stroke. Not surprisingly, this shift was remarked at Johns' precocious retrospective exhibition at the Jewish Museum in New York in 1964. For Tillim, among others, it signaled a clear downturn, an abandonment of strengths — the failure to implement the "solution" represented by the early work and thereby to "achieve a really major style"; and it found Johns, more recently, "trying to add 'meaning' to his work, reacting against his own ironic formalism."[12]

The year 1961 saw Johns introduce into his work a darkening voice. The color gray, which had originally allowed him "to avoid the color situation" and heighten the "literal qualities of the painting,"[13] now becomes a medium for philosophical negation (heightened by titles such as *Liar* and *No*). (This move is sometimes biographically ascribed to a break in the artist's relationship with Robert Rauschenberg.)[14] But into the early sixties, this manner actually coexists with the new colorism and other means. That is, the attainment of "style" can be said to have eluded Johns only if the very question of it had not already been largely obviated, or problematized, by him. For Kozloff, who was one of the few early authors to write at length about Johns throughout the 1960s, the Jewish Museum retrospective was confirmation of growth, an acceleration of "imaginative complexity" on the part of an artist who "almost single-handed, deflected the course of Abstract Expressionism about six years ago." There are references not to style per se but only to a continuing series of "operations" — "the most violent resistances — to logic, pictorial structure and coherent symbolism"; elsewhere, Johns' handling of paint "acts as palpable *interference* to meaning and metaphor." The wages of materiality is a running theme on which Kozloff strings his observations about the process of Johns' work and its negative relationship to the kind of work that process in painting normally accomplishes; even in the recent canvases now appended with real objects, Johns "demotes paint to the status of a mere covering, and yet deposits it so caressingly as to make one think that the canvas was once some vast erogenous zone."[15]

Shifts in Johns' manner are undeniable, but the works remain closely related to one another in an acutely critical fashion. The narrative structure to which the present exhibition is devoted addresses this relationship as a kind of internal logic. It is plotted around four motifs: the target; the "device"; the naming of colors; and the imprint of the body. Once introduced into Johns' work, each of these images appears in various combinations with the others in paintings, drawings, and prints. Virtually without exception, this is true for no other motif in Johns' oeuvre during the first decade. That is, one does not find the flag and the number, for example, appearing together or with any other image. Moreover, neither flag nor number — certainly two of the most familiar images from the first five years — is extrapolated in the service of further compositional strategies or types, an operation that Johns did perform on the target, the source of the "device." Rigorously tracked through ten years of work, the four motifs are seen to be inextricably linked: the fullest meaning of each derives from its relationship to the others. Isolating the structure of the linkage from the rest of Johns' production is a heuristic conceit, but the pattern it represents cuts through the center of Johns' activity, establishing terms by which process divulges itself to be the primary source for a poetics of the work. Establishing the viability of this narrative of motifs must begin with a careful descriptive account, a largely chronological itemization of the relevant works.

The target belongs to the group of flat, emblematic motifs employed by Johns at the outset of his proper career. The first of the group is the American flag, the "subject" of *Flag*, a painting in encaustic and oil over newspaper collage, produced in 1954–1955. The number and the target follow in 1955. The Target sequence — several dozen paintings and drawings produced over the course of the next five years — is initiated with two works: *Target with Plaster Casts* (cat. 1) and *Target with Four Faces* (cat. 3) (produced in that order, according to the artist). These paintings are also composed of encaustic and oil over newspaper on canvas. But in both cases the stretched canvas supports a boxlike construction that allows for the attachment of a compartmentalized shelf along the entire length of the upper edge. The compartments each contain a plaster cast: body parts, in one case, and faces — separate casts of the lower face of a single individual — in the other. The casts are painted (each body part is painted in one of multiple colors, while the faces are all poster-paint orange, a crude impersonation of skin pigment). Each of nine compartments in the first work is appended with a door hinged at the top; the "four faces" are surmounted by a single door, a plank that conceals / reveals all four faces at once. While the implication is that the doors can be either open or closed, the works have long been exhibited with the doors held open. Photographic evidence since the fifties shows both (though in an interview from 1991, Johns remembers being asked if *Target with Plaster Casts* could be shown in an exhibition at the Jewish Museum in 1957 with the compartments closed, presumably to conceal one of the body parts, male genitalia, and refusing[16]). More important, there is no correct permutation. "This aspect has been lost now that the pictures have become more museumized," Johns later explained, "but it was important at the time . . . In such a complex of activity, the painting becomes something other than a simplified image."[17]

Target with Plaster Casts is twice as big as *Target with Four Faces*. The target motif, which comprises blue and yellow bands against a red field in both paintings, is centrally placed: in the first painting, it floats within a generous red ground; in the second, and in most subsequent targets, the motif is bigger in relation to the square canvas or sheet, bringing it close to all four edges. Something similar occurs in the Flag series. In certain examples, the flag occupies the entire painting, such that its shape is identical to — inseparable from — the canvas, while other images of the flag are surrounded or framed by empty margins. An exact co-equivalence of found image and canvas (or sheet) pertains only to a handful of Flags. In the case of the target, a round image in a square field, it never quite pertains at all, although, in its dimensionality, the flatness of the target can be conflated with the canvas as plane.

Throughout the early period, Johns produced drawings after paintings. While some were exhibited during the late fifties and sixties, they were largely ignored by the early reviewers (something that would soon be redressed by Barbara Rose[18]) or misconstrued. Tillim called them preliminary sketches[19] (he also likened them to drawings by Giacometti, and indeed, Johns' early drawings, which isolate the motif on the sheet and within the matrix of draftsman's marks, are deeply vulnerable images). The drawings are often small, closely crafted works on paper in graphite with other mediums, such as charcoal, gouache, and pastel. There are at least four such early drawings that specifically reference the *Target with Plaster Casts* and the *Target with Four Faces* (the compartments are shown empty; in the case of two of the four drawings, the empty spaces are labeled "head" or "face") (cats. 2, 4, 20, 21). Johns' draftsmanship in graphite — a dense accumulation of fine, tiny strokes or marks — reads like the graphic equivalent of his slow, deliberate application of paint with encaustic in short, autonomous strokes. In mediums more broadly applied, such as pastel and various types of wash, the distinction between the techniques of painting and drawing is even less clear. For that matter, the activity of painting and drawing is further approximated by Johns' application of collage, an allover layer of paper fragments that is painstakingly laid down concurrent with the application of paint.

Each procedure — painting, drawing, collage — is a material analogue of the other. This analogy is the primary source of the seeming conundrum of object / image inherent to Johns' work, creating a slippage of medium specificity and of conventional roles attached to painting and drawing in particular (something that corresponds to drawing *after* painting, a reversal or deliberate disorientation of normal process). The image of the target is not a schematic transcription onto the canvas or sheet; it is *compiled* in such a way as to possess "visible tangibility" (Steinberg's phrase); its weight and depth belong both to the target as an image that is also a palpable thing in the world and to the canvas or sheet as a dimensional object (that which allows it to serve, in art-making, as a "support"). This results in a slow collapse of various kinds of distinctions we generally make — or take for granted — among image, representation, and thing, although early observers accounted for the ambiguous physical and material nature of Johns' paintings in conflicting ways.

Subsequent Target paintings, and therefore subsequent drawings of the motif, are solely devoted to the target image, now tightly fitted within a more nearly square format. At a time when Rauschenberg's "combines" — with their exposed pasted papers, sloshing paint, object-appendages, and boxy compartments — yanked and shoved painting into the realm of sculpture, Johns' work in the genre of assemblage was a deeply restrained, coaxing operation; examples include paintings such as *Canvas* (page 180, fig. 8) and *Drawer* (page 171, fig. 2), in which attached objects — a small stretched canvas in one case, round drawer pulls in the other — serve to declare the object-depth of a conventional stretcher. During the early period, Johns minimizes the use of objects; maximum attention is devoted instead to a much more subtle procedure: the objectification of the image and of painting itself.

While Johns continued to produce a handful of targets on canvas and paper in red, yellow, and blue, even as late as 1961 (cat. 43), virtually all other Target paintings are monochrome: green, gray, and white targets of various dimensions, most of them painted in encaustic over newspaper (cats. 5, 6, 8–11, 13, 15). Without being differentiated through color, the bands of a monochrome target are difficult to discern, distinguished only by narrow lines of demarcation. This is a form of drawing, which can be further deduced from the pinhole that is observed at the center of many Target paintings, where an instrument — a compass or string — was attached in order to trace or map the bands onto the surface of the canvas. The run of Targets connotes repetition, but not genuine seriality; that is, the works reveal no systematic form of permutation (in color or dimension, for example). If anything, the repeating image expresses instead compulsion or fixation. This quality is heightened when we consider the multiple Target drawings Johns produced at this

time. Executed with pencil as well as graphite wash (cats. 7, 12, 14, 22), these small sheets are the equivalent of the painted monochromes, with little or no value contrast between the bands of the image or between figure and ground. Close inspection alone — which reveals a changing density of marks and the buried presence of the schematic image — allows us to glimpse or extract the motif as such.

As a penetration, the pinhole originally enabled a compass to produce the image; left over, it is the physical expression of the center of the image as object or functioning thing. The pinhole is the point at the center of a target that one cannot see from a distance but that, nonetheless, one can locate visually through the agency of the concentric bands. It is also the negative space that identifies a thick, embodied painting — the built-up or deposited surface of encaustic, oil, pigment, and collage. In the first painting in which Johns extrapolates a new motif from the image of the target, *Device Circle* from 1959 (cat. 28), a slat of wood — the compass or "device" — is fixed with a screw at the center of the square canvas, free to rotate; its action is revealed by the trace it has been deployed to leave behind: a perfect circle etched into the paint surface by means of a stylus (a nail?) once fitted through a small hole at the other end of the device, pressed into the paint, and made to pivot. The sharply inscribed line — drawing again — is a channel defined by two narrow ridges of raised paint. Such a procedure makes a distinct sound, one that can now be imagined. It reminds us that the process of painting and drawing is not just visual and physical, but aural.

The mechanical procedure Johns used to produce a perfectly measured target is the one that he now applies to the etching of a single line. "I have few doubts," Kozloff wrote in 1964, "of the origin of this motif in the substitution of a stick for the string the artist had originally used in drawing a circle."[20] The chief distinction in its application is that the newly designated "device" — named, along with the image it manufactures, in large stenciled letters along the lower edge of the canvas, "DEVICE CIRCLE" — scrapes paint. The device takes the form of a wooden slat that remains attached to the canvas. *Device (Circle)* (Johns inscribed the title in this way on the back of the canvas) is an essential painting, for it establishes a key passage from the early works to those that postdate 1959. In addition to the device, it introduces a striking change in paint application:[21] broad, spiky bundles of strokes ("clusters of rough strokes, which always have something abbreviated and clipped to them," Judd said[22]) in paintings that will be either black, white, and gray throughout or, more commonly, red, yellow, and blue (with orange and green). Eventually, wax is abandoned for oil paint alone. From the nature of the strokes, which show the depletion of the loaded brush, we can infer that the new procedure is faster than the previous one. Indeed, in one of the few published accounts of Johns at work, John Cage described the mechanics of it: "he began painting quickly, all at once as it were, here and there with the same brush, changing brushes and colors, and working everywhere at the same time rather than starting at one point, finishing it and going on to another."[23] The paint surface of *Device Circle* is noticeably less dense than that of the paintings in the Target series. It is also one of the last paintings built up with newspaper, although the fact that the fragments of newsprint are now more sparsely applied is a measure of the shift away from earlier procedures. After incising the circle, Johns continued to work on the painting. The circle is overpainted in some places, and bits of paper are laid down along its very edge. The device, which is also painted, is not fixed in place; it retains its freedom to rotate and photographs show that, over the years, its position is often changed.

Because *Device Circle* introduces a new manner of brushwork, a new palette, and the appended device mechanism, it not only announces a battery of concerns, it joins them to one another. No other painting serves such a role in Johns' work. Here Johns relinquished his early process along with his interest in the emblematic motif. Yet just as he began to expose the track of the brush, he attached a mechanical instrument, one that operates through the agency of the hand but obviates the connoisseurship of touch. The procedure that once served the mapping of a flat image — the target — is now self-fulfilling. Johns' drawings manifest these shifts. Two target drawings from 1958 (cats. 22, 23) seem, exceptionally, to anticipate

the new brushstroke: the bands of the target are inscribed yet only incompletely filled with precise but wiry marks (one of these was used as the model for Johns' first lithograph, cat. 27). A graphite drawing after *Device Circle* (cat. 29), activated with vigorous marks, is virtually a depiction of the painting with its device arm. Several black, white, and gray target images from 1959–1960, variously executed in oil and graphite wash (cats. 24–26), show Johns applying something like the new manner of brushwork to the target motif itself. The persistence of the target through 1961 reflects the period of passage from target to device.

From *Device Circle*, Johns extracted two simultaneous sequences of work: a group of paintings and drawings in the new manner that bear the stenciled words RED, YELLOW, and BLUE; and works that deploy or image the device. The two sequences dovetail in a group of works that incorporate both the naming of colors and the device (including paintings that are understood to reference the poet Hart Crane). These tell us that the two elements — the color-names and the device — address a single set of premises pertaining to the nature of painting as a procedure and to painting's (perhaps dubious) ability to signify more than itself.

The largest, most prominent painting in the first sequence (the naming of colors) is *False Start* (cat. 30), the work from 1959 that, as we have seen, captivated Judd at Johns' Castelli show the following year: "Stenciled names of the various colors, seldom in their own, . . . penetrate and shape, since the color is opposed, the clusters of harsh, high-keyed blue, red and orange." *False Start* manages to be both clotted and expansive, a field of interlocking patches and passages of red, yellow, and blue with orange and gray, each of which is named throughout the composition. Such as it is, this "composition" is an allover affair with no hierarchy of parts, in good, second-generation abstract expressionist fashion. Of course, the stenciled names make an instant mockery of painterly style by introducing Judd's "abrupt formality and actuality."[24] The words represent an intrusion of the real, so to speak, in a realm that is normally taken to stand apart, and in conjunction with a manner of painting that had come to represent — even histrionically so — a manifestation of radical subjectivity. Only rarely stenciled in the colors they name (BLUE can be stenciled in red, and so on), the words stiffen our perception of the allover field; through their presence, they reveal the field itself to be less a dispersion of strokes than a configuration (even a methodical one, in the manner described by Cage). "All the brushmarking," Johns said in 1965 in reference to this sort of work, "other than paint put on through stencils, was arbitrary, and had to do with my arm moving."[25] Johns created two works that are closely related to *False Start,* each called *Jubilee* (cats. 34, 35), where fields of brushwork are stenciled throughout with color-names. Both are executed in a palette of black, white, and gray. One, a work on paper in graphite wash applied with a brush, is a fairly close replica of the other, a painting in oil and collage, with strokes and stencils conforming to a virtually identical pattern. Replication was an established methodology for Johns, but here it is motivated by work that signifies intuition rather than design. Spontaneity is represented as a conceit. Similarly, *False Start* itself was the "subject" of an eleven-color lithographic variant (cat. 32) in 1962.

Johns' new "brushmarking" was also applied to a separate sequence of works that specifically, and hieratically, names red, yellow, and blue. Four such works (both paintings and drawings) were produced over the course of three years, starting with *Out the Window* in 1959 (cat. 38), in encaustic and collage. These images are each vertical-format canvases or sheets divided into horizontal bands: three bands in *Out the Window* and the drawing by that title in charcoal and pastel (cat. 39); and four in *By the Sea* (cat. 40) and a related drawing, *Folly Beach* (cat. 41). *Out the Window* is painted in the high-key palette of *False Start,* but its configuration of passages and strokes is fragmented into smaller shards. The words RED, YELLOW, and BLUE — one for each band — are emblazoned on *Out the Window* but are subsumed by the activity of the brush. Something similar is accomplished in the drawing of the same name, a large sheet executed with extremely broad strokes. There, values are distributed in patches evenly throughout the composition, thus interfering with, but not quite canceling, the legibility of the words. There is a certain resemblance

here to the fractured, multidirectional, allover chiaroscuro of high analytic cubist painting, a shallow space flickering throughout with scattered passages of light and dark. Such a space, unusual in Johns' work, also obtains in *By the Sea* and *Folly Beach*, despite the lesser degree of light-dark contrast, and it brings to mind the role of the stenciled or typographical word in cubism in 1911–1912 (fig. 1), where the flatness of the word as sign, optically bound to the surface of the canvas, throws pictorial space into low relief.[26] The difference is that Johns paints the letters of the words as objects, causing some of them to advance or recede. The lights in *By the Sea*, a painting of silver tonality overall, almost resemble flashing representational highlights — although representing what, exactly, we could not say. The sumptuous range of smoky darks in *Folly Beach* is also filled with activity, even if it is solely the arbitrary activity of Johns' surface graphism (the movement of the arm or wrist) along with clouds of blue-gray chalk, which alternately define and obscure the letters of the words. RED, YELLOW, and BLUE are inscribed in descending order in both works, one name per horizontal frame; in the fourth frame, at the bottom, the three color-names are superimposed. Each frame in *By the Sea* is a separate stretched canvas.

Two works anticipate the banded pictorial structure of the red-yellow-blue images but are devoid of the color-names: the painting *Reconstruction* (cat. 36) and a charcoal drawing by the same title (cat. 37), both in black and white. The painting is composed of a large cut canvas folded and tacked down over the surface of the stretched canvas support, leaving a small margin around all four edges. In this, it is closely related to the earlier painting *Shade*, from 1959, in which a pulled-down window shade serves as the attached canvas; it is also recalled by *Disappearance II* (The Museum of Modern Art, Toyama), painted in 1961, a square-format painting on which cut canvas is laid down in the form of a diamond. *Reconstruction* is painted in the broad manner initiated in *False Start*. The drawing, which represents the structure of the painted image, is vigorously worked in charcoal, but the strokes of the charcoal closely approximate the brushwork in the painting and even its abstract distribution of lights and darks. This sheet is also extremely close in its design and surface quality to the large drawing after *Out the Window*.

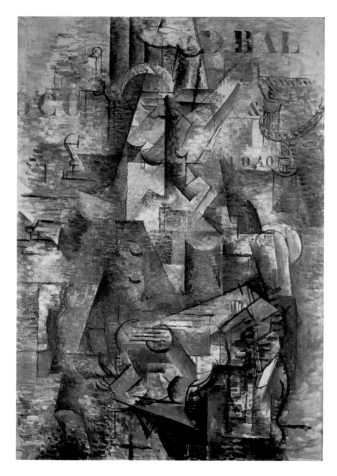

1. Georges Braque, *The Portuguese (The Immigrant),* 1911, Kunstmuseum Basel, Gift of Raoul La Roche, 1952

2. Robert Ryman, *Untitled,* 1959, Collection of the artist

Simultaneous with the red-yellow-blue sequence is a group of six Device paintings produced between 1960 and 1962, variously executed in black and white, gray, or a broader palette of hues. In most cases, a ruler has been employed as the device. The first, which is not yet a conventional Johns Device painting, is *Painting with Ruler and "Gray"* (cat. 44), a square-format work executed with a broad brush in black, white, and gray with patches of other colors — red and bare canvas — showing through. The effect is not unlike that of certain paintings by Robert Ryman from this moment (fig. 2), where passages of color and bare canvas show from underneath plainly visible strokes of white paint, almost as if they were being subsumed in real time. Indeed, Ryman and Johns, in many respects very different artists, share a painterly yet slow and reflective application of the brush, one that preserves the action of the stroke and manages to amass an accumulation serving no image — no "picture" — per se. The two artists should be understood as contemporaneous critical inheritors of abstract expressionism, although Johns' brushwork is a deliberately stiffer procedure. *Painting with Ruler and "Gray"* is what the title describes. The work is divided down the middle with a slat, possibly a stretcher bar, printed with the word GRAY, another color-name; the slat in turn is surmounted by a ruler that pivots in the center. The brush has deposited paint on both strips of wood.

The rest of the Device paintings apply the device — the wooden slat or ruler — as a scraping tool. Much more broadly activated than the device arm in *Device Circle*, the entire device in this series is pressed flat against the paint surface where, when it is made to pivot from one end, it pushes or smears paint in a precise arc. Johns' tiny *Do It Yourself (Target)* from 1960 (cat. 42) is relevant in this context because it is a highly schematic target image quite clearly drawn with a compass (a device), as evidenced by the pinhole in the center. As a target-making kit equipped with three dry watercolor disks in red, yellow, and blue, it also references the readymade nature of the target as object and motif. It is signed by the artist, but it is to be cosigned by whosoever paints the bands, thereby completing the image.

In the Device paintings, the device arm is usually attached at the end closest to the tacking margin (rather than at the center of the canvas). The arcs then stop or start at the edge of the canvas, implying a full sweep (the completion of the arc as a circle, a full rotation) in real rather than pictorial space — in the space beyond the frame. These paintings are all vertical in format. The first work in this sequence appears to be *Good Time Charley* (cat. 46), a broadly brushed gray painting in oil and encaustic with an attached ruler and a small dangling cup — actually, a sculpture in Sculp-metal. A surprisingly large drawing actually precedes this painting (cat. 45); it is one of Johns' most diagrammatic (and Duchampian). Here the arc of the device is described as a line with a directional arrow; the line is labeled ("scrape"), as are the cup (here identified as "painted bronze"), and the ruler (pictured in an upright position) and wing nut.

The largest painting in the Device sequence is the multicolored *Device* (cat. 50), painted in oil. Two scraping tools (stretcher bars with mitered corners) are appended with wing nuts to the left and right upper edge of the canvas. At rest, they stand away from the paint surface, but they have been fully deployed, leaving two symmetrical half circle smears of paint on the surface and a buildup of paint along the bottom edge of each slat. The exposed surfaces of the slats have also been painted. (Johns continued to paint after working the slats, as evidenced by a blue brushstroke that intrudes from below into the left-hand arc.) What appears to be a charcoal line can be glimpsed along the edge of the right-hand arc, perhaps indicating that the arcs were drawn before they were scraped. The word DEVICE is stenciled along the bottom of the image. A small drawing in black ink on translucent white plastic (cat. 51) roughly depicts this painting. There the arcs take the form of exposed support with traces of wiped ink representing the action of the device, which is labeled "scrape"; a small arrow indicates direction. The hardware elements are sketched and identified as "bolt with wing nut" and "stretcher strip." A second, smaller, but no less imposing work from 1962, also entitled *Device* (cat. 53), is broadly painted in various shades of gray oil paint and divided down the center by a wide wooden slat that is screwed through the canvas into the stretcher (and inscribed with the word "gray"). Like the larger painting, it has two device instruments attached with wing nuts along the left and right edges of the

canvas. Here, the slats are each thirteen-inch, paint-stained sections cut from a single yardstick. They have been used to scrape monochromatic arcs through the paint surface. The word DEVICE is stenciled twice in two sizes near the lower right edge, the smaller being superimposed over the larger. That year, Johns also produced a related image as a lithographic print (cat. 52).

Somewhat anomalous within the sequence of Device paintings is *Fool's House* (cat. 54), a narrow vertical-format painting in gray oil with attached objects, each labeled in the artist's hand: a folded towel, a small stretcher, a white cup, and, suspended from a hook screwed through the front of the canvas into the stretcher bar at the top, a well-used broom, slathered in gray paint, which has apparently been activated, in device fashion, to "sweep" an arc through a portion of the paint surface before which it hangs. The title of the painting is stenciled across the top of the canvas, beginning in the center, running off the right-hand edge, and finishing on the left. *Zone* (cat. 55), another gray painting from 1962, can be compared: there the cup in *Fool's House* dangles from a hook attached to the right-hand edge of the painting (where Johns has also inscribed the word "cup"). Most significant in *Zone* is the paintbrush that is suspended from a chain attached at the upper edge. This concretizes the analogy between brush and broom as well as the identity between "device" and brush. *Zone* also possesses a projecting neon "A" and toggle switch. The name of the painting is stenciled twice — superimposed small over large — in the lower left corner.

Five paintings and two works on paper produced in 1962 and 1963 form a body of images that can be described as a hybrid of the previous two sequences. These works incorporate the three- and four-part stratification or the stenciled color-naming of the red-yellow-blue paintings (or both) with the scraping device. One essential change in 1963 is the addition of the imprint of the body, specifically the palm of the artist's hand. The first two works from 1962 are *Passage* (cat. 63) and *Out the Window Number 2* (cat. 64), both encaustic paintings with a single appended ruler. The ruler-device (a portion of a yardstick, again, in *Out the Window Number 2*) has been used to scrape a quarter circle through the paint surface at the upper left. The two paintings loosely share a palette of gray, blue, and red (which is mixed to form a cool rose hue in *Passage*). Both works are very broadly painted, much more so than Johns' works thus far, and both stream with long rivulets of thin paint, something that is especially obvious in *Out the Window Number 2* where the rivulets run through large areas of exposed canvas. Both works are annotated: "scrape" appears along the edge of the scraped arc with arrows indicating that the action is two-directional. Both canvases show a second quarter circle at the lower left: in *Passage*, it is drawn through the paint layer as a single line; in *Out the Window Number 2,* it is delineated as a kind of reserve — a portion of bare canvas described by a line of runny gray paint. RED, YELLOW, and BLUE are stenciled across both paintings (BLUE in both cases is composed of a small and large word superimposed), although the color-names are partial and often overpainted. Both works are also divided across the top third of the canvas with various lines in paint and charcoal, including a red snap line in *Out the Window Number 2* and, in both cases, a line representing a taut wire attached to the handle of an ordinary spoon. *Passage* includes, at the upper left, the imprint of a household flatiron stenciled with the word IRON.

Two further paintings that join the device to RED-YELLOW-BLUE follow in 1963: *Land's End* (cat. 70) and *Periscope (Hart Crane)* (cat. 67), both virtually identical in dimensions. The dark palette of *Land's End* is gray with blue and passages of red and red-based hues. The vertical-format canvas is horizontally divided into thirds. Two different sizes of stencils have been used to name the colors red, yellow, and blue in descending order. RED is stenciled three times — backward, and forward twice, by turns large and small. The semicircular scrape is a dark gray smear with red, orange, yellow, and blue underneath; the device itself is a black-painted slat, but it shows red, yellow, and blue paint along its upper edge, indicating that the device was pivoted in an upward sweep. The backward-stenciled RED in the scraped field was applied over the smeared paint and then scraped back over (the colors may have been applied first, followed by the stencil and a second pass with black paint). The result pushes the dark-gray backward RED into shallow

pictorial space. Beneath the field is a large rectangular patch of gray paint with a downward-pointing arrow. Brushwork throughout is thick, aggressive, multidirectional, and uneven; here rivulets of running paint are less controlled than in the previous two works. Indeed, the painting seems to be filled with corrections. There is evidence of masking tape (the seepage of runny paint) having been used to establish the lines that divide the canvas, although these divisions are thickly and incompletely defined. Rising from the lower left at a slight tilt and extending two-thirds up the canvas is a long straight "arm" surmounted by an actual imprint of the artist's hand. The palette of *Periscope (Hart Crane)* is almost monochromatic (black, white, and gray), save for small passages with yellow paint (in the center section, labeled with the word YELLOW) and a red brushstroke along the bottom right edge. The composition is close to *Land's End*, although here the wooden slat is replaced by the human arm, which now represents the device (the semicircular field has, however, been scraped by an actual tool). The technique is also largely identical — broad brushwork and rivulets of running paint. Two works on paper, an untitled drawing (cat. 68) in charcoal, pastel, and collage with a shot of red Krylon spray enamel and *Hatteras* (cat. 69), a large lithograph, take up the device-arm in *Periscope (Hart Crane)*. The representation of a scraped field occupies almost the full height of the sheet (which, in both cases, is still divided into horizontal thirds); in the drawing it is inscribed with a target's concentric bands. *Hatteras* is twenty-nine and one-half inches wide, a fact revealed by ruler marks along its bottom edge.

The fifth painting, *Diver* (cat. 65), actually falls between the previous two pairs, having been executed, according to the Bernstein catalogue, at the end of 1962 following *Passage* and *Out the Window Number 2*. Unprecedented in scale (it measures just over fourteen feet in length), *Diver* is something of a compendium or catalogue of motifs. It is composed of five attached panels (the format follows works by Rauschenberg on this scale, such as *Rebus* or *Ace*). From left to right, the panels show: a multicolored half-circle device scrape against a field of black and white, with the word DIVER stenciled across the bottom; a painted gray scale; a broadly brushed field of red, yellow, blue, orange, green, and related mixed hues imprinted with two pairs of hands on either end of two straight devicelike arms and footprints at the very top (a cloth tape measure runs along the bottom edge of this section, which occupies two panels); and a continuation of this field, stenciled with the words RED, YELLOW, and BLUE. At the lower edge of the fifth panel, a knife, fork, and spoon are fixed by the tension of a chain and a wire that are pulled taut and attached to either end of the panel. The large charcoal drawing, also entitled *Diver* (cat. 66), began — uncharacteristically — as a study for the painting, specifically for the two-panel diver motif. It was completed after the painting. The texture that comes through the application of medium is the result of working the drawing against a rough wall.[27] Uniquely for Johns at this time, the dimensions of the drawing correspond to the area of the painting that it references.

Johns executed the four so-called Skin drawings prior to the painting *Diver*. Together with several prints from 1963–1965, they represent a related but distinct body of work. The Skin drawings, each called *Study for "Skin"* and numbered I through IV (cats. 56–59), were produced in preparation for an ultimately unrealized sculpture — a rubber cast of a head to be stretched on a board and cast in bronze.[28] They are composed of blurred impressions of the artist's head and hands in charcoal on mechanical drawing paper. Johns used baby oil as a medium, coating himself in order to leave a rolling trace of his entire head and the imprint of his palms; the sheet was subsequently rubbed with charcoal, which was absorbed with greater density by the oil than the exposed paper. It is useful to recall Johns' reference to "brushmarking" as a largely physical activity having "to do with my arm moving." Indeed, as the Skin drawings show, Johns applied the charcoal in broad strokes from the elbow, something that can also be observed in a remarkable series of studio photographs that record the process. These strokes are formed as arcs, reminding us that the arm and hand possess the purely mechanical pivoting motion of the device, something that Johns himself would soon figure in *Periscope (Hart Crane)* and related works. Johns used the Skin drawing

technique for his lithographic print *Skin with O'Hara Poem* (cat. 60) in 1963/1965, which incorporates a transcription of the poem "The Clouds Go Soft" by Frank O'Hara.[29] Several smaller related works show imprints of hands (cats. 74, 75); and a lithograph on newsprint entitled *Pinion* incorporates impressions of the artist's knee, hand, and foot labeled as such with stenciled words. There are two versions of *Pinion*: one with the imprint of a naked foot (cat. 72), and one in which FOOT labels the imprint of the sole of a shoe (cat. 71).

The Pinion lithographs and the Skin drawings recall us to *No* from 1961, with its imprint of the Duchamp *Female Fig Leaf* and the Sculp-metal impression of the object-word. The suspended letters are also mechanically related to the device (here imprint substitutes for scrape), although in *No* suspension responds to the pull of gravity. Several other works can, in retrospect, be situated within the orbit of *No*. The small *Painting Bitten by a Man* (cat. 48), also from 1961, is perhaps Johns' single most startling work and surely one of the most remarkable objects in the history of art since midcentury. It is composed of a thick field of yellow-gray encaustic — on canvas mounted on a wood type plate — that has been aggressively violated (both *by* a body and *as* a body). Left behind is a hollow bearing tracks from the scraping action of the artist's teeth. *Wilderness II* (cat. 73) from 1963, a large charcoal drawing with multiple handprints as well as an impression of the side of the artist's head, also belongs to the sequence shared by *No* and the Skin drawings. In 1970, a clear acrylic cast of the artist's hand was mounted at the upper right corner as if pressing down — wiping against the picture surface — on a rag (*Wilderness I* contains some of the same elements against a light ground but includes later images that do not correspond to the language of the work before 1965). *Wilderness II* also shows the schematic representation of a paintbrush drawn as if dangling from a wire (a direct reference to the brush in *Zone*, itself derived from the suspended letters in *No*) and verbal annotations: "brush," "screw eye," and "string or wire." Along the bottom of *Wilderness II*, Johns attached a twelve-inch ruler. This establishes a further relationship between the work and *No*, for Johns produced two No drawings in graphite, charcoal, and tempera the following year (cats. 84, 85) during his summer in Tokyo, both of which contain actual-size depictions of a ruler acting as a scraping device; here the device is pictured as scraping downward, a straight action rather than an arcing one (the scraping operation is labeled as such in the artist's hand). The ruler has descended roughly two-thirds down the sheet; the word NO is stenciled below it.

Two paintings from 1962 and 1963–1964 represent the further development of the red-yellow-blue motif, *Slow Field* and *Field Painting* (cats. 76, 77), which should be considered a pair. Both show the stenciled color-names RED, YELLOW, and BLUE in two joined vertical rows running through the center of the painting; they face each other in mirror fashion, so that one set of names is reversed. In *Field Painting*, commercially produced wooden letters (and one letter in neon) project from the canvas along with objects (cans of Savarin Coffee and Ballantine Beer) familiar from Johns' sculptural repertoire; paintbrushes and a printmaker's squeegee are also attached with magnets. The position of the letters, which are hinged, can be changed. An on-off switch floats above the center left. The four corners of the canvas are minutely designated as such ("upper right," etc.). A "field" of gray paint is partially brushmarked with broad strokes of red, yellow, lavender, and orange, as well as black and gray; along the upper right edge of the canvas appears the partial imprint of a left foot. *Slow Field* reveals instead a large area of exposed canvas. At the bottom right, a small canvas is hinged to the edge of the painting; swung open, it reveals a schematic drawing of itself — the back of a stretched canvas — before which is suspended the drawing of a brush.

In its broad brush, *Arrive/Depart* (cat. 78), painted in 1963–1964, relates to *Field Painting* and *Slow Field*. But, by contrast, this allover composition in red, yellow, orange, blue, and gray incorporates solid planes of color migrating along the edges of the canvas, a compositional device quite plainly adapted from the work of Hans Hofmann. There are no stenciled color-names; *Arrive/Depart* contains, instead, several imprints: a palm print; the Duchamp *Female Fig Leaf*; a skull; a seashell. Almost concealed at the center

of the painting is a stenciled label that warns of fragile contents: "Handle with Care — GLASS — Thank You." *Arrive/Depart* shows a liberal application of thin, running paint.

In the paintings *Souvenir* and *Souvenir 2* (cats. 79, 82), the red-yellow-blue motif appears imprinted on a tourist's "souvenir," a cheap, custom-made saucer or plate on which images could be photographically reproduced. (Johns spotted these novelty objects in Tokyo, where he stayed in the summer of 1964, and had them decorated with a self-portrait snapshot and the color-names.) The paintings are also appended with flashlights and mirrors. And drawings after *Souvenir* show that they were arranged in such a way that the light would reflect off the mirror and thereby illuminate the souvenir (thus, actual light substitutes for the representation of light). In *Souvenir 2*, Johns attached a small canvas facedown against the paint surface. *Souvenir* is painted in encaustic; *Souvenir 2* is painted in oil.

Watchman (cat. 86), another painting with assemblage, is constructed from two joined seven-foot vertical panels. At the top of the right panel, the wax cast of an entire leg "seated" in a cut-away chair has been inverted and attached to the stretcher. *Watchman* qualifies as a red-yellow-blue painting in its tripartite division and in the partial stenciling of the three color-names, one in each field. Johns has also painted a large color chart along the right-hand edge. At the bottom edge, a device — now a leaning slat — is attached at the end of a black, white, and gray streak, having come, as it were, to an abrupt stop. A *Watchman* drawing (cat. 87) depicts the painting in graphite, watercolor, and pastel as a gray image with faint colored marks; the drawing casts the aggressive physicality of the assemblage as a small, spectral afterimage. The device streak, now depicted, is labeled with the word "scrape," written in the artist's hand; in its placement, this element closely resembles the ruler images in the two drawings entitled *No*. All three drawings were produced in Tokyo in summer 1964.

According to What (cat. 89), painted in 1964, is sixteen-feet long. Like *Diver*, it comprises multiple conjoined panels. These contain three separate compositions: two closely resemble, respectively, *Field Painting* and *Arrive/Depart*; the third is an adaptation of *Watchman*, with its attached chair and cast leg; at the bottom left, a stretched canvas, affixed with hooks, is pressed facedown against the paint surface; a hinged panel attached to its bottom edge contains a negative profile silhouette of Duchamp. A painted color chart divides the painting vertically down the center; the photo silkscreen of a torn newsprint page is repeated across the center, forming a ragged horizontal band. At right, a twisted hanger is suspended by a wire.

The painting *Voice* (cat. 91) was painted in 1964 and repainted three years later after having been damaged in shipment. It is Johns' largest early gray painting, a seven-foot-high vertical-format field of gray oil paint on two conjoined stretched canvases. A stiff wire attached to the canvas at the far right edge is pulled tautly across the surface at an angle; at the far left, a wooden slat is attached at the end of an arcing scrape that was produced by pushing the slat downward through the paint surface. It begins at the upper edge and stops roughly one-third of the way down the length of the canvas. In 1967, the word VOICE was stenciled just beneath the scrape. This element is shared with Johns' two No drawings (also from 1964), where the device is an actual-size image of a ruler that partly obliterates the word NO. Two further elements were also added to *Voice*: cutlery dangling from the eye hook that also acts as a pivot for the wire; and an incised diagonal line near the bottom edge that is roughly parallel to the angle of the device wire. No large painting by Johns is so spare.

The preceding lengthy catalogue of objects itemizes a sequence that follows an established chronology but, within it, isolates bodies of work that relate to one another through a strict selection of motifs and procedures. Such an account is, of course, itself interpretive: it posits an internal logic within the work based on the evidence of the objects alone. Johns produced a great number of paintings and drawings during the first decade apart from those acknowledged here. Obviously, they are all relevant to the progress of the career,

and his work overall is already quite narrow in its formal and iconographical concerns. Yet the narrative or train of association pertaining to target, device, color-naming, and body imprint, while narrower still, can serve to expose a concrete set of relational meanings among various combinations of work.

The narrative is almost certainly a largely unself-conscious one (notwithstanding the intense deliberation that characterizes Johns' practice). It is grounded in the material process of the work, which process is either openly at stake in a given object or specifically figured in some way, and repeatedly spoken of by the artist throughout the period under consideration. We can admit that Johns' work first concerns *itself* more than anything else; this has often been claimed. But it does so in a way that represents the pursuit of values or terms through which "itself" implicates more than process in the technical sense. Here reflection on pictorial process (by way of a mechanics of resistance or interference, to use Kozloff's language) is a reflection on conditions of meaning at the end of an era in which the significance of painting, specifically of high abstraction, was otherwise taken for granted. In this way, Johns interrogates the practice of painting for the promise — or the last remaining shred — of moral content.

Is it possible, with respect to the identification of "motifs," to speak of iconography during this period of Johns' work? In fact, such a thing, in the conventional sense, can be considered barely relevant. Johns' work, especially during the first four years or so, is not premised on representation so much as incarnation; a painting by Johns is a temporal, embodied object. This is true of the Target, Flag, and Number paintings; but it also accounts for how the target specifically served Johns' subsequent work in a way that was not afforded by the other two images. For the target is the most abstract of the three, being closest to mere geometric pattern. One cannot forget the cultural significance of a flag or the meaning of the number as a conceptual sign, and there are few simple visual cognates for either one. But it is easy to imagine examples of targetlike concentricity in the world of artifacts that have little or nothing to do with the target per se. This is true even as the meaning of the target as target — more than that of a flag or a number — is visual and physical before it is anything else. That is, its form and its meaning are close to being one and the same, although meaning implicates multiple things: intention, focus, projection, and the physical traversal of empty space. In its form, the target both signifies and heightens a state of attention; within a broad field of vision, it signals and attaches the searching gaze. From a great distance, the bands of the target isolate a single point, one that is both real (target as object) and abstract (target as sign).[30] Of course, the premise of isolation and focus is shut down by the monochrome, which deprives the target of its function as an instrument of vision through deep space. This is anticipated by *Target with Four Faces*, in which the plaster casts are identically cut off below the eyes. Yet within the reversal created by the monochrome, a condition of seeing remains at stake. Built up as collage, the bands of the monochromatic target paintings have material presence. Drained of its original function but haunted by it, the monochrome ironically invites a different sort of gaze — an inspecting one, a prolonged roving attention to pure tactility (to borrow from Steinberg) or topographical detail. This is differently true of the various Target drawings, which, again, were — like most of Johns' drawings — executed after individual paintings. Here, of course, we can speak less of topography than of a varying density of marks. Substituting tactility and density for the visual cues that typically make a target an instrument of seeing (and that, colloquially, also identify the target itself as a staring — a "bull's" — eye[31]), the monochrome targets specifically take blindness or, better, frustrated vision as their proper subject.

Given the nature of the target as an image and the way it is treated by Johns (as an abstract motif endowed with physical body by Johns' process, a functional image-form that simultaneously serves and represents a specific condition of seeing), conventional iconographical considerations hardly obtain. We recall Steinberg's early recognition: that Johns' target presents itself as such, in isolation, and might just as well be shot at as be subjected to an esthetic gaze; that it is, we might say, no less an actual target than a representation of one. Johns' two Target paintings with plaster casts of body parts and faces might at

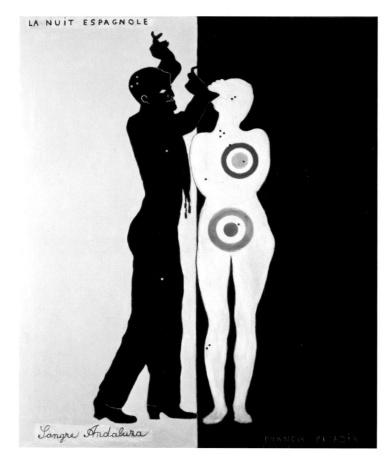

LA NUIT ESPAGNOLE

Sangre Andaluza

FRANCIS PICABIA

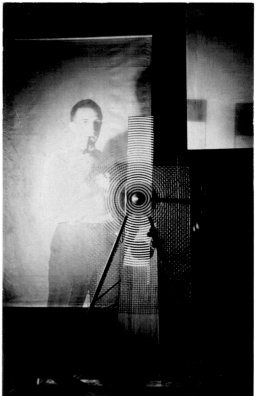

3. Francis Picabia,
La Nuit espagnole, 1922,
Museum Ludwig,
Cologne

4. Man Ray, *Marcel
Duchamp with His Rotary
Glass Plates Machine
(in Motion)*, 1920, Col-
lection Timothy Baum,
New York

first seem to contradict this, for here the target is but one of multiple elements in the work. But these paintings clearly reference the domain of the shooting gallery, and that brings us back to the target as a functional thing. It is worth noting that the shooting gallery was evoked in the work of Francis Picabia, including a large painting from 1922, *La Nuit espagnole* (fig. 3), which appeared at the landmark Dada exhibition presented by the Sidney Janis Gallery in New York in the spring of 1953. *La Nuit espagnole* is an image of a male-female couple flatly painted in black and white Ripolin (commercial enamel paint introduced into modernist easel painting by Picasso in 1911). Over the naked silhouette of the woman, the artist has superimposed two targets in red (or pink) and yellow, which hover before her breast and crotch. Simulated bullet holes are scattered across both figures; it is clear that this image is intended to evoke a perverse form of target practice.[32] The sexualized violence implied by the targeted body in this strange painting is not far removed from the more oblique (and perhaps therefore more unsettling) juxtaposition of target and fragmented body in the two works by Johns.

While Johns could not have seen the Janis exhibition (having been discharged from the army in May, he did not return to New York until the summer), Picabia's work of the 1920s is filled with black-and-white targetlike images, figures derived from or related to Duchamp's optical experiments ("precision optics") with rotating disks and glass blades (fig. 4). Such works remind us that the target is also a kind of optical device, a fact that is certainly relevant to the target motif as a functional yet abstract instrument of the

5. Marcel Duchamp,
*To Be Looked at (from the
Other Side of the Glass)
with One Eye, Close to,
for Almost an Hour,* 1918,
The Museum of Modern
Art, New York, Katherine
S. Dreier Bequest

focused gaze. In a review of the publication of an English translation of Duchamp's *Green Box* (the notes for the *Large Glass*) in 1960, which was also reviewed at the time by Johns, a critic observed that evidence of Duchamp's fascination for young artists can be found in "the 'targets' which so frequently appear in American and English 'hard-edge' abstraction"; these constitute "a direct homage to his optical experiments with 'rotatives.'"[33] Duchamp's *To Be Looked at (from the Other Side of the Glass) with One Eye, Close to, for Almost an Hour* (fig. 5), a work on glass acquired by the Museum of Modern Art in 1953, is a mechanical image that includes a targetlike form composed of concentric circles presumably intended to channel the gaze. In fact, the *Green Box* reveals explicit notes by Duchamp for a "target," planned for the upper realm of the *Large Glass,* that "corresponds to the vanishing point (in perspective), to be shot at with matches tipped in fresh paint, in order to form a figure"— the "visible flattening . . . of the demultiplied body."[34]

In his own published review of the *Green Box* in 1960, Johns described the *Large Glass,* in which "the walls of the Philadelphia museum show through," as a "painting" (Duchamp's own word) that "allow(s) the changing focus of the eye, of the mind, to place the viewer where he is, not elsewhere."[35] *Where he is:* if a target is an instrument relating both to mesmerizing opticality (Duchamp, Picabia, and the "rotative") and to the searching gaze through real space, then Johns' target (in which heavy materiality substitutes for the transparency of glass) is also an instrument of the present tense, calling up representation only to defeat the metaphorical terms on which the very practice of representation (and even most abstract image-making) depends, especially in the conjuring of a realm of light and atmosphere within the frame. The beholder of a Target painting enters no fictive realm; instead, he is where he is (or, as Steinberg would claim, he is obviated by the painting's self-sufficiency — which amounts to an identical claim for the painting as an object in real time). Johns' painted and built-up image is not just a surrogate for the target; it functions in the manner of the actual thing, and that condition fixes us in place.

In Duchampian terms, the target, the flag, and the number are often referred to in Johns' work as "readymade" images. Johns himself described them, now famously, as "things the mind already knows"[36] — that is, predetermined and self-evident ("preformed, conventional, depersonalized, factual, exterior elements"[37]); elsewhere, he said that, with flags and targets, he used "the whole picture at a time, only to make 'seeing' meaningless."[38] In its identity as an image-object, the painting (or drawing) of the target aspires to the condition of the readymade,[39] the ordinary hardware appliance selected by the artist and thereby deactivated, having entered the realm of "art." Johns' target is not, in the end, something we shoot at; but like the Duchamp readymade, its status as painting reflects no irrevocable diminishment of use-value (it could, in principle, be reactivated, returned intact to the world from which it was extracted). If anything, it relocates function as a premise: "The machined ready-mades," Johns wrote in his Duchamp review, "*serve* as works of art and *become* works of art through this service." In Johns' formulation, estheticism has become a utilitarian function.

This is an essential turn, since the thingness and functionality of a painting preoccupied Johns in statements and interviews throughout the period. The nature of painting was described by him in notably practical terms: repeatedly, Johns spoke of painting practice as a concrete problem-solving operation composed of "physical actions."[40] His now-celebrated note (from 1963 or 1964) concerning process as procedure must be understood in this way: "Take an object / Do something to it / Do something else to it." Indeed, the remark is followed on the same page by a variant: "Take a canvas / Put a mark on it / Put another mark on it." Applying paint to canvas is, then, the equivalent of "doing something" to an object. There is a second variant: "Make something / Find a use for it / and / or / Invent a function / Find an object."[41] The theme of the three passages is the literality and *functionality* of the painting as thing, and as late as 1965, by which time his work had arguably begun to change scope, Johns was still inventing rhetoric in order to describe the work in this way: "I personally would like to keep the painting in a state of shunning statement, so that

one is left with fact." He likes the thickness of the paint surface, for it reminds him that paint has a "three-dimensional objective quality." "It seems to me," he continues, in this interview with David Sylvester, "it is simply an extension of that recognition to get to the point where you use an object in the painting the same way you use the paint in the painting . . . The canvas is an object, the paint is an object, and object is object." Johns is speaking, in the last clause, of appended objects (the broom and cup in *Fool's House,* for example), but his rationale is internalized and ingenuous: "What of the objects you began with," Sylvester queries, in response to the artist's claim about the meaning of an object. Reflexively, Johns asks back: "The empty canvas?"[42] And, in fact, Johns makes a similar point when, in his works, he addresses the stretched canvas back to front: by employing stretcher bars as instruments for scraping the paint surface, and mounting them there; by attaching wooden slats, which could at first be mistaken for strainers, up the center of the front of the canvas; and by affixing a stretched canvas facedown against the surface of a painting, in *Fool's House, Souvenir 2,* and *According to What.* ("In many of my paintings one has a sense that there is a back and side to them too.")[43] But the acute objectification of painting had already been expressed in a startling claim from 1959, one made in relation to the practical recognition of painting as surface with respect to the monochrome. There Johns had explained that the readymade nature of the target (and other motifs) allowed him to "work on other levels . . . : For instance, I've always thought of painting as a surface; painting it one color made this very clear. Then I decided that looking at a painting should not require a special kind of focus like going to church. A picture ought to be looked at the same way you look at a radiator."[44]

When a painting is likened to a radiator, a heavy, inert, functional entity that possesses some genuine visual interest but that exists in a state of shunning statement, what ontological realm is being claimed for the painting as art? The public progress of *Target with Plaster Casts* is useful in this regard. In 1957 it was solicited by the Jewish Museum for an exhibition called *Artists of the New York School: Second Generation* (although, as already noted, it was withdrawn; ultimately only *Green Target* was shown).[45] After having appeared in Johns' first solo exhibition at the Castelli Gallery (and at one in Milan), it was included in *New Forms — New Media,* an exhibition of recent assemblage and "junk" sculpture at the Martha Jackson Gallery in 1960.[46] Historical categories become fixed over time but are often originally fluid or vague. The shifting identity of *Target with Plaster Casts,* surely one of the most generative objects in art since midcentury, is revealing: first taken for a late abstract expressionist painting, it was soon to be claimed, as an assemblage, for the emergence of "new forms." Early criticism of Johns' work reflects the slippage. In "After Abstract Expressionism," published in 1962, Greenberg tried to characterize Johns as a late example of a phenomenon he referred to as "homeless representation," his phrase for the paradox of "descriptive painterliness" in abstract painting (exemplified, above all, in work by de Kooning and his followers), which, Greenberg maintains, evokes a representational impulse on the part of the painter. Following Greenberg, Fried believed Johns' manner after 1959 placed him in a historical moment that had already passed, even if the artist was obviously wielding a De Kooningesque brush with some critical irony.[47] But, in 1963, Kozloff credited Johns instead with "call[ing] a halt to the faltering advance of Greenbergian 'modernism,'" having replaced "the exhausted conventions of Abstract Expressionism with an entirely new set of conventions, themselves elaborately pre-exhausted by everyday usage." Even the abstract expressionist claim for the subjectivity of facture "was a masquerade whose bluff was decisively called by Johns . . . , an act which still has many disquieting overtones."[48]

Target with Plaster Casts was homeless indeed, although not only in Greenberg's sense of the term. Further, regarding its frank representation of the body, the sexual dimension of *Target with Plaster Casts* (which was, after all, kept out of the Jewish Museum exhibition due to the jury's discomfort), was barely addressed by critics of the period. In 1960, Johns sent the work to Paris for *L'Exposition Internationale du Surréalisme: 1959–1960;* Duchamp, whom Johns had come to know, recommended him to André Breton

for the show. Johns was asked to submit "work of an erotic nature," and Johns and Castelli understood Duchamp to mean the *Target with Plaster Casts*.[49] Few of Johns' early observers were at all prepared to address his work in this way.[50] But then none of them, for all their formal acuity, even acknowledged the fact that Johns' early paintings were executed over layers of collage — that they were embodied in another way. Johns' brushwork was observed in the relationship of the tangible stroke to an evocation of pictorial space, and the "flat" motif was addressed for the way it doubles or maps the surface of the canvas. But the wax medium is barely mentioned, and collage is wholly unremarked, apparently unrecognized, notwithstanding Johns' conviction (as evidenced in his notebooks as late as 1963) that the surface of collage and encaustic is "heavy."[51] There would, then, seem to be a selective manner of addressing the material (not to say somatic) nature of Johns' work early on, one largely conditioned by the properties of abstract expressionist painting Johns was understood to engage or eschew.

About the newsprint, Johns said, looking back in 1965, that the text and photographic images were not his concern (except in the example of *Flag above White with Collage*, where a repeating face shows through the paint surface). According to the artist, any relationship of lexical sense to the work in question is arbitrary or coincidental. It may be hard to accept this claim at face value, but, in fact, reading the legible passages of fine print that show through from underneath a painting by Johns is a singularly unrewarding occupation; at best, one is left to select those words that possess a punning or oblique relationship to the work and to reject the ones — far outnumbering them — that don't.[52] "Sometimes I looked at the paper for different kinds of color, different sizes of type, of course, and perhaps some of the words went into my mind; I was not conscious of it."[53] It would be a mistake, however, to characterize Johns' formal motivations as simply a function of taste. It is, instead, as *medium* that newsprint — the paper and the type — participates in the ontology of the work, for the proliferation of mundane, monochromatic text, fast and disposable by nature, has a sort of cultural currency that directly opposes the unthinking emblematic significance of Johns' visual "schemata" (to use Kozloff's term)[54] — the target, as well as the number and the flag. "It had a different kind of information on it," he later said about newsprint, "an information that was contrary, that had nothing to do with the activity." "It also gives a three-dimensional sense to the work," a quality that reminds Johns of the way a newspaper is actually used, by turning pages.[55] The information of the newsprint is canceled or obscured by Johns' process, even as the bulk of the paper — carefully laid down in small juxtaposed and overlapping fragments or units like the strokes of the brush — endows the painting with its heightened object-quality. That quality in turn corresponds to Johns' claims for the materiality of paint. Indeed, in the early paintings with collage, most of the paint surface is not applied directly to the canvas support; instead, the intervening newsprint renders paint something like an appended material. If newsprint serves as anything else, it is as a form of underdrawing, the graphic pattern of the type manifesting an arbitrary play of hatching marks that connote — while failing to depict — volume through shadow and light. In this we take our cue from Johns' actual drawing procedure, where a mechanical, repetitive deposit of marks accumulates in varying material densities but is — given the agency of the schematic image — denied the ability to conjure volumetric chiaroscuro; nonetheless, a palpable depth and substance can be sensed. Beginning in 1955, this is an unprecedented function for drawing.

Johns' concern for the objectification of paint and the painted canvas certainly corresponds in principle to Rauschenberg's work of the same period, his so-called Combines. Indeed, one of the Combines now in Johns' own collection virtually allegorizes the condition of painting — and Johns' position within it — during the second half of the 1950s. Called *Paint Cans* (fig. 6), this small assemblage from 1954 is a shallow wooden box containing cans of house paint — two cut open and laid flat and four vertically stacked in a compartment

flush with the work's right side (somewhat in the fashion of the shelf along the top of *Target with Four Faces*); spilling over with running paint, *Paint Cans* neatly addresses paint itself as a kind of readymade — or, better, as a found object. The Rauschenberg *Paint Cans* references nonart paint in abstract expressionist painting (Jackson Pollock's, above all), and it anticipates Frank Stella's post-Pollock ambition several years later in works that also explicitly drew on Johns' repetitive stripe for their deadpan anticompositional strategy (fig. 7): "to keep the paint as good as it was in the can."[56] Stella's housepainter technique is an extrapolation of Johns' nonmetaphorical application of paint. In relation to Johns, it also addresses the subjectivity of abstract expressionist facture as a bluff (even if the affect of Stella's Black paintings is no joke), and it does so in canvases of ab-ex scale.

Johns' collage surface, composed mostly of the daily press, is as banal a material as anything in Rauschenberg's work (newsprint itself was used by Rauschenberg as well, just as it was painted over by De Kooning before him). But Johns' oil paint medium is a fine-art one that includes the addition of wax, which invokes ancient practice, not the hardware store.[57] Johns' paint runs much like Rauschenberg's does, although the rivulets are more the residue of chance, which he patiently courts by applying the medium thinly, rather than a function of deliberate spillage. Between 1955 and 1965, in evolving ways, then, Johns compressed multiple mediums into a single body of work, privileging none yet positioning them (or layering them) in critical relation to one another. Schematic images; language; the mechanical device; the plaster cast or imprint of the body; a form of drawing that solicits chiaroscuro but does not deploy it, physically depositing charcoal and graphite as a mass that coalesces around an image no deeper — yet no less substantial — than the sheet: these elements show that, through his mediums, Johns was negotiating a realm of signification that is neither abstract nor representational. More properly speaking, it could be called a realm of perpetual correction and cancelation.

Above all, despite shared concerns, the character of Johns' work of the 1950s in its formality and deliberation and in its peculiar staring power is unlike — even utterly opposed to — that of Rauschenberg's. Kozloff compared Johns' approach to the image with "certain aspects of Carolingian and Byzantine art": "He does not really 'represent' these schemata, even though they are almost always recognizable objects or signs, but rather he *upholds* them as vessels of some mysterious efficacy."[58] But it is the material nature of the work that sustains and expresses this upholding, and it does so during the fifties through embodiment

6. Robert Rauschenberg, *Paint Cans*, 1954, Collection of Jasper Johns

7. Hollis Frampton, *Frank Stella, New York, 1959*, Addison Gallery of American Art, Gift of Marion Faller, Addison Art Drive

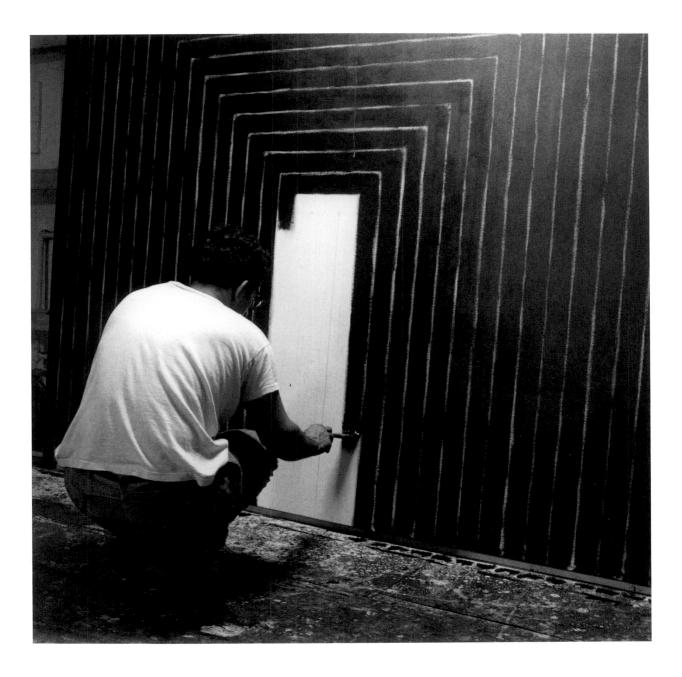

and objectification, which lend physical weight to the predetermined (and "pre-exhausted") image — the image that is present but that somehow, as even Johns' contemporaries observed, defies the conventions of representation. Beginning in 1959, the single image is replaced by procedures and operations, indexical techniques and applications of language that differently objectify painting and drawing, where canvas and sheet emerge primarily as activated sites. This is something a painting or drawing always is, to a degree; now it is primarily such a thing — although, to be sure, not exclusively so.

One measure of the alterity of Johns' work comes in the form of a small, almost unknown drawing from 1964 (cat. 83), a square diagram divided into four ruled columns, each labeled at the top with a separate technical procedure that is demonstrated below: *cut, tear, scrape, erase.* Conspicuous in its absence is the word "mark" or "deposit" or anything that references addition rather than subtraction. This drawing cannot be imagined as the work of any other artist at that time, although the impulse behind it will subsequently be relevant to scores of them. Most prominent of all is Richard Serra, whose "verb list" (fig. 8), composed three years later, is an inventory of physical actions ("to cut," "to tear," and "to erase" among them) to be performed — as "sculptural" operations — on mediums or materials. Serra's list roughly stands

to roll
to crease
to fold
to store
to bend
to shorten
to twist
to dapple
to crumple
to shave
to tear
to chip
to split
to cut
to sever
to drop
to remove
to simplify
to differ
to disarrange
to open
to mix
to splash
to knot
to spill
to droop
to flow

to curve
to lift
to inlay
to impress
to fire
to flood
to smear
to rotate
to swirl
to support
to hook
to suspend
to spread
to hang
to collect
of tension
of gravity
of entropy
of nature
of grouping
of layering
of felting
to grasp
to tighten
to bundle
to heap
to gather

to scatter
to arrange
to repair
to discard
to pair
to distribute
to surfeit
to complement
to enclose
to surround
to encircle
to hide
to cover
to wrap
to dig
to tie
to bind
to weave
to join
to match
to laminate
to bond
to hinge
to mark
to expand
to dilute
to light

to modulate
to distill
of waves
of electromagnetic
of inertia
of ionization
of polarization
of refraction
of simultaneity
of tides
of reflection
of equilibrium
of symmetry
of friction
to stretch
to bounce
to erase
to spray
to systematize
to refer
to force
of mapping
of location
of context
of time
of carbonization
to continue

8. Richard Serra, *Verb List*, 1967–1968, Collection of the artist

9. Richard Serra with Philip Glass at East Houston Street in 1970, making *Splash Piece: Casting*, Photograph by Mark Lancaster

for a generation, or period, of "process" art (best defined in a landmark essay by Robert Morris, who coined the phrase "the phenomenology of making"[59]). It is no coincidence in this regard that Serra's most extreme incarnation of process, the throwing of molten lead into the space of a room where wall meets floor (the lead cools to form a negative cast), was conducted in two places: the Castelli warehouse exhibition space in 1969 and, the following year, at Johns' studio on Houston Street (fig. 9). As Kirk Varnedoe has observed, this performative work, called *Splash Piece: Casting*, "embodies Johns' transmission of Duchamp's ideas — in this case about measurement and systems of chance — into physical . . . terms," terms that also pertain to the legacy of Pollock for artists of Serra's generation. Serra told Varnedoe that he valued Johns' early process as a form of labor, demonstrating an "aggressive indifference that refused to distinguish between major and minor activities."[60] How the physical expression of chance procedures and labor flourished within Johns' own circle can be demonstrated by the work of John Cage and Merce Cunningham. Cunningham's experiments in dance are especially relevant, pertaining as they do to the actions of the body. In *Solo Suite in Space and Time*, a piece from 1953, for example, "the spacial [*sic*] plan for the dance, which was the beginning procedure, was found by numbering the imperfections on a piece of paper (one for each of the dances) and by random action the order of the numbers. The time was found by taking lined paper, each line representing 5″ intervals. Imperfections were again marked on the paper and the time lengths of phrases obtained from random numbering of the imperfections in relation to the number of seconds." In *Crises* (1960), the dancers' instructions are selected from various lists by the toss of a coin. Specified actions are recorded as nonrepresentational procedures: "bend rise extend turn glide dart jump fall" (fig. 10).[61]

Johns' small drawing (which was produced in Tokyo, and clearly corresponds to the two No drawings — each annotated "scrape" — that were executed at the same time, cats. 84, 85) reflects the past ten years of his practice, his concern with the procedures of "art" from within painting's condition of "exhausted possibilities." It is Johns' own "verb list," and it is a remarkable inventory, representing process as a sequence of physical operations with itemization itself an example: the activity of art-making as a

10. Merce Cunningham, Notebook page (detail), *Crises*, 1960, Cunningham Dance Foundation, New York

repertoire of deliberate actions taken against a resistant medium or, more specifically, against the sheet or canvas as a support. (It is equally remarkable *as* inventory in that Johns' list predates list-making itself as a strategic activity among conceptual artists during the midsixties.)[62] Notably, Serra's transitive verbs are recorded in the infinitive; the implication of process is primarily one of action (result is secondary). Johns' verbs can also be read as nouns labeling actions — violations — already accomplished. Serra would have us move on; Johns asks us to linger over the object as a site of intervention. "Scrape" means "*to* scrape" as well as "*a* scrape." This probably unself-conscious ambiguity is one that privileges embodiment or objectification over the action alone.

"Find ways to apply paint with simple movement of objects."[63] The fact is, the practice of painting has always been such a thing. But for Johns the making of a work consists of the following: a series of procedures that *manifest* but do not *represent* according to the conventions of figuration. Johns' target, as we have seen, obviates depiction in that it is both referent and representation — the painting being, for all practical purposes, as "good" as a functioning example of the "real" thing. The plaster cast and the imprint of hand or foot (or the biting mouth) portray the body by being indexically derived from it. The name of a color is not the color but identifies it (strictly according to the conventions of language). The device scrape solely references the instrument's mechanical action — the redeployment of the paint stick or the stretcher bar. The ruler, as device, heightens this literality by measuring the scrape according to "actual" (again, conventional) standards of quantification, which previously had no place in painting and drawing — in picture-making as a fictive enterprise (but for the genre of nineteenth-century trompe l'oeil, which did interest Johns). In this setting, Johns' brushwork both before and after 1959 must be understood as, at least, meaning to exist independently of the metaphorical application of paint; for application, we substitute the word "deposit." And the studied "subjectivity" of the brush in the later works "calls the bluff" of abstract expressionist facture, representing as it does a mechanical or ritualized performance of allover painting — with Johns' (recalling Cage's description) "working everywhere at the same time rather than starting at one point, finishing it and going on to another."[64]

These operations form the substructure of the narrative of motifs from 1955 to 1965, a period during which painting — both the procedure and the thing — is scrutinized in primarily material terms. Here process is a function of physical actions. It is also addressed as a state of focus or attention. Johns' work was spoken of by critics as expressing irony or doubt, and Johns himself credited Duchamp with establishing a useful element of philosophical doubt about the nature and practice of art.[65] But doubt should not be isolated from distraction, which is Duchamp's primary mode of operation (or inoperativeness), for physical labor in the service of the "retinal" nature of painting is precisely what Duchamp claimed to shun, replacing it in part with the equally philosophical pursuit of boredom. Johns substituted the principle of labor only; that is, he reversed the direction of Duchamp's move, maintaining its premise (painting as labor devoid of ideas), even its relationship to boredom, but further recognizing that Duchamp's position equally supports an "aggressive indifference" to the distinction between major and minor activities — a no-claim approach to material practice. Working through (where Duchamp, instead, had simply stopped), Johns brought the labor of painting to a new place, one that might be associated with the epistemology of the absurd.

Rosalind Krauss, one of the first critics to examine Johns' admitted interest in the philosophy of Ludwig Wittgenstein, observed that the ruler as scraping device in Johns' work after 1960 is nothing less than a demonstration of a specific Wittgensteinian distinction between the identification of an object through name versus use. This distinction employs an image — a yardstick — that the philosopher uses to illustrate a proposition from the *Philosophical Investigations* concerning measure versus number in the meaning of the number "one."[66] There is no question that Wittgenstein was important to Johns. But the device (derived from the delineation of the target, thus substituting mechanical rotation for the function of focused seeing) tells us more.

"The only other object of note in Erskine's room was a picture, hanging on the wall, from a nail. A circle, obviously described by a compass, and broken at its lowest point, occupied the middle foreground of this picture. Was it receding? Watt had that impression. In the eastern background appeared a point, or dot... And he wondered what the artist had intended to represent (Watt knew nothing about painting), a circle and its centre in search of each other, or a circle and its centre in search of a centre and a circle respectively, or a circle and its centre in search of its centre and a circle respectively, or a circle and a centre in search of its centre and a circle respectively, or..."[67] This excerpt from a passage that occupies an entire page of Samuel Beckett's novel *Watt*, first published in 1953, brings us close to the optical shift represented by the gradual substitution of device for target and to the quality of attention figured by mechanical rotation, or by repetition, through which Beckett (another of Johns' authors, with whom he would later collaborate on a project) transfixes the reader, inhibiting his ability to make descriptive sense of the text. Beckett's device yields syntactical circularity — frustration and trance. "Concentricity" in the metallic stripe paintings of Frank Stella (fig. 11), a form of abstraction that "could never have developed without the spectacle of [Johns'] contrariness," was taken by Kozloff to reveal a concern for "boredom, monotony, even hypnosis" (ultimately revealing "the painter's purposeful blankness of mind").[68] This observation helps us define the parameters of Johns' move from concentric target to rotating device — from focused attention to the mechanics of the distracted gaze. And boredom, which Johns himself sometimes cites as one condition for his work,[69] describes rotation as monotony in the world of Duchampian physics.

SLOW LIFE; VICIOUS CIRCLE; ONANISM; ROUND TRIP; MONOTONOUS FLY WHEEL: these words, among others, copied from Duchamp's *Green Box* by Johns in the drawing *Litanies of the Chariot* (cat. 49) in 1961, bring *Watt*'s observations back to Duchamp's realm of optical daze. And what does Watt derive from his "prolonged and irksome meditations"? A question "of great importance in Watt's opinion: Was the picture a fixed and stable member of the edifice, like Mr. Knott's bed, for example, or was it simply a manner of paradigm, here to-day and gone to-morrow, a term in a series... like the centuries that fall from the pod of eternity. A moment's reflection satisfied Watt that the picture had not been long in the house, and that it

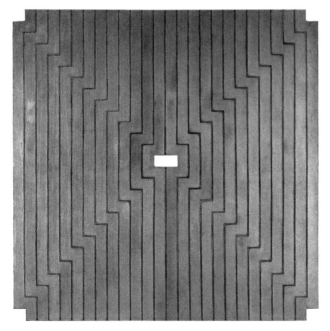

11. Frank Stella, *Avicenna,* 1960, The Menil Collection, Houston

12. Mel Bochner, *Measurement: 90 Degrees,* 1968, Installation, artist's studio, 1968, Collection of the artist

would not remain long in the house, and that it was one of a series." Johns' formulation is grounded in Watt's query: the painted canvas as furniture, as functional thing, versus the painting as an element in a series that expresses a paradigm. The operations of Watt's Johns would include concentricity, rotation, and repetition; there the target as an instrument of seeing (a paradigmatic, quasi-functional object-image) becomes a pinion, a mechanical fixation, a constraint, a tautological trace.

Cut. Tear. Scrape. Erase. These words name actions and describe them; they are also imperatives. *Painting Bitten by a Man.* As violations or subtractions, such demonstrations stand apart from the application of a medium to a support — apart, that is, from the means through which the artist *produces* an image (unless we invoke the figure of the tabula rasa, sometimes specifically understood to reference a wax tablet, blank in anticipation of a physical impression). What they represent are modes of addressing the art object as such — *as* an object. In Johns' words, one "stares" at a painting, without focus; one "uses" it; one "adds [pictorial] space" to it while trying to maintain its character as an "object painting"; finally, "one likes to think there is no difference between looking at a work of art and looking at not a work of art."[70] The device is a key element here, for it possesses multiple implications that wholly obviate the representational or subjective mark: it draws; it is deployed to act against a medium; it measures or maps a support; it excludes and contains space; it signifies the body as an instrument of extension, as a compass. In fact, in all of these functions, Johns' device can be said to have introduced the notion of the "cut," soon to be a primary conceptual tool for artists emerging just after Johns — above all Serra, who sometimes used the word "device" to describe instruments of measure or division in his work, and Carl Andre. A work such as Serra's *Cutting Device: Base Plate Measure* from 1969 explicitly names the "device" in this way, as a formal mechanism that, in this case, demonstrates the cut as a new means through which to achieve and express the raw, abstract division of material and, ultimately, of space.[71] But it was Mel Bochner who adapted the device as compass for "mechanical" drawing in a sequence of Measurement works (fig. 12). Nails, string, and charcoal or chalk diagram the degrees of an angle on the wall and floor of the studio. (The apparatus functions simultaneously to demonstrate and to represent; the drawing divides real as well as abstract space, yet it occupies a state of arbitrary significance in relation to experience versus memory or thought.)

Johns' prescriptions regarding the use and the objectification of a painting were all made during the early 1960s, when he had become well enough known to be sought after for interviews and when he clearly felt he wanted to articulate the premises of his work (he is often portrayed as evasive in this regard, but no artist of his generation has tried to explain more than Johns has in print[72]). They are dialogic observations, not statements, provoked by questions about process and representation, and they are repeated by Johns throughout this period. Johns seems to describe his efforts as a matter less of invention than of discovery or recognition. Painting represents itself first; the techniques of art-making are maintained as such, and kept in place; the artist acknowledges them. Shunning statement, Johns deployed procedures that are solely or largely mechanical. If the work has a "subject," then it is seeing as a state of attention. If the painting has a life in the world, then it is first and foremost as a manifestation of its own process: "The processes involved in painting are of greater certainty and of, I believe, greater meaning than the referential aspects of the painting. I think the processes involved in the painting in themselves mean as much or more than any reference value that the painting has."[73] Johns is not withholding interpretation. He is explaining that these qualities are the only ones the artist can truly control (as opposed to the interpretive fate of the work after it enters the public domain).

Johns said that the first painting of a flag appeared to him in a dream.[74] Of course it did, for it had to be an object disembodied (the dream) and then reembodied (the work), an example of incarnation — of image as thing. But he also said, remarkably, that the object-quality of a painting is "tragic": being finished, the painting becomes familiar; it can no longer "astonish." "It becomes," he said, "a kind of real object; you have to pick it up and move it about the room and pack it in a box."[75] For Johns, a painting is something to be physically addressed, even violated, as a material entity, and an image is deployed only insofar as it, too, is understood to be a tangible thing.

Are there clear terms according to which these qualities can specifically be said to produce conditions for meaning? In fact, such terms have been established, and, given what I want to claim is the peculiarity of Johns' work (its foreignness, as distinguished from novelty or invention), it is apt that they belong to a field of study that is otherwise unrelated to New York in 1960. In sacred art of the premodern West, the ontological and functional object-quality of the image was not only taken for granted, but integral to the life of the work as an instrument of seeing and apprehension — the "dynamics of contemplation."[76] Above all, the early Christian and medieval icon represents a class of object — including the cult figure, the woodblock print, the reliquary, the effigy, and other signifying artifacts of popular and cultic religious practice — that can be dissociated in certain ways from the identity of the art object in modern Europe. The application of the icon and related objects is a ritualized one; as such, it adheres to specific rules or prescriptions that pertain as much to the material nature of the object as to its role as image. Indeed, such objects allow us to designate terms for a separate identity of the image as thing, terms that often directly pertain to the body.

This historical phenomenon is in no way to be taken as a model for Johns per se or as a specific "source." Sacred objects derive from doctrine and a shared belief system (this is partly signified by the recourse to anthropology that has come to characterize one method of advanced scholarship in the field of medieval studies) that obviously places them out of reach as an ideological model of any kind for Johns.[77] But the notion of a class or genus of object is useful to the interpretation of Johns' work, which has often been described or apprehended as — to redirect Greenberg's epithet — "homeless." The work's procedures, then, allow us to identify it with a distinct condition of premodern image-making that is theoretically coherent.

The portrait icon of Christ or the Virgin — the *imago* (as opposed to a *historia*, or narrative image) — functions through its presumed authenticity, which confirms its viability as an object of liturgical practice or private veneration. Within a system organized around concepts of archetype, prototype, original, and copy, the holy image serves a structure of purposes: to record the historical personage of Jesus or Mary; to recall or perpetuate the *acheropsita*, the "original" or miraculous icon portrait; to stimulate contemplation and thereby summon the divine archetype (Christ, the Virgin); to incarnate the divinity and so to serve as a surrogate or intermediary. Beyond the icon, such terms and functions also characterize the larger realm of holy objects: the relics and reliquaries of the saints and the portable tools (books, woodcuts, small panel paintings) of private Passion devotion. The holy image can be said to attain an extreme state of literality in the form of the impression or mechanical trace, a prime instance being the early Christian *Mandylion,* later reborn in the West as Saint Veronica's veil, the *vera icona,* or "true image" of Christ's face. Produced through direct contact, the veil's image was understood, somewhat paradoxically, to be "both a relic of Christ's earthly life and evidence of his divinity without human agency."[78] The imprinted veil as *imago* is depicted in many medieval allegorical representations of both Veronica and Christ. Since the practice of icon painting is partly one of replication or permutation, authorship in the modern sense is not a prominent factor in the early discourse; the miraculous mechanical image of the veil takes that premise — the absence or obviation of the author — to a material and conceptual extreme. The Greek word *acheiropoieton,* which designates a miraculous image (from which *acheropsita* is derived), translates as "not made by human hands."

Objectification of the icon and related images pertains to actualization, to the way the image is required to function. According to the conventions of the icon, the image as object is correctly addressed by the beholder in part through direct contact, or "intervention," which activates its role as surrogate or object of veneration. Public liturgical rituals also subjected certain icons to practices such as procession, and, over time, to modifications resulting from an object's sometimes changing role (and physical location) within a given church. More, objectification is often specifically related to the role of the body — of Christ's human incarnation, above all, and of the passage through bodily suffering to the sublime. Therefore, the embodiment of the image as object is encountered through the bodily operations of the beholder: art was not just seen, but "felt, kissed, eaten and smelled."[79] In this regard, given the interventions endured by the icon and related images, the utility of the object might be manifested by its eventual effacement (where repeated touching, for example, could wear through a painted or engraved image).

The place of early woodblock printmaking in this larger historical theory of images is pointedly germane. The woodblock print itself is, inherently, a replica or imitation; it was identified as such with the medieval Latin term *contrafactur* or (in sixteenth-century German printmaking) the word *counterfeit*, or *abconterfeitung*, implying derivation from an "original" prototype. This language represents a specific claim to authenticity,[80] a condition that is strikingly relevant, as it introduces a concept with virtually no role in art-making after the late medieval period, but with renewed pertinence to art after the mid-twentieth century: actual size. The very number of identical images permitted by the woodblock print — the nature of the print as a widely disseminated repetition — allowed it to function as a standard of accuracy in practical terms. This was true for both the secular and the sacred image. A German broadsheet from 1501 advertises

13. *Broadside: An Invitation to an Arms Competition,* German, in or after 1501, National Gallery of Art, Washington, Rosenwald Collection, 1951

14. *The Crucifixion of Christ in a T-Cross,* German, c. 1500, Kupferstichkabinett, Staatliche Museen zu Berlin

 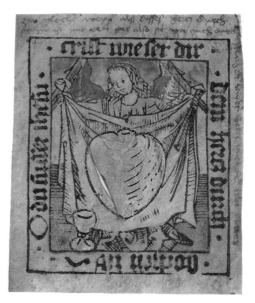

15. *Arma Christi*, 1320, Bibliothèque Royale de Belgique, Brussels, MS 4459-70, fol. 150v

16. *The Measure of the Side Wound and the Body of Christ*, German, c. 1484–1492, National Gallery of Art, Washington, Rosenwald Collection, 1943

17. *The Sacred Heart on a Cloth Held by an Angel*, Nuremberg, c. 1480–1490, The Metropolitan Museum of Art, New York, Bequest of James C. McGuire, 1931

a shooting contest for crossbow and musket (fig. 13), announcing the range to be 300 feet. As a unit of measure, the "foot" was not yet standardized; the print includes a linear element or gauge that allowed prospective competitors to ascertain proper distance in preparation for the event. The image also contains a circle and a smaller bar — the correct measure of the actual target and the increments of spacing.[81] In other words, this representation belongs to the object world in precise utilitarian terms through the concept of literal dimension or scale.

In popular (or quasi-magical) sacred image practice, literality lends stark immediacy to the visual language of allegory when the concept of actual size is applied to the representation of Christ's wounds. A cult of the Five Wounds in late medieval Europe motivated images portraying Christ's wounds (hands, feet, and side) as discrete, disembodied objects. Beginning in the fourteenth century, printed images of this kind possessed precise information value in that they were often designed to represent the actual dimension of, for example, the driven nails (fig. 14) or the Savior's side wound, which is always portrayed in the shape of a mandorla (fig. 15). (The dimensions of the wound, which are fairly consistent throughout representations of this kind, were determined through varied sources: some were said to derive from the actual measure of the Holy Lance, while others were ascribed to visionary encounters with Christ. In some cases, the measure itself, as an entity, was transported in a reliquary.)[82] These images were often explicitly intended for physical devotion; in one example (fig. 16), a seven-year indulgence is offered to whomever "kisses this wound with remorse and sorrow." This print also includes images of the stigmata and a depiction of the Veronica veil, as well as a cross that itself represents a standardized measure; multiplied by forty, it allows the beholder to ascertain the exact length of the body of Christ.[83] That is, the image is dedicated throughout to indexical traces and quantifications of the body, whether actual or depicted (the veil). In this it is related to printed images of the Sacred Heart (fig. 17), which were often pierced or cut as a form of veneration. Cultic wound images also represented an exegetical practice of Eucharistic synecdoche, through which the parts stand for — or allow the reconstruction of — the body of Christ. In turn, reference to actual size permitted a form of direct corporeal identification between Christ and the beholder's own body.

With the veneration of relics, the corporealization of the object is dialectically related to the objectification of the body itself. The relic implicates a practice of bodily partition, which is, of course, both concretely and allegorically derived from the physical trials of martyrdom, transforming the body into a ritual object or site — into a kind of image. Posthumous corporeal fragmentation was variously debated and sometimes proscribed given theories of the Resurrection, which implicates the integrity of the body.[84] Further, in the image-type known as the *arma Christi* (fig. 18), the instruments of the Passion of Christ, such as the cross, the lance, the nails, the crown of thorns, the chalice, and the veil, are generally distributed across a matrix or incipient pictorial grid, a diagrammatic approach to pictorial space that posits a realm between representational space and the flat space of the sheet. While it is not indexical in its imaging or necessarily subject to intervention in its function, the *arma Christi* allegorizes the itemized inventory of objects pertaining to the corporal punishment of Christ (and sometimes includes, among these objects, a linear measure for determining the actual length of the body of Christ).

Recent research shows that the concept of a corporealized sacred image further pertains to the materiality of the parchment pages of medieval manuscripts, often allegorically related to their textual and visual contents.[85] Specifically, manuscripts containing narratives of martyrdom and, above all, of flaying, can show signs of material actualization on and *in* the parchment leaves, themselves composed of flayed skin. Such a practice heightens the apprehension of the body as alternately mortal or — through sacrifice and transformation — sublime. Flaying narratives themselves allegorize the skin as an outer container of the immortal inner being; to be flayed is to be stripped of sin through penitence. Christ's skin could be likened to a text, the so-called Charter of Christ (a parchment washed in blood and stretched on the cross); such a comparison bears obvious implications for the vellum (sheepskin) page. Here the preparation of parchment with pumice could be invoked to recall or enact the actual and symbolic violence of the Passion, while chance material imper-

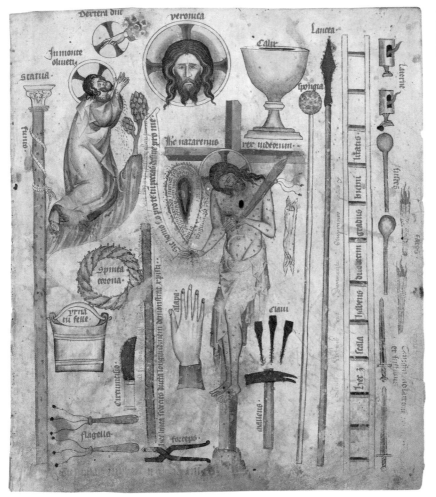

18. *Arma Christi,*
National and University
Library, Prague,
Lib. xiv A17, fol. 10r

fections in the page could be incorporated into the meaning of the text. Manuscripts further show deliberate acts of violation: vellum is "scraped, cut, split, holed [and] torn," even stitched and repaired, resulting in "visible scars." In relation to flaying and Crucifixion narratives, such violations "demand that we envisage three-dimensional bodies simultaneously as two-dimensional surfaces."

Krauss refers to Johns' painting *Passage* — with its device / ruler, its wired spoon, and the annotation "scrape" — as "a diagram of uses."[86] Later, Kozloff would remark that *Field Painting* is "about its own history."[87] Indeed, the ambition of Johns' work is one not of merely exposing process but of being plainly self-describing (if not quite *ekphrastic*). The work insists that any further claims for meaning must respect its physical and material dimensions — its object identity and the "aggressive indifference" of its labor, which are the only things about it that can be quantified or fully known. As we have seen, Johns has nothing to say about the inner life of his work, although he freely acknowledges or accepts suspicions of such a thing by his observers. Of course Johns' work is not "literal" in the manner of Stella's stripe paintings, for example (which partly derive from the targets and flags). But, despite its tangible openness, neither is it mostly formal. In this regard, its early resistance to the kind of analysis that had sustained the critical project around abstract expressionism is revealing, for the work cannot be accounted for in teleological terms pertaining to late modernist abstraction. Instead, it is, in various senses of the term, *functional*. In order "to mean" in other ways, it must operate within the bounds of a kind of instrumentalized presentness.

Johns is at pains in the work to make such a fact continually clear — albeit not programmatically so. The ten-year narrative from target to trace, drawn from cues represented by the close reciprocity of key motifs, can be cast as a form of image theory, one to which the premodern language of the sacred cult object is relevant precisely because it predates the centuries-long development of estheticism that, under conditions that were historically overdetermined, Johns would be the first to shut down. Indeed, it is as an *anti*narrative agent that the premodern image serves to portray, as it were, the mechanics — the object-quality, the functionality, and the temporal presentness — of the Johnsian *imago*.

The target is a readymade image that is itself an instrument of seeing; Johns does not replicate the image so much as construct it, concretely; it is an effigy, a materialized thing. The schematic image, as Kozloff observed, is "upheld" (as in Byzantine or Carolingian art) "as a vessel of mysterious efficacy."[88] Attention, focus, abstracted gaze, and boredom can be described as a sequence of conditions that subtend the target as object and sign. And these conditions further belong to the very slowness of Johns' procedure: the drawing of concentric bands; the tearing and pasting of newspaper fragments; the application of autonomously preserved strokes in oil paint and encaustic — all mechanical or quasi-mechanical forms of labor (with no metaphorical role pertaining to representation) that remain undisguised.

The beholder's experience of the target is, then, a two-beat operation: fast-slow, in keeping with its character as sign and as labored object. That experience further incorporates an abrupt shift when we account for the plaster casts of faces and body parts. Sequestered like relics behind lidded compartments, they demand separate orders of observation, for the cast appears to possess no relationship to the target, while its quality as a fragment directly contradicts the wholeness of the image below. The two together (target and cast) create an undeniable psychological charge by joining bodily partition to an instrument of physical risk — of seeing through space as a form of violation.[89] Even so, the modular repetition of the compartments and the casts draws from a visual language of ritual or ceremony; as an abstracting procedure, it complements the stasis of the target as a centripetal form. The lids were intended to be lifted and shut, to be subject to intervention: "the painting becomes something other than a simplified image."

The doubling of procedure and sign recurs again in the case of the target as sequence: in Johns' laborious replication of a prototype in over a dozen paintings, small and large, and as many works on paper, where rich materiality does battle with monotony and fixation. The very tactility of the works, with their thick surfaces, is amplified as a property by the monochrome target, wherein the instrument of seeing

approaches an apparitional, or quasi-invisible, state: focus becomes fixation; fixation becomes gaze; gaze becomes boredom; boredom slips into a realm of suspended temporality where seeing is an operation of contemplation in the existential present tense. Between *eikon* and attention also lies the conception of the target as a proliferated object-sign, a vehicle of intercession. The status of the Johns target as a perpetual repetition or copy (*eikon* translates as "copy") engenders a form of stylelessness. Yet as a readymade image, repetition is not *derived from* authority (in the manner of the sacred icon, for example, a copy authorized and empowered by doctrine), but *establishes* authority. A second concept of the counterfeit dating to late medieval and Renaissance sacred and secular image-making is useful: the *imago contrafacto*, which can be translated as "replica," "likeness," or even "forgery" (or, of course, "counterfeit"). The term appears in inscriptions (largely in printmaking) to indicate the explicit reproduction of a preexisting image.[90] The relevance here is to the target as a handmade repeating image (multiple times removed from a prototype) that is critically related to notions of function or use-value and originality. Indeed, Johns' procedures of brushmarking or mark-making further implicate the counterfeit in relation to, say, the mark as something like the replica of a stroke (or a passage of deposited medium as the counterfeit of an applied fragment in collage, even within a single work, but certainly in drawings after paintings).[91] Above all, as a replica, a substitute or effigy, the *contrafactum* permits representation to become, literally, an abstract operation. This directly pertains to Johns' effort — through the replication of the flat image-sign and its embodiment as image-object — to recast representation as an operation of imitation or repetition, thereby engaging it while rejecting the contrivances of illusion.

The target *eikon*, in this regard, might be said to concern itself with a desacralized, "empty" act of seeing. To make seeing "meaningless," as Johns claimed to do through the repetition of a readymade image, is to rob vision of its capacity to figure higher perception — seeing as a medium through which to glimpse

19. Eva Hesse, *Untitled*, 1967, Tony and Gail Ganz, Los Angeles

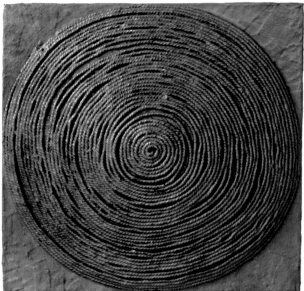

20. Eva Hesse, *Untitled,* 1967–1968, The Balti-more Museum of Art, Purchased in honor of Tom L. Freudenheim, Director, The Baltimore Museum of Art, 1971–1978, with funds con-tributed by his friends, BMA 1978

21. Eva Hesse, *Untitled,* 1966, Collection Mel Bochner and Lizbeth Marano, New York

the absolute. The legacy of the Johns target lends confirmation to the claim. In 1967–1968, Eva Hesse produced a series of Circle drawings (figs. 19, 20), precisely inscribed images of banded circles in gray ink wash or watercolor that have been delineated with the aid of a compass. They are, it would appear, derived from a series of gray-painted reliefs of flat disks of coiled twine mounted on papier-mâché (fig. 21).[92] The mechanical procedure is exposed by a pinhole in the center of each circle, a hole — recalling the punctured center of the Johns target — that for Hesse is such a pronounced element of her process that it can be made (playfully, absurdly) to channel an extrusion, a filament that protrudes like a follicle through each one. The proliferation of Hesse's motif (on single sheets and from work to work, like Johns' sequence of mono-chrome targets) is partly a testimony to repetition as a natural extension of the continuous motion that produces the banded disk, now no longer a target per se (although clearly derived from one) — no longer a motif endowed with authority. Nonetheless, it is still a figure for seeing (and for drawing) as a function of focus and drift.

In the Device paintings the mechanics of rotation (or gyration), once deployed to produce the target, come to substitute for the target as image. Any vestige of an image that is more than the sum of the opera-tions through which it was created falls away. As both a trace and an intervention, the inscribed line and the scrape solely issue from the mechanical instrument (the pivoting slat) and the pressure of the hand. If the device *describes* at all, it is only in that it produces an indexical image (of the line or arc: here describ-ing is *in*scribing). The target disappears and the device (the target's means) remains, a present-tense instru-ment of touch as much as, or more than, of seeing. The device arm takes the form of a stretcher bar or a ruler, two objects that quantify the canvas as a literal object possessed of measurable (but not metaphorical) dimension — in other words, of "actual size." That concept, with its early history in medieval representa-tion, was acquired from Johns by younger artists, including Morris and Bochner (figs. 22, 23), who took it up during the 1960s as a tool for demonstrating the vagaries of quantification as a system of meaning.

(In reference to the Johnsian device, it is surely no coincidence that Bochner's hand is the object of this exercise, in which the photographic image is used to examine the truth value of representation). At the same time, with the advent of a more promiscuous palette and a broader brush, Johns introduced the stencil, another literalizing device. Repetition in the manner of the Target sequence is diminished, although Johns continues to produce drawings and other works on paper that derive from — even almost replicate — some paintings. Collage surfaces and wax or encaustic are gradually eliminated, but the device and other appended objects proliferate, an annotated inventory of the instruments — the "arms" — of the studio: broom, rag, cup; dangling brush; ruler; even the stretched canvas.

 To the mechanical trace of the device Johns adds the direct cast of the body. The cast body part (which we might now also characterize as an effigy) was introduced in 1955 and returns in *Watchman* and *According to What*. The technique of the imprint is the sole procedure in producing the Skin drawings, where the full gyration of the artist's head results in a lateral image revealed by devicelike movements of the arm. (Johns would again take up the imprint as an imaging procedure during the midseventies in order to capture his full upper body and pelvis, fig. 24.) In these works the three-dimensional body is "envisaged" as a two-dimensional surface; such a thing is Johns' *vera icona*. Further corporeal interventions — applications *of* the body as well as acts that implicate the somatic nature of the work — recur throughout the early sixties, when a painting or drawing is not only seen but touched and bitten; impregnated; ironed; cut, torn, scraped, and erased. The recurring presence of forks and spoons (attached to wires or depicted as such) relates to this manner of addressing the work. "'Looking,'" Johns wrote, in a note from 1964, "is & is not 'eating' & also 'being eaten.'"[93]

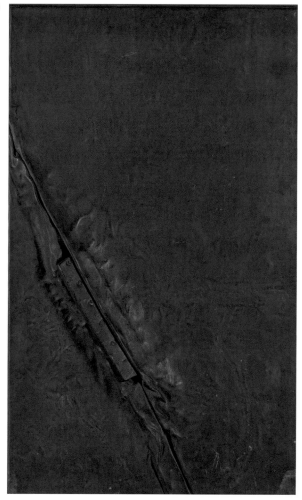

22

23

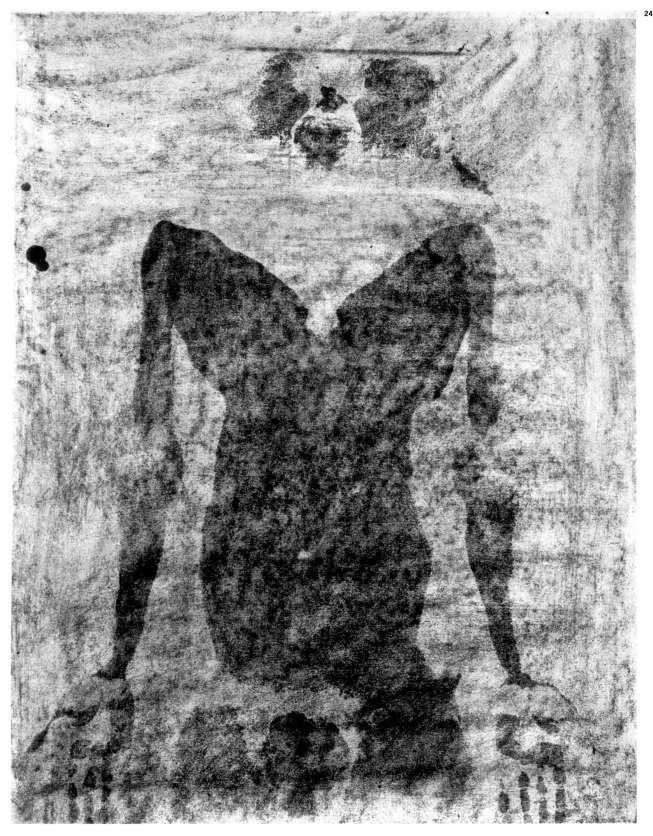

22. Robert Morris, *Slab with Ruler,* 1964, Yale University Art Gallery, Lent by Richard Brown Baker, B. A. 1935

23. Mel Bochner, *Actual Size (Hand),* 1968, Collection of the artist

24. Jasper Johns, *Skin,* 1975, Mr. Richard Serra and Ms. Clara Weyergraf-Serra

"The mind makes / marks, language / measurements."[94] What is foreign to Johns' work with respect to the premodern object is the role of the referent in the functioning of the early icon. For Johns, marks, language, and measurements tautologically reference the work itself. Compare Cunningham, for whom the imperfections of the page (in contrast to the example of the parchment) motivate the random organization of a dance. That is not just nonrepresentational but mechanical, aggressively *emptied* of authorized meaning. In the rhetoric of the work, the body is itself; the dance solely consists of position and change. The *mind* makes marks, language, measurement: even the conceptual nature of Johns' work between 1955 and 1965 is largely relegated to the marking and the quantification of a support. If the work is allegorical, then its referents in that regard are the exhausted *conventions* of painting and drawing, and a new role — literally, a concrete *place* — for the body (and, by implication, for the self). But, the premodern image is referential according to largely concrete or mechanical means (including the procedure of the copy); these can help us characterize the otherwise estranged operations of Johns' art, which replicate, figure, and corporealize but do not depict. As a scarred, embodied image, a Johns object is an effigy or a simulacrum that, although serving no collective practice, does mean to be derived from an ethical position concerning the ontology of the image as a functioning *thing*. The name: as object, language is mechanically applied; it names color or — in *Zone, Diver, No, Voice* — it serves to name the work itself. As representation, the name is an abstraction, but its stenciled presence (to paraphrase Judd) "introduces an abrupt actuality."

In his work on the nature of the image "before the era of art," Hans Belting describes the relationship of the image, as simulacrum, to the body with a terminological triad: *Bild-Körper-Medium* (image-body-medium). Indeed, the early icon is both a "copy" and an embodied image, a double identity that structures the narrative of target / device / trace. Throughout the early 1960s, Johns applies the device scrape and the body imprint to individual paintings. Both elements are examples of the "mechanical" trace; both are forms of "representation" that minimize the conventional questions of authorship; both address the surface of the painting as an object or a material site. Used together, in a work such as *Periscope (Hart Crane)*, they recall the Target paintings with plaster casts and establish a compound relationship between instrument and body — as a narrative arc from the first Targets to the bodily trace. The imprint reveals the body to be a tool; pictorially attached to the device (or to an image of the device)[95] in paintings where the device is likened to an outstretched arm, the palm print is therefore explicitly identified with the mechanical "compass" of the artist's reach.

The armlike image in *Periscope (Hart Crane)* has been said to allude to an event: Crane's drunken suicide leap from the deck of a ship in 1932 (and the impression some fellow passengers had of the signaling, drowning man). More, as Alan Solomon was the first to discuss, the image of a "periscope" appears in Crane's "Cape Hatteras," section IV of *The Bridge* (directly referenced in Johns' print *Hatteras*): "What whisperings of far watches on the main / Relapsing into silence, while time clears / Our lenses, lifts a focus, resurrects / A periscope to glimpse what joys or pain / Our eyes can share or answer — then deflects / Us, shunting to a labyrinth submersed / Where each sees only his dim past reversed...."[96] It should be noted that "Cape Hatteras," a Whitmanesque song to aviation, is also filled with images of dimensionality, specifically of space and the cutting of space ("But that star-glistered salver of infinity, / The circle, blind crucible of endless space, / Is sluiced by motion, — subjugated never"). The compass as measuring device also occurs prominently in one of Crane's best-known works, "At Melville's Tomb," a poem that was the subject of a landmark letter by the poet regarding the "logic" or "dynamics" of metaphor (elsewhere of "inferential meaning"). The letter, which is reprinted in the two standard early biographies of Crane,[97] was addressed to Harriet Monroe, editor of *Poetry* magazine. Monroe published "At Melville's Tomb" but saw fit to request revisions from Crane (who refused), occasioning an exchange between them that appeared with the poem,

in October 1926. There we find Crane explaining the "relationship between poetic metaphor and ordinary logic": how the "apparent illogic" of a poetic figure "operates so logically in conjunction with its context in the poem as to establish its claim to another logic, quite independent of the original definition of the word or phrase or image thus employed." Such an operation, he observes, depends on the receptivity of the reader, demanding "completely other faculties of recognition than the pure rationalistic associations permit." Monroe, in turn, itemizes her objections to the "illogic" of specific metaphors in the poem, and Crane patiently responds to each complaint. One passage from the final stanza of "At Melville's Tomb" reads: "Compass, quadrant, and sextant contrive / No farther tides…" (ellipsis in the original). Monroe observes that compass, quadrant, and sextant do not *contrive* tides but merely record them. Given Johns' interest in Crane, the poet's reply is worth quoting in full: "Hasn't it often occurred that instruments originally invented for record and computation have inadvertently so extended concepts of the entity they were invented to measure (concepts of space, etc.) in the mind and imagination that employed them, that they may metaphorically be said to have extended the original boundaries of the entity measured? This little bit of 'relativity' ought not to be discredited in poetry now that scientists are proceeding to measure the universe on principles of pure *ratio,* quite as metaphorical, so far as previous standards of scientific methods extended, as some of the axioms in *Job.*"

Crane's letter suggests how metaphor (distinct from the anecdotal image of the waving arm) functions in Johns' art, even as the representational role of metaphor has been drained from the application of pasted collage scrap, graphic mark, or stroke of paint. Indeed, brushmarking, we recall, had been "arbitrary": it "had to do with my arm moving," the mark signifying the trace of a physical procedure. The device-arm (with its imprinted — not depicted — hand) does not humanize the compass but accomplishes the reverse, in that it further implicates an exclusively mechanical operation for the pivoting arm. The device as slat — above all, as ruler — is only capable of recording a trace (the arc) that is no bigger and no smaller than the instrument's actual size. This is also true for the imprint of the hand. Together these two elements literalize and mechanize notions of touch and reach. The compass does, then, both measure and contrive in that it maps the physical limits of the canvas or sheet, thereby (re)defining its boundaries. The device is as much a metaphorical representation of dimension as an actual one; better, it portrays measure itself (Crane's "ratio") as a figure, a metaphorical conceit the logic of which is thoroughly internal to the character of the work. By declaring the dimensions of the work to be a bounded world, the arm discloses the physical condition of the body — of the artist's own body — to be that of a device.

The absurd remains in play. As device, the body is literally circumscribed in its functionality. The device-circle can be a tragicomic figure of mechanical witlessness (rotation, gyration); of repetitive, monotonous physical activity; of concentricity as principle, if no longer as design (the "purposeful blankness of mind" that Kozloff attributed to Stella's Johnsian stripes). Rotation, tracing back to Duchamp, is both optical (target / precision optics) and mechanical, as in the blades of the *Rotary Glass* (or the onanism of the *Chocolate Grinder,* soon to be the bachelor surrogate in Duchamp's *Large Glass*),[98] or it constitutes the instrumentalization of seeing as a purely physical state. But rotation also represents the potential energy of the *Bicycle Wheel,* Duchamp's readymade of 1914, which, set into an inverted fork (a truing stand mounted on a stool), is deprived of its original purpose, now responding spinningly to the artist's occasional whim. The original function of the common bicycle wheel would be valued by Beckett, as Hugh Kenner discusses in his groundbreaking book on the writer published in 1962.[99] For Beckett, the abject body — decrepit, disabled, or confined — is abetted by the simple machine (Kenner identifies the figure on a bicycle, which recurs in the novels, as a "Cartesian centaur"). Beckett's characters all seek recourse to a device, and are, at some point, deprived of it. The Unnamable loses his stick ("That is the outstanding event of the day"), a loss that results, "painfully, in an understanding of the Stick, shorn of all its accidents, such as I had

25. Hans Namuth, *Jackson Pollock,* 1950, National Portrait Gallery, Smithsonian Institution, Washington, Gift of the Estate of Hans Namuth

26. Richard Serra throwing lead, 1969, Collection of the artist

27. Anzai Shigeo, *Richard Serra at Tokyo Biennale,* 1970, Collection of Museum of Contemporary Art, Tokyo

never dreamt of." And observe the crippled Molloy: "Molloy, after his bicycle has been abandoned, does not then resign himself to the human shuffle and forego that realm where arc, tangent and trajectory describe the locus of ideal motion." For the bicycle Molloy substitutes crutches, which, as fulcrum, enable him to achieve, with "rapture," a "series of little flights." Throughout his notes, Cunningham calls the prescribed gestural inventory of a given dance the "gamut of movement"; in *Crises,* parts of the body are — according to chance determination — restricted from use (and in some cases literally bound to the body).[100] Johns' gamut of movement is mechanical rotation, which figures the gesture of the body as instrument, while every other procedure in the work deploys a device: "brushmarking," stenciling, rotation, imprint. Such operations are all that is left to art-making in an era of looming inarticulateness and doubt, when the object-nature of a painting is tenaciously asserted yet deemed to be "tragic."

Any claim for the literal and allegorical significance of circumscription and extension or reach as a pictorial operation around 1960 is haunted by one figure: Jackson Pollock. For it is Pollock who, abandoning the direct application of the brush for brushes and sticks[101] as implements for flinging paint (for deploying paint, rather than applying it, according to the laws of gravity), addressed painting as a concrete procedure of physical reach (fig. 25). (Indeed, it was Pollock whom Serra invoked in Johns' studio when Serra, arms outstretched, threw molten lead there in 1970. The occasion can be imagined using the celebrated photograph of Serra at the Castelli warehouse, fig. 26.) Pollock's process is, in fact, a series of extensions and rotations: circling the canvas, which is spread across the floor (the "ground"), and reaching out across it, dribbling and propelling paint — from the pivoting shoulder as much as from the elbow or wrist. Pollock's work exceeds the sum of its operations. Its gyrations are expressions of high subjectivity, even histrionically so; and the pictorial space is, in its way, almost as metaphorical as the space of representation — the painting is "bigger" than the canvas. Yet the work is equally concrete: even as it is the final domain of the metaphorical application of the medium, it is the first articulation of the medium's pictorial life in the world of the real. The apparent likeness between Johns' handprints and Pollock's (which occur in a number of Pollock's large canvases[102]) is something of a pseudomorphism; yet the indexicality of Pollock's print does find a certain fulfillment on the surface of Johns' work.

Rotation, reach as compass, and the mechanical condition of the body were subconsciously repre-
sented by Johns in a dream, one that, unlike the oft-remarked dream-state incarnation of the first painting
of a flag, has gone unobserved. As related by Cage, the dream was inspired by the sight of a legless amputee
in the New York subway, a man who sold pencils and got around in a wheeled cart. In the dream, "Johns
was that man, devising a system of ropes and pulleys by which to pull himself up so that he would be able to
paint on the upper parts of the canvas, which were otherwise out of his reach. He thought, too, of changing
the position of the canvas, putting it flat on the floor. But a question arose: How could he move around
without leaving the traces of his wheels in the paint."[103] These traces return us to the footprints that appear
in the two versions of *Pinion*, named for a mechanical restraint and solely composed of impressions of the
body and their stenciled names. We also think of the footprints in *Diver*. Produced by placing the sheet (or
lithographic stone) on the floor, such elements signify the standing body's literal relationship to the support.
Yet, in the artist's dream, it is the wheel that designates the body as a device.

Johns is Pollock is Molloy. Pollock's compass is an instrument of release, the mechanical procedure
as a skittering corporeal one in actual space — large enough to contain efforts that, from around or within
the very edge, just barely exceed reach. "In seeing such work as 'human behavior,'" Morris wrote of Pollock,
"several coordinates are involved: nature of materials, the restraints of gravity, the limited mobility of the
body interacting with both."[104] Johns' compass is an instrument of containment, the body compressed into
the mechanical "actuality" of two-dimensional space, the flat canvas no larger than a rotation of the arm. His
dream concerns the end of abstract expressionism, but it sublates Pollock's instrumentalization of the body,
now an expression of both mobility and constraint. In 1970 an extrapolation of Johns' Pollock was enacted
when Serra mapped the circular plan for a work, *To Encircle Base Plate Hexagram, Right Angles Inverted*, with
chalk and a string compass on the ground (fig. 27); the diagram contains the body because the body is the
very device that measures and records the delineated form.

27

*in*to the support (we imagine Johns stepping onto the panels of *Diver,* laid out on the floor, in order to create footprints, standing in pictorial space at the very brink of the real). He applies himself to it, rotating his head across the page like a cylinder seal; the surface of the head is spread across the sheet in the form of a lateral — perhaps scriptural — imprint. The result indexes both the surface of the body and the temporality of the procedure. Johns created the impression by leaning toward the wall from his waist, in the fashion of a prop (returning to Serra's verb list, we read: "to roll," "to impress," "to smear," "to rotate," "to hinge," "to mark"). Imprints of the artist's palms are applied in the manner of a stamp. The traces of the oil are revealed by strokes of charcoal produced in repeated motions from the elbow and shoulder, as the photographs also show.

A decade later, certain implications of the Skin drawings were taken up by Morris in his series of Blind Time drawings (fig. 32). Produced directly with the artist's fingers in an eyes-shut state of self-imposed "blindness," each drawing possesses its own procedural instructions and an estimated time for execution, listed along with the actual elapsed time. But Johns' Skin drawings, although executed in an equally mechanical fashion, are decidedly eerie.[111] Prefiguring Morris, the engineering draftsman's paper Johns uses contains a box at the lower right corner to be filled in according to a standardized list of quantifying or descriptive categories: "drawn by"; "chk'd"; "traced"; "scale"; "date"; "material"; "drawing no."; and "revisions," changes made to the drawing (interventions), which are to be initialed. By contrast, the sheet, with its flattened image of an expressionless face and pressing hands, "reads" like a kind of trap, one that is delimited by the dimensions of the body. The plane of painting and drawing is a confining space, and it is dramatized in that way even as Johns' peculiar but deadpan procedure declares confinement to be no more than the physical perimeter within which one must necessarily work. The corporeal is manifested as sheer surface; through the mechanics of the oil trace and the application of charcoal, a drawing is identified as a flayed skin. The impression of the face, which is partial, is both an *envisagement* and an *effacement.*

"To keep me busy." This is Bruce Nauman's reply to the question, "Who is your art for," put to him in an interview of 1971. We have no photograph of Johns producing *Painting Bitten by a Man,* but we do have film and videotape records of Nauman pursuing simple or banal actions alone in his California studio in 1966, when "there was nothing in my studio because I didn't have much money for materials."[112] Nauman turned to himself quite literally as medium and device. Under the sign of Beckett and Wittgenstein, he took up language and the body: accidental meanings propagated by puns and language games; geometric and organic moulds in fiberglass and rubber; casts and impressions of body parts in plaster and wax;

and mechanical repetition as an expression of confinement and fatigue. Cunningham, too, was cited by Nauman as an important figure, and we recall the choreographer's *Crises* when we observe studio films that show Nauman moving and permuting the positions of his body within deliberately circumscribed spaces: "stamping in the studio"; "bouncing in the corner"; executing extensions "on the perimeter of a square"; performing a "Beckett walk" (fig. 33). Nauman's pursuits were, of course, historically overdetermined by circumstances on the West Coast during the midsixties, but his work can surely be used to leverage an interpretation of Johns' oeuvre through 1965. For Nauman, like Serra, Bochner, Morris, and Hesse, belonged to a population of artists for whom the complex legacy of abstract expressionist painting had already been partially processed by Johns, among others, and whose work was variously occupied by questions of materiality and procedures such as gestural repetition, naming, and trace-making. The body as device and the corporealizing operations of art-making as a mechanical activity were fundamental during the period and never ceased occupying the deep structure of future work.

"Press as much of the front surface of / your body (palms in or out, left or right cheek) / against the wall as possible. / Press very hard and concentrate. / Form an image of yourself (suppose you / had just stepped forward) on the / opposite side of the wall pressing / back against the wall very hard. / Press hard and concentrate on the / image pressing very hard. / (the image pressing very hard) / Press your front surface and back surface / toward each other and begin to ignore or block the thickness of the wall. (remove / the wall)."[113] What do these instructions — the partial text from Nauman's *Body Pressure* (1974) — represent if not (perhaps unintentionally) the procedure for *Studies for "Skin" I–IV* (fig. 34) hauntingly configured as a two-part operation: reincarnation (the trace) and deincarnation (the disappearance of the wall as support)? In the end, only the indexical *vera icona* remains, a freestanding manifestation of both corporality and confinement.

Perhaps even more fantastical but no less mechanical is *Flayed Earth / Flayed Self; Skin / Sink*, an installation and prose piece from 1973:[114] "The problem is to divide your / skin into six equal parts / lines starting at your feet and / ending at your head (five lines to make six / equal surface areas) to twist and spiral / into the ground, your skin peeling off / stretching and expanding to cover the surface / of the earth indicated by the spiraling / waves generated by the spiraling twisting / screwing descent and investiture (investment / or investing) of the earth by your swelling body. / Spiraling twisting ascent descent screwing

33. Bruce Nauman, Still from *Slow Angle Walk (Beckett Walk)*, 1968, Distributed by Electronic Arts Intermix, New York

34. Johns producing a Skin drawing, Photograph by Ugo Mulas, Archivio Ugo Mulas, Milan

all was fading, waves and particles, there could be no things but nameless things, no names but thingless names." His struggle is a struggle with meaning, of course: "I had quite a sensitive ear, and sounds unencumbered with precise meaning were registered perhaps better by me than most." But he admits to "a defect of the understanding perhaps, which only began to vibrate on repeated solicitations, or which did vibrate, if you like, but at a lower frequency, or a higher, than that of ratiocination." Communication is almost impossible: "the words I heard, and heard distinctly, having quite a sensitive ear, were heard for a first time, then a second, and often even a third, as pure sounds, free of all meaning, and this is probably one of the reasons why conversation was unspeakably painful to me." Molloy's condition is one of multiple disorientations. The futile operations of speech appear to double the constrictions of space and of the physical conditions of the body. Disorientation is manifested not only by the content of Beckett's sentences but by his deployment of language as a form of groping (through repetition, for example). Sense eludes him but not sensation: "And without going so far as to say that I saw the world upside down (that would have been too easy), it is certain that I saw it in a way inordinately formal, though I was far from being an aesthete, or an artist. And of my two eyes only one functioning more or less correctly, I misjudged the distance separating me from the other world, and often I stretched out my hand for what was far beyond my reach, and often I knocked against obstacles scarcely visible on the horizon."[117] When we take aim at a target, we close one eye.

The arcing band in *Voice* brings us (full circle) back to the origin of the device mechanism in the image of the target and to the original role of the compass in the production of the concentric field. The device and the implements — the spoon and fork — that are suspended down the right edge of this painting signify the kinetic as well as the potential energy of intervention, both of which, from the beginning, had characterized the target as object-image. The indexical scrape discloses an inscription of the body (within a canvas of dimensions large enough to contain it) that in the Targets of 1955 originally took the more explicit form of the cast mould, of partition and trace. *Voice* draws itself, then, close to the Target series, even as it draws the implications of the target to something of a close. One would want to describe the painting — in its economy and its scale — as a summa, but the ethic of process in Johns' work of the first decade permits nothing like the false security of a conclusion. Indeed, if *Voice* concerns itself with language (as sound deprived of meaning), inscribing the name of the medium of the spoken word within the material space of painting where the word as thing becomes a thingless name, then it does so in the form of a new negation. As much as the painting *Voice* belongs to the pictorial space of the drawing *Diver*, it also belongs to the melancholic paradigm established by the single painting that contains an utterance: *NO*.

Why is *Painting Bitten by a Man* set onto a type plate? A related object makes a brief but instructive appearance in *The Recognitions* by William Gaddis, an epic novel published in 1955, concerning originality and counterfeit writ large, the debasement of art by mass culture and the search for soul and redemption amidst the shards of sacred culture. The book can be read in multiple ways for the conflicted condition of esthetic faith at midcentury. Even brief moments in the narrative signify a crisis regarding the viability of meaning in art and language. "A minute later, she'd pulled the frame of type from the flatbed handpress in the corner, unlocked it and spilled the letters all over the floor, banged the Bible closed, hesitated a moment over it and then pushed it off into the pile of metal spellingless letters."[118] There, in Johns' studio, amidst a tangled heap of jars, brushes, and rags on the floor beneath *Periscope (Hart Crane)*, are the letter stencils, a "pile of metal spellingless letters" — the tools but also the ruins of painting and language (fig. 36). Johns' appreciation of the simple reversibility of the stencil, whereby the color-name appears backward in *Periscope (Hart Crane)* and other paintings, is the ultimate portrayal of the word as an arbitrary symbolic object. His use

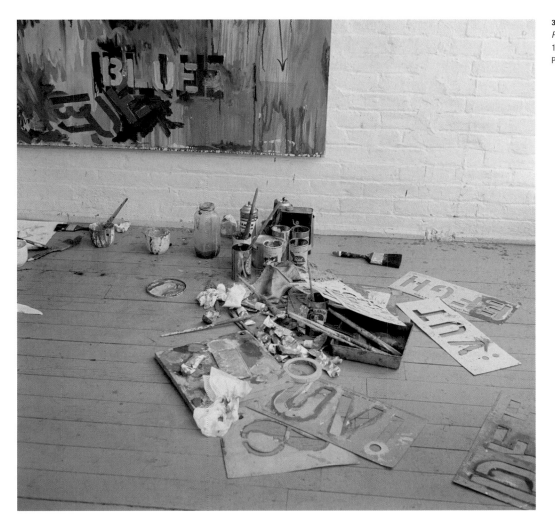

of a type plate for *Painting Bitten by a Man* may have been a function of convenience, but such an object does serve to support the agency of the body (the bite) with a substratum belonging to the materiality of printed language — not of utterance, but of the mechanical word.

The two were inseparable for Johns. We might take our cue in this case from the very word "imprint," which establishes an adequation of the body (and its trace) with the word as object. One notebook entry from 1963 reads like verse: "There seems to be a sort / of 'pressure area' 'underneath' / (spatializing) / (find another / way to picture / this) / language which operates in / such a way as to force the / language to change. (I'm / believing painting to be / a language, or wishing / language to be any sort / of recognition). If one / takes delight in that / kind of changing process / one moves toward new / recognitions (?), names, / images."[119] For Gaddis, a "recognition" expresses an authentic apprehension of the conditions of the past; for Johns, "recognition" signifies change, and it must be said that, among the ruins, Johns means to rebuild. But for both artists, "recognition" is opposed to invention or originality. The literal coordinates are clear: for Johns, the place of the self in the work is a projection of the place of the self in the world. And in a series of extraordinary "notes," another painter, the one in Gaddis' novel, gropes with the object-image in just these Johnsian terms: "Whether I, myself, am object or image, they at once, are both, real or fancied, they are both, concrete or abstract, they are both, exactly, and in proportion to this disproportionate I, being knowingly or unknowingly neither one nor the other, yet to be capable of creating it, welded as one, perhaps not even welded but actually from the beginning one, am also both and what I must, without changing, modifying, or compromising, be."[120]

38. Yoshiaki Tono, "Jasper Johns in Tokyo," *Bijutsu Techo* (August 1964); reprinted in Varnedoe, *Writings,* 1996, 104.

39. Robert Rosenblum was the first to make the comparison; see Rosenblum, "Castelli Group," *Arts Magazine* (May 1957), 53.

40. Walter Hopps, "An Interview with Jasper Johns," *Artforum* (March 1965); reprinted in Varnedoe, *Writings,* 1996, 109.

41. Reprinted in Varnedoe, *Writings,* 1996, 31.

42. Sylvester, "Jasper Johns," in *Interviews,* 2001, 159, 167, 170.

43. Sylvester, "Jasper Johns," in *Interviews,* 2001, 166.

44. "His Heart Belongs to Dada"; reprinted in Varnedoe, *Writings,* 1996, 82.

45. *The New York School: Second Generation* [exh. cat., The Jewish Museum] (New York, 1957); *Green Target* is listed there as *Target in Green.* The exhibition also included work by Rauschenberg, as well as some twenty abstract and figurative painters; the catalogue introduction is by Leo Steinberg, although he makes no mention of Johns.

46. The catalogue text was written by Lawrence Alloway, an essay entitled "Junk Culture as a Tradition." For a recent consideration of the significance of this exhibition in the formation of early Pop, see Graham Bader, "Donald's Numbness," *Oxford Art Journal* 29, no. 1 (2006), 98–100.

47. Fried, "New York Letter," 1963, 60–61.

48. Kozloff, "Letter to the Editor," 1963, 88–89.

49. Information from a letter in the Leo Castelli Archives, quoted in Varnedoe, *Retrospective,* 1996, 387 n. 23.

50. This situation has changed radically in recent years. The *Target with Plaster Casts* itself has been examined for its association of "danger with the nude male body," and said therefore to reflect "the male homosexual experience" as a "system of understanding," especially in the context of American culture in 1955; see Kenneth E. Silver, "Modes of Disclosure: The Construction of Gay Identity and the Rise of Pop Art," in *Hand-Painted Pop,* 1993, 190.

51. In a notebook from 1963, the annotation "heavy collage" is sandwiched between "encaustic" and "relief." See Varnedoe, *Writings,* 1996, 30, 53.

52. As a strategy, the veiling of the chatter of newsprint and other printed and handwritten papers certainly demands consideration. Whether or not to decipher the text will remain debated, however, for it is ever possible to retrieve putatively "meaningful" passages from within these paintings. This is the premise of Joan Carpenter, "The Infra-Iconography of Jasper Johns," *Art Journal* (Spring 1977), 221–227, who observes a horoscope and an article on astrology in the *Target with Four Faces* and has it recall that "one of Johns' early patrons was an astrologer," which "seems appropriate in a collage design of wheels whirling within wheels." The problem, apart from the question of what to read and what to ignore, is the very value of addressing Johns' work as a catalogue of "references." There is also the matter of selected application: Carpenter remarks on "handwritten papers" and a typed text concerning the work of Merce Cunningham in *Green Target,* and further observes that the newsprint component "respond[s] to Johns' more abstract, less emblematic conception of that particular work as a whole," as opposed to *Target with Four Faces.* It is unclear why this should necessarily be true of cuttings extracted from "the travel section [and the] theater, sports and comic pages" or why those cuttings should obviate the other papers, which are more personal to the artist. Nor is it certain that such a claim can be made for the numerous other monochrome targets that Johns produced during the midfifties. Infrared imaging has since shown that *Green Target* includes pages torn from Suzanne Langer's *Philosophy in a New Key.* See Jim Coddington and Suzanne Siano, "Infrared Imaging of Twentieth Century Works of Art," in Ashok Roy and Perry Smith, eds., *Tradition and Innovation: Advances in Conservation* (London, 2000), 43. Are we to change our understanding of the painting as a result of this, or do we favor the newspaper clippings instead? Would such a change apply to all the monochrome targets? Perhaps more subtle is Orton's uniquely exhaustive account of the text that lurks beneath Johns' first *Flag,* which, he observes, is largely composed of trivial news items, avoiding the headline stories of the moment and establishing instead a "camp" superficiality meaningfully out of step with the patriotism of the flag itself. See Orton, *Figuring,* 1994, 125–130.

53. Hopps, "Interview with Johns," in Varnedoe, *Writings,* 1996, 106.

54. Kozloff, *Renderings,* 1968, 208.

55. David Bourdon, interview with Johns from 1977, transcribed in full in Varnedoe, *Writings,* 1996, 161–162.

56. Bruce Glaser, "Questions to Stella and Judd," a radio interview published in *ARTnews* (September 1966); reprinted in Gregory Battcock, *Minimal Art: A Critical Anthology* (Berkeley, 1995), 157.

57. In a later interview, Johns refers to having started the Flag paintings with enamel paint, but found that it did not dry fast enough to preserve the brushstrokes. Roberta J. M. Olson, "Jasper Johns: Getting Rid of Ideas," *The SoHo Weekly News* (November 3, 1977); reprinted in Varnedoe, *Writings,* 1996, 166.

58. Kozloff, "Letter to the Editor," 1963, 89.

59. Robert Morris, "Some Notes on the Phenomenology of Making: The Search for the Motivated," *Artforum* (April 1970); reprinted in *Continuous Project Altered Daily: The Writings of Robert Morris* (Cambridge and London, 1993), 71–93.

60. Varnedoe, "Fire: Johns' Work as Seen and Used by American Artists," in *Retrospective,* 1996, 102.

61. From commentary and original notebook pages reproduced in Merce Cunningham, *Changes: Notes on Choreography* (New York, 1968), unpaginated.

62. For an important discussion of Mel Bochner, Ed Ruscha, Serra, and others in this regard, see Briony Fer, *The Infinite Line: Re-Making Art After Modernism* (London and New Haven, 2004), 145–162.

63. This quotation is drawn from the Johns epigram at the beginning of the essay; see Johns, Book A, c. 1963, 32; reprinted in Varnedoe, *Writings,* 1996, 52.

64. Johns manner of painting after 1959 was described in 1965 by Rosalind Krauss — wrongly, I think — as an "abandoned painterliness unprecedented in his work"; see Krauss, "Jasper Johns," 1965, 88. Krauss was certainly not suggesting, however, that Johns meant to be anything less than a critic of the painterly terms of abstract expressionism. We need, nonetheless, to be careful to distinguish between Johns' procedure and the appearance of the results of the procedure.

65. Johns, "Thoughts on Duchamp," *Art in America* (July–August 1969); reprinted in Varnedoe, *Writings,* 1996, 23.

66. Krauss, "Jasper Johns," 1965, 92. Consideration should also be given to a role for Josef Albers in Johns' statements concerning the elusiveness of the identity of color — the quality itself and the representation of color through language. Albers taught at Black Mountain and at the Yale School of Art during the 1950s and 1960s, and his students included Robert Rauschenberg. In 1963, his teachings were published as a book, *Interaction of Color.* There, he wrote, at the head of chapter 1: "If one says 'Red' (the name of a color) and there are 50 people listening, it can be expected that there will be 50 reds in their minds. And one can be sure that all these reds will be very different." Compare Johns, in an interview from that year: "You are assuming red exists, and 'red' only exists once there's been a widespread agreement that there is such a thing…In a new language or in a new painting, all of those things have not been determined on any general level." See previously unpublished excerpts from Johns' interview with Billy Klüver in March 1963, in Varnedoe, *Writings,* 1996, 87. The premise of Albers' work is that "in visual perception a color is almost never seen as it really is — as it physically is." For Albers, color is "relative" and "deceptive." See Albers, *Interaction of Color* (New Haven and London, 2005), 1. Of course, we also recognize Albers' likely acquaintance with Wittgenstein's speculations on color.

67. Samuel Beckett, *Watt* (New York, 1953), 128–129.

68. Kozloff, "Art and the New York Avant-Garde," 1964, 538.

69. See, for example, Hopps, "Interview with Johns," in Varnedoe, *Writings,* 1996, 109; *U.S.A. Artists 8: Jasper Johns,* TV documentary for N.E.T, 1966; reprinted in Varnedoe, *Writings,* 1996, 124; and Sylvester, "Jasper Johns," in *Interviews,* 2001, 154–155.

70. Interview with Yoshiaki Tono, in *Geijutsu Shincho* (August 1964); Gene R. Swenson, "What is Pop Art Part II," *Art News* (February 1964); Hopps, "An Interview with Jasper Johns"; all in Varnedoe, *Writings,* 1996, 93, 98, 110, 120; and Sylvester, "Jasper Johns," in *Interviews,* 2001, 168.

71. For device and measure in Serra's work, see, for example, his early film, *Frame,* about which the artist explained: "I found the illusion of measurements to be very interesting for the contradictions it posted in relation to the illusion of film.

At that time I was also making a sculpture called *Base Plate Measure* in which I was using measurement, and it didn't seem to be very difficult to go from one measuring device in one material to another device in film. We used a small ruler in order to make it very clear that the film was about the increment of measurement." See Anette Michaelson, "The Films of Richard Serra: An Interview" (1979), in Hal Foster and Gordon Hughes, eds., *Richard Serra* (Cambridge, Mass., 2000), 32.

72. It may simply be the case that Johns has not said what his interlocutors have wanted him to say. The claim that Johns is unforthcoming in discussing his work is a corollary to the argument that would have the work itself be encrypted, or its true content sublimated or repressed. See, for example, Charles Harrison and Fred Orton, "Jasper Johns: Meaning What You See," *Art History* (March 1984), 78–101. Harrison and Orton quote Johns' remark, "I didn't want my work to be an exposure of my feelings," as signaling a "neat trick" through which Johns "could address Modernism and not worry about self-expression." They continue: "Then in 1961 Johns' subject matter and mode of representation changed. It was as if he became a different type of artist. In general terms, after the impersonality and frequent high coloration of the previous years, the works of 1961 are subdued in color — predominantly grey — and are titled in such ways as to connote emotional conditions" (pages 92–93). Put this way, the shift is almost entirely refutable from an examination of the work; in any case, "self-expression" (whatever that is) hardly represents an imperative in art-making, especially in work as otherwise occupied, and as generative, as Johns'. The authors are faulting the artist for not performing an operation that did not seriously concern him to begin with.

73. Sylvester, "Jasper Johns," in *Interviews*, 2001, 159–160.

74. "One night I dreamed that I'd painted a flag of the United States of America, and I got up the next morning, and went out, and bought materials and began to paint this flag. That's the way the first painting, as is generally known, was done." In *U.S.A. Artists 8: Jasper Johns*; reprinted in Varnedoe, *Writings*, 1996, 123.

75. Varnedoe, *Writings*, 1996, 127. See also Johns' remark from the previous year in connection to procedures that emphasize the object nature of the painted canvas: "I always wanted to be reminded that the canvas was there, and one is reminded in one's studio because one constantly has these things to drag out; you turn it one way and you don't see it, so you turn it another way and you do see it." Sylvester, "Jasper Johns," in *Interviews*, 2001, 167.

76. The term is borrowed from Herbert L. Kessler, "Turning a Blind Eye: Medieval Art and the Dynamics of Contemplation," in J. F. Hamburger and A.-M. Bouché, eds., *The Mind's Eye: Art and Theological Argument in the Middle Ages* (Princeton, 2006), 413–439. I wish to thank Herb Kessler and Peter Parshall for patiently guiding me through some basic issues relating to the production and function of the medieval image.

77. Hans Belting, *Bild-Anthropologie: Entwürfe für eine Bildwissenschaft* (Munich, 2001). For a challenging critique, see the review by Christopher S. Wood in *Art Bulletin* (June 2004), 370–373.

78. Herbert L. Kessler, *Seeing Medieval Art* (Toronto, 2004), 73. See also Belting, *Likeness and Presence* (Chicago, 1994), 208–224; and, for other approaches, the essays in Kessler and Gerhard Wolf, eds., *The Holy Face and the Paradox of Representation* (Florence, 1998). The literature concerning the functioning of the medieval image-object is vast, although the topic is fairly new to medieval studies, reflecting recent methodological shifts in the discipline.

79. Kessler, *Seeing Medieval Art*, 2004, 176.

80. Peter Parshall, "Imago Contratacta: Images and Facts in the Northern Renaissance," *Art History* (December 1993), 554–579.

81. David Landau and Peter Parshall, *The Renaissance Print 1470–1550* (New Haven and London, 1994), 239.

82. David S. Areford, in Peter Parshall and Rainer Schoch, *Origins of European Printmaking* [exh. cat., National Gallery of Art] (Washington, 2005), 258–260, no. 78; and Areford, "The Passion Measured: A Late Medieval Diagram of the Body of Christ," in *The Broken Body: Passion Devotion in Late-Medieval Culture* (Goninger, 1998), 211–238.

83. Areford, "The Passion Measured," in *Broken Body*, 1998, 225. Areford has observed that images of the side-wound share their form with early examples of the *mappa mundi*, creating an allegorical relationship between Christ's

body and the cartographic representation of the world. This development coincided with the introduction of graphic scale-bars used to gauge depicted distances (pages 228–237). The image of the side-wound is also susceptible to allegorical sexualization; see Caroline Walker Bynum, *Fragmentation and Redemption: Essays on Gender and the Human Body in Medieval Religion* (New York, 1992), 278.

84. Bynum, *Fragmentation and Redemption*, 1992, 265–297, concerning the practice and representation of bodily partition in medieval culture.

85. Sarah Kay, "Original Skin: Flaying, Reading, and Thinking in the Legend of Saint Bartholomew and Other Works," *Journal of Medieval and Early Modern Studies* (Winter 2006), 35–73. Kay concludes with an account of various psychoanalytic theorizations of skin and of the body as an internal psychic space in the work of Melanie Klein, Gilles Deleuze, and, above all, Didier Anzieu, whose concept of the *Moi-peau* or "Skin Ego" holds clear potential for an interpretation of Johns' work of the early sixties.

86. Krauss, "Jasper Johns," 1965, 92.

87. Kozloff, "The Division and Mockery of the Self," 1970, 12.

88. Later, Kozloff described the *Target with Four Faces*: "The picture has been devaluated as a sequence of discoverable relations, but becomes hypnotic as an icon." In Kozloff, "The Division and Mockery of the Self," 1970, 11.

89. This appears to have been only first observed of Johns' Targets in 1970, by Kozloff, "The Division and Mockery of the Self," 1970, 11.

90. Parshall, "Imago Contrafacta," 1993, 554–579.

91. Conversations with Kristin Holder introduced me to the idea of the procedure of mark-making itself as a form of counterfeiting.

92. It was upon seeing Hesse's *Ishtar*, a relief consisting of two columns of circles, at the Graham Gallery's *Abstract Inflationism* exhibition in March 1966 that Mel Bochner recalls observing to Hesse their mutual interest in Johns' work. Bochner, in conversation with the author, May 18, 2006.

93. Johns, S-27, Book A, 1964, 55; reprinted in Varnedoe, *Writings*, 1996, 59.

94. Johns, Book A, c. 1963, 29; reprinted in Varnedoe, *Writings*, 1996, 51.

95. It is the case, as described in the text, that, in paintings with imprinted palms, Johns did sometimes remove the actual device and depict one instead. In *Periscope (Hart Crane)*, for example, the painted image of a slatlike arm is superimposed over the arc of smeared paint (although it is clear that this image is partly the result of the imprint of an actual slat). In *Land's End*, a similar, but longer, image of the device-arm rises from the lower edge of the painting and is associated with no arc or scrape; the scrape, placed as in *Periscope (Hart Crane)* along the upper right, still incorporates its actual device. Images of the device-arm also occur in both versions of *Diver*.

96. *Complete Poems of Hart Crane*, Marc Simon, ed. (New York and London, 1986), 77–78. See also Solomon, "Jasper Johns," in Solomon, *Johns*, 1964, 16, and Roberta Bernstein, *Johns: Paintings and Sculpture*, 1985, 109–110. For further consideration of Crane in light of sexual identity, see Orton, *Figuring*, 1994; Silver, "Modes of Disclosure," in *Hand-Painted Pop*, 1993, 184–185; and Jonathan Weinberg, "It's in the Can: Jasper Johns and the Anal Society," *Genders* (March 1, 1998), 40–56.

97. Philip Horton, *Hart Crane: The Life of an American Poet* (New York, 1937); reprinted in 1957 by Compass Books; and Brom Weber, *Hart Crane: A Biographical and Critical Study* (New York, 1948). Bernstein reports that Johns owned the Horton biography; see *Johns: Paintings and Sculptures*, 1985, 231 n. 14.

98. On the rotation of the device and Duchamp's rotary machines, see also Rose, "The Graphic Work of Jasper Johns, Part II," 1970, 71.

99. Hugh Kenner, *Samuel Beckett: A Critical Study* (London, 1962), 117–132.

100. Cunningham, *Changes*, 1968, unpaginated.

101. Kozloff remarks on the stick as a tool for both Pollock and Johns; Kozloff, "Johns and Duchamp," 1964, 44. See also Bernstein, *Johns: Paintings and Sculptures*, 1985, 47. Kozloff observes the "sudden muteness" of this "automatist element" as it is deployed in Johns' work.

102. Observed by various authors, first by Bernstein, *Johns: Paintings and Sculptures*, 1985, 230 n. 23, who cites Kozloff as having named De Kooning and Duchamp as precedents; it should also be noted that handprints occur in the paintings of Miró, among others. Precedents, in other words, are perhaps virtually meaningless.

103. Cage, "Stories," in Solomon, *Johns*, 1964, 82.

104. Morris, "Some Notes on the Phenomenology of Making," 1970; reprinted in Morris, *Continuous Project Altered*, 1993, 77.

105. Samuel Beckett and Georges Duthuit, "Three Dialogues," *Transition* 5 (1949), 97–103. The three painters under consideration, Tal Coat, André Masson, and Bram Van Velde, seem like odd choices to us now and, indeed, their identity is probably of little importance to the significance of the text. A small fragment from the Beckett / Duthuit dialogue, from a passage in Kenner's book on Beckett, was reprinted by Rosalind Krauss in "Jasper Johns: The Functions of Irony," *October* (Summer 1976), 99. But the relevance of the dialogue — which is structural as well as thematic — is only clear when it is more fully transcribed from the original, Beckett's rhetorical repetition being a significant factor in the present context. In the exchange, "unable to express / obliged to express" and "unable to act / obliged to act" are merged, becoming, at the end, the impossibility / obligation of "an expressive act."

106. Bernstein, *Johns: Paintings and Sculptures*, 1985, 108.

107. Bernstein, *Johns: Paintings and Sculptures*, 1985, 108.

108. Weber, *Hart Crane*, 1948, 425.

109. Cunningham, *Changes*, 1968, unpaginated.

110. Johns, S-23, Book A, 1964, 51; reprinted in Varnedoe, *Writings*, 1996, 57.

111. Kozloff referred to the "effect of imprisonment, of the artist himself striving to break free from the physical limits of a work into which he has willfully impregnated his own image." (The remark repeats Steinberg's choice of "impregnation" as a description for a procedure of impression that is both mechanical and, at least allusively speaking, organic.) Kozloff, "Johns," in *Renderings*, 1968, 47. Importantly, David Joselit positions the Skin drawings in this regard within a psychic history of optical and material flatness, beginning with Pollock and Greenberg. See Joselit, "Notes on Surface: Toward a Genealogy of Flatness," *Art History* (March 2000), 24–27. In Johns' art, as in Pollock's, "traces of the body are generated through performative processes which allegorize the mind." (Joselit's allegorical figure for Johns is the "magic picture pad," to which Johns likens the Skin drawing process in a notebook passage from 1970, an image, Joselit reminds us, that is close to the child's Mystic Writing Pad that Freud used to characterize the relationship between perception and memory.)

112. Interview with Willoughby Sharp, 1970; reprinted in Janet Kraynak, ed., *Please Pay Attention Please: Bruce Nauman's Words* (Cambridge, Mass., 2005), 118.

113. Nauman, "Body Pressure" (1974); reprinted in Kraynak, *Please Pay Attention Please*, 2005, 83–85.

114. Nauman, "Flayed Earth / Flayed Self (Skin / Sink)" (1973); reprinted in Kraynak, *Please Pay Attention Please*, 2005, 67–74.

115. Johns, Book A, 1964, 49; reprinted in Varnedoe, *Writings*, 1996, 34.

116. Johns, S-28, Book A, c. 1965; reprinted in Varnedoe, *Writings*, 1996, 60.

117. Beckett, *Molloy* (1953) (New York, 1997), 31, 53.

118. William Gaddis, *The Recognitions* (New York, 1993), 438. The novel takes its title from the third-century *Clementine Recognitions*. In the book, the protagonist's father invokes a *Diver*-like image by describing the martyrdom of Saint Clement, who was tied to an anchor and thrown to the bottom of the sea, where an open tomb appeared, signifying his redemption and beatification.

119. Johns, Book A, c. 1963–1964, 34; reprinted in Varnedoe, *Writings*, 1996, 53.

120. Gaddis, *Recognitions*, 1993, 472.

121. Judd, "Specific Object," *Arts Yearbook* 8 (1965); reprinted in *Judd: Writings*, 2005, 181–189.

122. Beckett, *Malone Dies* (New York and Toronto, 1997), 250.

Catalogue

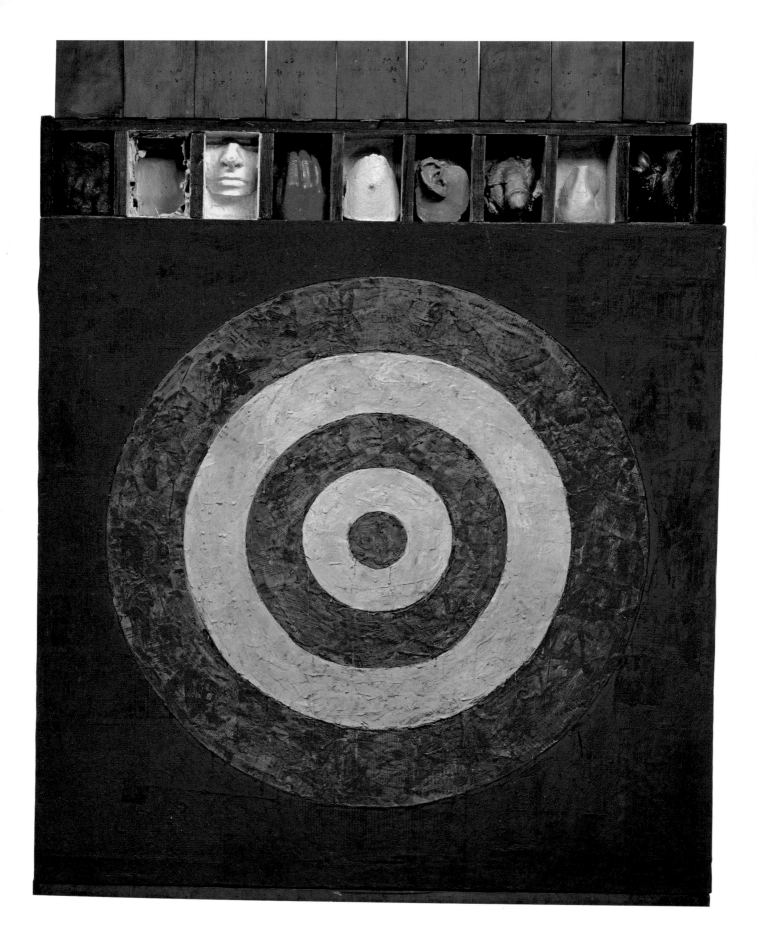

1. *Target with Plaster Casts*, 1955

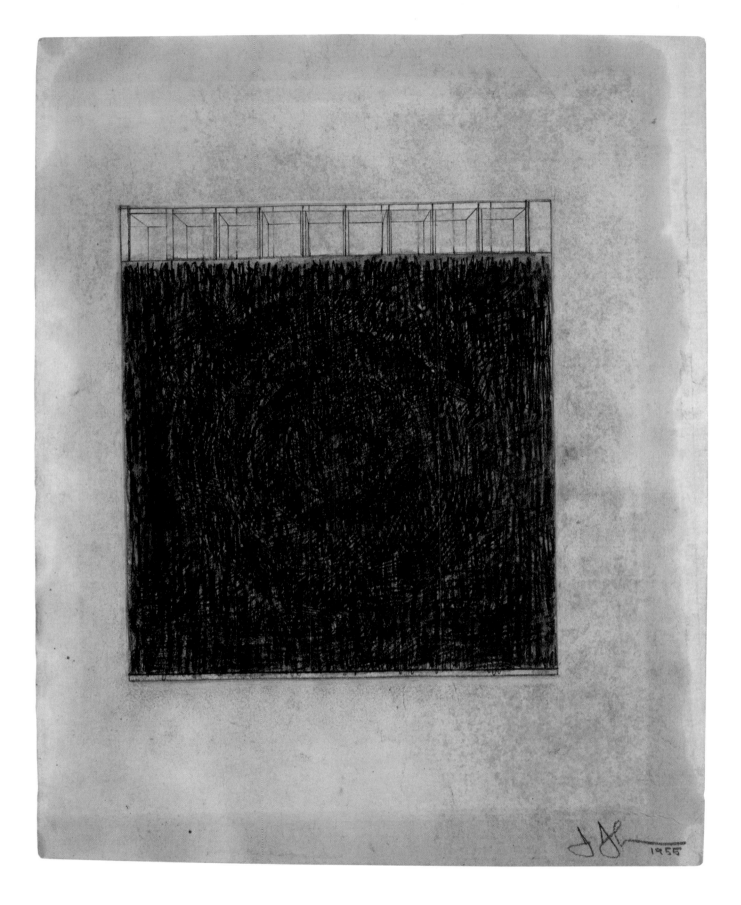

2. Target with Plaster Casts, 1955

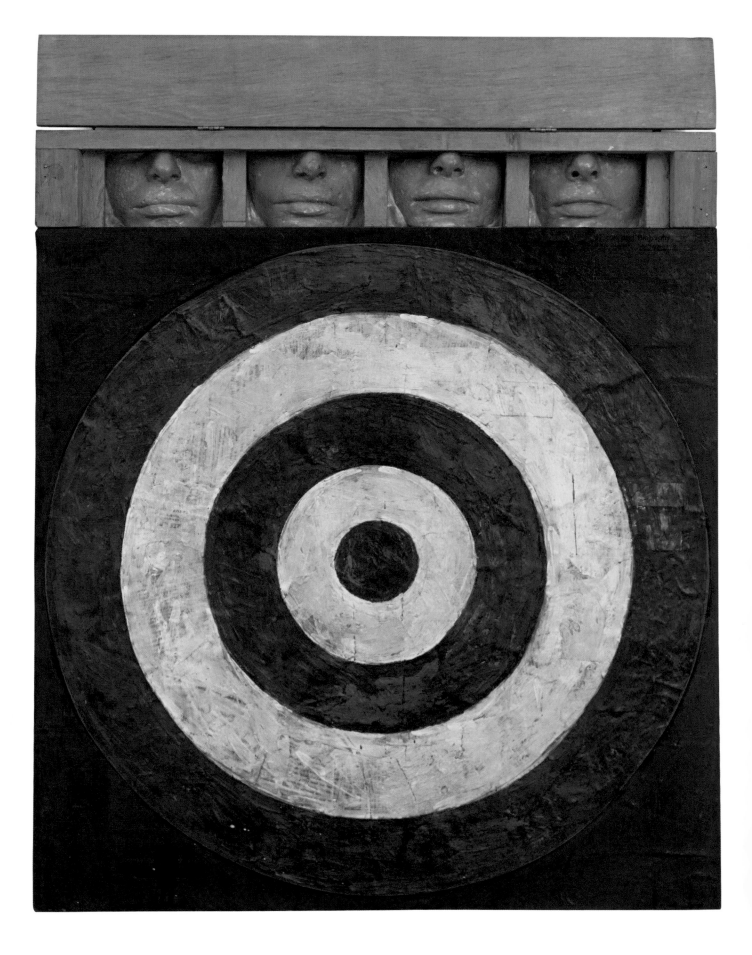

3. *Target with Four Faces*, 1955

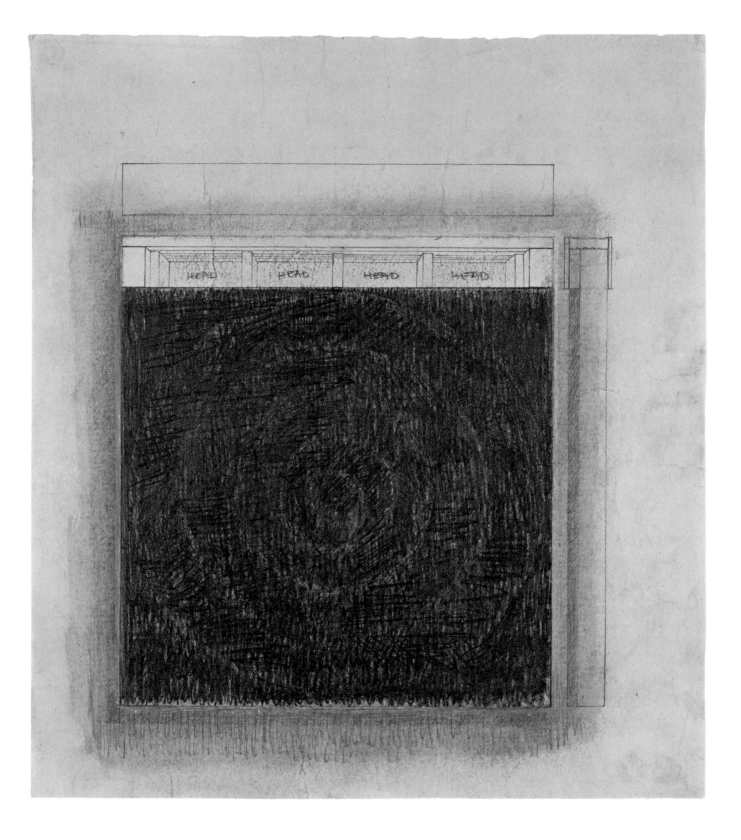

4. *Target with Four Faces*, 1955

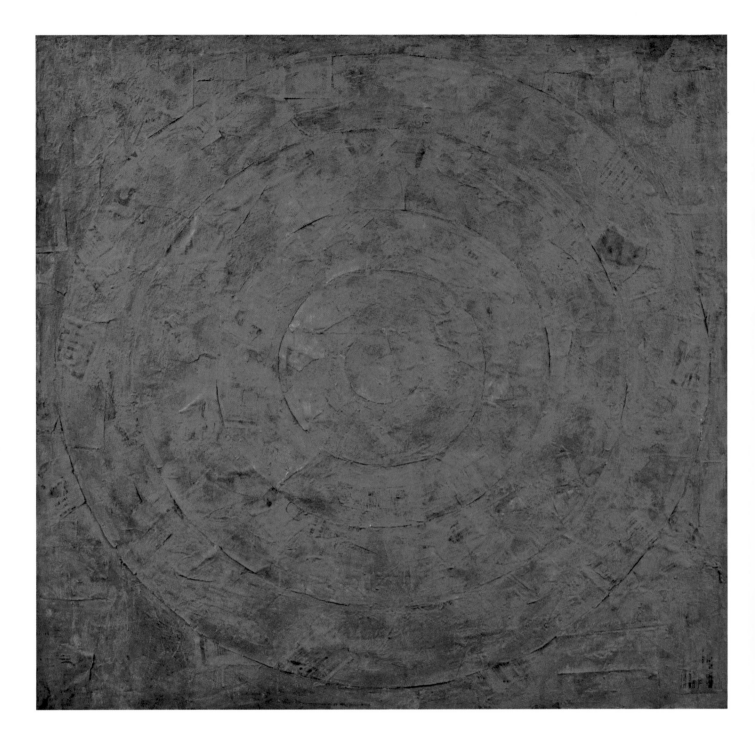

5. *Green Target*, 1955

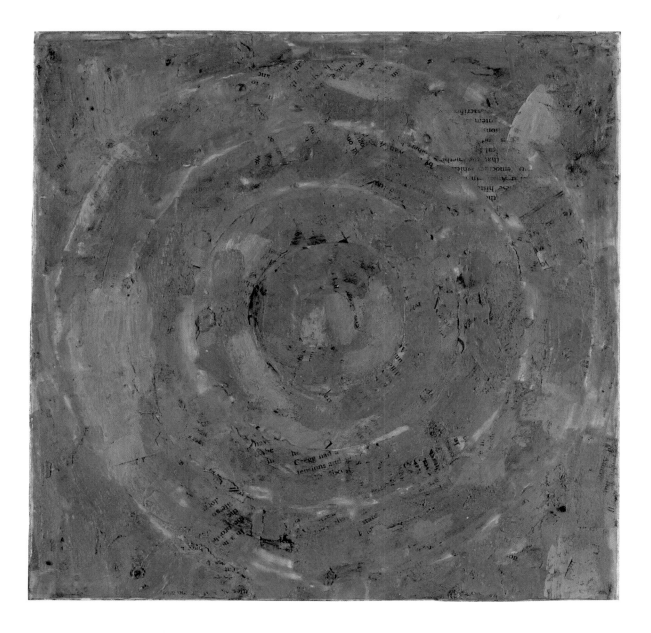

6. *Green Target*, 1956

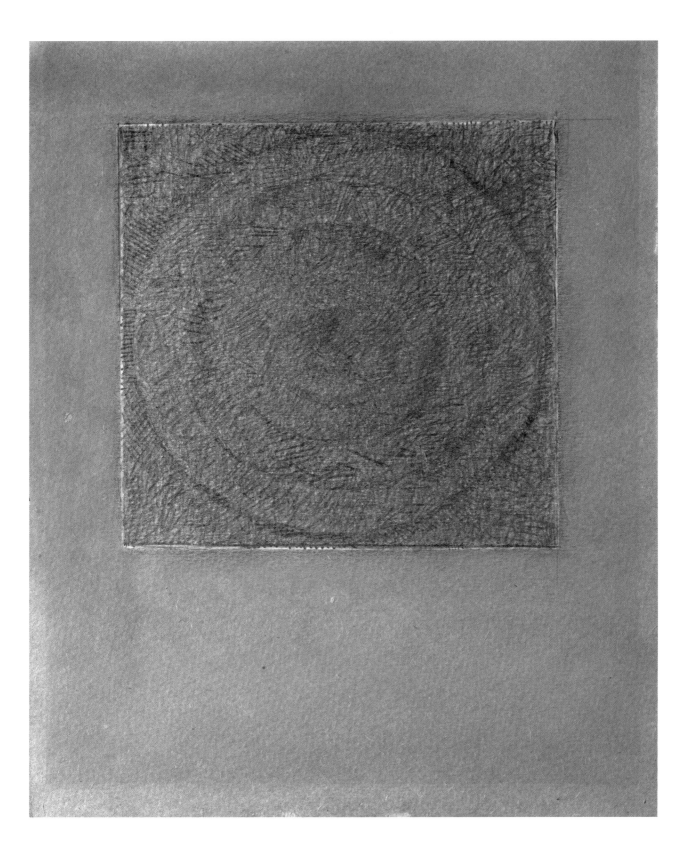

7. Target, 1956

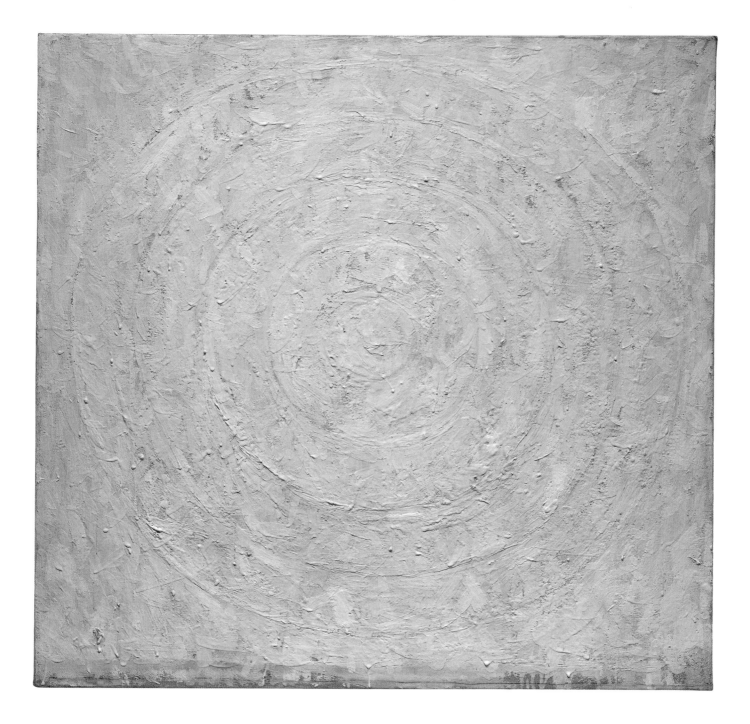

65 8. *White Target*, 1957

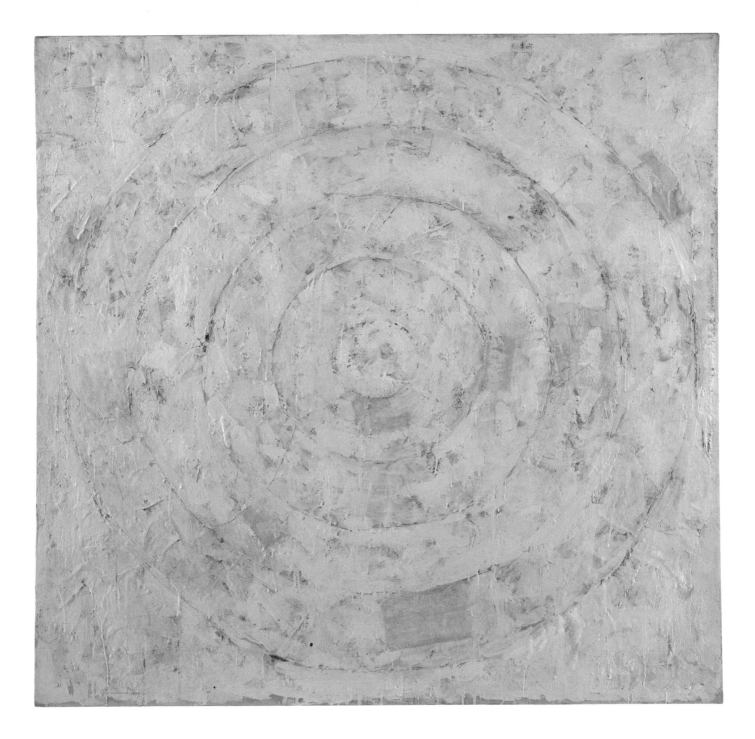

9. *White Target*, 1958

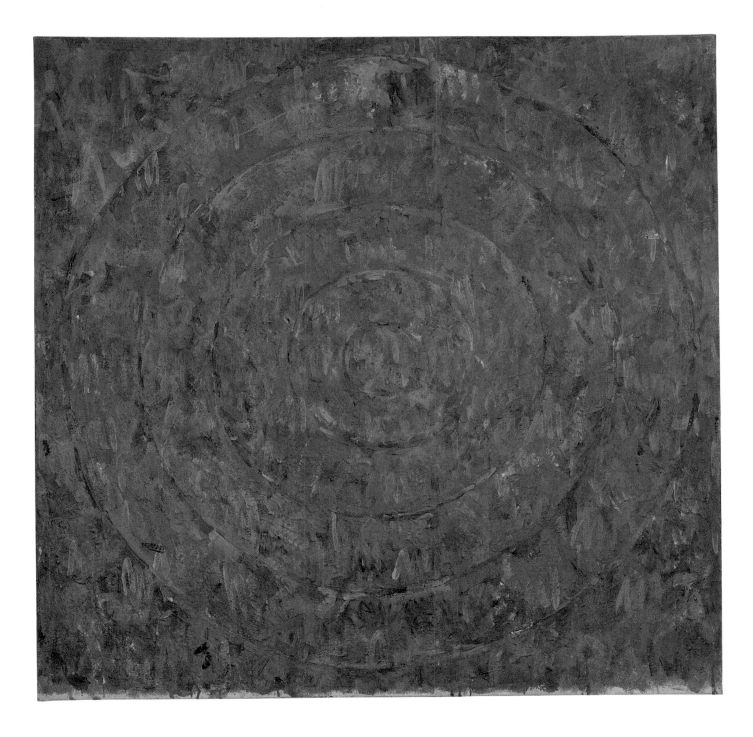

67 10. *Gray Target*, 1958

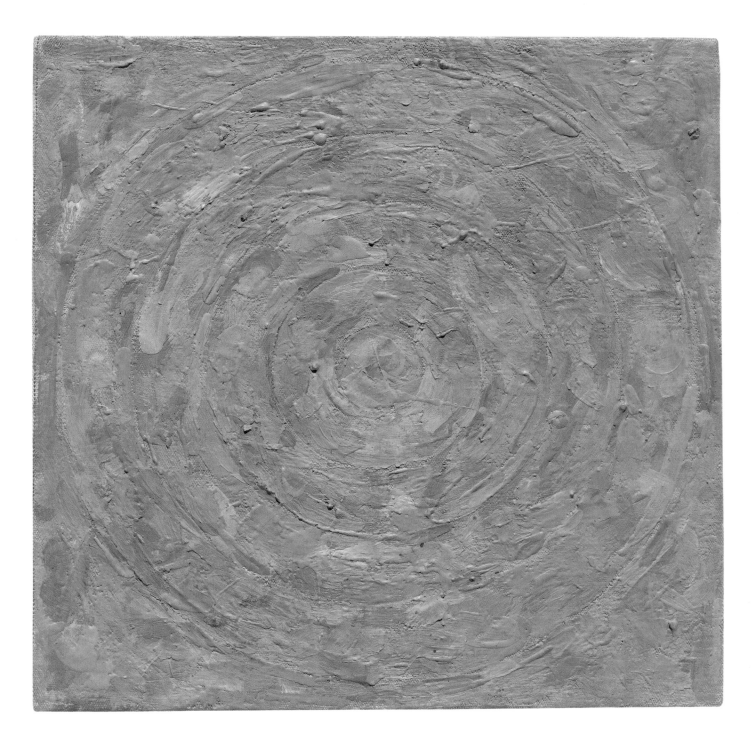

11. *Gray Target*, 1958

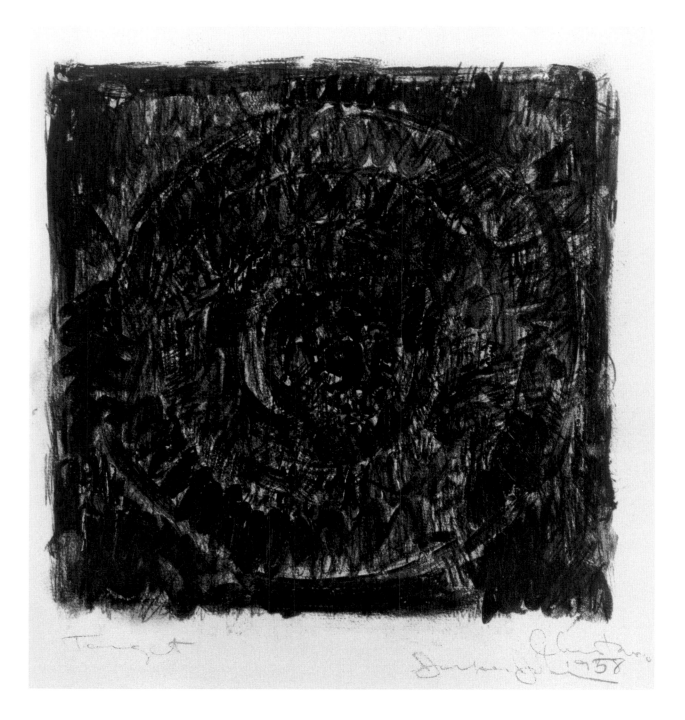

69 12. *Target*, 1958

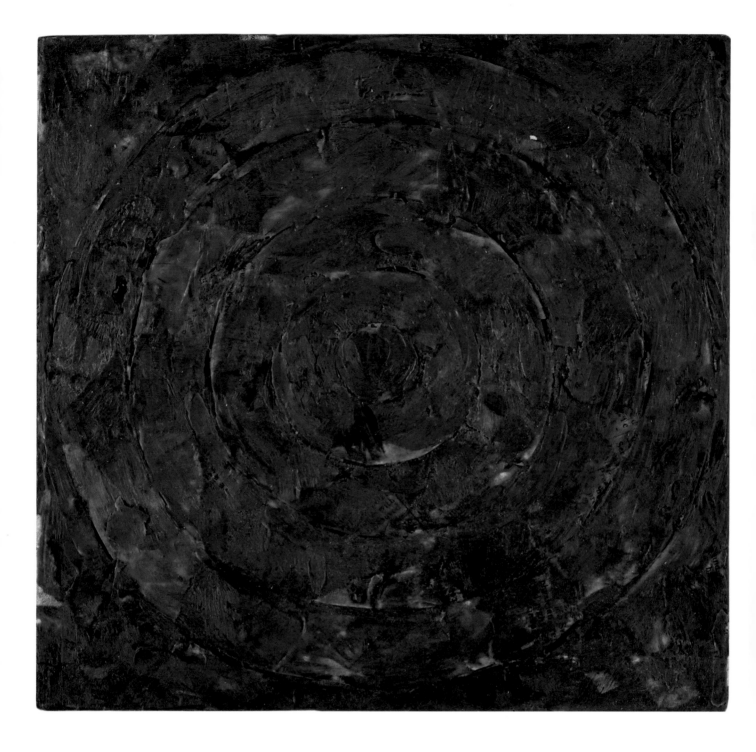

70 13. *Green Target*, 1958

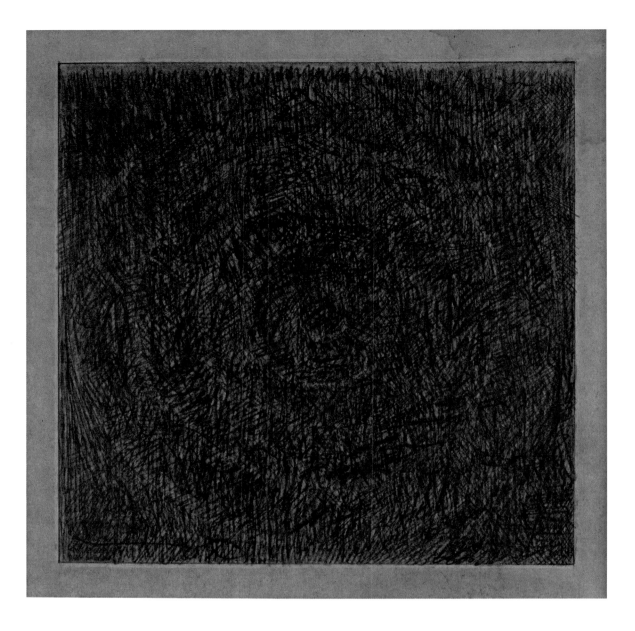

14. *Green Target*, 1958

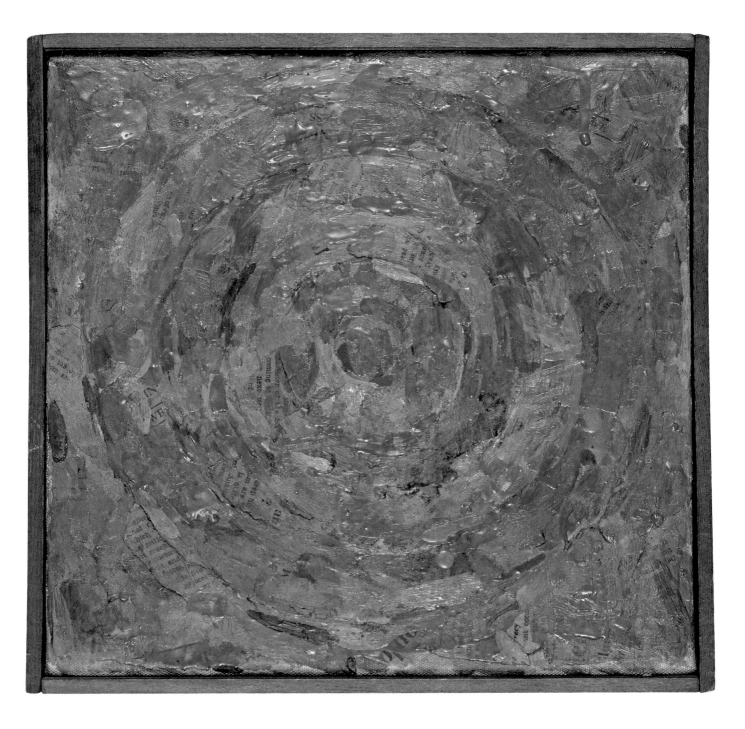

15. *Green Target,* 1959

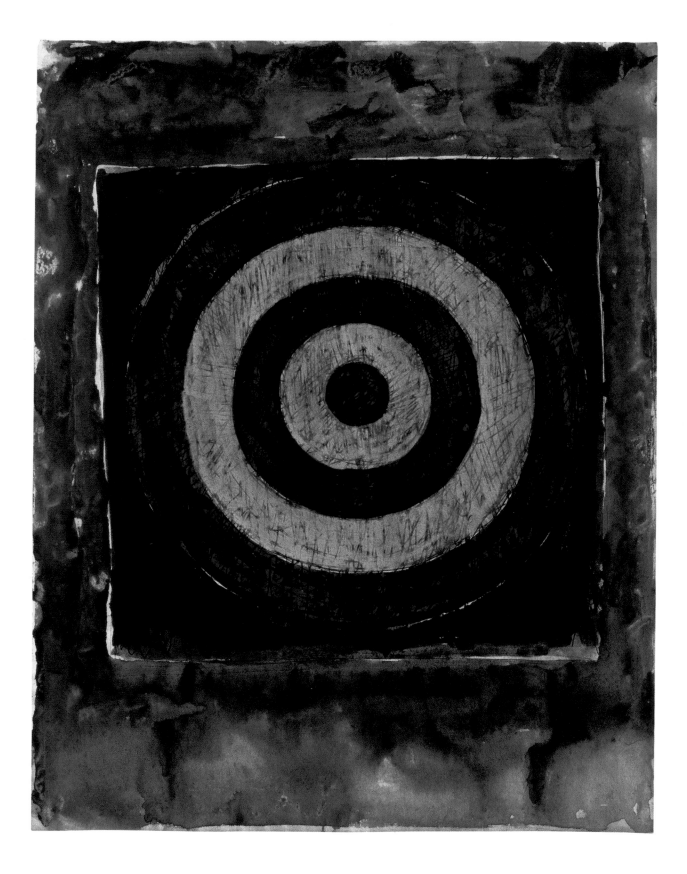

16. *Target on an Orange Field*, 1957

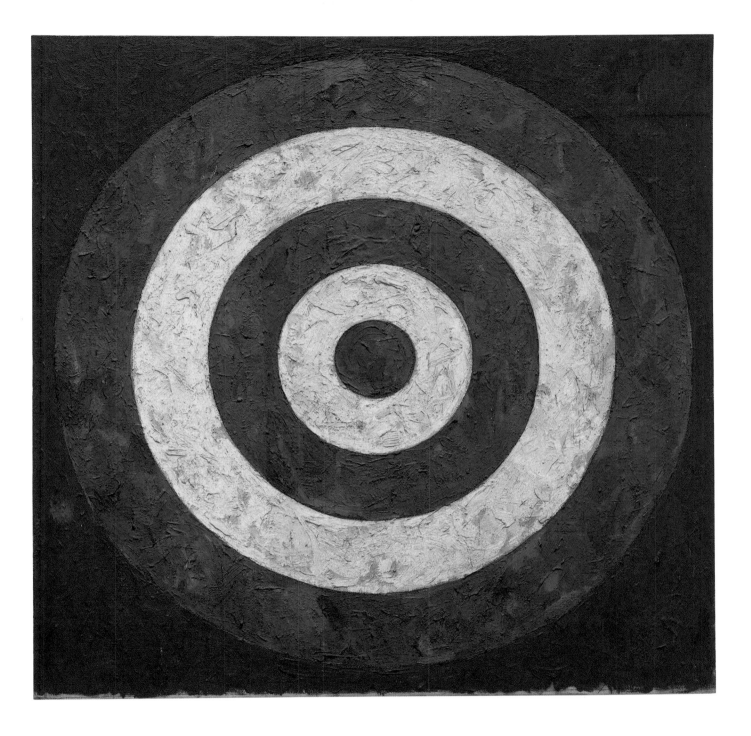

75 17. *Target*, 1958

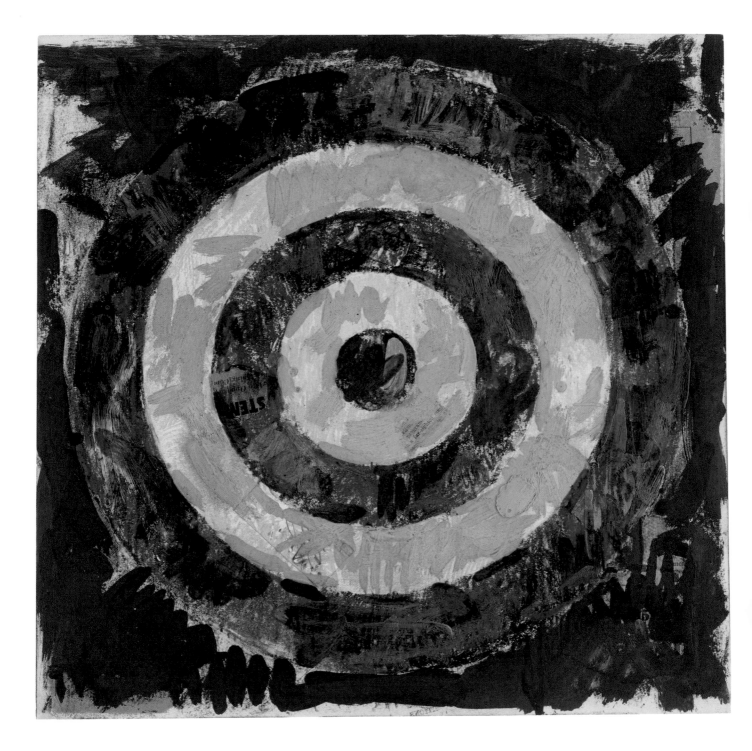

76 18. *Target*, 1958

77 19. *Target Sketch*, 1959

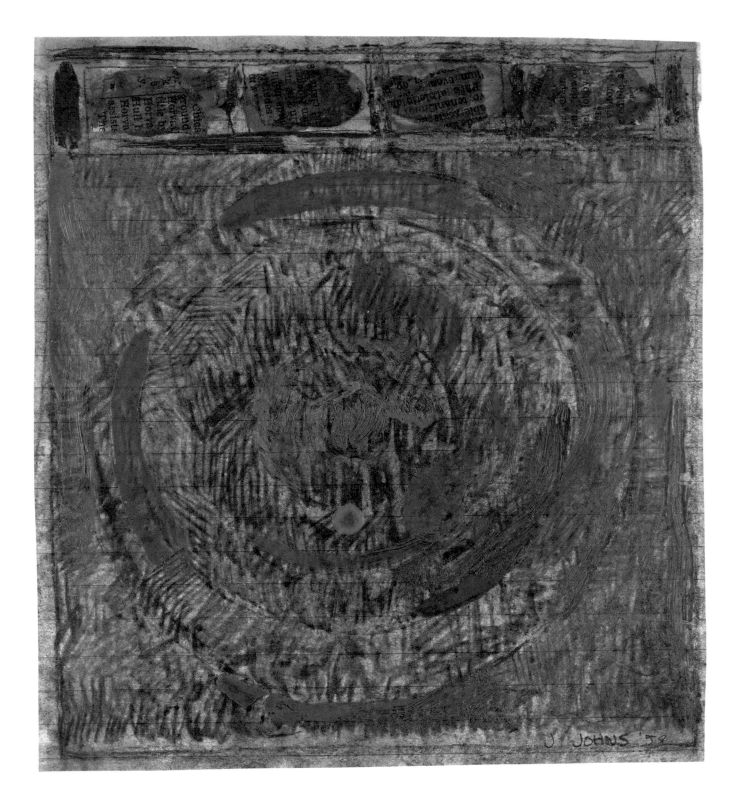

20. *Green Target*, 1958

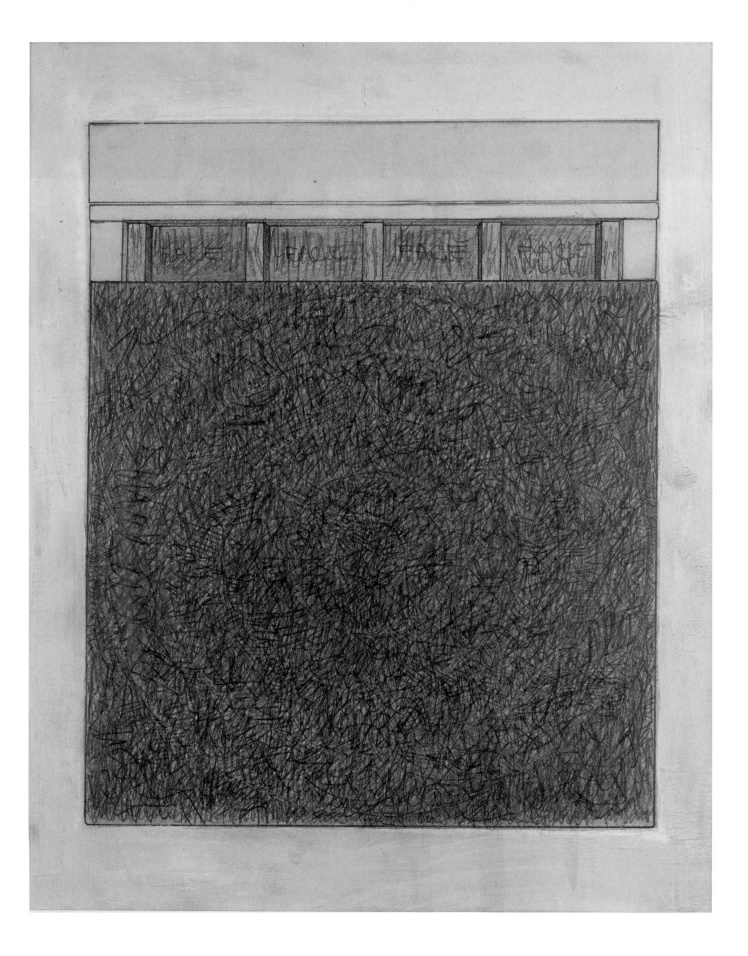

21. *Target with Four Faces, 1958*

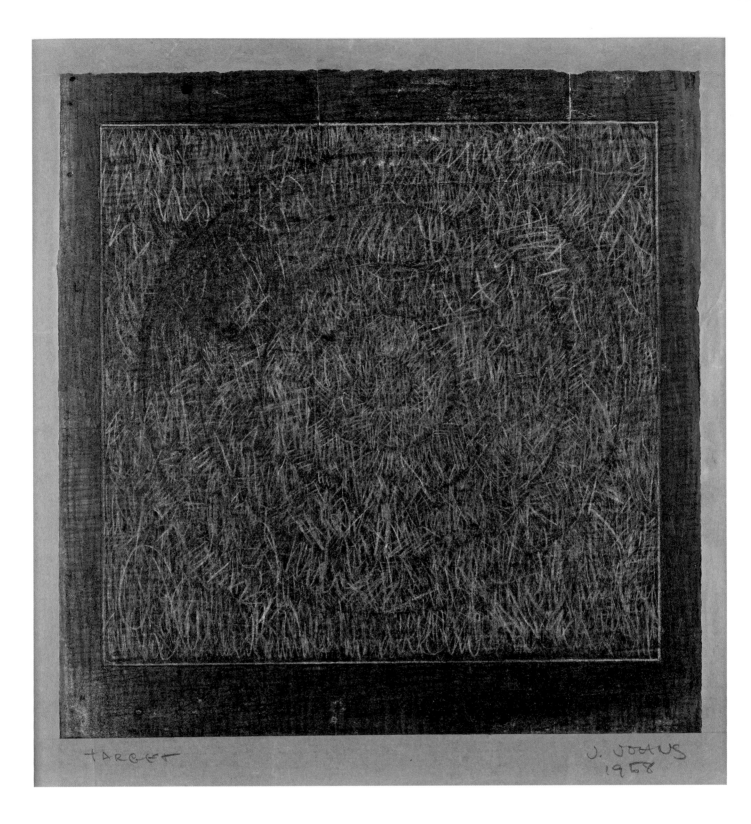

TARGET J. JOHNS
 1958

22. *Target*, 1958

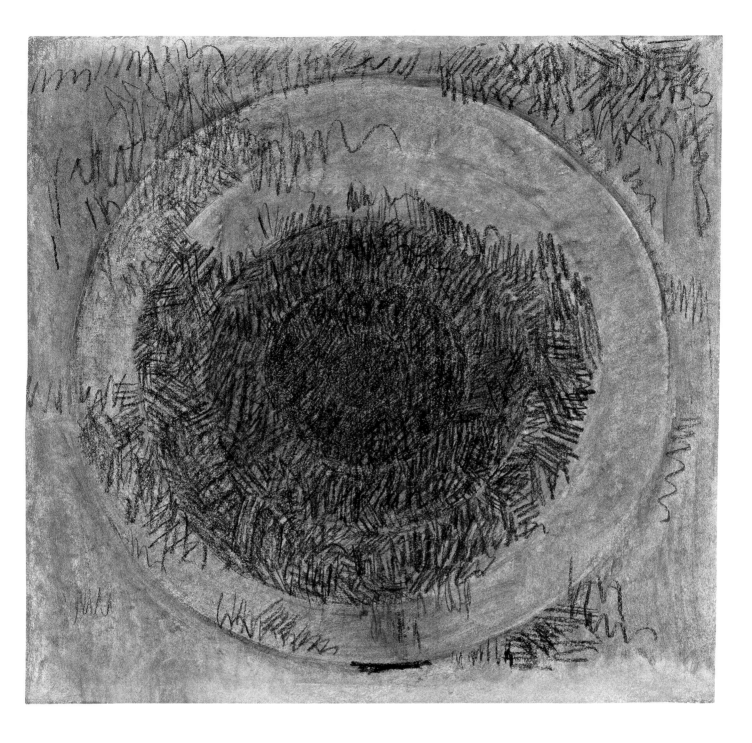

81 23. *Target*, 1958

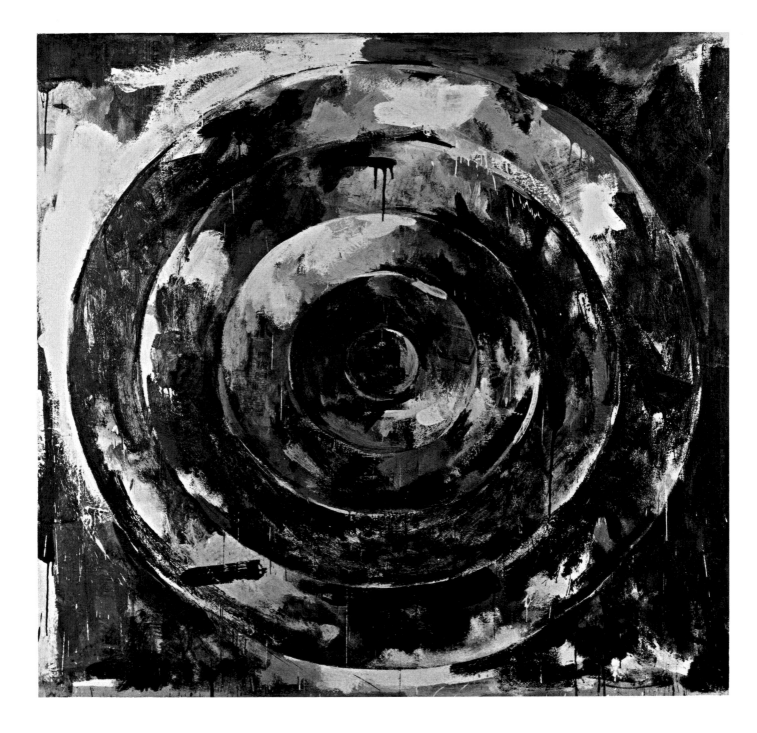

24. *Black Target*, 1959 (Destroyed in fire in 1961)

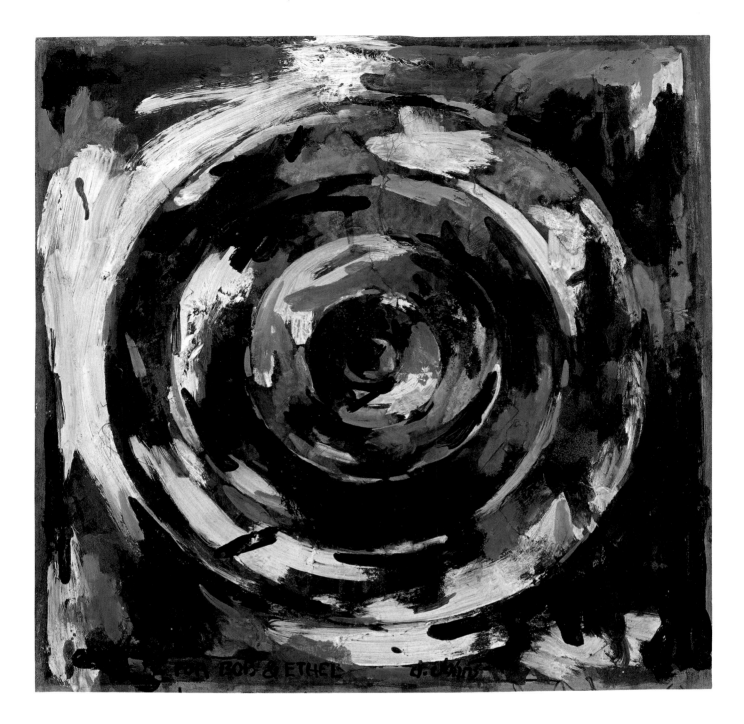

83 25. *Target*, 1959–1960

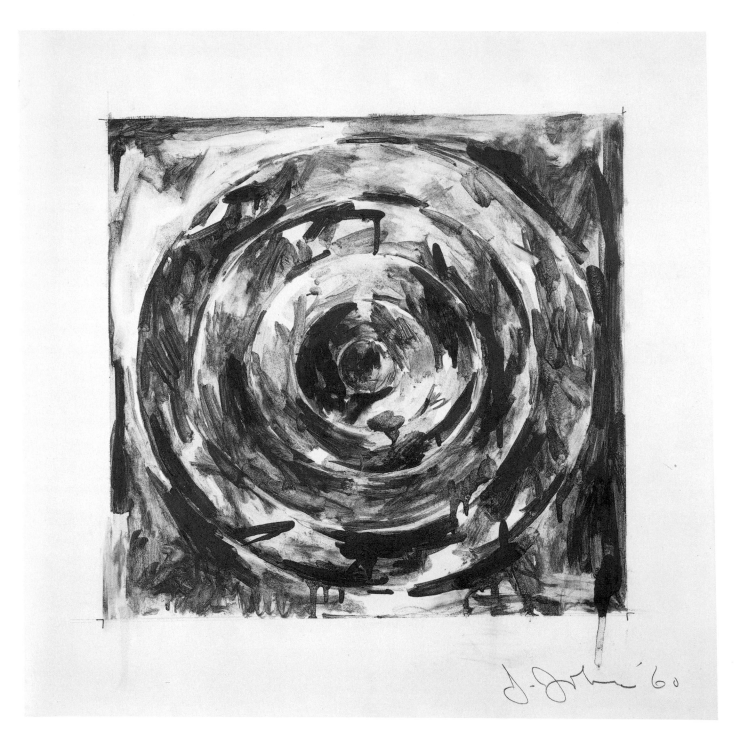

84 26. *Target*, 1960

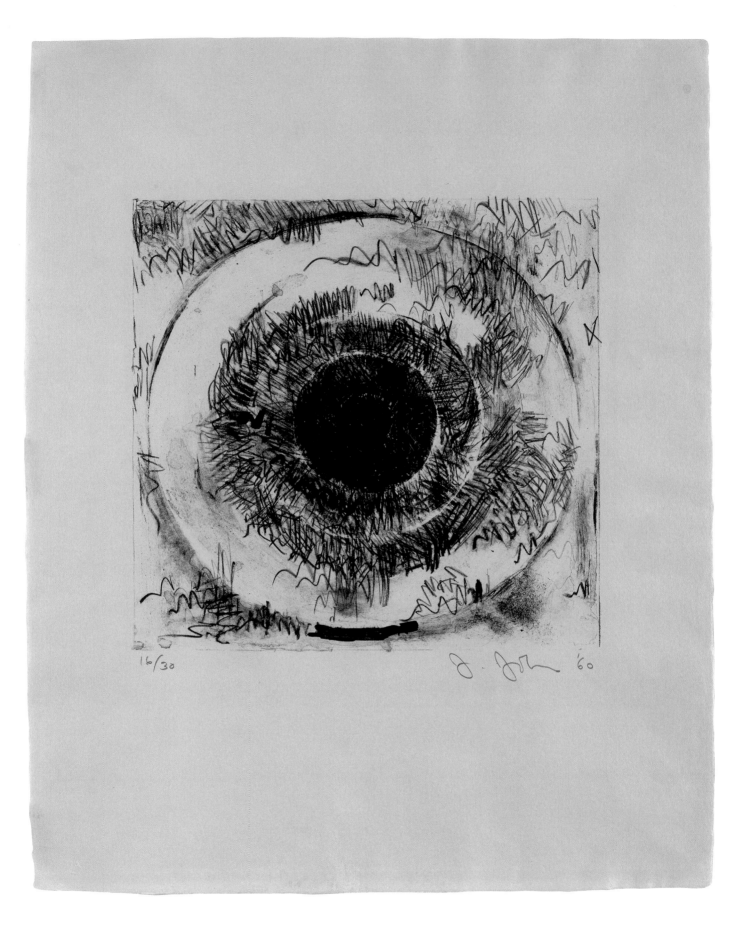

16/30 J. Johns '60

 27. *Target*, 1960

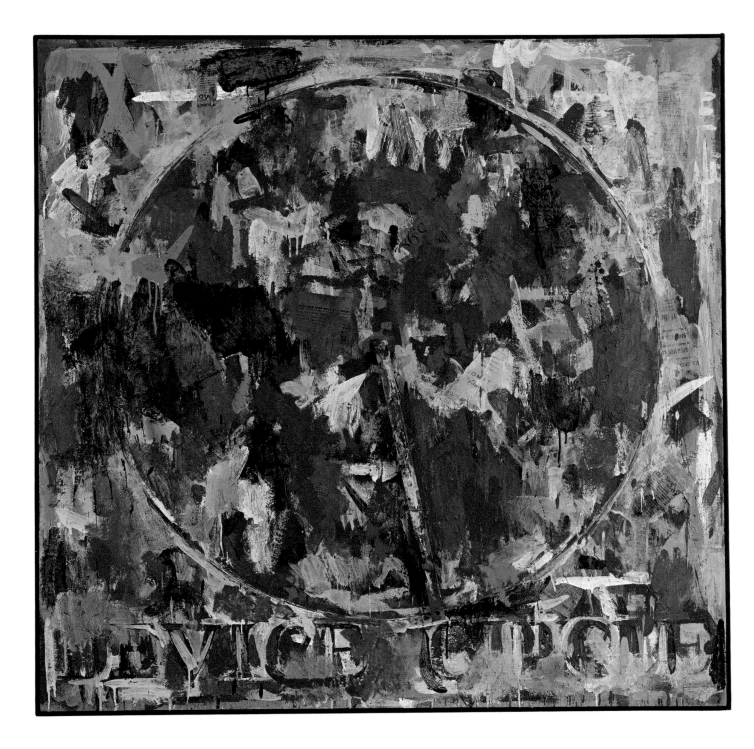

28. *Device Circle*, 1959

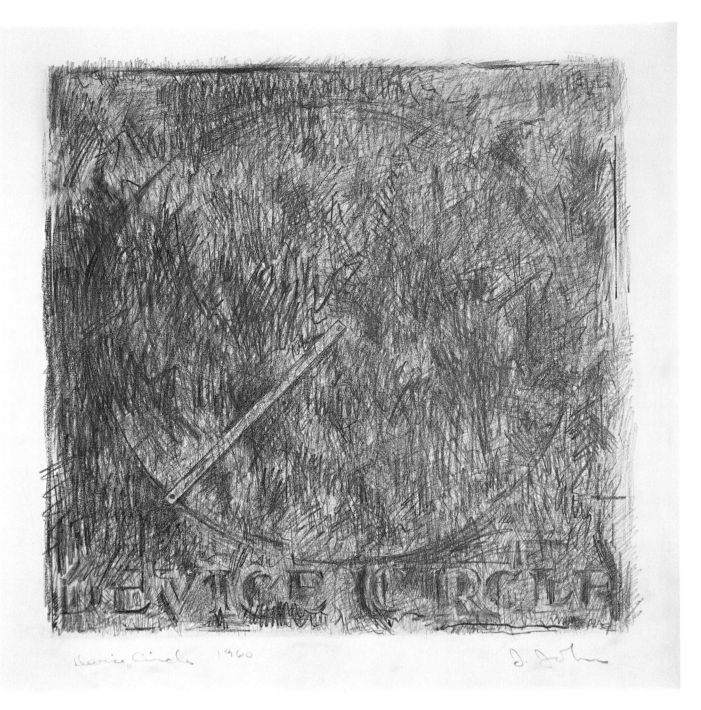

Device Circle 1960 J. Johns

29. *Device Circle*, 1960

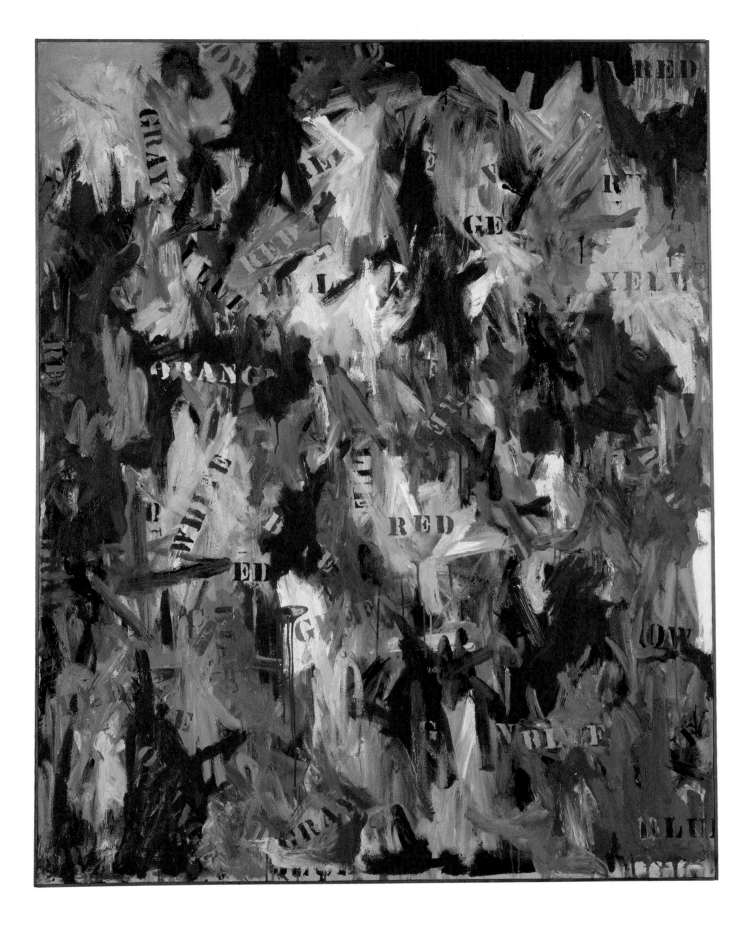

30. *False Start*, 1959

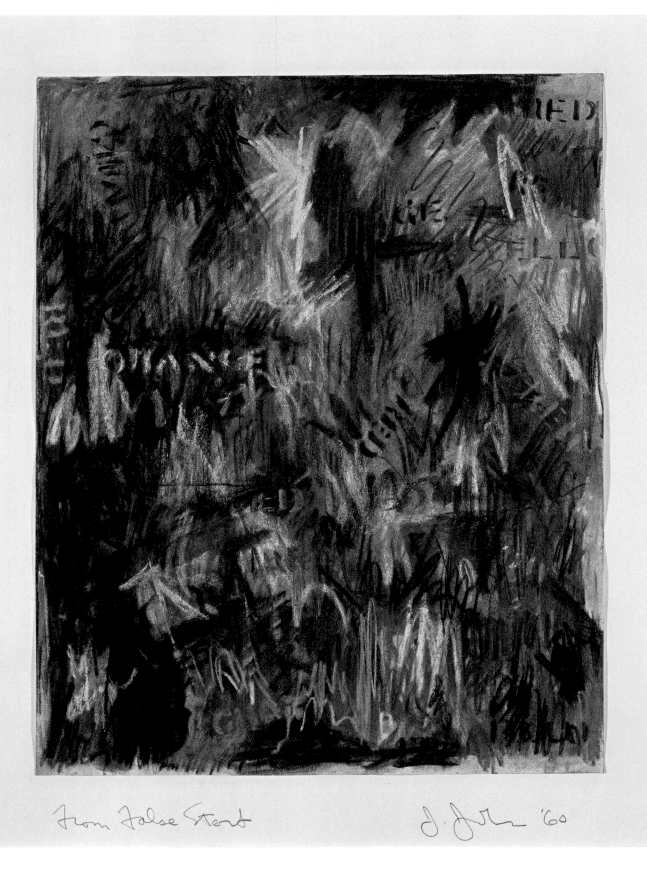

From False Start

J. Johns '60

31. *From False Start*, 1960

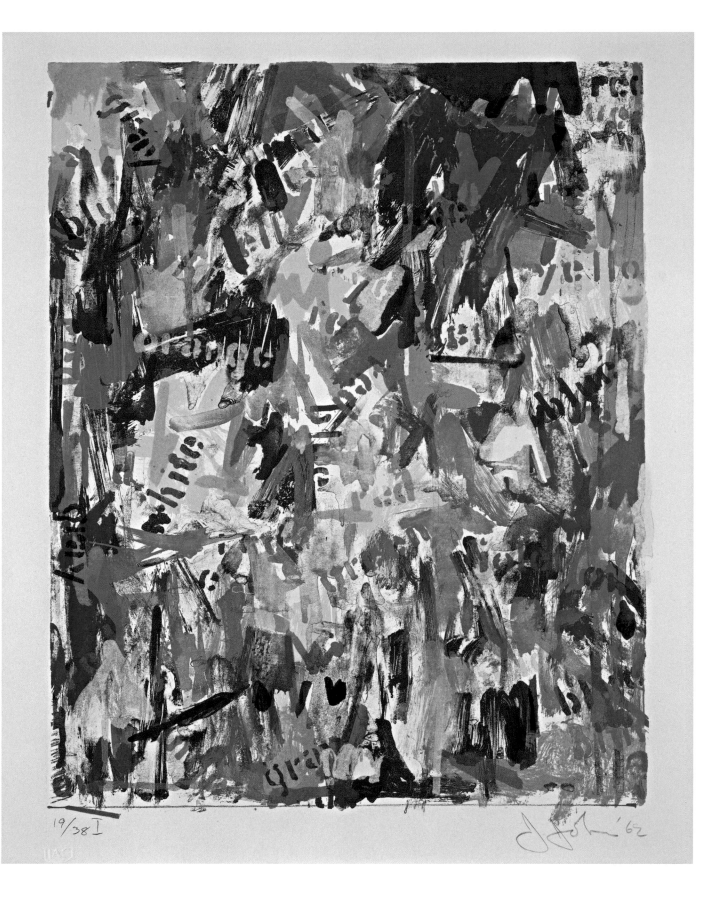

19/38 I

32. *False Start I*, 1962

90

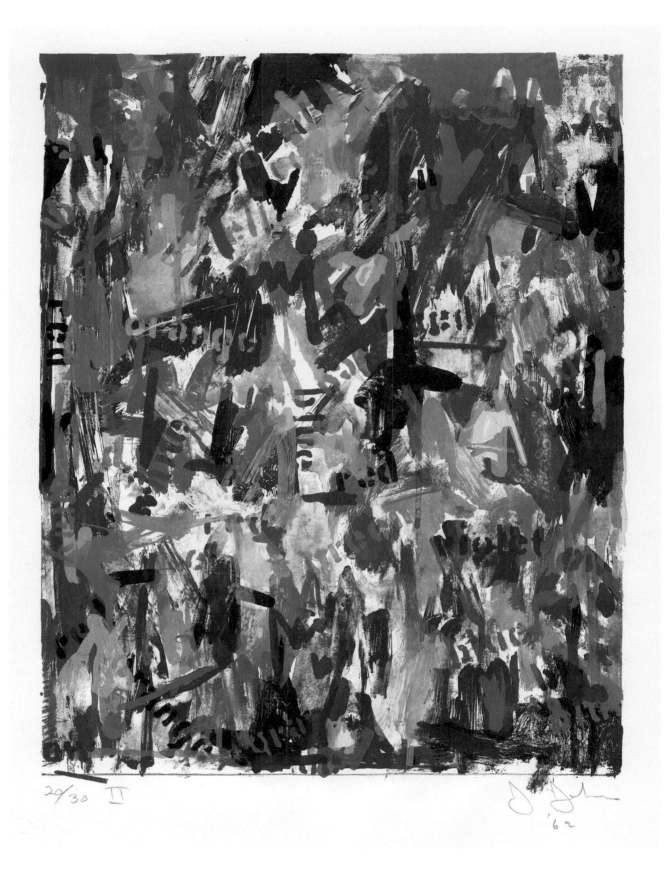

20/30 II

33. *False Start II*, 1962

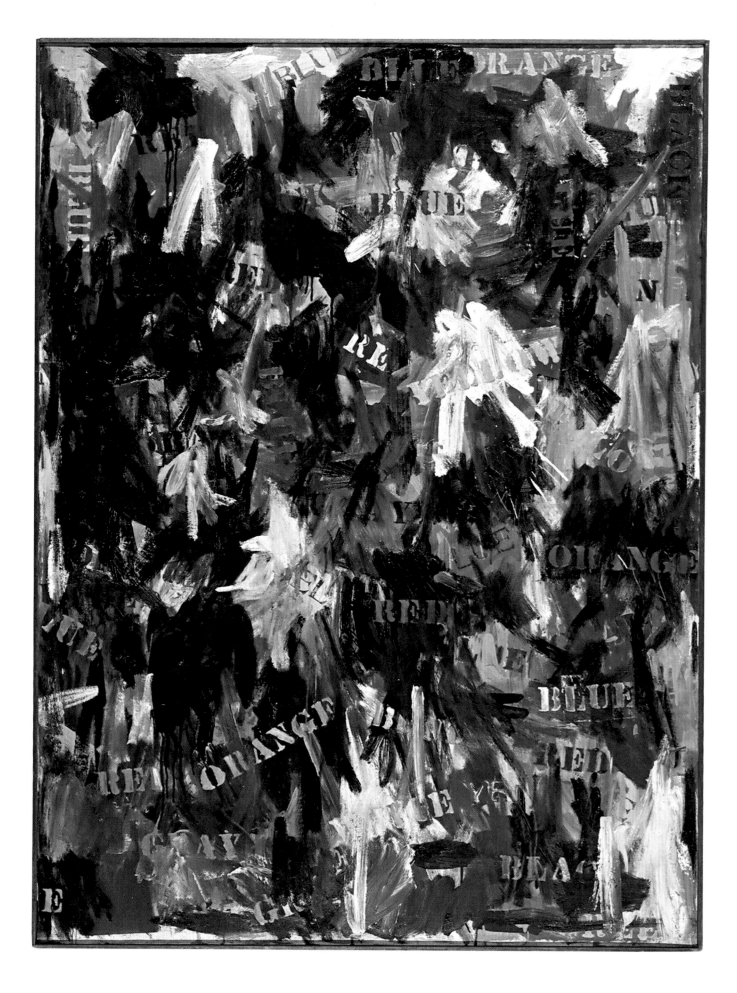

34. *Jubilee*, 1959

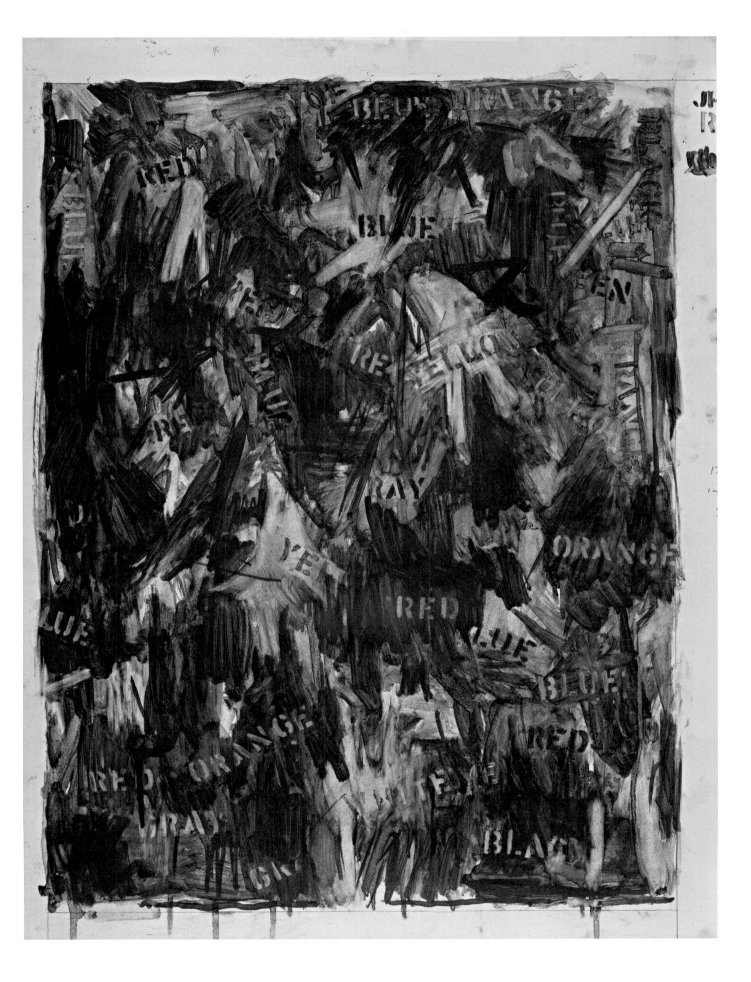

35. *Jubilee*, 1960

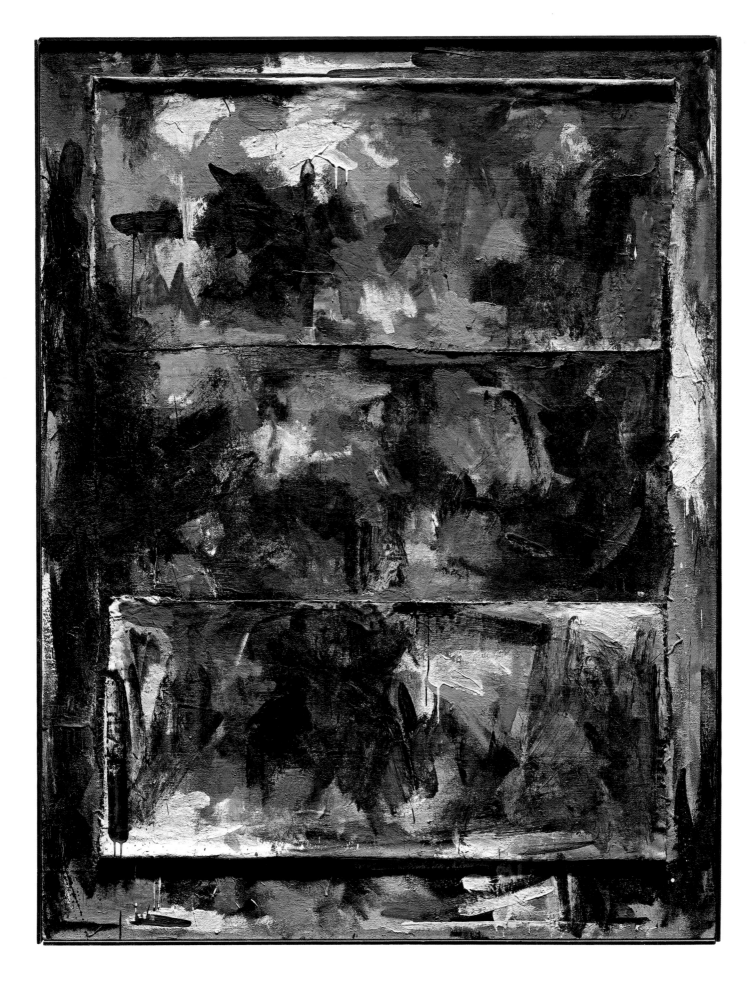

94 36. *Reconstruction*, 1959

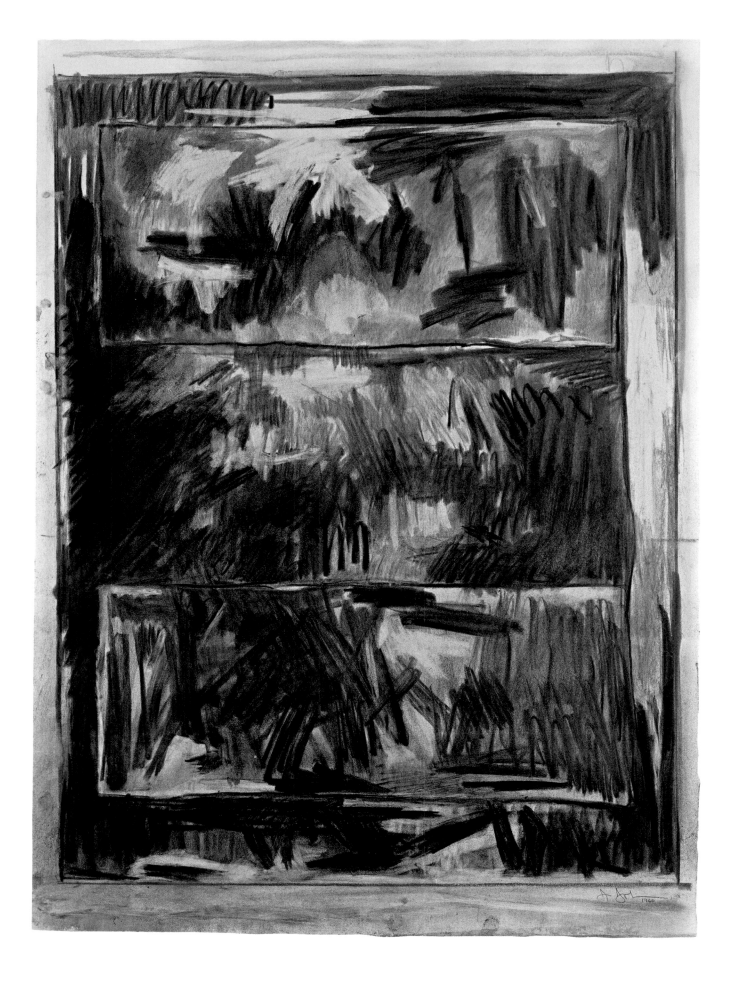

37. *Reconstruction, 1960*

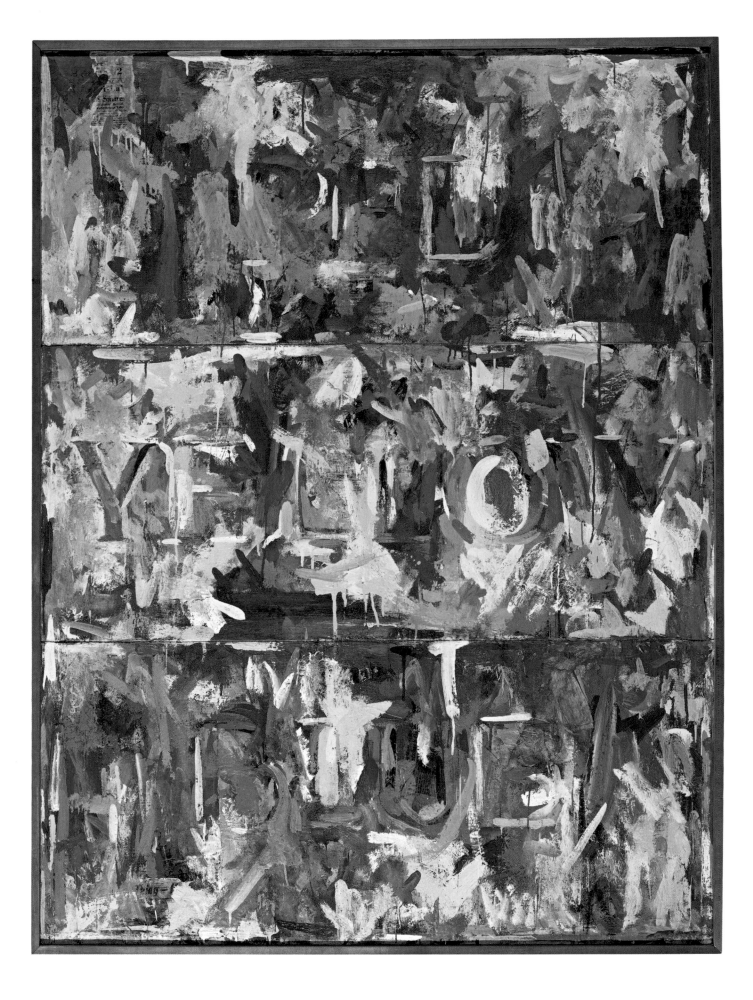

38. Out the Window, 1959

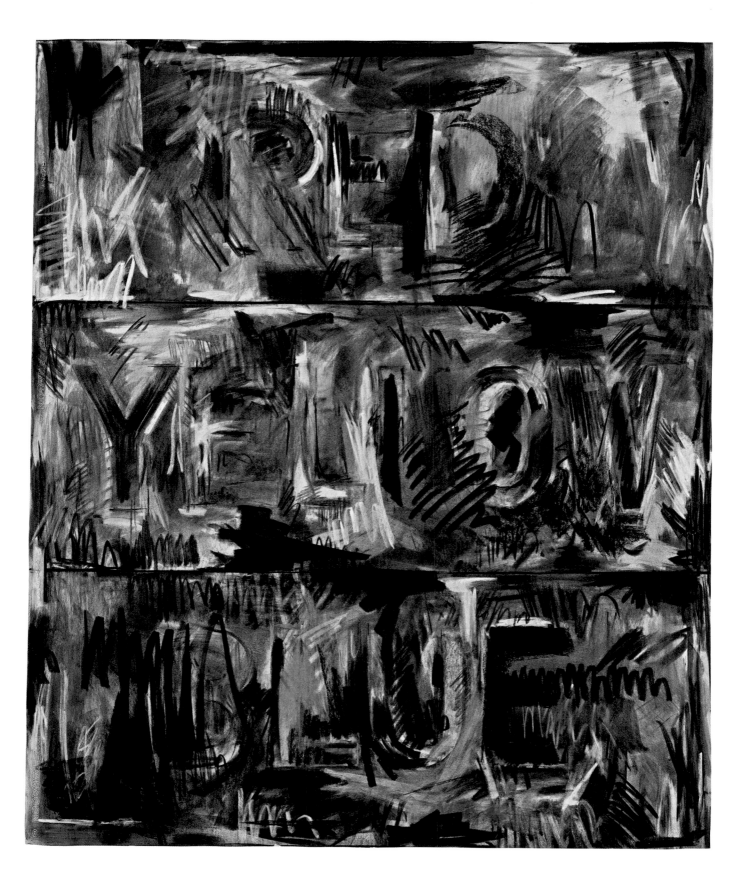

39. *Out the Window*, 1960

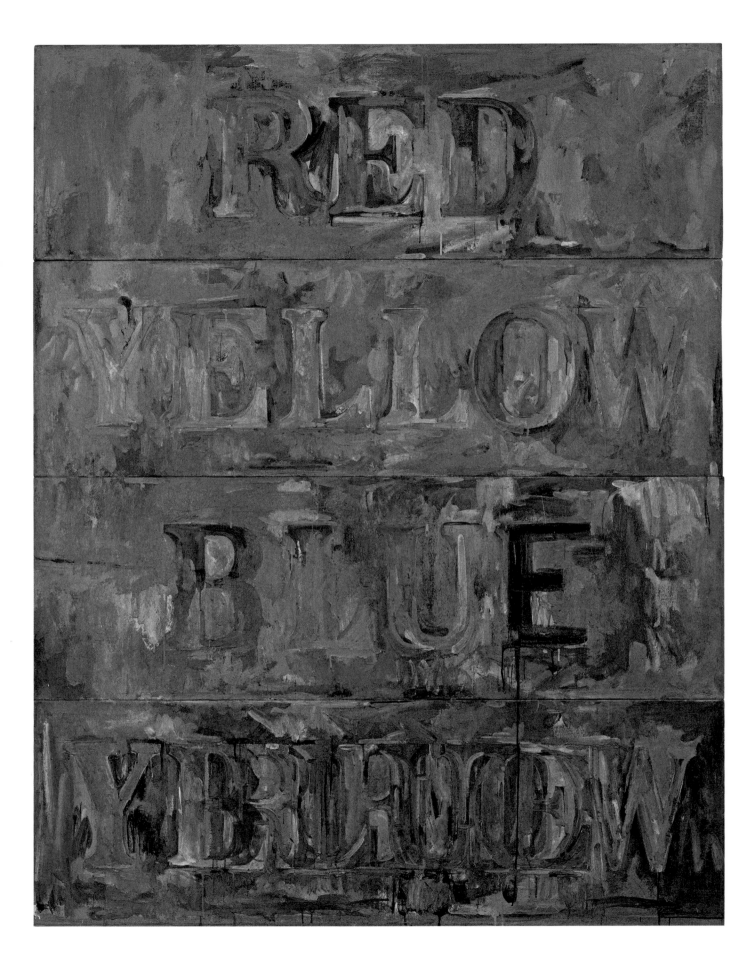

98 40. *By the Sea*, 1961

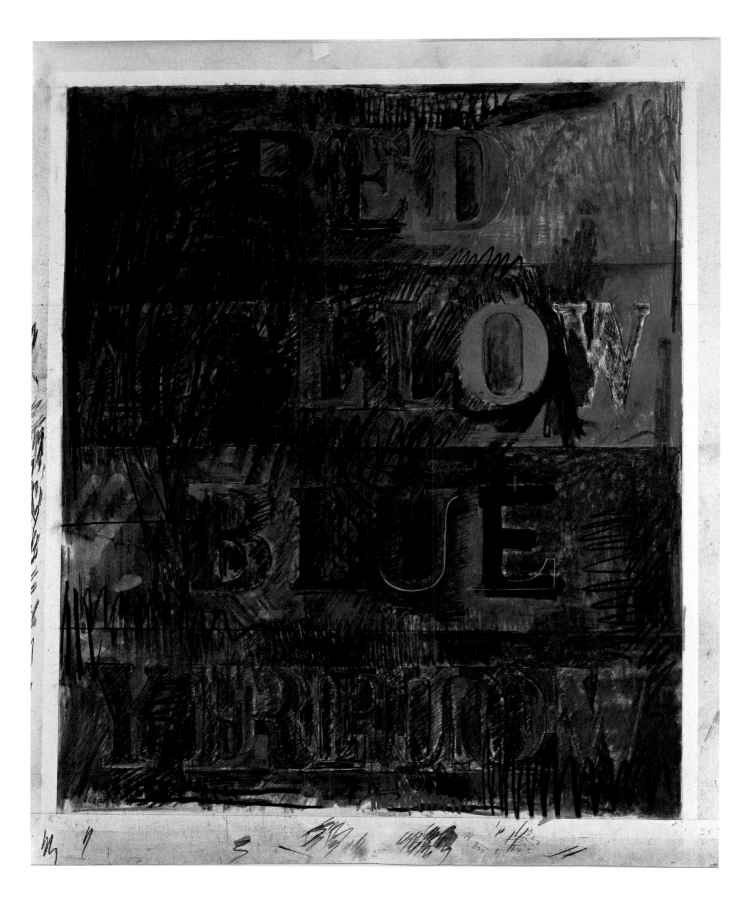

41. *Folly Beach*, 1962

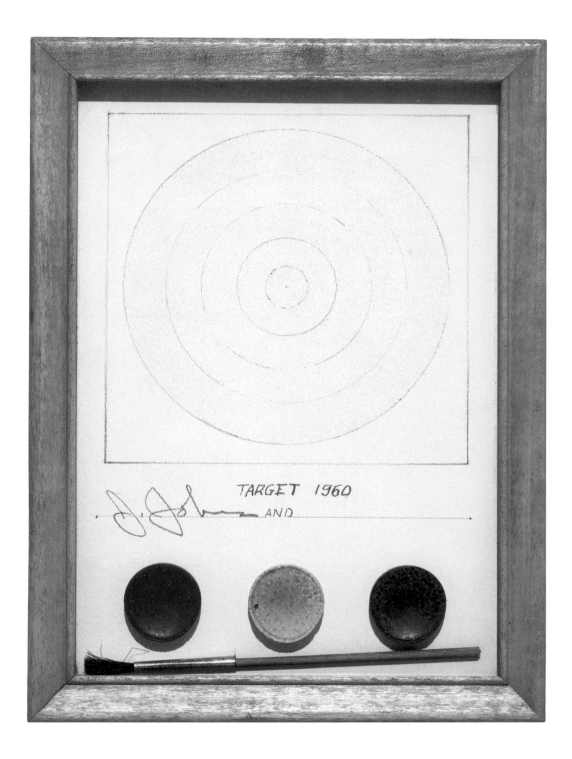

42. *Do It Yourself (Target)*, 1960

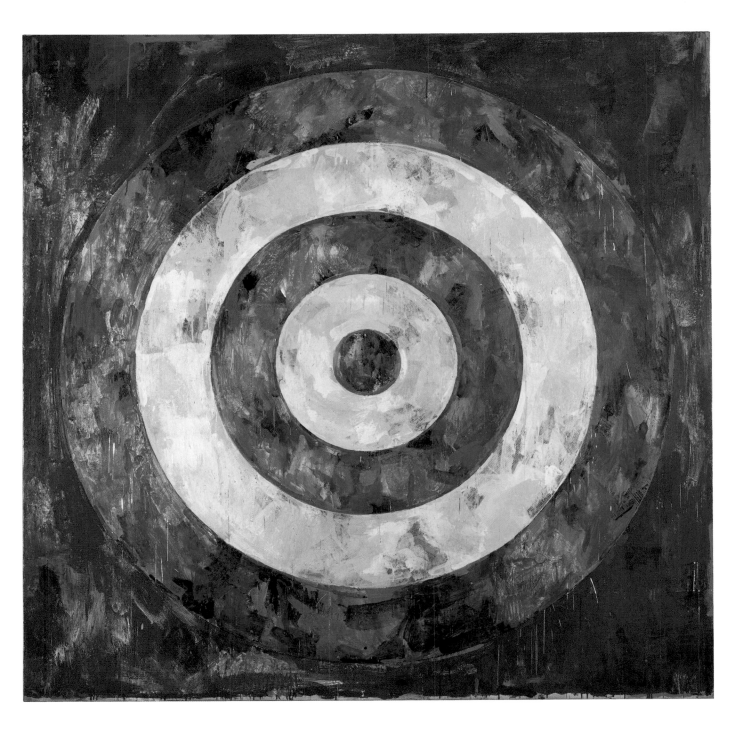

101 43. *Target*, 1961

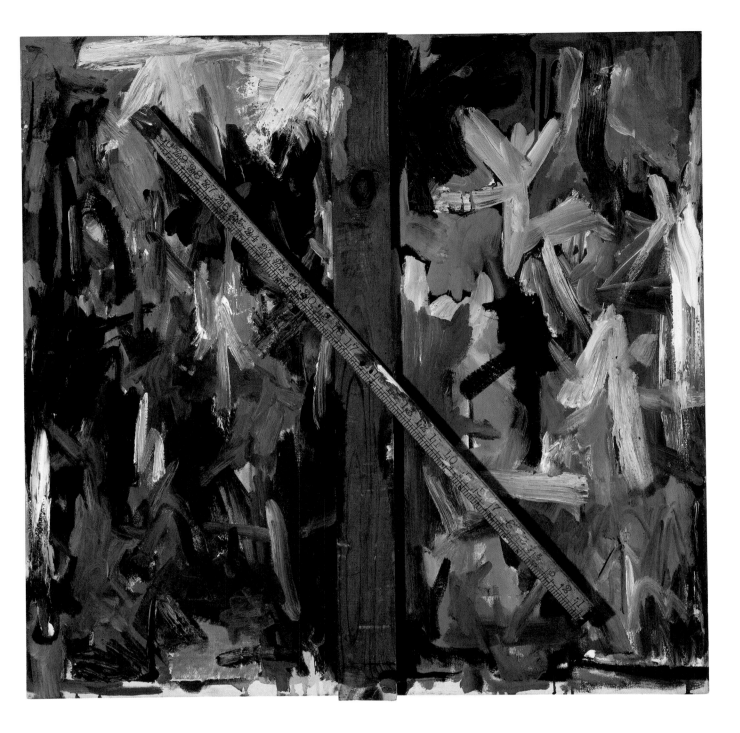

103 44. *Painting with Ruler and "Gray,"* 1960

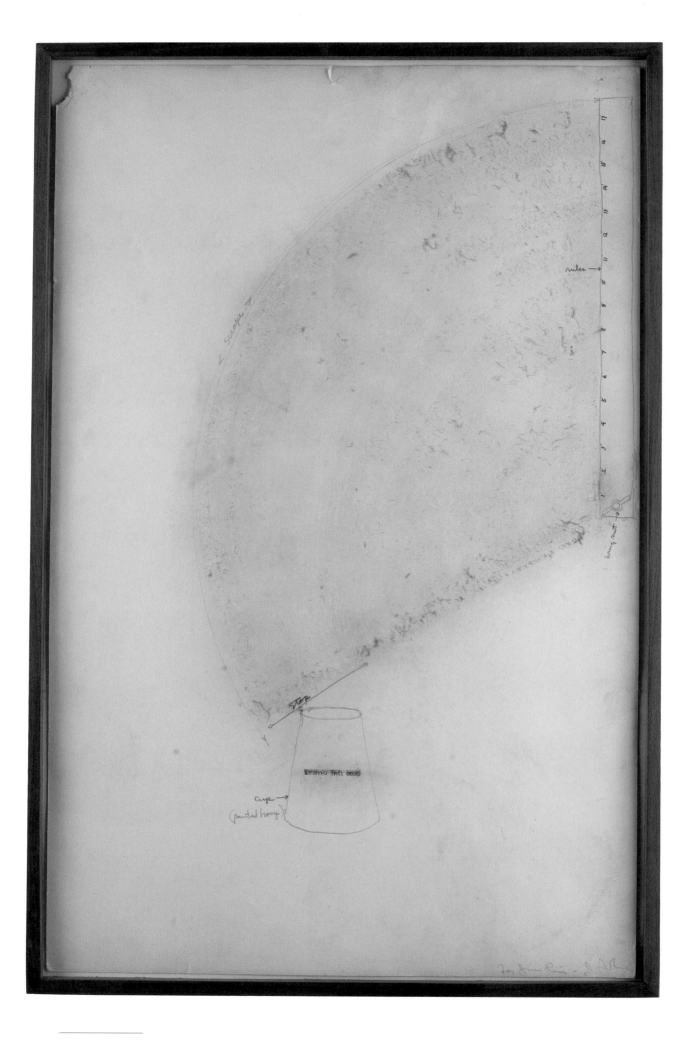

45. *Sketch for "Good Time Charley,"* 1961

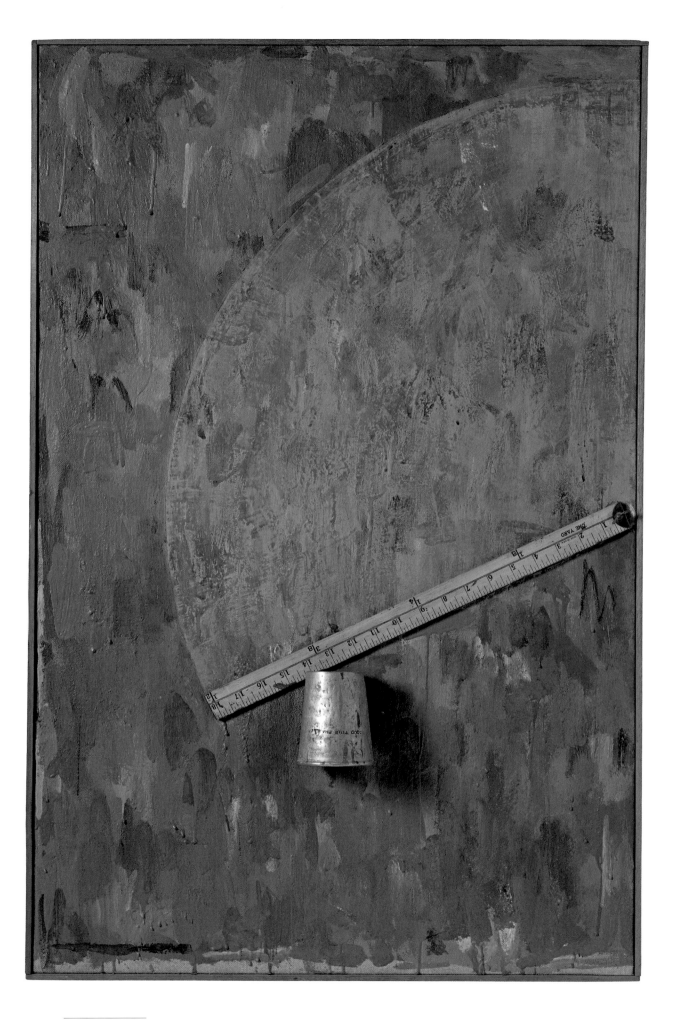

105 46. *Good Time Charley*, 1961

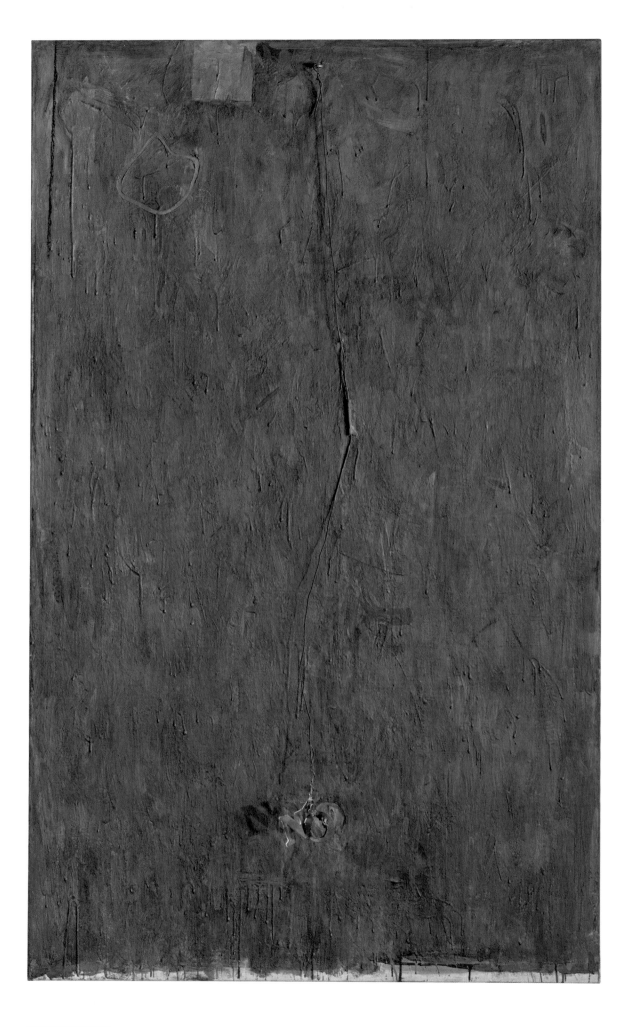

47. *No*, 1961

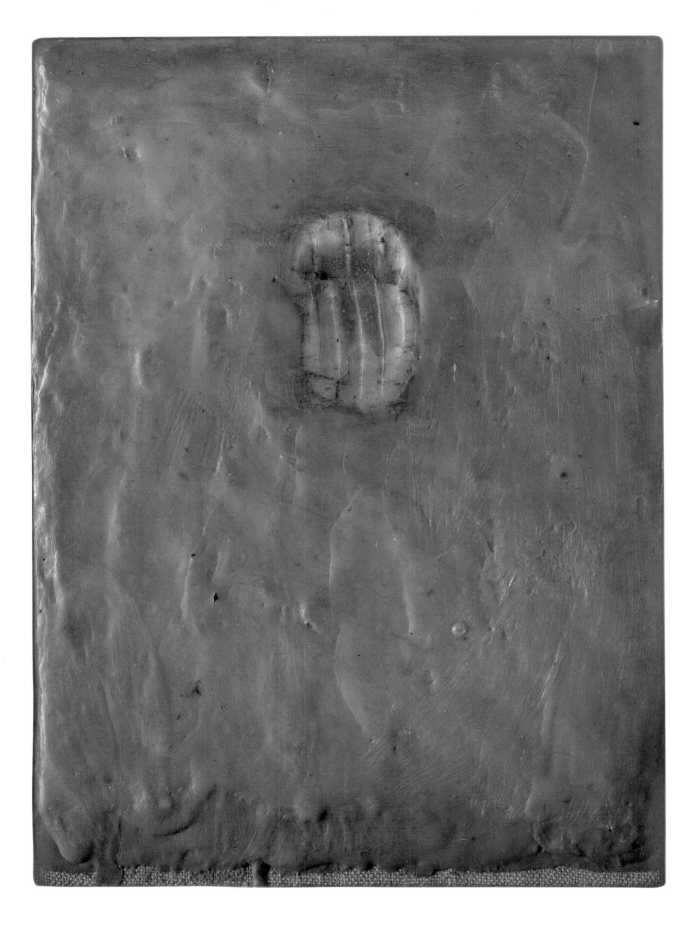

48. *Painting Bitten by a Man*, 1961

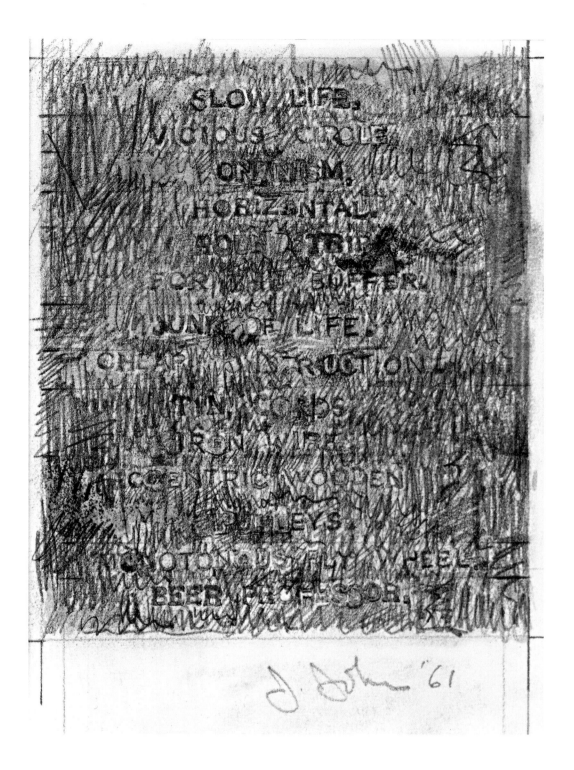

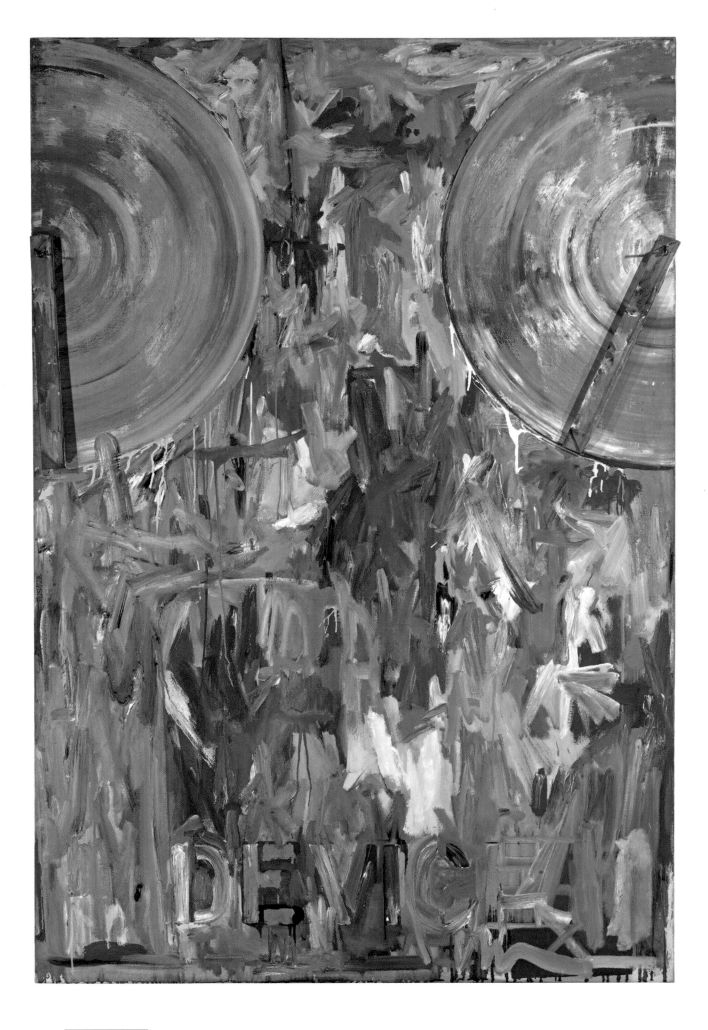

50. *Device*, 1961–1962

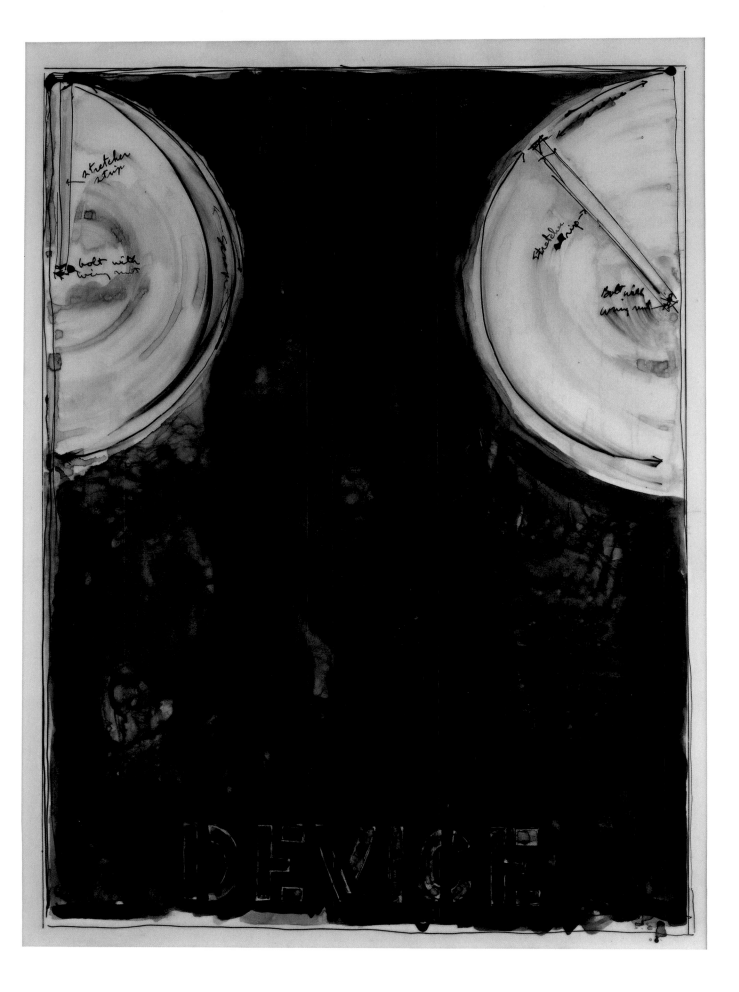

51. *Device*, 1962

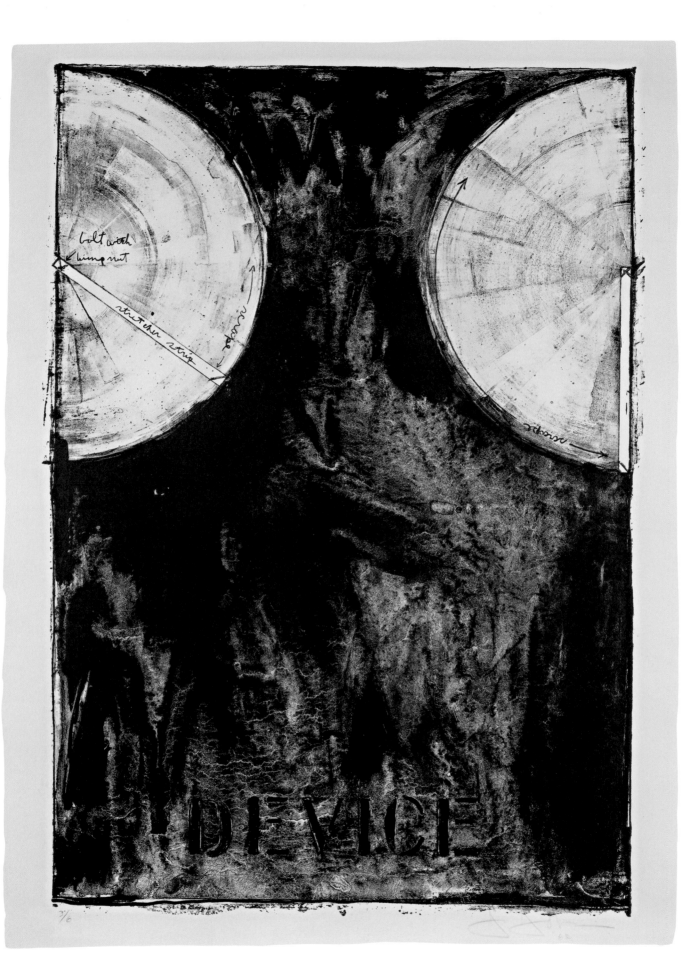

52. *Device,* 1962

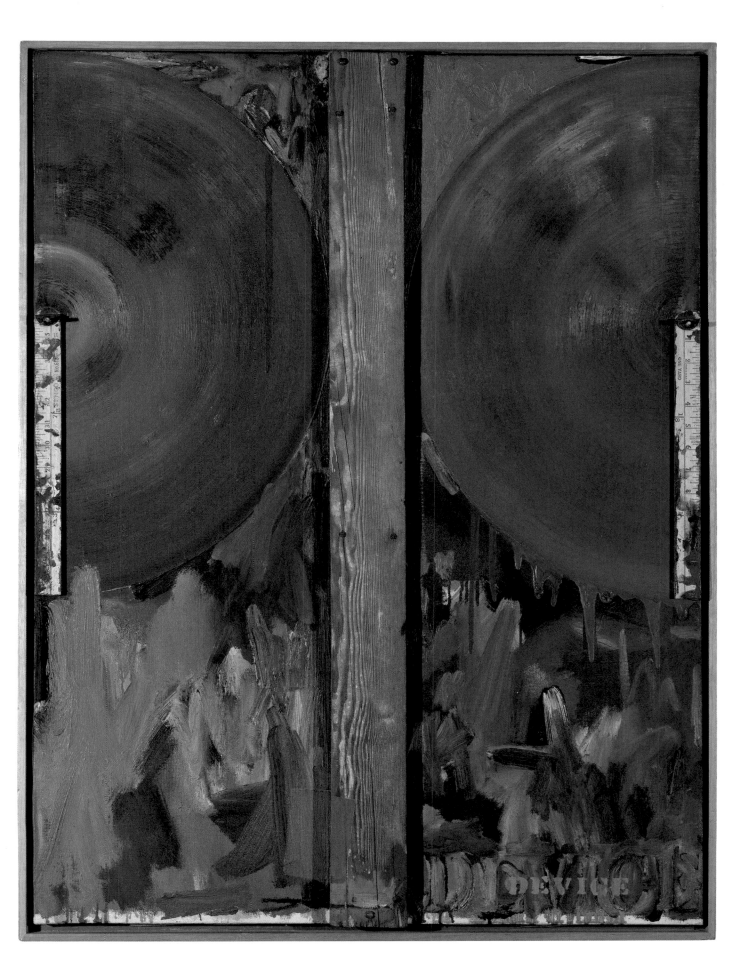

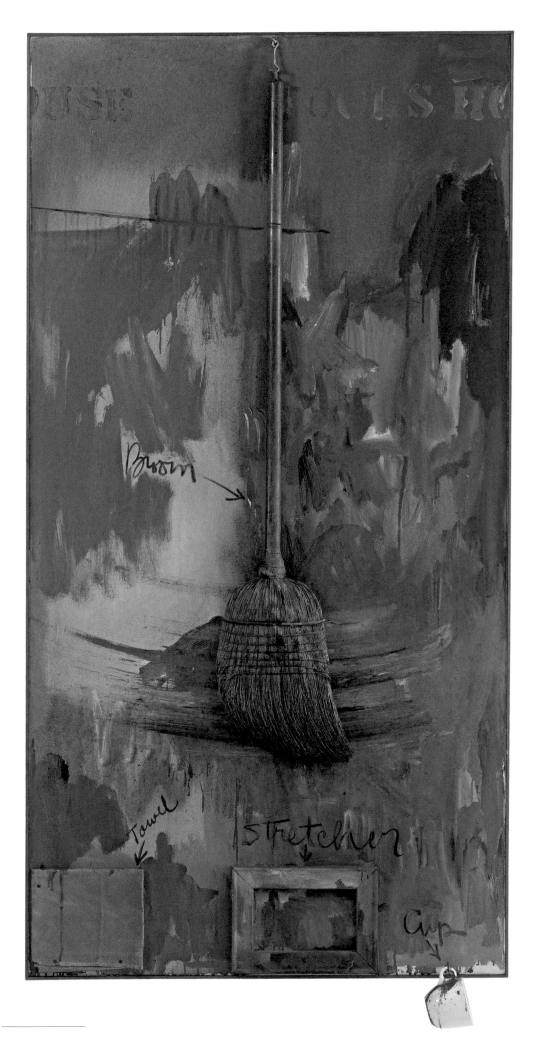

54. *Fool's House*, 1961–1962

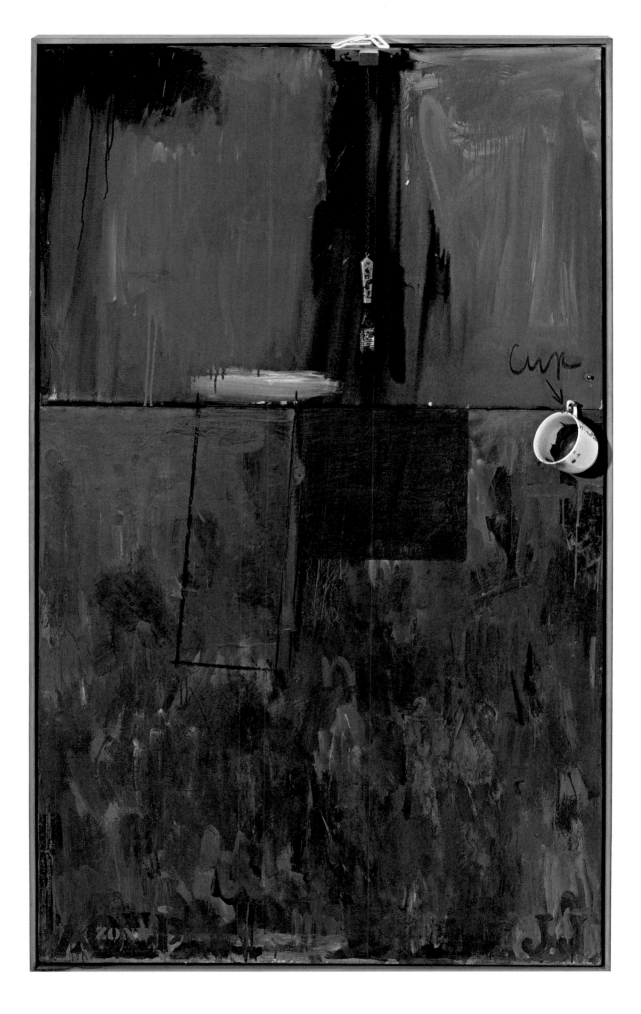

55. *Zone*, 1962

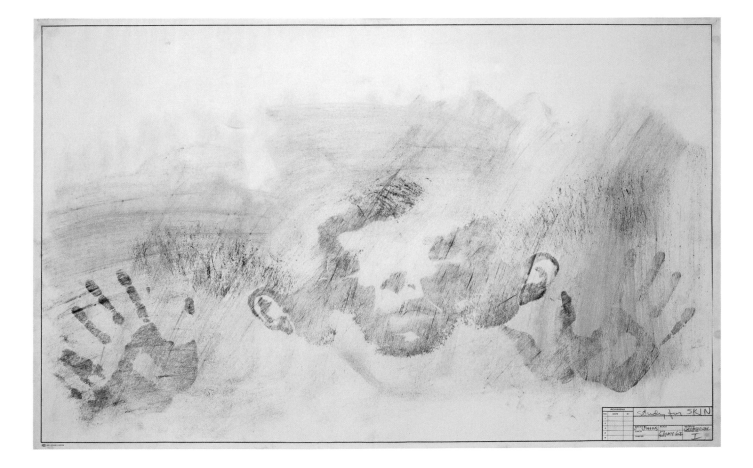

116 56. *Study for "Skin" I*, 1962

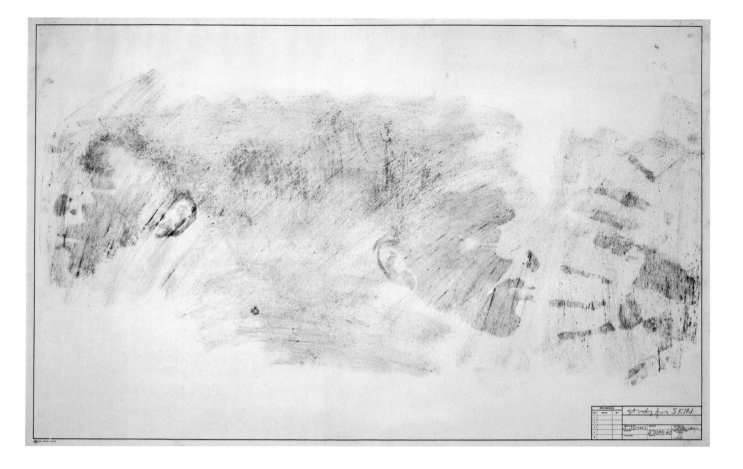

Study for SKIN

117 57. *Study for "Skin" II*, 1962

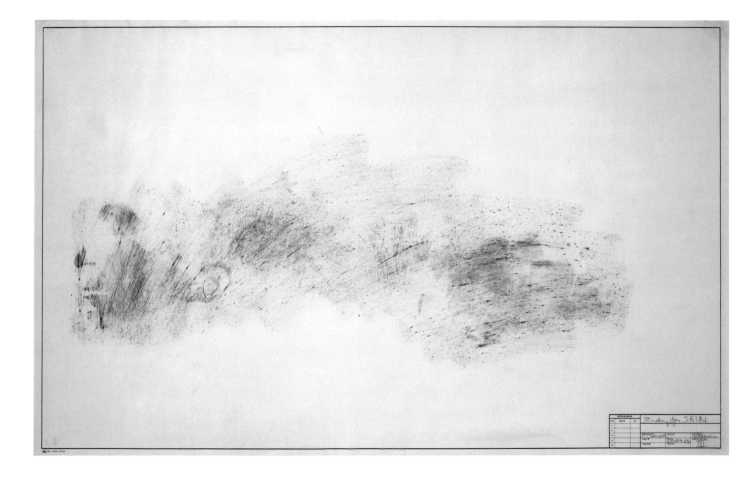

58. *Study for "Skin" III*, 1962

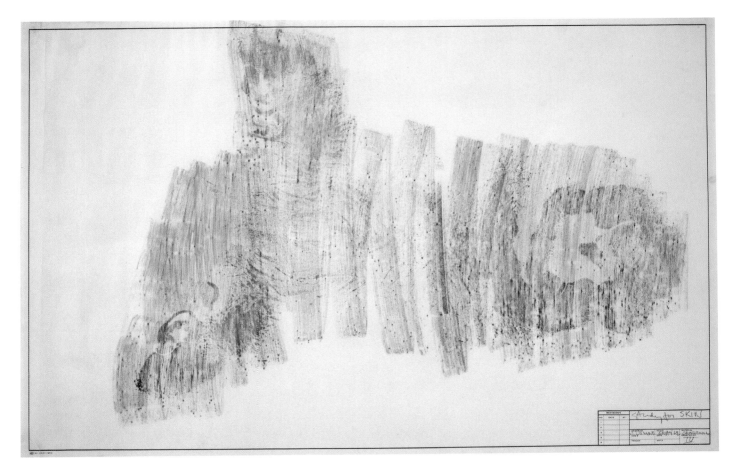

119 59. *Study for "Skin" IV*, 1962

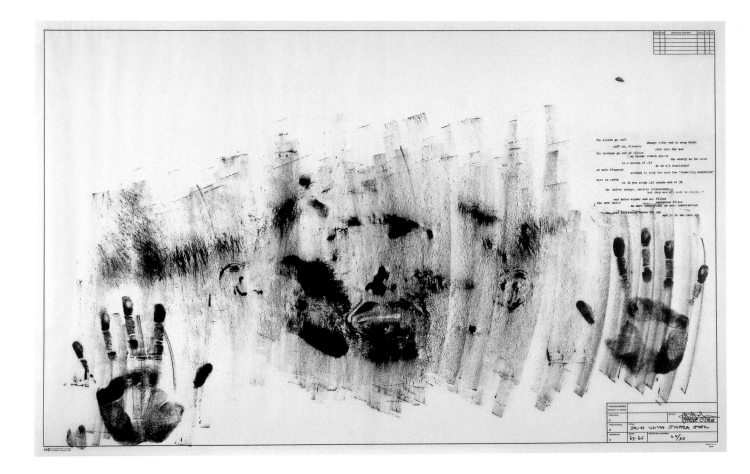

120 60. *Skin with O'Hara Poem*, 1963/1965

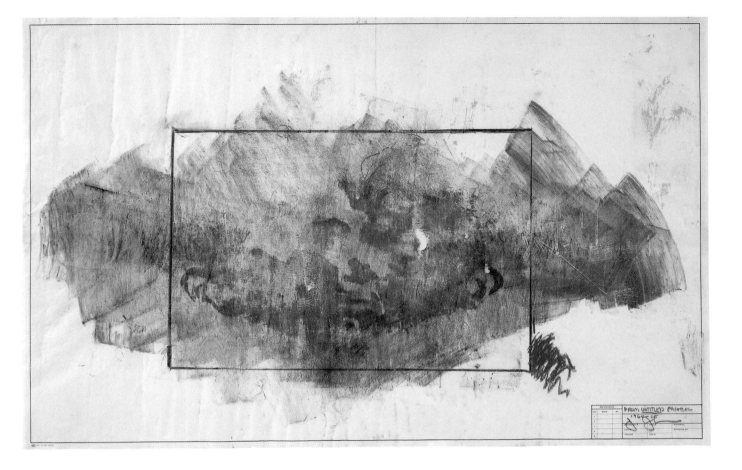

61. *From "Untitled" Painting*, 1964–1965

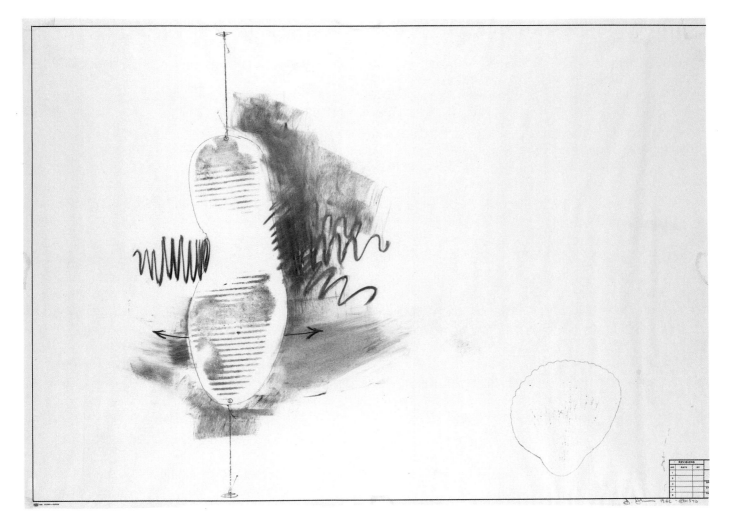

123 62. *Edisto*, 1962

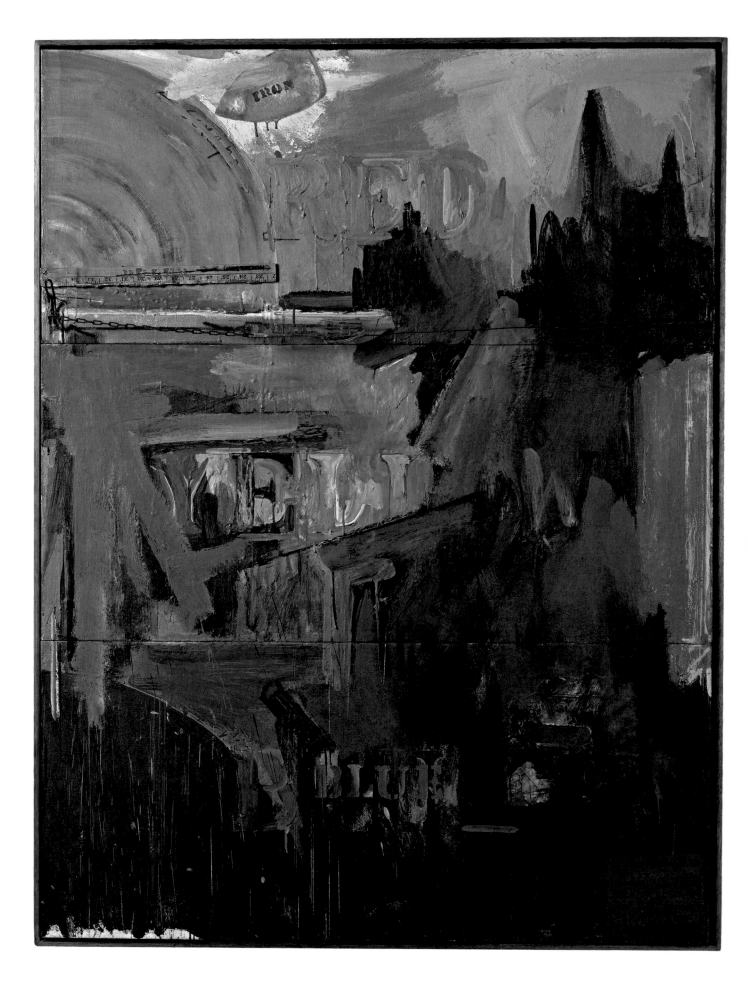

63. *Passage*, 1962

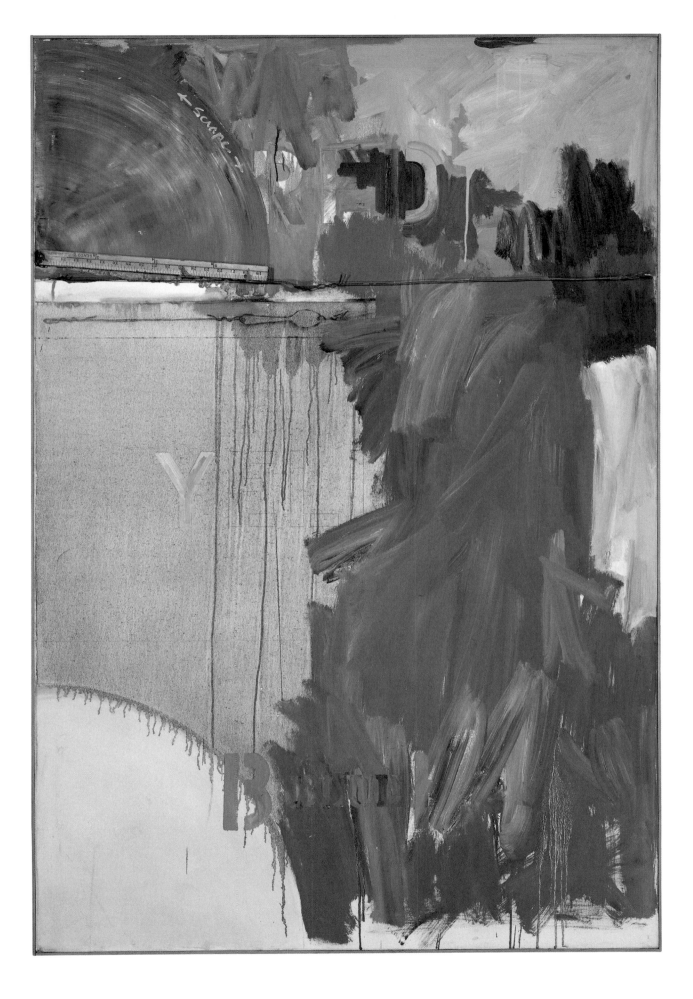

64. *Out the Window Number 2*, 1962

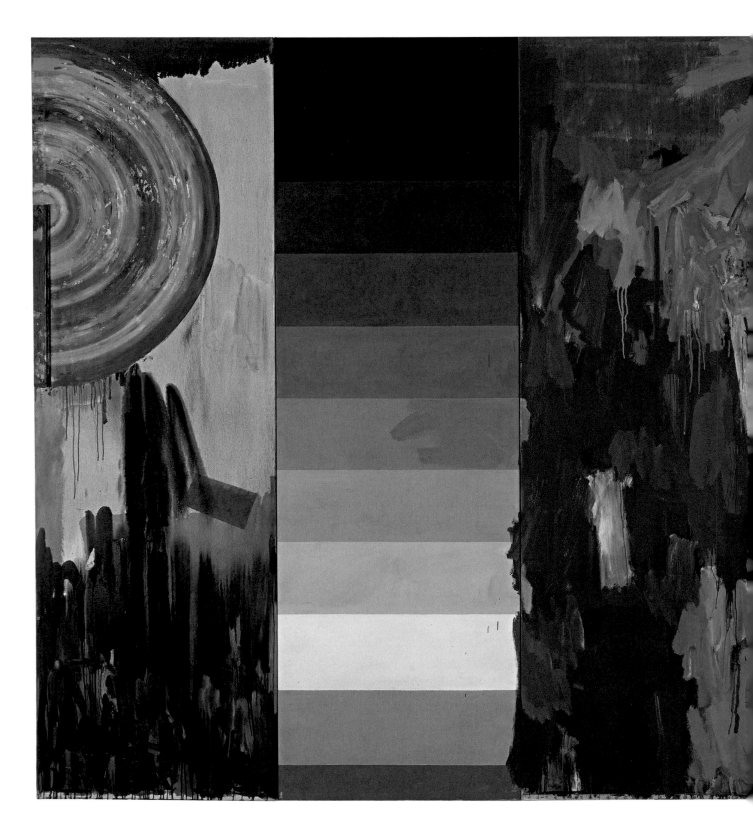

65. *Diver*, 1962

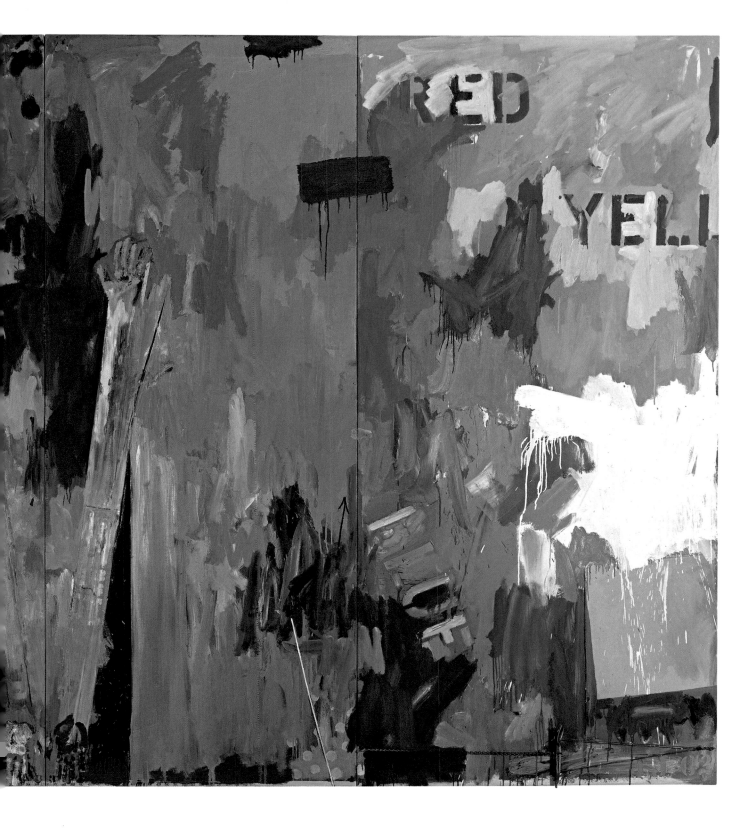

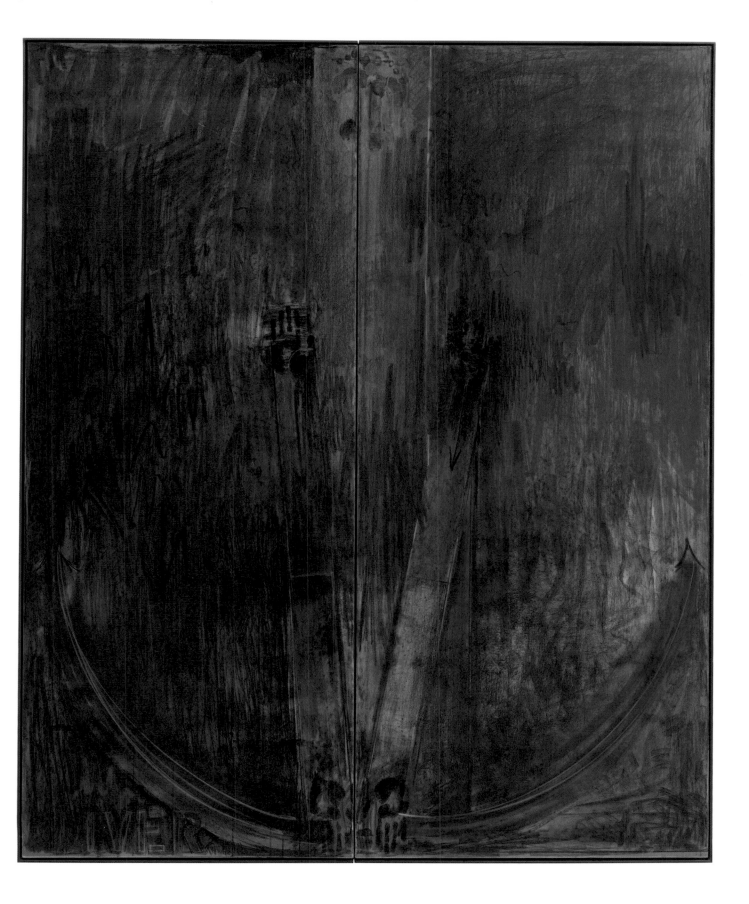

66. *Diver*, 1962–1963

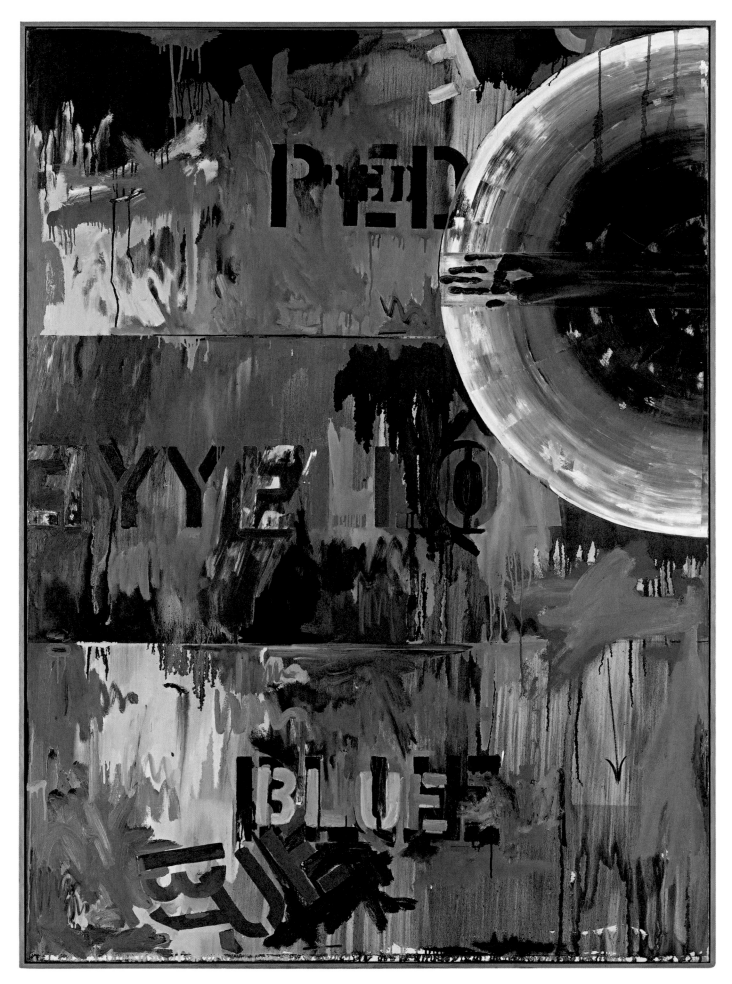

67. *Periscope (Hart Crane)*, 1963

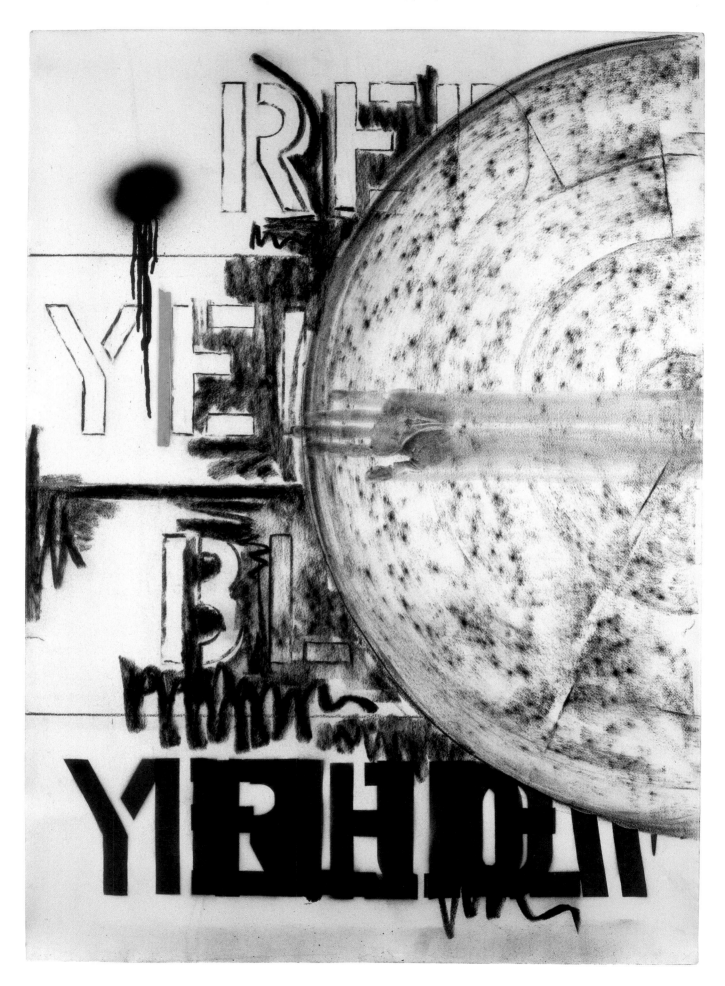

131 68. *Untitled*, 1963

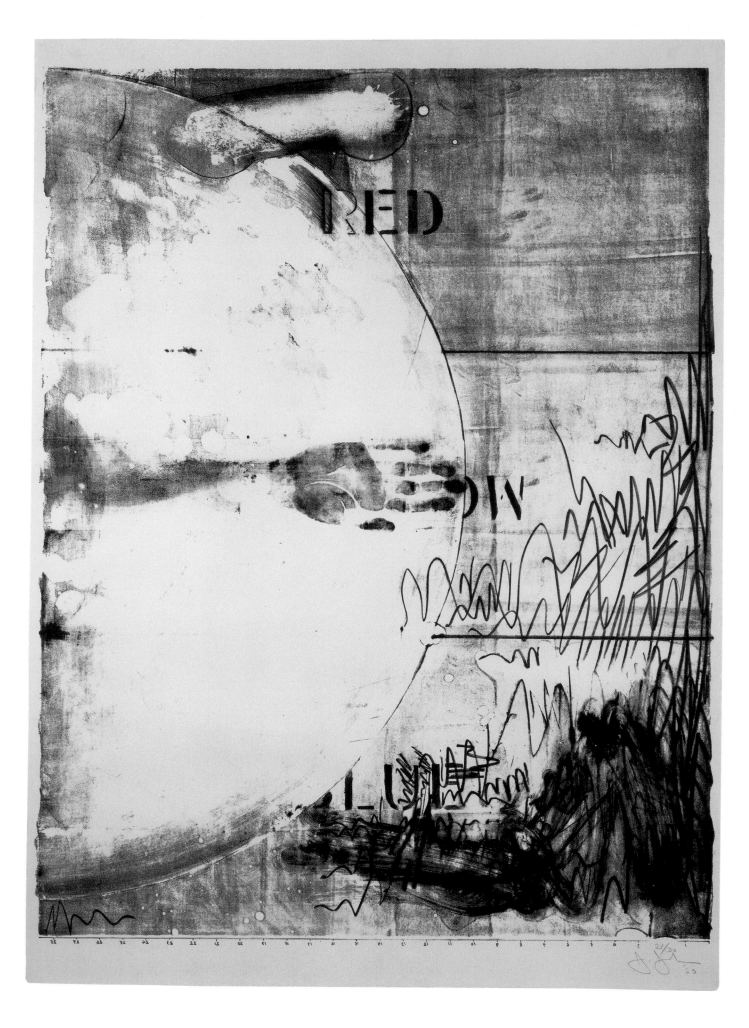

69. *Hatteras*, 1963

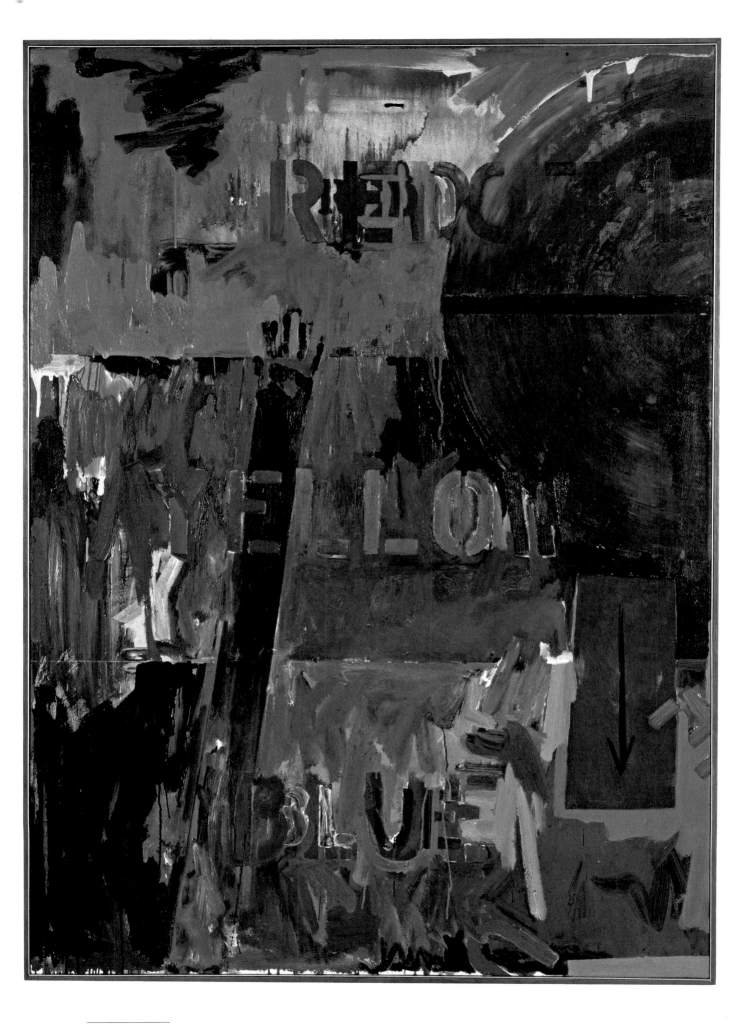

133 70. *Land's End*, 1963

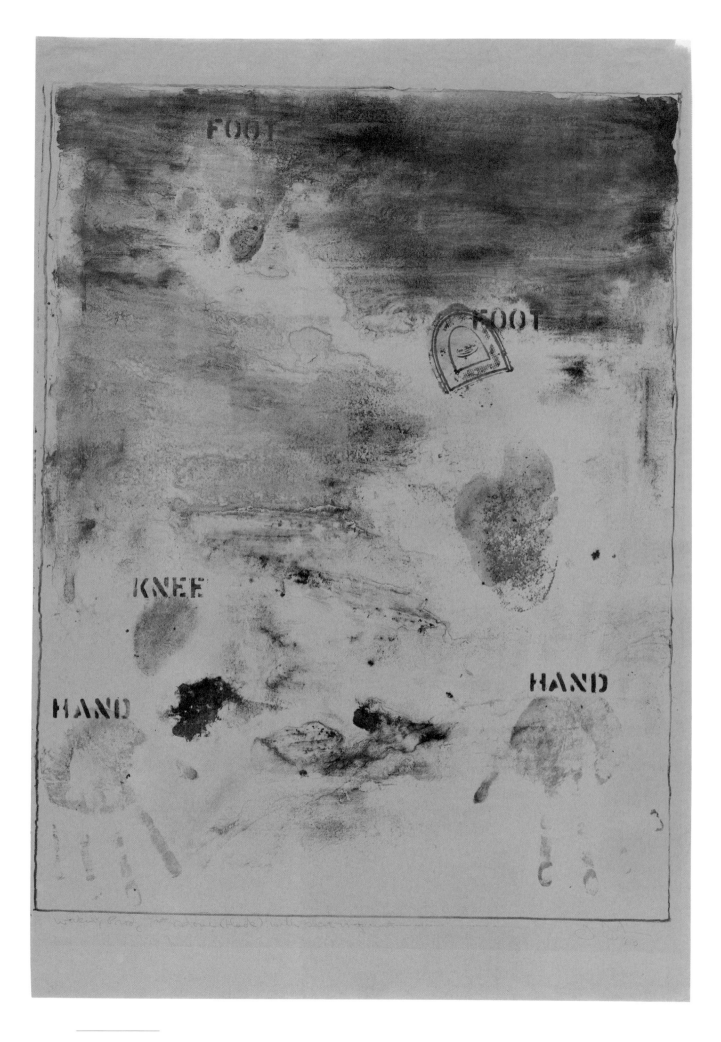

FOOT

FOOT

KNEE

HAND

HAND

72. *Pinion*, 1963

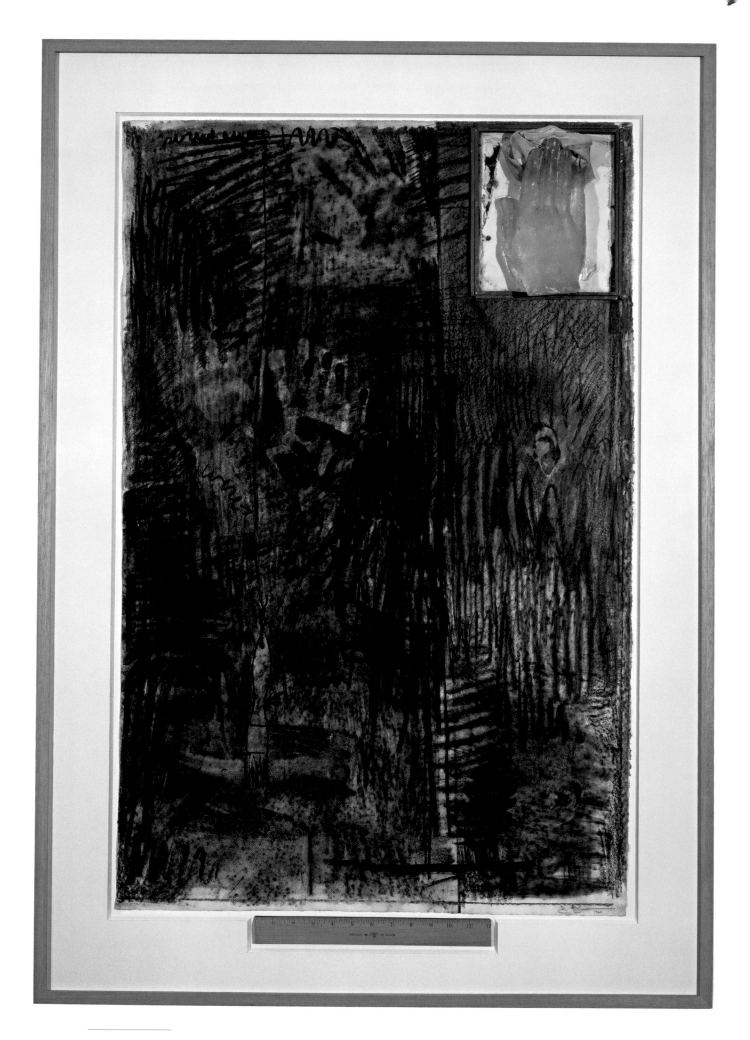

136 *73. Wilderness II, 1963–1970*

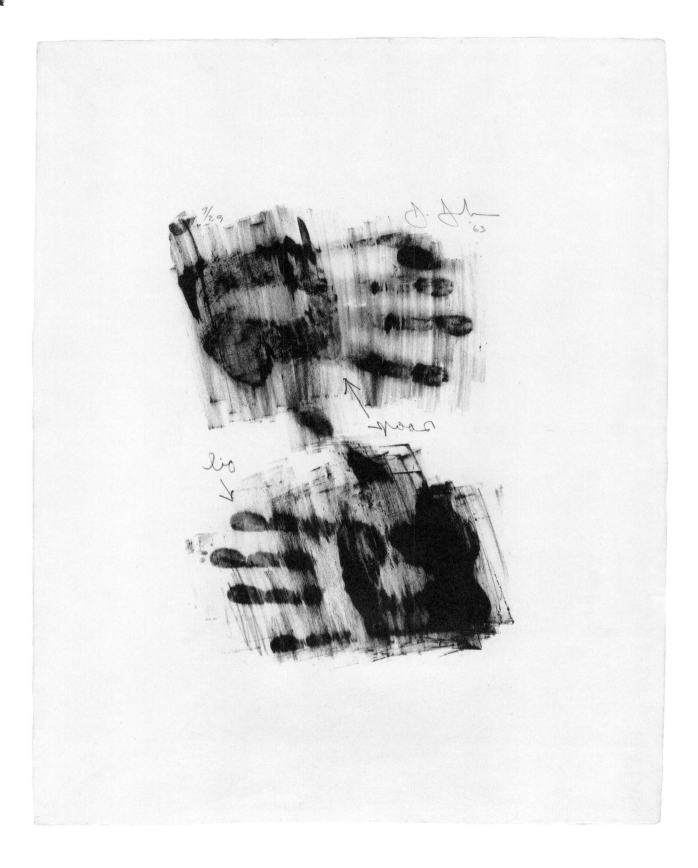

74. *Hand,* 1963

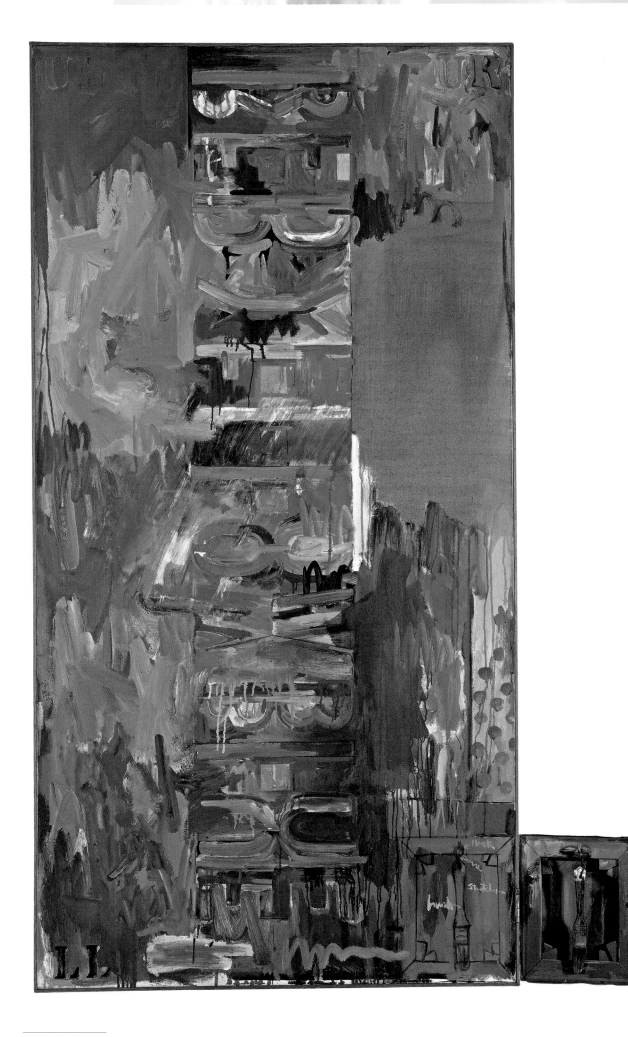

76. *Slow Field*, 1962

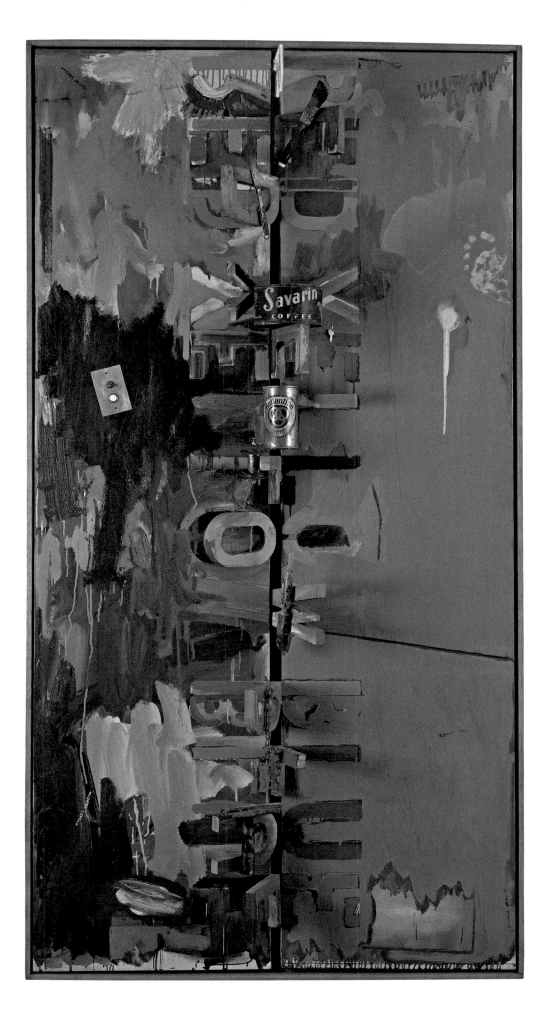

77. *Field Painting*, 1963–1964

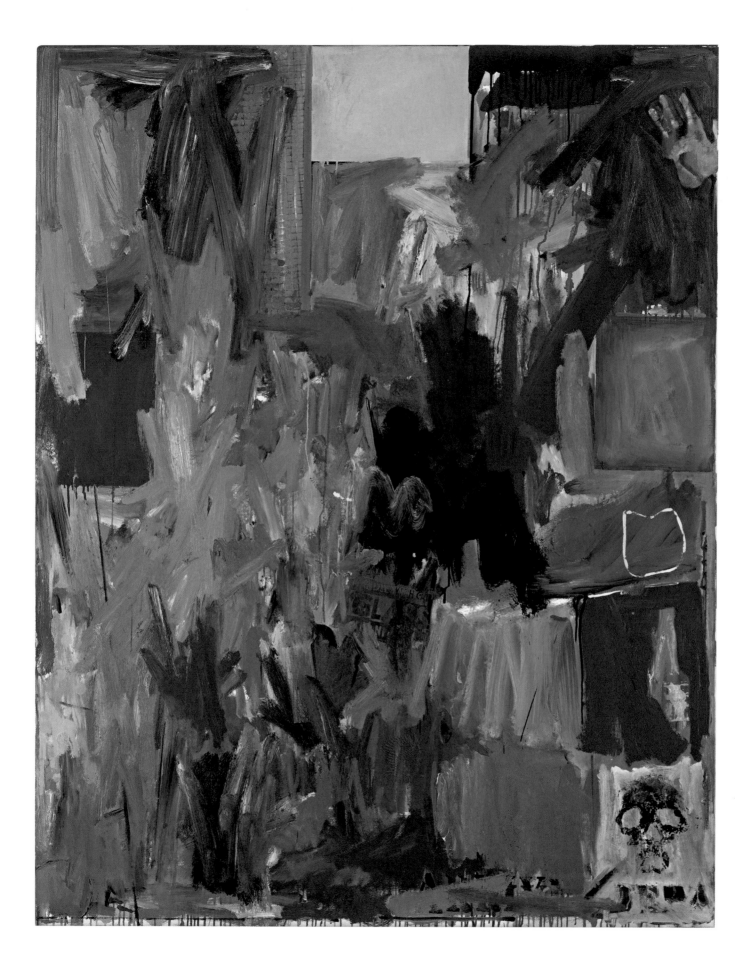

78. *Arrive / Depart*, 1963–1964

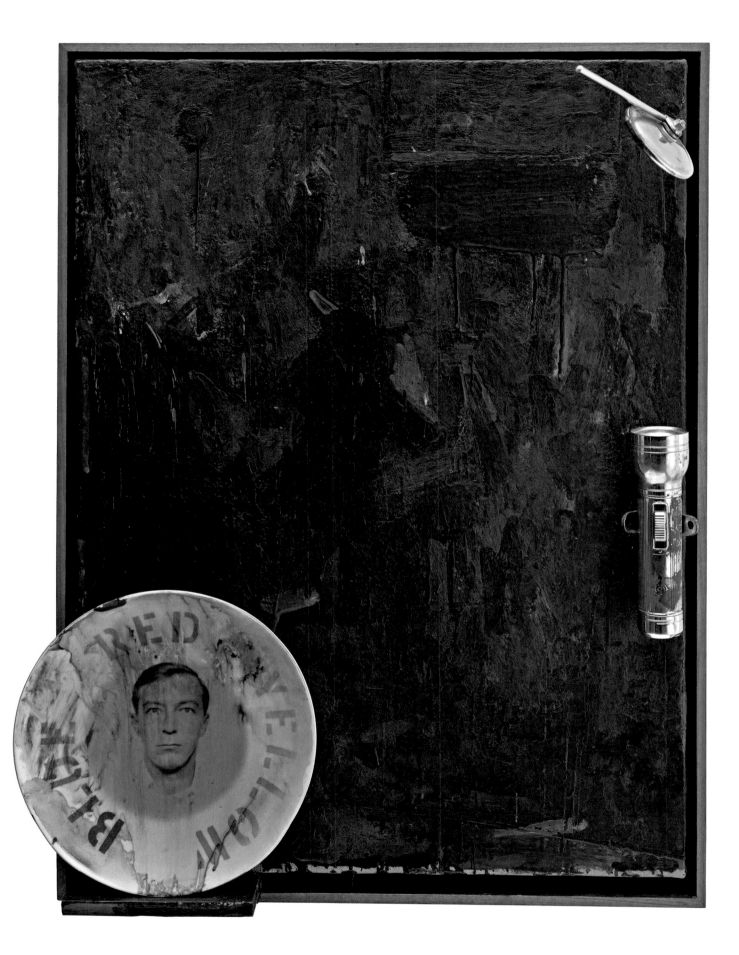

79. *Souvenir*, 1964

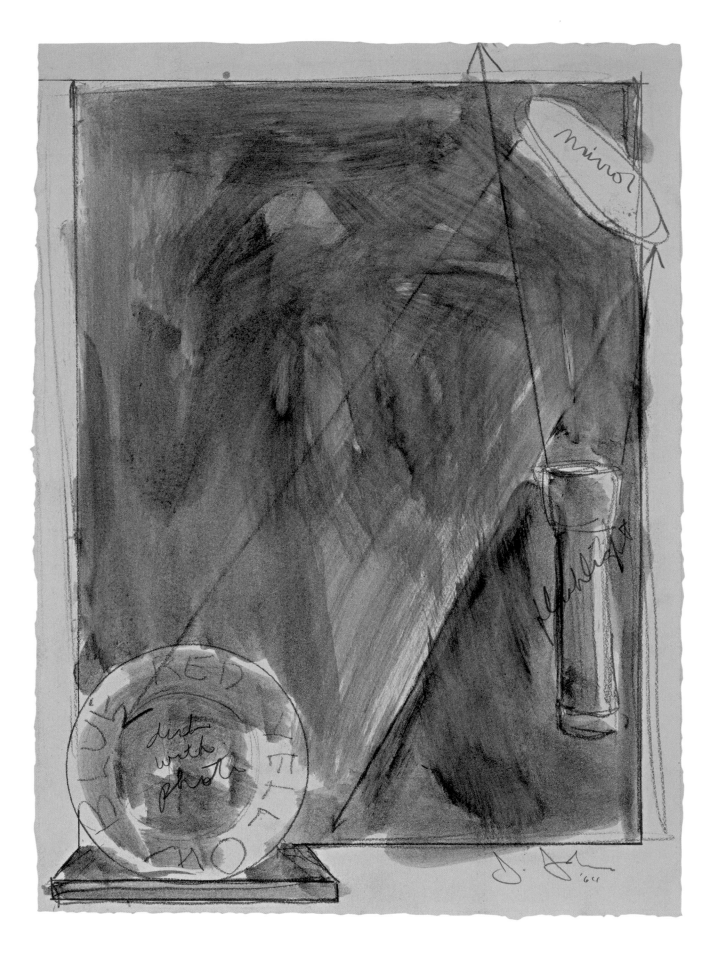

Within the image, the following handwritten text appears: "Mirror", "flashlight", "dirt with photo", "RED", "YELLOW", "BLUE"

80. *Souvenir*, 1964

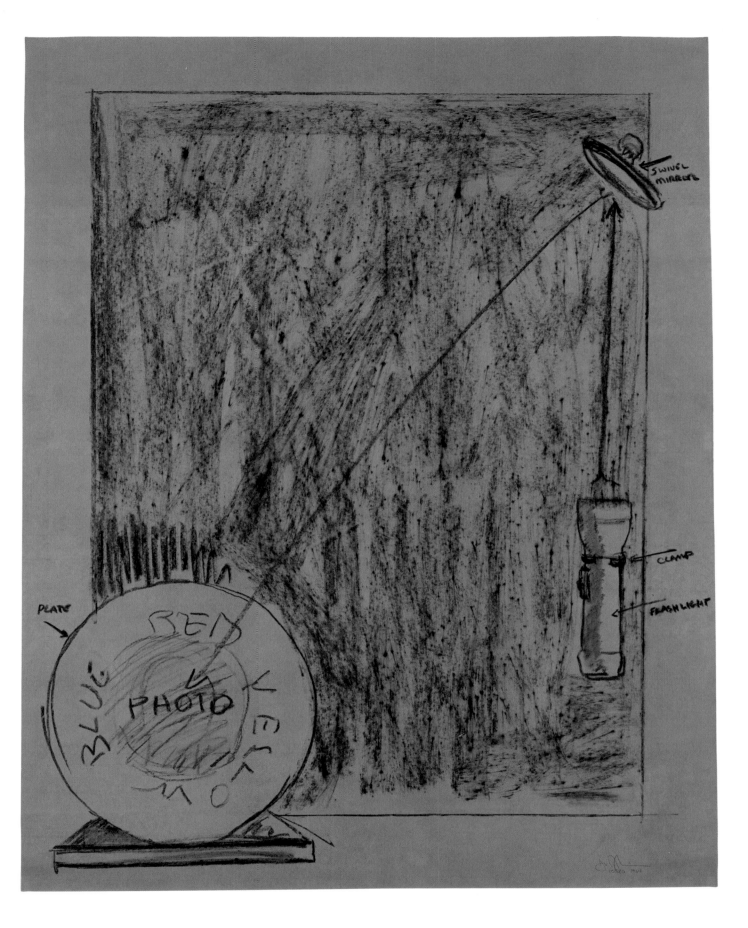

The labels within the image read: SWIVEL MIRROR, CLAMP, FLASHLIGHT, PLATE, BLUE, RED, YELLOW, PHOTO

81. *Souvenir*, 1964

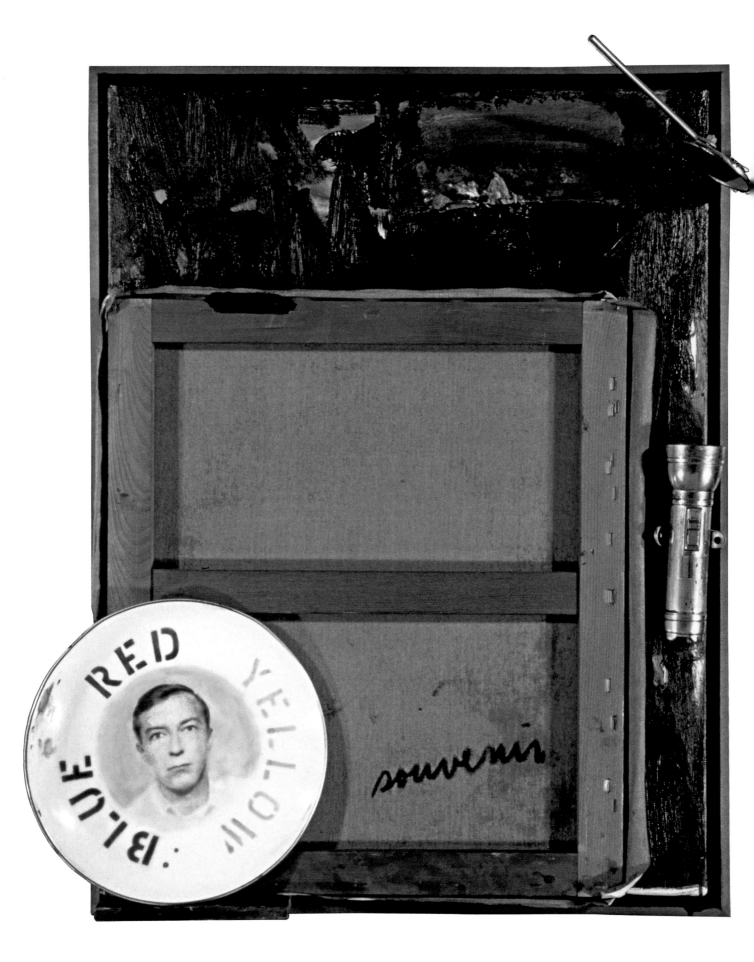

82. *Souvenir 2*, 1964

83. *Untitled (Cut, Tear, Scrape, Erase)*, 1964

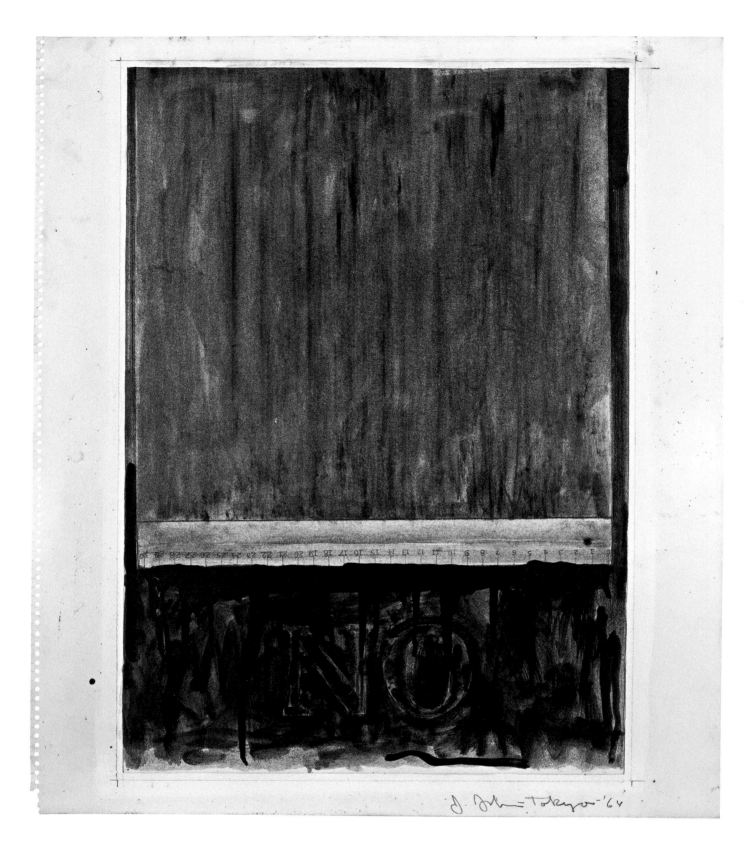

84. No, 1964

85. *No*, 1964

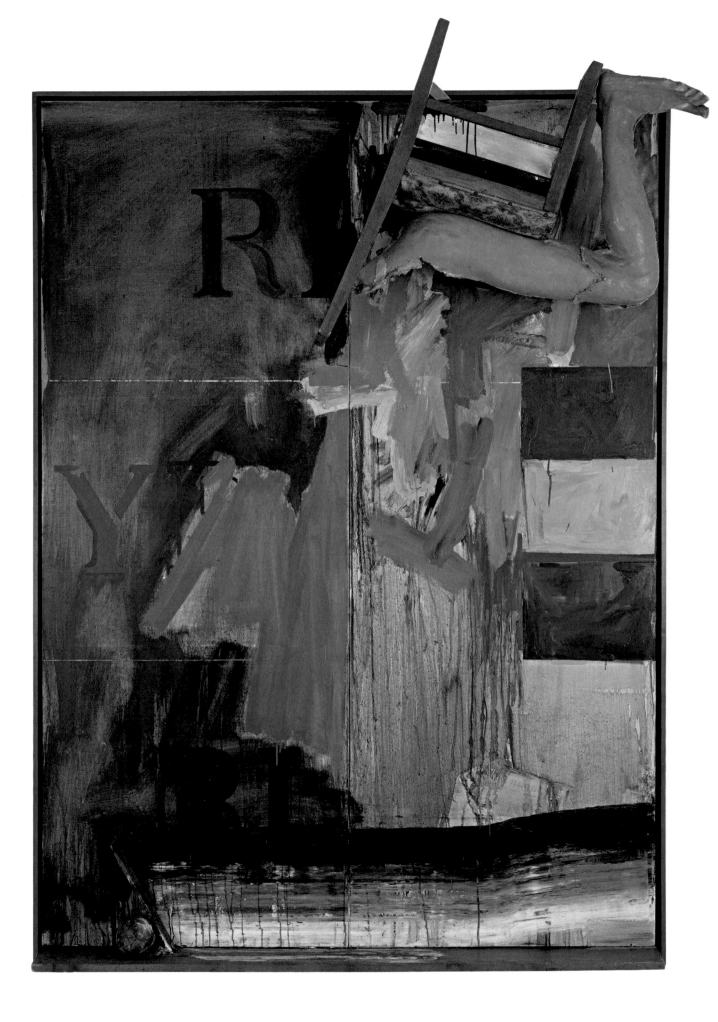

86. *Watchman*, 1964

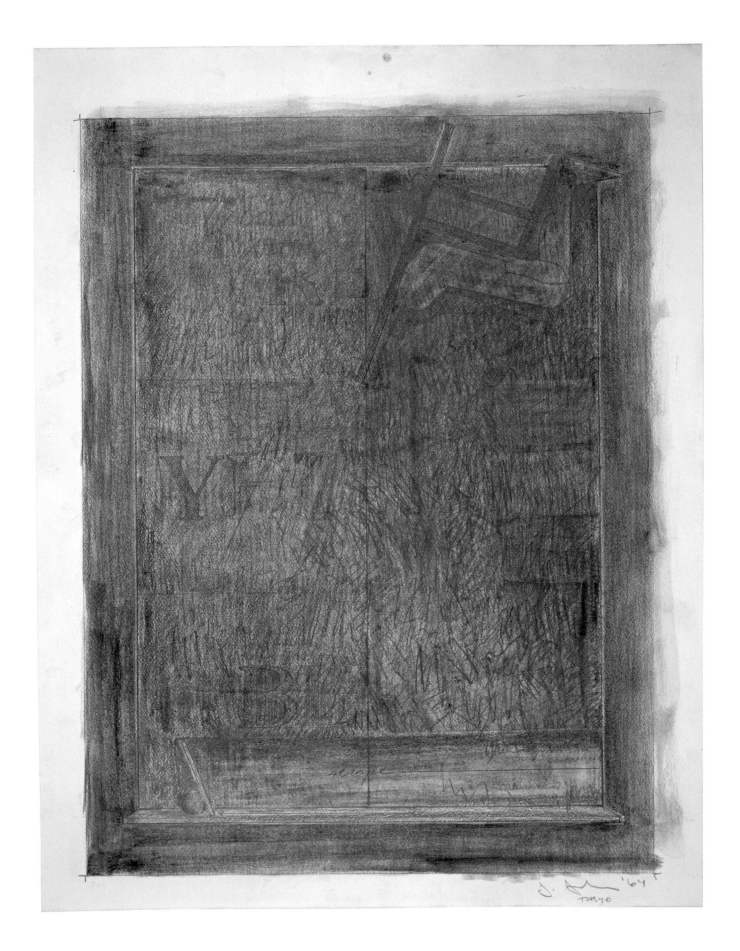

151 87. *Watchman*, 1964

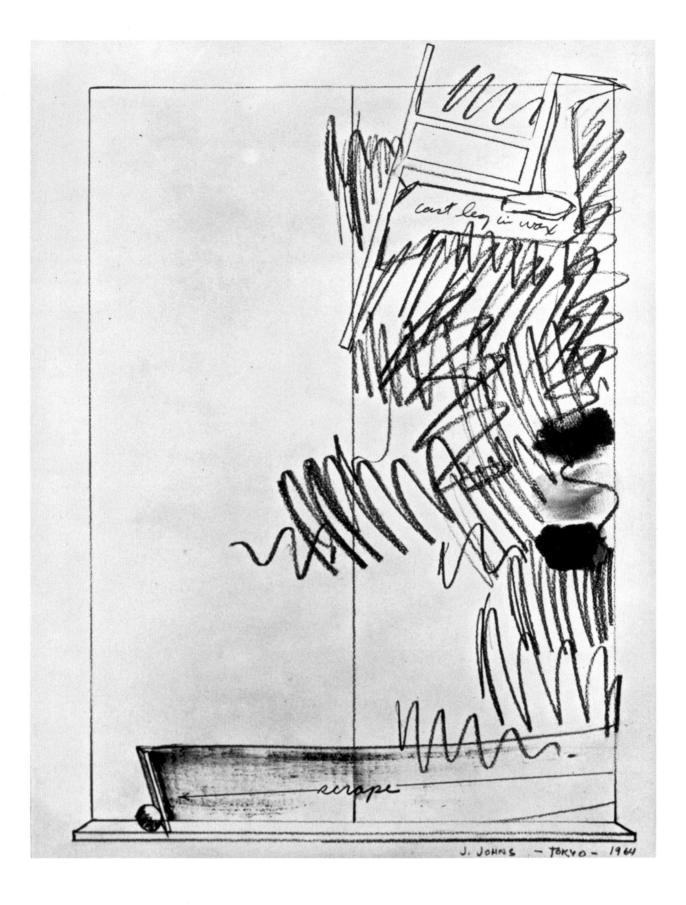

cast leg in wax

scrape

J. JOHNS — TOKYO — 1964

153 88. *Watchman*, 1964

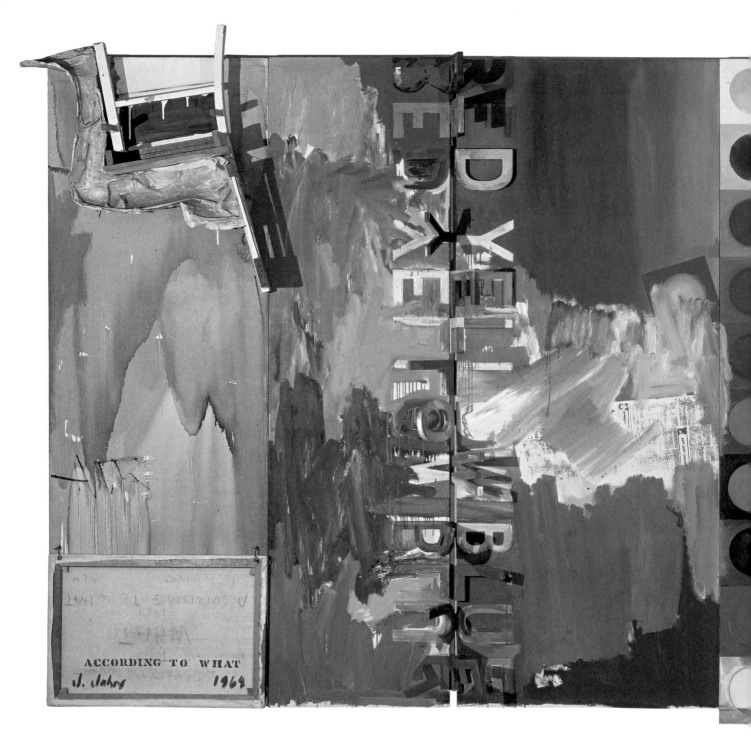

89. *According to What*, 1964

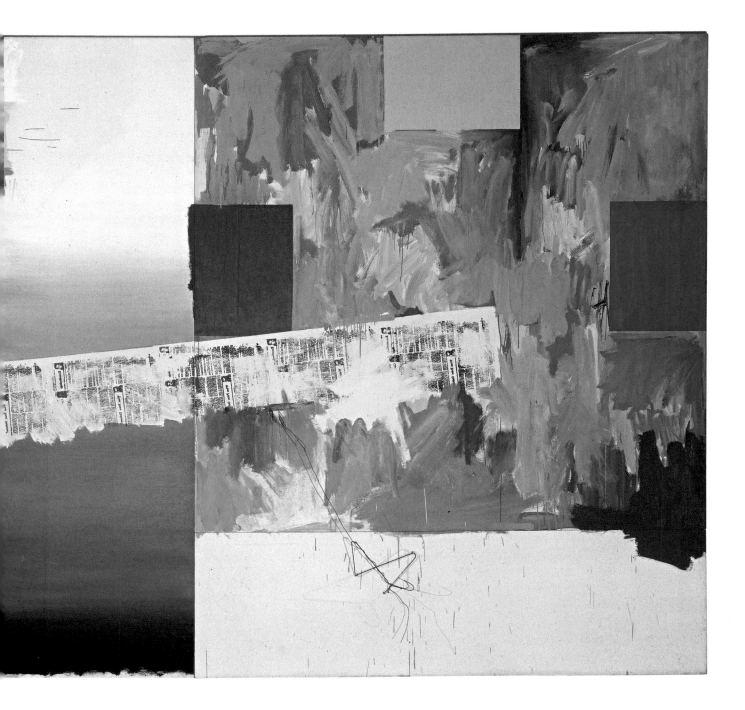

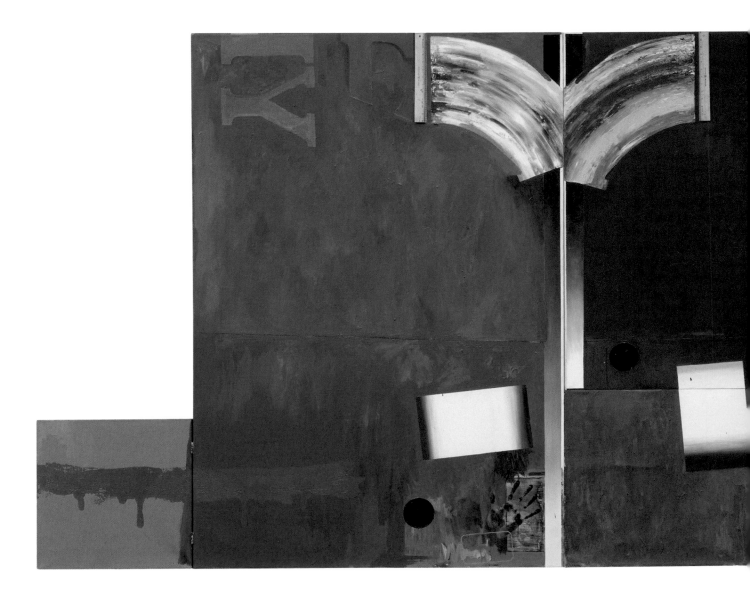

90. *Untitled*, 1964–1965

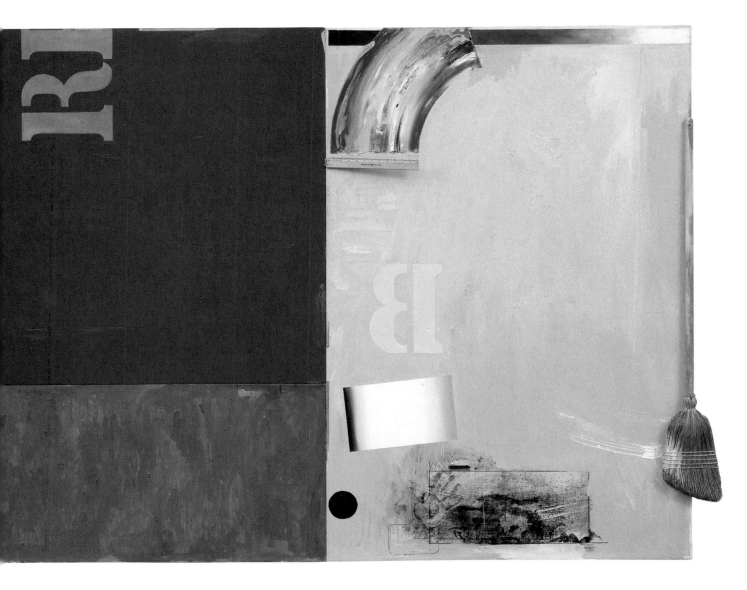

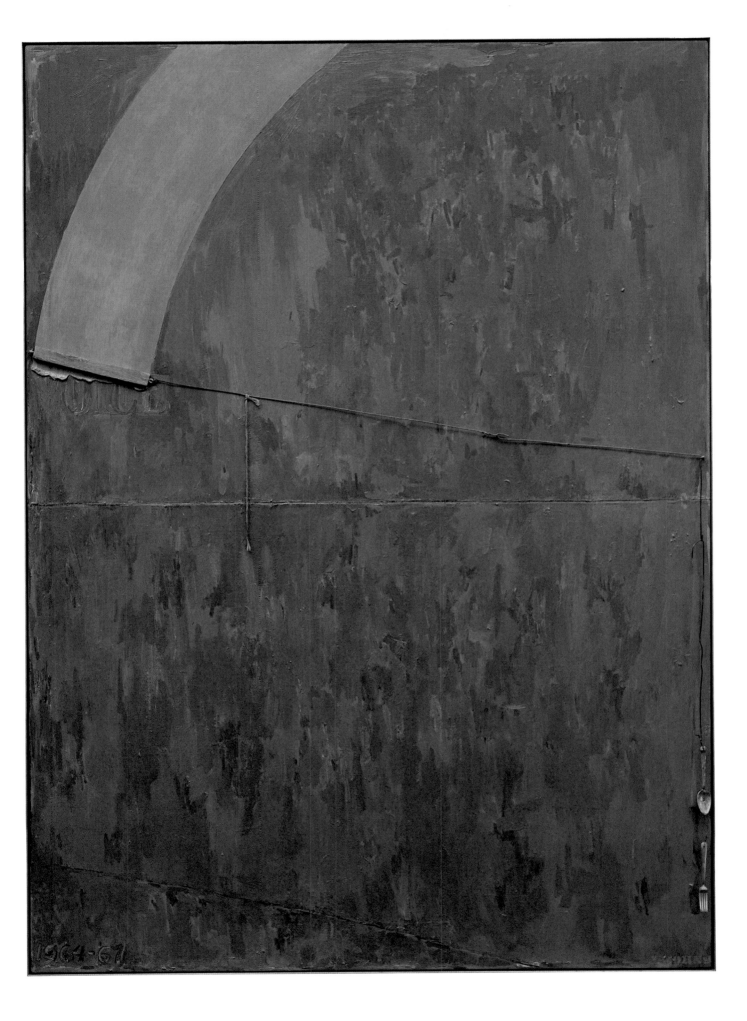

91. *Voice*, 1964–1967

Checklist

Note: cats. 5, 6, 18, 24, and 88
do not appear in the exhibition.

All works of art by Jasper Johns
are © Jasper Johns / Licensed
by VAGA, New York, NY

1. *Target with Plaster Casts*

1955, encaustic and collage
on canvas with painted plaster
casts, 129.5 × 111.8 × 8.8
(51 × 44 × 3 7/16), Collection of
David Geffen, Los Angeles

2. *Target with Plaster Casts*

1955, graphite pencil on
paper, 22.9 × 19.1 (9 × 7 ½),
Collection Jean-Christophe
Castelli

3. *Target with Four Faces*

1955, encaustic on news-
paper and cloth over canvas
surmounted by four tinted-
plaster faces in wood box with
hinged front, overall with box
open 85.3 × 66 × 7.6 (33 9/16
× 26 × 3), canvas 66 × 66 (26 ×
26), box (closed) 9.5 × 66 × 8.9
(3 ¾ × 26 × 3 ½), The Museum
of Modern Art, New York,
Gift of Mr. and Mrs. Robert
C. Scull, 1958

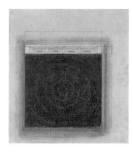

4. *Target with Four Faces*

1955, graphite pencil and pastel
on paper, 23.5 × 20 (9 ¼ × 7 ⅞),
Collection of the artist

5. *Green Target*

1955, encaustic on newspaper
and cloth over canvas, 152.4 ×
152.4 (60 × 60), The Museum
of Modern Art, New York,
Richard S. Zeisler Fund

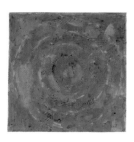

6. *Green Target*

1956, encaustic and collage on
canvas, 23.5 × 23.5 (9 ¼ × 9 ¼),
Private collection

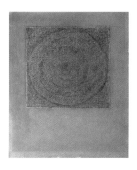

7. *Target*

1956, graphite pencil on board, 25.4 × 20.3 (10 × 8), Private collection

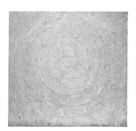

8. *White Target*

1957, encaustic on canvas, 76.2 × 76.2 (30 × 30), Whitney Museum of American Art, New York, Purchase

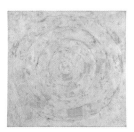

9. *White Target*

1958, encaustic and collage on canvas, 107.9 × 107.9 (42 ½ × 42 ½), Steven A. Cohen

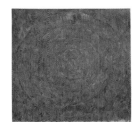

10. *Gray Target*

1958, encaustic on canvas, 106.7 × 106.7 (42 × 42), Private collection

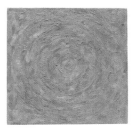

11. *Gray Target*

1958, encaustic on canvas, 30.5 × 30.5 (12 × 12), Courtesy Sonnabend Collection, New York

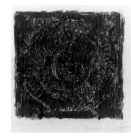

12. *Target*

1958, graphite wash and graphite pencil on paper, 29.5 × 27 (11 ⅝ × 10 ⅝), Collection of Kimiko and John Powers

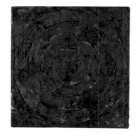

13. *Green Target*

1958, encaustic and collage on board, 21.6 × 21.6 (8 ½ × 8 ½), Private collection

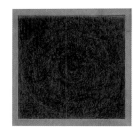

14. *Green Target*

1958, pencil and wash on board, 26.9 × 24.1 (10 ⅝ × 9 ½), Collection of Barbara Bertozzi Castelli

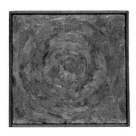

15. *Green Target*

1959, encaustic and collage on canvas, 25.4 × 25.4 (10 × 10), Louisiana Museum of Modern Art, Humlebaek, Denmark, Donation, Elena and Nicolas Calas

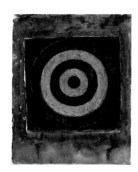

16. *Target on an Orange Field*

1957, watercolor and pencil on paper, 27.9 × 21.6 (11 × 8 ½), The Museum of Contemporary Art, Los Angeles, Bequest of Marcia Simon Weisman

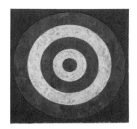

17. *Target*

1958, oil and collage on canvas, 91.4 × 91.4 (36 × 36), Collection of the artist

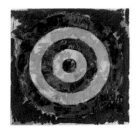

18. *Target*

1958, encaustic, oil crayons, and newsprint collage on board, 35.6 × 35.6 (14 × 14), Private collection

19. *Target Sketch*

1959, pencil and crayon on paper, 27.9 × 21.6 (11 × 8 ½), The Menil Collection, Houston, Bequest of David Whitney

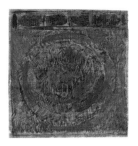

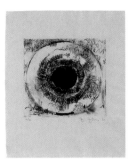

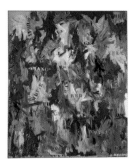

20. *Green Target*

1958, graphite pencil, encaustic, and collage on paper, 19.1 × 17 (7 ½ × 6 ¹¹⁄₁₆), Collection of the artist

23. *Target*

1958, Conté crayon on paper, 41 × 41 (16 ⅛ × 16 ⅛), Andrew and Denise Saul

27. *Target*

1960, lithograph, 57.6 × 45.2 (22 ¾ × 17 ⅞), Kunstmuseum Basel, Kupferstichkabinett

30. *False Start*

1959, oil on canvas, 170.8 × 137.2 (67 ¼ × 54), Kenneth and Anne Griffin

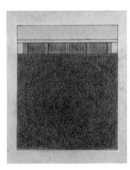

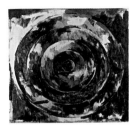

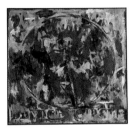

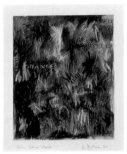

21. *Target with Four Faces*

1958, pencil and gouache on tracing paper mounted on board, 41.3 × 31.7 (16 ¼ × 12 ½), The Menil Collection, Houston, Bequest of David Whitney

24. *Black Target*

1959, encaustic and collage on canvas, 137.1 × 137.1 (54 × 54), Destroyed in fire in 1961

28. *Device Circle*

1959, encaustic and collage on canvas with object, 101.6 × 101.6 (40 × 40), Andrew and Denise Saul

31. *From False Start*

1960, pastel, watercolor, and graphite pencil on paper, 41.9 × 35.6 (16 ½ × 14), The Collection of Barbara Bluhm-Kaul & Don Kaul, Chicago

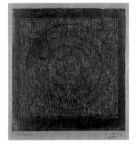

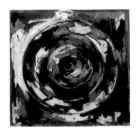

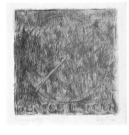

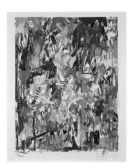

22. *Target*

1958, pencil, graphite wash, and collage on paper mounted on cardboard, 38.1 × 35.2 (15 × 13 ⅞), Collection of the Modern Art Museum of Fort Worth, The Benjamin J. Tillar Memorial Trust

25. *Target*

1959–1960, oil and collage on paper, 39.1 × 39.1 (15 ⅜ × 15 ⅜), Jane & Marc Nathanson, Los Angeles

29. *Device Circle*

1960, pencil on paper, 38.4 × 38.4 (15 ⅛ × 15 ⅛), Private collection

32. *False Start I*

1962, lithograph, 76.2 × 56.8 (30 × 22 ⅜), National Gallery of Art, Washington, Gift of the Woodward Foundation, Washington, D.C., 1976

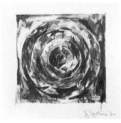

26. *Target*

1960, graphite and wash on paper, 33.7 × 33.7 (13 ¼ × 13 ¼), Allen Memorial Art Museum, Oberlin College, Oberlin, Ohio, Fund for Contemporary Art and National Foundation for the Arts and Humanities, 1968

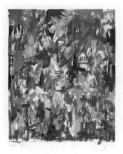

33. *False Start II*

1962, lithograph, 76.8 × 56.8 (30 ¼ × 22 ⅜), National Gallery of Art, Washington, Gift of the Woodward Foundation, Washington, D.C., 1976

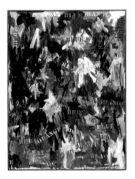

34. *Jubilee*

1959, oil and collage on canvas, 152.4 × 111.8 (60 × 44), Private collection

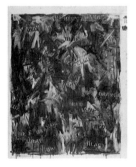

35. *Jubilee*

1960, graphite wash on paper, 79 × 63.5 (31 ⅛ × 25), The Museum of Modern Art, New York, The Joan and Lester Avnet Collection

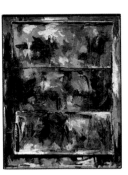

36. *Reconstruction*

1959, encaustic and collage on canvas, 154.9 × 111.8 (61 × 44), The Cleveland Museum of Art, Accessions Reserve Fund and Andrew R. and Martha Holden Jennings Fund 1973.28

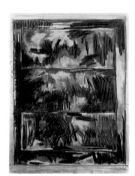

37. *Reconstruction*

1960, charcoal on paper, 74.3 × 53.3 (29 ¼ × 21), Collection of Tony and Gail Ganz, Los Angeles

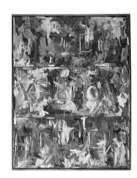

38. *Out the Window*

1959, encaustic and collage on canvas, 138.4 × 101.9 (54 ½ × 40 ⅛), Collection of David Geffen, Los Angeles

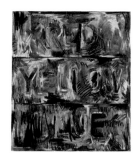

39. *Out the Window*

1960, charcoal and pastel on paper, 87.3 × 72.1 (34 ⅜ × 28 ⅜), Steven A. Cohen

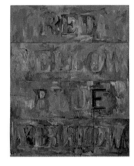

40. *By the Sea*

1961, encaustic on canvas (four panels), 182.9 × 138.4 (72 × 54 ½), Private collection

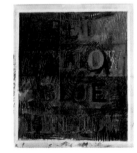

41. *Folly Beach*

1962, charcoal and chalk on paper, 91.4 × 74.6 (36 × 29 ⅜), Private collection, New York

42. *Do It Yourself (Target)*

1960, pencil on board with paintbrush and dry watercolor cakes, wood frame, 19.7 × 14 (7 ¾ × 5 ½), Courtesy Sonnabend Collection, New York

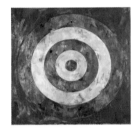

43. *Target*

1961, encaustic and collage on canvas, 167.6 × 167.6 (66 × 66), Stefan T. Edlis Collection

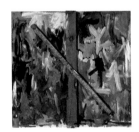

44. *Painting with Ruler and "Gray"*

1960, oil and collage on canvas with objects, 81.3 × 81.3 (32 × 32), Frederick R. Weisman Art Foundation, Los Angeles

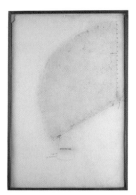

45. *Sketch for*
"Good Time Charley"

1961, pencil and ink on blotting
paper, 96.5 × 61 (38 × 24), Lent
by The Metropolitan Museum
of Art, Gift of Jim Dine, 1978

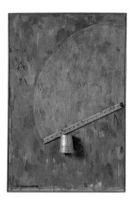

46. *Good Time Charley*

1961, encaustic on canvas
with objects, 96.5 × 61 × 11.4
(38 × 24 × 4 ½), Collection
Mark Lancaster, Courtesy of
Philadelphia Museum of Art

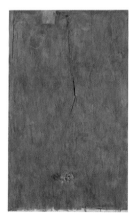

47. *No*

1961, encaustic, collage, and
Sculp-metal on canvas with
objects, 172.7 × 101.6 (68 × 40),
Collection of the artist

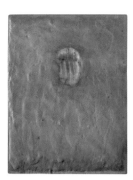

48. *Painting Bitten by a Man*

1961, encaustic on canvas
mounted on wood type
plate, 24.1 × 17.5 (9 ½ × 6 ⅞),
Collection of the artist

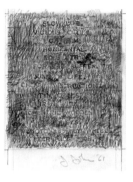

49. *Litanies of the Chariot*

1961, pencil and graphite wash
on paper, 13 × 9.2 (5 ⅛ × 3 ⅝),
Private collection, Houston

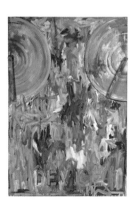

50. *Device*

1961–1962, oil on canvas with
objects, 183 × 123.8 × 11.4
(72 ¹⁄₁₆ × 48 ¾ × 4 ½), Dallas
Museum of Art, Gift of The Art
Museum League, Margaret J.
and George V. Charlton, Mr.
and Mrs. James B. Francis,
Dr. and Mrs. Ralph Greenlee,
Jr., Mr. and Mrs. James H. W.
Jacks, Mr. and Mrs. Irvin L.
Levy, Mrs. John W. O'Boyle,
and Dr. Joanne Stroud in honor
of Mrs. Eugene McDermott

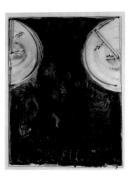

51. *Device*

1962, ink on plastic, 60.7 ×
45.7 (24 × 18), Collection
of Barbara Bertozzi Castelli

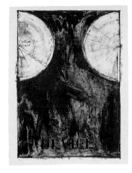

52. *Device*

1962, lithograph, 80 × 57.8
(31 ½ × 22 ¾), Kunstmuseum
Basel, Kupferstichkabinett

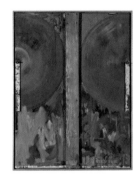

53. *Device*

1962, oil on canvas with
objects, 101.6 × 76.2 (40 × 30),
The Baltimore Museum of Art,
Purchased with funds provided
by the Dexter M. Ferry, Jr.
Trustee Corporation Fund and
by Edith Ferry Cooper

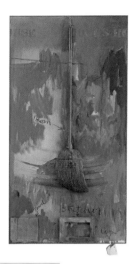

54. *Fool's House*

1961–1962, oil on canvas
with objects, 182.9 × 91.4 ×
11.4 (72 × 36 × 4 ½), Collection
Jean-Christophe Castelli

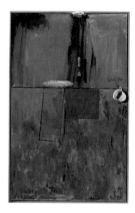

55. *Zone*

1962, oil, encaustic, and
collage on canvas with objects,
153 × 91.5 (60 ¼ × 36),
Kunsthaus Zürich

56. *Study for "Skin" I*

1962, charcoal and oil on
drafting paper, 55.9 × 86.4
(22 × 34), Collection of
the artist

57. *Study for "Skin" II*

1962, charcoal and oil on
drafting paper, 55.9 × 86.4
(22 × 34), Collection of
the artist

58. *Study for "Skin" III*

1962, charcoal and oil on
drafting paper, 55.9 × 86.4
(22 × 34), Collection of
the artist

59. *Study for "Skin" IV*

1962, charcoal and oil on
drafting paper, 55.9 × 86.4
(22 × 34), Collection of
the artist

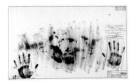

60. *Skin with O'Hara Poem*

1963/1965, lithograph, 55.9
× 86.4 (22 × 34), National
Gallery of Art, Washington,
Gift of the Woodward
Foundation, Washington,
D.C., 1976

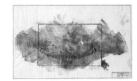

61. *From "Untitled" Painting*

1964–1965, charcoal, oil, and
pastel on paper, 55.5 × 86
(21 7/8 × 33 7/8), Werner H. and
Sarah-Ann Kramarsky

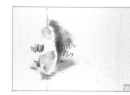

62. *Edisto*

1962, charcoal and graphite
pencil on paper, 55.9 × 75.9
(22 × 29 7/8), Collection of
the artist

63. *Passage*

1962, encaustic and collage
on canvas with objects, 137.2
× 101.6 (54 × 40), Museum
Ludwig, Cologne

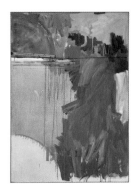

64. *Out the Window
Number 2*

1962, oil on canvas with
objects, 183 × 122 (72 1/16 ×
48 1/16), Kunstmuseum Basel,
Gift of the artist in memory
of Christian Geelhaar, 1994

65. *Diver*

1962, oil on canvas with
objects (five panels), 228.6 ×
431.8 (90 × 170), Collection
of Irma and Norman Braman

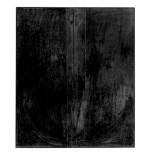

66. *Diver*

1962–1963, charcoal, pastel,
and watercolor on paper
mounted on canvas (two
panels), 219.7 × 182.2 (86 1/2 ×
71 3/4), The Museum of Modern
Art, New York, Partial gift
of Kate Ganz and Tony Ganz
in memory of their parents,
Victor and Sally Ganz, and in
memory of Kirk Varnedoe;
Mrs. John Hay Whitney Be-
quest Fund; Gift of Edgar
Kaufmann, Jr. (by exchange)
and purchase; Acquired by the
Trustees of The Museum of
Modern Art in memory of
Kirk Varnedoe, 2003

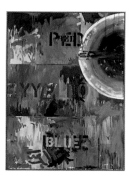

67. *Periscope (Hart Crane)*

1963, oil on canvas, 170.2 ×
121.9 (67 × 48), Collection
of the artist

68. *Untitled*

1963, charcoal, Krylon spray
enamel, pastel, and collage on
paper, 108 × 76.2 (42 1/2 × 30),
Victoria Ganz DeFelice

69. *Hatteras*

1963, lithograph, 105.1 × 74.9
(41 3/8 × 29 1/2), Kunstmuseum
Basel, Kupferstichkabinett

70. *Land's End*

1963, oil on canvas with object, 170.2 × 122.6 (67 × 48 ¼), San Francisco Museum of Modern Art, Gift of Harry W. and Mary Margaret Anderson

71. *Pinion*

1963, lithograph (working proof) on heavy newsprint, 92.1 × 61.9 (36 ¼ × 24 ⅜), National Gallery of Art, Washington, Patrons' Permanent Fund, 2004

72. *Pinion*

1963, lithograph (working proof) with hand additions in lithographic crayon on heavy newsprint, 88.9 × 61.9 (35 × 24 ¼), National Gallery of Art, Washington, Patrons' Permanent Fund, 2004

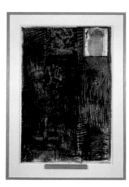

73. *Wilderness II*

1963–1970, charcoal, pastel, and collage on paper with objects, sheet with ruler 108.6 × 65.4 (42 ¾ × 25 ¾), with frame 127 × 87.3 × 7.6 (50 × 34 ⅜ × 3), Collection of the artist

74. *Hand*

1963, lithograph, 57.2 × 44.5 (22 ½ × 17 ½), National Gallery of Art, Washington, Gift of Tom Levine, 2002

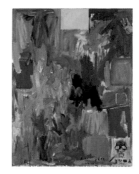

75. *Handprint*

1964, oil on paper, 51.6 × 43.8 (20 ⁵⁄₁₆ × 17 ¼), Collection of the artist

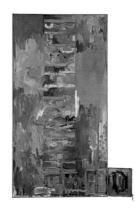

76. *Slow Field*

1962, oil on canvas with objects, 181 × 90 (71 ¼ × 35 ⁷⁄₁₆), Moderna Museet, Stockholm

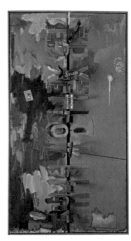

77. *Field Painting*

1963–1964, oil on canvas with objects (two panels), 182.9 × 93.4 (72 × 36 ¾), Collection of the artist

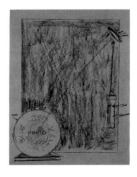

78. *Arrive / Depart*

1963–1964, oil on canvas, 172.7 × 130.8 (68 × 51 ½), Bayerische Staatsgemäldesammlungen, Pinakothek der Moderne, Munich

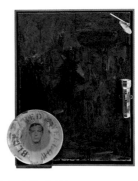

79. *Souvenir*

1964, encaustic on canvas with objects, 73 × 53.3 (28 ¾ × 21), Collection of the artist

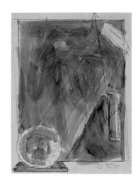

80. *Souvenir*

1964, graphite wash and graphite pencil on paper, 49.7 × 37.6 (19 ⁹⁄₁₆ × 14 ¹³⁄₁₆), Collection of the artist

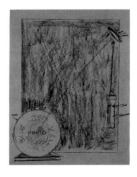

81. *Souvenir*

1964, charcoal on paper, 88.6 × 69.2 (34 ⅞ × 27 ¼), Collection of the artist

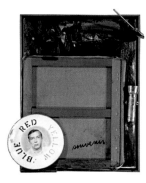

82. *Souvenir 2*

1964, oil and collage on canvas with objects, 73 × 53.3 (28 ¾ × 21), Barbara and Richard S. Lane

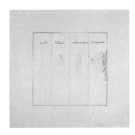

83. *Untitled (Cut, Tear, Scrape, Erase)*

1964, graphite pencil on paper, 28.9 × 28.9 (11 ⅜ × 11 ⅜), Collection of the artist

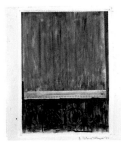

84. *No*

1964, graphite, charcoal, and tempera on paper, 51.4 × 44.5 (20 ¼ × 17 ½), Werner H. and Sarah-Ann Kramarsky, Fractional and promised gift to The Museum of Modern Art, New York

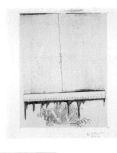

85. *No*

1964, graphite and graphite wash on paper, 51.8 × 44.5 (20 ⅜ × 17 ½), Collection of Tony and Gail Ganz, Los Angeles

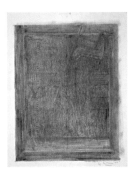

86. *Watchman*

1964, oil on canvas with objects (two panels), 215.9 × 153 (85 × 60 ¼), The Eli and Edythe L. Broad Collection, Los Angeles

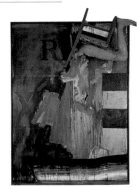

87. *Watchman*

1964, graphite pencil, graphite wash, watercolor, and pastel on paper, 52.4 × 39.4 (20 ⅝ × 15 ½), Collection of Tony and Gail Ganz, Los Angeles

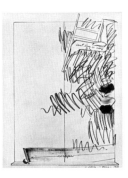

88. *Watchman*

1964, graphite pencil and oil on paper, 51.6 × 44.5 (20 ⁵⁄₁₆ × 17 ½), Private collection

89. *According to What*

1964, oil on canvas with objects (six panels), 223.5 × 487.7 (88 × 192), Private collection

90. *Untitled*

1964–1965, oil on canvas with objects (six panels), 182.5 × 478 (72 × 192), Collection Stedelijk Museum, Amsterdam

91. *Voice*

1964–1967, oil on canvas with objects (two panels), 243.8 × 176.5 × 6 (96 × 69 ½ × 2 ⅜), The Menil Collection, Houston

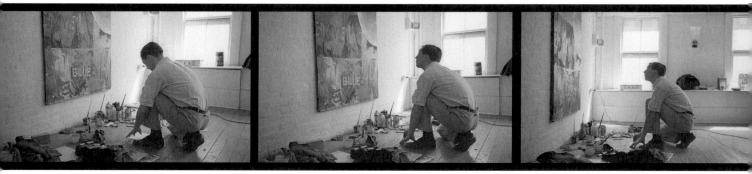

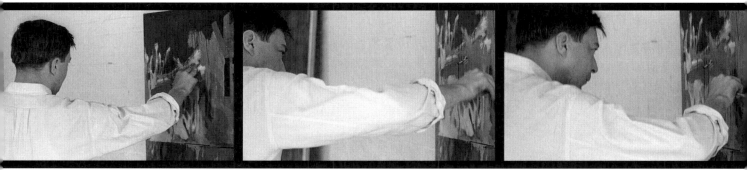

The Color and Compass of Things:
Paul Cézanne and the Early Work of Jasper Johns

Kathryn A. Tuma

In a few centuries it will be quite senseless to be alive, everything will be so flattened out. But the bit that remains is still very dear to the heart and to the eye.[1] *Paul Cézanne*

Personality must be kept secret before the world.[2]

Reclusive by inclination and reserved in manner; by social reputation, possessed of a peculiar combination of decorous politeness and an often impenetrable opacity; loathe to any form of attention to his private life; reluctant to elaborate extensively on the nature of his work: there are any number of similarities in disposition one could point to that are shared by Paul Cézanne and Jasper Johns.[3] Cézanne, especially in later years, sought to avoid attention to himself: for the aging artist, this was not a question of personal preference but rather a moral position with profound aesthetic implications. When it pertained to the art of painting, Cézanne was clear: "The man must remain obscure."[4] If Johns has similarly embraced such an Epicurean stance with respect to his art,[5] that position, over the course of his career, has typically been interpreted less as a matter bearing any philosophical or ethical weight than as a sign of willful perversity of character. Where Johns will state plainly that "I am interested in things which suggest the world rather than suggest the personality. I'm interested in things which suggest things which *are*,"[6] his critics have tended to fixate on his reticence as a kind of hermetic furtiveness, an extension of his "sphinx-like" character, his work analogously full of "devious manoeuvers."[7] Johns' "reluctance to explain, confess, describe, or theorize goes against the behavioral drift of contemporary artists," one critic has averred. "His refusal to be a source of answers for the questions directed toward his art, his reluctance to say what he's doing or to fulfill the intentional fallacy by telling critics what he means to do, has left him alone and us confused."[8] Cézanne, too, faced isolation and misunderstanding over the course of his lifetime. Even upon his death he was described in memoriam with acute critical ambivalence: "Enclosed within the strict limits of the technique of his art, living uniquely through his eyes and mind, [Cézanne] did not participate in any way in the life of his fellow men... Egoistically incurious about everything but colors and the relationship between colors; [he was] a magnificent monster."[9] Incessantly attacked for the obscure nature of his art and the hermetic character of his life, Cézanne cursed the critics; vowed to remain silent until he was sure of his path; wrapped himself in a "profound and self-protective irony"; and got on with the business of painting.[10]

If a quality of deep reserve has been a distinguishing feature of Johns' public face from the beginning, one truth he has never sought to conceal: the centrality of Cézanne to his art and to his practice. Ironically, this straightforwardly proffered fact is one that writers about Johns — despite his explicit entreaties[11] — have tended either to ignore or to allude to in only piecemeal fashion. From the earliest days of Johns' artistic career Cézanne was a touchstone figure. In a statement issued on the occasion of Dorothy Miller's *Sixteen Americans* exhibition at the Museum of Modern Art in 1959 — precisely, in other words, at the moment he was emerging as one of modern art's most meteoric successes — Johns candidly named Cézanne, Leonardo da Vinci, and Marcel Duchamp as the most meaningful points of reference for his art.[12] Later

Johns would indicate that it was Cézanne who had been the most significant all along.[13] Yet though Johns declared the significance of Cézanne in such unambiguous terms, *how* Cézanne meant something to him during the early years of his career has proved difficult to define.

There are multiple ways one might begin to approach the question of Cézanne's "influence"— a word, it should be noted, with which Johns has expressed having difficulty, especially in regard to his relationship with Cézanne.[14] With few exceptions, writers about Johns have tended to invoke Cézanne's name in fits and starts.[15] Most critics date the explicit pictorial manifestation of Cézanne's influence with the more painterly brushwork of the canvases Johns executed in 1959 and after, such as *False Start* (cat. 30), 1959, where dynamically interlocking passages of vivid, high-key color — a palette notably *un*like Cézanne's — are deployed like starbursts over the large canvas surface. Yet one could also address resonances among certain motifs Johns adopted in the early work, whether openly or obliquely suggestive of a connection to Cézanne's art. Take, for instance, the blunt factitious flatness of the table drawer in Cézanne's *The Card Players* (fig. 1) — squared off neatly parallel to the picture plane — which might have sponsored Johns' artistic conceit in *Drawer* (fig. 2),[16] where a rectangular element with two protruding knobs has been fitted into a same-sized slot built into the surrounding canvas, both panels painted in the same pale gray. Or, think of Johns' Skin drawings of 1962, which might bear kinship — distant or direct — to Cézanne's obsession with the figure of the *écorché*, a model of a flayed man crouching in anguish, which he drew frequently, especially toward the end of his life, and with whom the artist felt a powerful personal identification.[17] In terms of motifs, Johns' alphabets, number sequences, and targets have each in turn been analogized with Cézanne's apples.[18] Cézanne's name is also invoked in regard to the matter of color. Johns' formidable grays in early

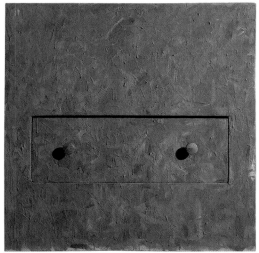

1. Paul Cézanne, *The Card Players,* 1890–1892, The Metropolitan Museum of Art, New York, Bequest of Stephen C. Clark, 1960

2. Jasper Johns, *Drawer,* 1957, The Rose Art Museum, Brandeis University, Gevirtz-Mnuchin Purchase Fund, 1962

canvases such as *Drawer, Gray Rectangles,* 1957, or *Tennyson* (see page 219, fig. 8), 1958, can be seen as successors to Cézanne's inimitable blue-grisaille — a baffling and complex color that appears as if lit from within or, as the poet Wallace Stevens might have worded it, that verges on "the basic slate, the universal hue."[19] And in the matter of form: Johns' pursuit of the keenest ambiguation of the distinction between figure and ground has led him to take up and elaborate on Cézanne's multiplication of contours drawn around pictorial objects pulsating in spatial indeterminacy. And brushwork: both wield an intensely controlled brush that lays down applications of paint in palpably distinct units that present something like "tout ce qui reste qui n'est que peinture," as one critic wrote in 1894, straining to describe the unique quality of Cézanne's art.[20]

Johns and Cézanne also share a playful verbal wit as well as a highly sophisticated sense of visual irony. Although known less for such playfulness than for his dead seriousness when it came to all matters related to painting, Cézanne enjoyed engaging in verbal and visual puns. Might Cézanne haunt the double entendre of Johns' *Painting with Two Balls* (fig. 3), where two sphere-shaped objects appear as if they had been wrenched into the gap between the upper and middle panels of the painting, the stenciled title at the canvas' lower edge playing on the literalism of the included objects and the metaphorical "ballsiness" of the sometimes histrionic gesturalism (not to mention rhetoric) of abstract expressionism? It was Cézanne, after all, who first provocatively designated his early palette-knife troweling of paint in works of the 1860s as *peinture couillarde.* One might also point out that it was Cézanne who, long before Johns, expressed the fundamental artifice of picture-making through the leitmotif of pictures-within-pictures, enmeshing representations of his own work and that of others in his paintings.[21] The gamefulness of Cézanne's *Still Life with Plaster Cast* (fig. 4) — a veritable anthology of the complex games pictorial illusionism can play — falls not so far in kind or spirit from Johns' *Fool's House* (cat. 54), 1962, after all. There, Johns attached

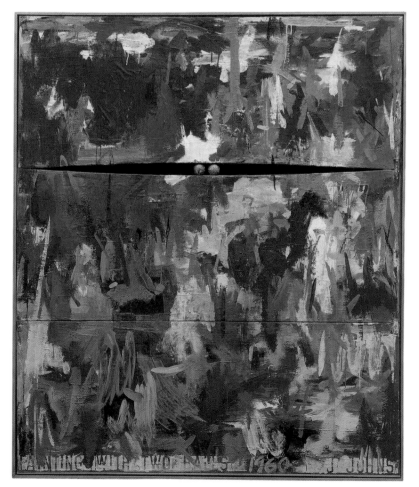

3. Jasper Johns, *Painting with Two Balls,* 1960, Collection of the artist

various objects, each labeled by name, which as a group reference instruments of painterly practice: a cup, a towel, a stretcher, a broom. Though Cézanne never moved beyond the two-dimensionality of the medium of painting, he nonetheless confessed late in his career to his sometime painting companion Auguste Renoir that "It took me forty years to find out that painting is not sculpture."[22] *Still Life with Plaster Cast* was the first painting he had executed since the 1860s representing a sculptural form, and it remains one of the most conceptually dense of Cézanne's late canvases. A watershed painting in the transition to the work of the artist's last ten years, it can also be read as a defining work in the context of his confessed realization. Depicting an illogical and irresolvable space rife with illusionistic paradox — where an onion on the table next to the cupid fuses with a contiguous onion painted in the canvas propped up behind it, even as yet another at the right of the cupid also merges with the floor — the picture also presents a compact allegorical disquisition on the relationship between painting and sculpture. From the vantage of the conceptual and practical intercourse between those two mediums for which Johns is above all known, and in which *Fool's House* stands as an exemplary early statement, he is surely one of Cézanne's most profound and witting heirs.

In 1952, at the onset of the formative artistic years when Johns recounts that he began to paint seriously,[23] the young artist visited a landmark Cézanne retrospective at the Metropolitan Museum of Art in New York. A "beautiful, big show," as Johns remembered it, the exhibition was widely greeted as one of the most important international loan exhibitions of Cézanne's work to date.[24] The presentation was a welcome redress for what had, for several years, been a dearth of opportunities to see a broad range of canvases by Cézanne outside the permanent collections of the Met and the Modern.[25] The Met found itself so overwhelmed with crowds that it felt obliged to keep its doors open several additional evenings each week in order to accommodate the unprecedented number of visitors.[26] The press predicted that the exhi-

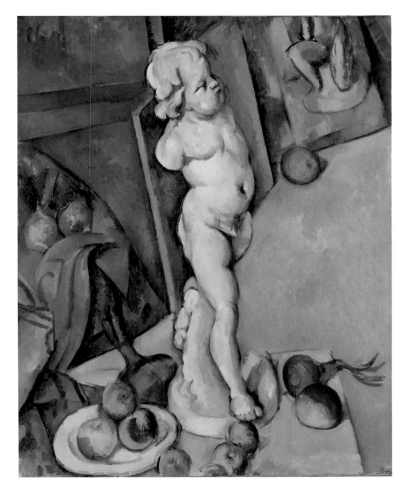

4. Paul Cézanne, *Still Life with Plaster Cast,* c. 1894, Courtauld Institute of Art Gallery, London, The Samuel Courtauld Trust

bition "might affect painting in this country to a considerable extent," declaring that "despite all that the expressionists, the fauves and the cubists have learned from Cézanne, much remains to be learned from his handling of color, from his use of line."[27] On the occasion of the exhibition, Erle Loran, the eminent Cézanne scholar whose idiosyncratic analyses of Cézanne's compositional structures dominated the interpretation of the painter's work throughout the 1940s, assessed the changing nature of his influence: "The day of Cézanne imitators seems to be over but his influence, far from diminishing, seems to have passed into a new dimension. At this revised level one no longer looks for superficial resemblance to Cézanne's painting; the concern of the painter now reaches for ultimate values, for what may be called the bare essentials of painting."[28] In 1952 few scholars or critics would have looked much beyond the abstract expressionist group as the preeminent heirs of Cézanne's legacy. Certainly no one would have been thinking of a twenty-two-year-old Jasper Johns. Yet it was his name, perhaps more than any other, that would shortly answer to the deeper spirit of Loran's prognosis: with Johns, an artist of a new generation had arrived, unquestionably the artistic progeny of Cézanne, yet in whose work less is yielded by pinpointing "superficial resemblances" than by considering something more akin to "the bare essentials of painting."

A mere twelve years after Johns walked into the Metropolitan that spring, the artist's spectacular ascent to the highest echelons of American contemporary art had already been confirmed. The 1964 retrospective exhibition organized by Alan Solomon at the Jewish Museum laid out the staggering breadth and depth of Johns' achievement. At the age of thirty-four, he was already being touted as an *"éminence grise* of post Abstract-Expressionist art."[29] Consistent with most contemporaneous analyses of Johns, the catalogue essay for the Jewish Museum show situated the artist vis-à-vis not Cézanne but rather Duchamp and the then-ascendant idea of an emerging neo-dada aesthetic. Some version of this interpretation of Johns has long predominated in the literature on the artist's early work. This essay means to take up the question of Cézanne, however, by exploring what he might have meant for Johns' early work as a philosophical and conceptual touchstone. I say "might have meant," for if I have recourse to a speculative tone here, it is partly because, despite the incontrovertible magnitude of Cézanne's significance for Johns in the remarks he has openly made about the artist, direct references are few in number. During the early years there are but two — and one is no more than a private jotting in a notebook. In this, we come up against Johns' reticence, a tendency that has arguably intensified in degree over the years.[30] The art, too, is restrained on the subject. In Johns' later work, there are moments when the artist makes direct iconographic reference to Cézanne, first in *Tracing* (fig. 5) to Cézanne's *Large Bathers* in the collection of the National Gallery, London. In 1994, Johns again pays homage in a series of six ink drawings on plastic to what he has described as one of his "favorite works of art," Cézanne's *Large Bathers* in the Barnes Foundation collection in Merion, Pennsylvania.[31] During the early period, however, no such direct quotations are made.

What might one say, then, generally, about Johns' earliest engagement with Cézanne in the absence of overt allusion in his work? Certainly, to have been engaged with Cézanne's legacy during the late 1940s and early 1950s was a very particular thing. In many ways postwar America was a golden age for Cézanne. The show at the Met was an unprecedented success. Cézanne's paintings broke records in sales.[32] In both public and private spheres, Cézanne's art was garnering broader attention than ever. For any young artist with an intensifying admiration for Cézanne, the early 1950s offered an especially rich cache of critical literature to tap into. If the catalogue essay for the exhibition at the Metropolitan might have struck the inquisitive reader as a bit uninspiring in its old-fashioned academicism,[33] one could have readily picked up the slim but lavishly illustrated volume on Cézanne's work newly published by Harry Abrams with its subtle yet groundbreaking analysis articulated by the eminent art historian Meyer Schapiro.[34] Alternatively, one could have dug up last year's volume of the *Partisan Review* where Clement Greenberg's magisterial "Cézanne and the Unity of Modern Art" had been printed. Nor would one have been limited to Greenbergian modernist orthodoxy: the 1950s witnessed a wide-ranging diversification of theoretical perspec-

5. Jasper Johns, *Tracing,*
1977, Collection of David
and Lindsay Shapiro

tives on Cézanne's art. Building on the pioneering research of John Rewald, Schapiro, and others, the young Theodore Reff was rising through the academic ranks during this decade, setting a high bar for scholarly treatments grounded in scrupulously researched primary source material, as well as representing early forays into psychoanalytic readings of Cézanne's art.[35] Outside New York, French phenomenologist Maurice Merleau-Ponty had written "Cézanne's Doubt" in 1945 (translated in English in the international review *Art and Literature*, notably in the very same volume of 1964 in which an excerpt from Johns' own "Sketchbook Notes" as well as Greenberg's "Modernist Painting" were also published[36]) and was already preparing the even more provocative "Eye and Mind" of 1960. The American philosopher Forrest Williams opened up the subject of Cézanne and phenomenology to an American audience in 1954; George Heard Hamilton followed in 1956 with his influential essay "Cézanne, Bergson and the Image of Time." Toward the close of the decade, the first explorations into the relationship between Cézanne's art and modern science were also being outlined, from investigations into the optics of depth perception to questions about the nature of binocular and "natural" perspective.

Everything looks very busy to me.[37]

When addressing the relationship between Johns and Cézanne, scholars have tended to focus on matters of painterly technique — brushwork, color, form. This approach is consistent with the familiar reading of Johns as responding to the legacy of concerns established by abstract expressionism. For Greenberg, one key to abstract expressionism's triumphant modernism had always been its thorough assimilation of the lessons of Cézanne as mediated by the language of cubism — an arc of painting's evolution whose telos was an ever

keener engagement in the self-reflexive critique of the medium. In a well-known line from Greenberg's essay "Modernist Painting," the critic declared: "The essence of Modernism lies . . . in the use of characteristic methods of a discipline to criticize the discipline itself."[38] Modernist art, in other words, "used art to call attention to art [and] the limitations that constitute the medium of painting — the flat surface, the shape of the support, the properties of the pigment."[39] Yet for the early Johns, Cézanne was an artist as much obsessed with the matter of *looking* as he was with the modernist precept of the self-reflexive facticity of the canvas' painted surface. While the curator of the Metropolitan's exhibition promoted a Cézanne who was "the creator of a new way of seeing,"[40] Greenberg's Cézanne was never especially focused on plumbing the ambiguities and paradoxes inherent in the nature of vision. For evidence of the former, one need only to think of a canvas such as the Metropolitan's *Mont Sainte-Victoire* (fig. 6), a painting Johns would have seen not only at the 1952 show but also on permanent display as one of the Metropolitan's modern treasures. A view of the Arc River where Cézanne swam as a boy, the painting is enmeshed with the tricks and feints of visual apprehension. Look, for instance, at how the branch of the central tree trunk appears not so much in front of the valley's fields but embedded within them, the tuft of green perched at the branch's right tip as convincing as a swath of pasture as it is as a patch of leaves. The road that traverses the landscape at a bias from the left to the right side of the canvas, too, appears as if it could be a lower branch, a perceptual instability that further muddles the distinctions among foreground, midground, and background. Or look at how a tree to the left of that main bisecting vertical seems to be growing out of the roof of a nearby house.

6. Paul Cézanne, *Mont Sainte-Victoire and the Viaduct of the Arc River Valley*, 1882–1885, The Metropolitan Museum of Art, New York, H. O. Havemeyer Collection, Bequest of Mrs. H. O. Havemeyer, 1929

Such ambiguities are familiar characteristics of Cézanne's mature paintings, where seeing is an activity incessantly cast in the shadow of epistemological doubt. An emphatic flatness of the picture plane may be one result of giving form to such moments of visual uncertainty, but that flatness follows as much from the challenges inherent to visual apprehension as it does from an insistent acknowledgment of the "limitations" of the medium's physical support.

Steeped in the culture of American postwar painting, Johns' early work is, of course, imbued with the artistic concerns of the day. For Greenberg, Johns was an artist "interested in the literary irony that results from *representing* flat and artificial configurations which in actuality can only be *reproduced*." "Nonetheless," Greenberg adds, "the abiding interest of his art lies largely in the area of the formal or plastic."[41] Johns himself would describe his use of objects as "com[ing] out of, originally, thinking of the painting as an object and considering the materialistic aspect of painting: seeing that painting was paint on a canvas, and then by extension seeing that it occupied a space and sat on the wall."[42] Yet the primary reference Johns makes to Cézanne during his early career reveals a distinctly non-Greenbergian interest. Johns, rather, seems invested in retrieving the figure of Cézanne as a painter tirelessly committed to "studying" nature, as the artist unstintingly exhorted younger painters to do. In his quest to represent the world in the most doggedly faithful terms, Cézanne was an artist obsessed with the idiosyncrasies of human vision. By focusing on this aspect of Cézanne, not only did Johns successfully circumvent, if only provisionally, the immediate legacy of advanced painting's allover abstraction, thereby securing an alternative route to one of abstract expressionism's key sources — or, as Barbara Rose neatly put it, "*reculer pour mieux sauter*"[43] — he also recuperated a crucial aspect of Cézanne's practice and, arguably, an ethic of Cézanne's pictorial project that had been partly obscured by Greenberg's emphasis on the self-reflexive character of Cézanne's painted surfaces. That ethic proved to be as much of an engine in Johns' early work as any modernist conceptual matrix.

Cézanne once wrote that "The painter must consecrate himself entirely to the study of nature and strive to produce pictures that will be an education."[44] Johns' Cézanne is, first and foremost, the artist who writes to his son the month before he died that "here, at the edge of the river, the motifs multiply, the same subject seen from a different angle offers a subject for study of the most powerful interest and so varied that I think I could occupy myself for months without changing my place, simply leaning myself a little more to the right, a little more to the left."[45] This line is the original source for the famous remark Johns makes about Cézanne in his statement for the *Sixteen Americans* show:

At every point in nature there is something to see. My work contains similar possibilities for the changing focus of the eye ... what a teacher of mine (speaking of Cézanne and cubism) called "the rotating point of view" (Larry Rivers recently pointed to a black rectangle, two or three feet away from where he had been looking in a painting, and said "... like there's something happening over there, too").[46]

While Johns states here that he heard about the idea of the "rotating point of view" from an influential early art teacher, he could also easily have come across the notion in one key source for this interpretation of Cézanne's work that became widespread in the 1940s: Loran's *Cézanne's Composition* of 1943.[47] One can only wonder, too, if Johns had come across Cézanne's original letter, quoted at length in Rewald's biography of Cézanne, a book first published in 1948 and the richest and most obvious starting point for any artist seeking to understand in greater depth Cézanne's ideas about painting.[48] Larry Rivers' remark, on the other hand, recalls — if only inadvertently — a lesser-known anecdote about Cézanne. Entertaining visitors at his studio in Aix during the very last years of his life, Cézanne, in order to emphatically demonstrate a thesis that all forms apprehended visually appear convex, simply pointed to a studio wall as proof of his claim.[49]

Cézanne's curiously counterintuitive observations about the world were not infrequent. Nor are Johns' often hermetic notations to himself in his notebooks and sketchbooks. The second time Johns explicitly evokes Cézanne's name is in one such sketchbook of 1964. There we read:

The watchman falls "into" the "trap" of looking. The "spy" is a different person. "Looking" is + is not "eating" + also "being eaten." (Cézanne? – Each object reflecting the other.) That is, there is continuity of some sort among the watchman, the space, the objects.[50]

Much ink has been spilt trying to decode Johns' allegory of the watchman and the spy, and this essay will not add to the controversy. In the context of our subject here, however, what is worth noting is the specific language of Johns' invocation of Cézanne. The singling out of the idea that each object for Cézanne reflects the other distinctly recalls the language of yet another passage in Rewald's biography (and not, as some have somewhat eccentrically suggested, the thoughts of Gertrude Stein on the subject of the painter[51]). There, describing the young Cézanne's tutelage at the side of his early mentor, the impressionist painter Camille Pissarro, Rewald relates that Cézanne "learned that objects have no specific color of their own, but reflect each other, and that air intervenes between eye and object."[52] Compared to this passage, Johns' phrasing is quite faithful, as he hones in on the quality of continuity between observer, space, and objects that would preoccupy Cézanne for the rest of his life.

It is worth returning to the passage from Johns' *Sixteen Americans* statement, where he introduces his first remark about Cézanne: "Sometimes I see it and then paint it. Other times I paint it and then see it. Both are impure situations, and I prefer neither." Johns, like Cézanne, set himself the project of engaging in an acutely self-conscious investigation into the relationship between notional preconceptions about seeing and objects, and the difficulties involved in the accurate perception of a given "object" in the act of representing it in painted form. The notion that "the object itself is a somewhat dubious concept" was one that preoccupied Johns from early on.[53] Johns stated in 1964 that he was "concerned with a thing's not being what it was, with its becoming something other than what it is, with any moment in which one identifies a thing precisely and with the slipping away of that moment."[54] By taking commonplace objects such as numbers or flags for subjects, Johns' art likewise compels the viewer not only to attend to how one construes the object of one's attention — to see as if for the first time — but also to reconsider what it is one is doing when one "looks" at all.[55] This, at the very least, would seem to be part of what Johns takes away from Cézanne's observations about the nature of his visual experience on the bank of the river. In a later statement, Johns echoes the language of Cézanne's original commentary and further elaborates:

Now, the idea of "thing" or "it" can be subjected to great alterations, so that we look in a certain direction and we see one thing; we look in another way and we see another thing. So that what we call "thing" becomes very elusive and very flexible, and it involves the arrangement of elements before us, and it also involves the arrangement of our senses at the time of encountering this thing. It involves the way we focus, what we are willing to accept as being there. In the process of working on a painting, all of these things interest me. I tend, while setting one thing up, to move away from it to another possibility within the painting, I believe. At least, that would be an ambition of mine.[56]

An early review of Johns' first show at Leo Castelli's gallery in 1958 intuited this aspect of Johns' work, detecting that "it has to do with looking. Not looking as sensation, nor about the visual world; nor is there a concern with myth . . . He looks for the first time, like a child, at things that have no meaning to the child, yet, or necessarily. What meaning [the works] have may be irrelevant to his absorption in looking . . . Johns' paintings compel your attentiveness: they bring you back to what art is in itself, before its

meaning, before its usefulness."[57] Solomon, the curator of the 1964 show at the Jewish Museum, also picked up on this notion: "What Johns does . . . is to raise a very serious problem about what we might call the identity of objects. He makes us wonder seriously about whether things are actually what they seem to be, and he forces us to acknowledge that we never really look at objects, except through highly conditioned eyes which shut out a large potential of intuitive response, a kind of response which could again liberate our consciousness and enrich our experience of the familiar world."[58] The idea of looking for the first time — "like a child" — is, of course, an old hangover from the rhetoric of impressionism. For all its impossibility, Cézanne, like his impressionist colleagues, would seem at times to have subscribed to the notion, relating his willful effort to forget everything — "*en oubliant tout*" — that he "knew" about an object when engaged in the act of painting.[59] For his critics who took this language at face value, such remarks usually launched ascriptions of Cézanne's visual "objectivity," his paintings arriving "at the essence of things," his theory of painting "excluding all knowledge sullied by intellectualism, [thus] allowing vision to appear in its perceptible purity."[60]

For Johns, unadulterated vision was never the goal. Rather, he sought a philosophical acceptance and a practical exploration of the complexity of a pictorial and perceptual arena where thought and vision inescapably act upon one another. Justifying his use of "found" motifs such as flags or the alphabet, the early Johns stated his preference for "things which are seen and not looked at."[61] As the artist famously explained: "Using the design of the American flag took care of a great deal for me because I didn't have to design it. So I went on to similar things like targets — things the mind already knows. That gave me room to work on other levels."[62] Johns identified his appreciation for "the most conventional thing, the most ordinary thing" as being related to his determination that "those things . . . can be dealt with without having to judge them: they seem to me to exist as clear facts, not involving aesthetic hierarchy."[63] From a particular vantage, one could likewise say that Cézanne chose to paint things "the mind already knows" — or, things *his* mind already knew: an apple, Mont Sainte-Victoire, the face of his wife. Once, when asked for advice for beginning painters, Cézanne replied without hesitation, "Copy your stovepipe" — the most familiar, the most banal of objects.[64] Johns would later subtly modulate Cézanne's dictum when he remarked, in 1959, shortly following on his comment about "things the mind already knows," that "A picture ought to be looked at the same way you look at a radiator."[65] In such a way, Johns' relationship to the picture — or to pictorial technique or to artistic process — as the object of painting might be analogized to Cézanne's relationship to an object in the studio or even to nature itself. From either vantage, the core concern is the same: looking.

True to his word, Cézanne had copied his own stovepipe in the early study *The Stove in the Studio* (fig. 7). Although this canvas was not exhibited at the Metropolitan show in 1952, a black-and-white image of the picture was reproduced in Rewald's biography where Cézanne's comment is recorded. There a dark stove, pot sitting atop it and pipe vertically bolstering the composition, is set against the view of a canvas whose face is turned toward the wall. Much like Cézanne's *Still Life with Plaster Cast* where the compositional and conceptual strategy places the central plaster cupid against an empty canvas, Cézanne's *Stove in the Studio* sets the stove against the frame of a canvas within the canvas. An early instantiation of the trope of pictures-within-pictures so frequently seen in Cézanne's oeuvre, this is a Johnsian Cézanne if ever there was one. This motif handily echoes a common one employed by Johns. *Canvas* (fig. 8) readily comes to mind as an example, a strikingly ascetic work in which the frame of an empty canvas becomes the "object" of the painting, as much as the painting is reframed as an object.[66]

Yet Johns and Cézanne both well knew that there is nothing straightforward about either looking at a radiator or copying a stovepipe — and the matter of the unstraightforwardness of that activity lies at the heart of both artistic projects. Take, for instance, certain basic observations that have been made about one of Johns' best-known early motifs, the target. A thing "the mind already knows," the target has been

7. Paul Cézanne,
The Stove in the Studio,
probably 1865–1870,
National Gallery, London

8. Jasper Johns,
Canvas, 1956, Collec-
tion of the artist

described as "an image of the measure of accuracy," one through which, as Johns explained, he explored the question of whether such a notion as accuracy could exist in painting at all.[67] Johns once stated that he admired that Duchamp "brings into focus the shifting weights of things, the instability of our definitions and measurements."[68] Much the same could easily be said about Cézanne. Themes of flux and instability, of measurement and its impossibility, are pervasive in Johns' work, especially after 1960, where, as Rose has observed, "the mode of the work is not static but shifting. Point of view, context, boundaries, space and distance perceptions, are seen in a perpetual state of flux and change."[69] Such concerns are cornerstones of Cézanne's art.

For these are surely the legacy of Cézanne's lessons in sitting by the riverbank, leaning right, then leaning left. For Johns, as Cézanne's heir, such concerns endure in his art; they lie, too, at the heart of his revisionism of Cézanne's broken brushwork. Johns' appreciation of the complexity and depth of Cézanne's facture is not the same as that of Greenberg, who saw Cézanne's "abiding" and "unequivocal" pictorial marks as the registration of "units" of visual experience, rendered with the tip of a brush.[70] What Johns draws from the philosophical implications of the nature of Cézanne's brushwork is of another order. For Johns, Cézanne's marks pertain instead to erasure, doubt, and ambiguity, like Johns' own proliferation of strokes, his building up of notational "cancellations," as Max Kozloff put it.[71] In the case of Cézanne, there is ample evidence drawn from his letters that he constantly struggled to find painterly adequation for his visual experience of what he called "the diversity of the tableau of nature,"[72] and there is equal indication that he found himself endlessly unable to do so. As Cézanne is reported to have declared late in life, "Nature . . . I wanted to copy it; I did not succeed."[73] I have argued elsewhere that Cézanne's lifelong struggle might best be described as an endless asymptotic approach toward the philosophical as well as practical impossibility of painterly equivalence, and that Cézanne's late work, above all, openly admits as much.[74] For there, in splendid multihued array, we see Cézanne building the failure of something like "accuracy" *into* the mark, where the regularized brushwork of midcareer pictures of the 1880s is inflected in the work of the 1890s and after by equivocation and doubt, the blur of painted color's applications enstructuring the fundamental imprecision, perhaps the radical irrepresentability, of perceptual information about the natural world. Crucially, it is at first Cézanne's classic constructive stroke of the 1880s, with its patiently methodical brushwork — those small, somewhat sloping, singular applications of paint for which he is best known — that is evidenced in Johns' early manner of applying paint to canvas. As Johns noted in retrospect, looking back on paintings like *White Target* (cat. 9) of 1958, "My marks in the early pictures were shorter and more discrete."[75] Quick-drying encaustic was then his preferred medium, where the picture surface was built up of a history of overlapping strokes, none ever fully obscured by those that followed. Yet a year later, Johns returned to oil, as his mark shifted toward a manner more characteristic of Cézanne's late work, where self-questioning, probing marks — what Johns described as a "sum of corrections"[76] — teeter on the edge of a potentially catastrophic failure to describe and specify. "My concerns in the paintings," Johns laconically explained, "[had] shifted."[77] In an interview of 1963, he elaborated: "The work I do now . . . is less concerned with accuracy . . . since there didn't seem to be any such thing anyway, it was never achieved."[78]

I am in the mood for disappearing.[79]

With characteristic insight, David Sylvester observed as early as 1964 that Johns was most interested in "re-creating the *process* of perception rather than the objects perceived."[80] He further suggested that "total curiosity" would be "Johns's ideal of an attitude of mind."[81] Total curiosity is necessarily predicated on a kind of withholding, not only of judgment but also of self — the selfsame withholding for which Johns has been so roundly criticized. For all the consternation Cézanne inspired in his contemporaries, he always

insisted on a level of theoretical transparency: "I have nothing to hide when it comes to art."[82] Long before Johns ever set foot in the Metropolitan's 1952 exhibition on his way to becoming a "serious" painter, another landmark Cézanne retrospective prompted another transformative artistic encounter. During the autumn of 1907 the young poet Rainer Maria Rilke found himself immersed in the work of Cézanne at the Grand Palais in Paris. In a "conflagration of clarity," he was metamorphosed by it both as a man and as a poet. There Rilke absorbed what he imagined to be Cézanne's "good conscience" as a painter. Describing Cézanne's method of painting, the poet imagined that Cézanne "sat in front of [nature] like a dog and simply looked, without any nervousness or ulterior motive...He [painted] only what he knew, nothing else."[83] In this context, I think it important to emphasize a related ethical tone that is indicated in much of Johns' commentary on painting and his process:

Johns sees no separation between decisions made in art and those in life. His decisions have unmistakable moral implications, for he is among those artists for whom the activity on the canvas is the exemplar of his understanding of right human conduct. In Johns's case, morality is, purely and simply, an effort at picturing the way things are. His method of working is consequently his morality. He is forced to make endless painful revisions and corrections, to smudge and correct, because this effort does not represent an esthetic, but a moral position...He can no longer, after a certain point, picture a stable world of fixed definitions closed boundaries and a single point of view because it does not seem to him "accurate," that is, true.[84]

"All my life I have worked to be able to earn my living," Cézanne confessed late in his career to a friend. "But I believed that one could paint good paintings without drawing attention to one's private life. Certainly, an artist wishes to elevate himself intellectually as much as he can, but the man must remain obscure. The pleasure must reside in the study...As for me, all that remains for me to do in my situation is to fade away."[85] For Johns, the effort to remain "obscure" in the face of painting was no less enmeshed in his work from early on. We can see it in the inexpressiveness of the faces in *Target with Four Faces* (cat. 3), whose stony countenances are uncannily reminiscent of Cézanne's portraits of his wife; in the material qualities of the waxy surfaces of the encaustic that proved the preferred medium of his early career, a medium that necessarily realized both a literal and a figurative opacity; and in the deadpan impassivity with which everyday objects and motifs were presented, from flags to flashlights, and coffee cans to canvas itself (see fig. 8).

Cézanne once famously promised to deliver to the next generation of artists the "truth in painting,"[86] a truth whose specific nature the elder artist never verbalized and which came to inspire, because of that ultimate withholding, endless critical speculation. The enigmatic phrase "truth in painting" comes up elsewhere in the literature on Cézanne, but only once. In conversation with a young poet he befriended during his later years, Cézanne remarked that "one swims in the truth in painting."[87] If the truth of painting is itself a liquid medium through which one moves, it would above all be the figure of the bather that appears best suited as the instrument of its discovery. Following the deaths of Pablo Picasso and Henry Moore, Jasper Johns may be the last living artist to own one of Cézanne's Bathers,[88] a small but exquisite *Bather with Outstretched Arms* (fig. 9). One wonders whether Johns' interest in such a work might perhaps have been inspired by Reff's poignant and insightful study in 1962 of the group of paintings Cézanne executed after this basic motif. Reff interprets the work as "an image of [Cézanne's] own solitary condition"[89]: "For the study of the personal content of Cézanne's art, few pictures are more difficult to interpret yet ultimately more revealing" than those works depicting this figure, "a solitary male bather with arms extended stiffly from the body," whose "outstretched arms seem to reach and reject simultaneously."[90]

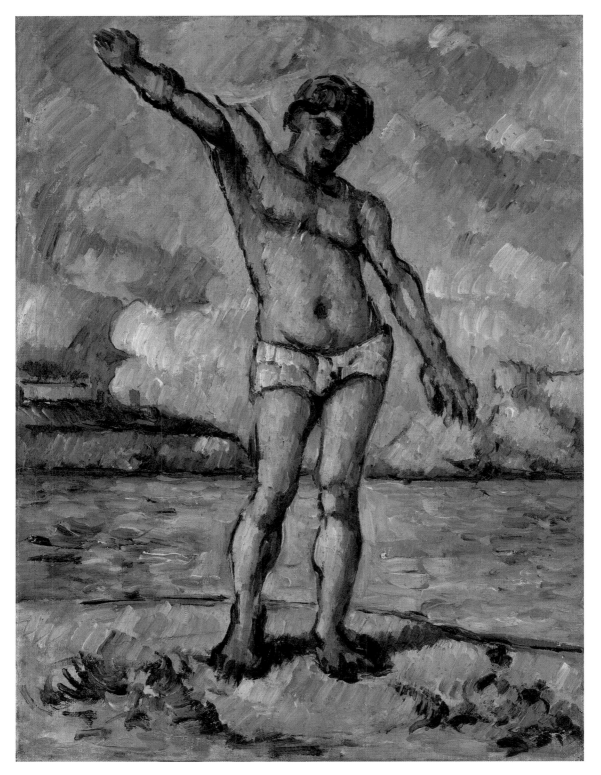

9. Paul Cézanne,
*Bather with Outstretched
Arms,* 1883–1885,
Collection of Jasper
Johns

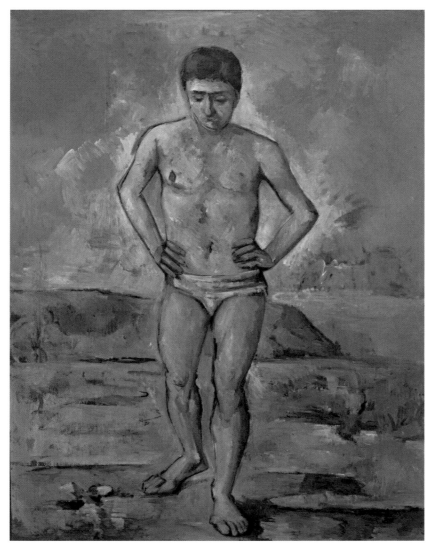

Roberta Bernstein suggests that it was around the time Johns was considering copying the Museum of Modern Art's *Bather* (fig. 10) that he may have conceived the drawing *Diver* (cat. 66), thus creating a "monumental figure of his own instead of copying or tracing the Cézanne figure directly."[91] Christian Geelhaar confirms that some time during the early 1960s Johns thought of copying the painting in gray, but "not want[ing] to sit in the museum and work in front of the picture," Johns abandoned the idea.[92] Gray continues to be a preferred vehicle for the Johnsian project of training the eye to increasingly subtle modulations of surface texture and tone. As Solomon observes of the early work, "Johns works hard to keep the relationships underplayed and close, so that we become absorbed in much more sensitive and finer readings than we ordinarily bring to bear on such experience. For the same reasons, he preferred to work with grays in these early pictures. The subtleties involved seemed so great to him that color would become a distraction."[93] Kozloff, considering the conceptual operations of *Diver,* the masterwork that arguably bookends the early phase of Johns' career, takes up the question of doubt: "To transubstantiate the picture into an object, as Johns does, and then to paint over the included objects (as in *Diver*) is perhaps to cast doubt upon certain conceptions of reality, but to contain that doubt as a visual encounter."[94] Insofar as this observation rings profoundly true not only of *Diver* specifically but of Johns' early work more generally, this quality of capturing the doubt endemic to visual encounter and sustaining it without pictorial resolution has, to my mind, to do far more with the legacy of Cézanne than that of Kozloff's Duchamp.

There is a very early, quite small, and infrequently exhibited work on paper by the young Cézanne called *Woman Diving into the Water* (fig. 11). The six-inch-square watercolor depicts an ambiguously gendered body launching diagonally into turbulent waters. Though an orange-tinted sphere looms in the sky, the overall tonality of the dark image suggests night. It is a mysterious little picture; Lionello Venturi sought to capture the enigmatic intensity of the otherwise modest work by entitling it "The Fall of Icarus."[95] The figure, however, is decisively not falling but diving with purpose. If painting's metaphorical bather — the figure who would "swim" in the medium's truth — is he who engages with the full force of his body in an art of infinite regressions of liquid metaphors and concrete suspensions — pigment in oil, oil on canvas, canvas from wall — then both Cézanne's plunging swimmer and Johns' diver, both captured in a moment of radical descent, both simultaneously compliant with and defiant of the laws of gravity and nature's force, both supported by nothing but the medium of painting itself, fall toward waters whose depths may hold ultimately unfathomable things.

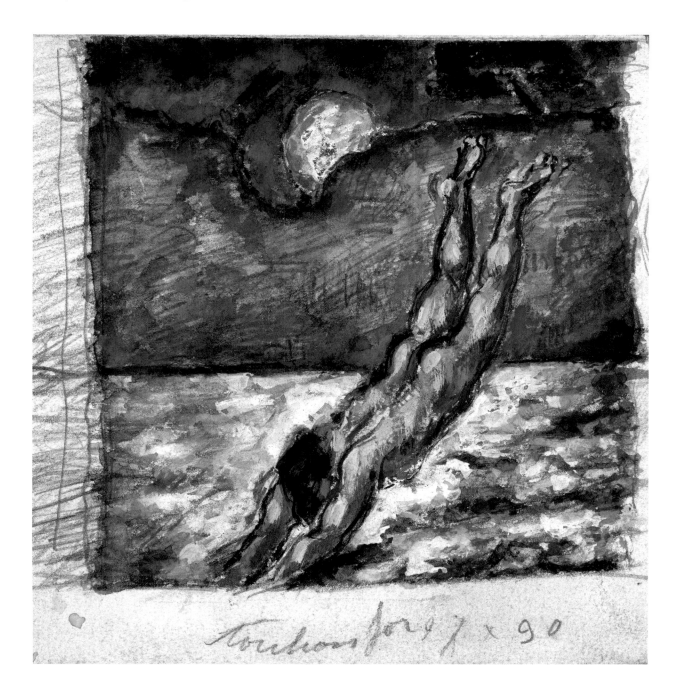

Notes

1. John Rewald, *Paul Cézanne: A Biography* (New York, 1948), 132.

2. Wallace Stevens, journal entry, July 28, 1900, in *Letters of Wallace Stevens*, Holly Stevens, ed. (Berkeley, 1996), 44. My title is likewise taken from Stevens, journal entry, April 18, 1904, 71.

3. Roberta Bernstein's *Jasper Johns' Paintings and Sculptures, 1954–1974: "The Changing Focus of the Eye"* (Ann Arbor, 1985) includes a short section on Cézanne and Johns, noting that the two "have a similar artistic sensibility," 68.

4. Cézanne, letter to Joachim Gasquet, April 30, 1896, in John Rewald, ed., *Paul Cézanne: Correspondance*, revised and augmented (Paris, 1978), 249. All translations are my own. This letter is also quoted in Rewald, *Biography*, 1948, 182–183.

5. Cézanne's language echoes the Greek Λάθε βιώσας, or "Live in obscurity," a well-known dictum of Epicurean philosophy.

6. Jasper Johns, in David Sylvester, "Jasper Johns 1965," *Interviews with American Artists* (New Haven, 2001), 152. Johns has been consistent on this point: "I have attempted to develop my thinking in such a way that the work I've done is not me...I didn't want my work to be an exposure of my feelings." Vivien Raynor, "Jasper Johns: 'I have attempted to develop my thinking in such a way that the work I've done is not me,'" *ARTnews* 72 (March 1973), 20; reprinted in Kirk Varnedoe, ed., *Jasper Johns: Writings, Sketchbook Notes, Interviews* (New York, 1996), 145.

7. Max Kozloff, "The Division and Mockery of the Self," *Studio International* 179 (January 1970), 10.

8. John Yau, "Target Jasper Johns," *Artforum* 24 (December 1985), 80. This tone is commonplace in the literature. To take another example that circumvents the ad hominem tone of many authors, Barbara Rose describes how "the later works...are stubbornly, one might even say petulantly, resistant to attempts to fix their definitions with any exactitude." Barbara Rose, "The Graphic Work of Jasper Johns, Part II," *Artforum* 9 (September 1970), 66.

9. Charles Morice, "Paul Cézanne," *Mercure de France* (February 15, 1907), 579.

10. Cézanne, in Rewald, *Biography*, 1948, 183: "I curse the X...s and the few rascals who, to write an article for fifty francs, drew the attention of the public to me." Cézanne, letter to Octave Maus, November 27, 1889, in Rewald, *Correspondance*, 1978, 229–230. Clement Greenberg, "Cézanne and the Unity of Modern Art," *Partisan Review* (May–June 1951); reprinted in John O'Brian, ed., *Clement Greenberg: The Collected Essays and Criticism*, vol. 3, *Affirmations and Refusals, 1950–1956* (Chicago, 1993), 86.

11. Bernstein, *Johns*, 1985, 69, recounts that, after informing Johns that she was writing a section of her doctoral dissertation on the influence of Duchamp on his work, Johns told her to write about Cézanne instead.

12. Jasper Johns, artist's statement, in Dorothy C. Miller, ed., *Sixteen Americans* [exh. cat., The Museum of Modern Art] (New York, 1959); reprinted in Varnedoe, *Writings*, 1996, 20.

13. Christian Geelhaar, "The Painter Who Had the Right Eyes: On the Reception of Cézanne's Bathers," in *Paul Cézanne: The Bathers*, Mary Louise Krumrine, ed. [exh. cat., Museum of Fine Arts] (Basel, 1990), 297–298.

14. When posed a question about Cézanne's influence on his drawing, Johns responded: " 'Influence' ...It's very hard for me to play with that word, because one is influenced by everything." Johns, in an interview with David Bourdon, 1977; reprinted in Varnedoe, *Writings*, 1996, 157.

15. Roberta Bernstein has been the only Johns critic to write at length about the relationship between Johns and Cézanne. See her doctoral study, "Jasper Johns' Paintings and Sculptures, 1954–1974: 'The Changing Focus of the Eye' " (Columbia University, 1975) and her catalogue essay, " 'Seeing a Thing Can Sometimes Trigger the Mind to Make Another Thing,' " in Kirk Varnedoe, *Jasper Johns: A Retrospective* [exh. cat., The Museum of Modern Art] (New York, 1996), 39–91. Richard Shiff, "Constructing Physicality," *Art Journal* 50, no. 1 (Spring 1991), 42–47, explores the relationship between the figure of "touch" and the physicality of painting in the work of Cézanne and Johns. Johns once described Cézanne's *The Bather* (fig. 10) as having "a synesthetic quality that gives it great sensuality — it makes looking equivalent to touching." Johns, in Grace Glueck, "The 20th-Century Artists Most Admired by Other Artists," *ARTnews* 76, no. 9 (November 1977); reprinted in Varnedoe, *Writings*, 1996, 166.

16. Bernstein, *Johns*, 1985, 34, has also suggested *Still Life: Jug of Milk and Fruit* (c. 1890, Nasjonalgalleriet, Oslo) as an alternative source. This picture was included in the Metropolitan's 1952 exhibition.

17. For more on Cézanne and the figure of the *écorché*, please see my "Un Peau de Chagrin," in *Picasso: The Cubist Portraits of Fernande Olivier*, Jeffrey Weiss, ed. [exh. cat., National Gallery of Art] (Washington, 2003), 127–163. While we do not know exactly when or how Cézanne procured the model, it had been in his possession possibly as early as the mid- to late-1860s, when the first extant drawing from the model was executed. A metaphor for the anxiety and suffering of the artist, the flayed man was a figure with whom Cézanne had been identified since childhood. As Roger Fry put it, lacking "that excellent rhinoceros hide which protected Courbet," Cézanne was "so far indeed...from possessing any sort of hide, that his fellow students nicknamed him 'l'écorché,' the man without any skin to protect his sensitiveness from the strokes of fate and the malice of his fellows." Roger Fry, *Cézanne: A Study of His Development* (New York, 1958), 7.

18. Robert Rosenblum first made the association in "Jasper Johns," *Art International* (September 1960), 75. Others have followed with variations along the theme. See, for instance, Sidney Tillim on Johns' numbers, "Ten Years of Jasper Johns," *Arts Magazine* 38 (April 1964), 22; and Rose on Johns' targets, "The Graphic Work of Jasper Johns, Part I," *Artforum* 8 (March 1970), 41.

19. Wallace Stevens, "Le Monocle de Mon Oncle," in Wallace Stevens, *The Collected Poems of Wallace Stevens* (New York, 1995), 15.

20. Thadée Natanson, "Exposition, Théodore Duret," *La Revue blanche* 30 (April 1894), 34. Italics in citation. This passage is virtually untranslatable, but a rough one might be "everything that is left over that is but mere painting."

21. See, for instance, Theodore Reff's important statement on the subject in "The Pictures Within Cézanne's Pictures," *Arts Magazine* 53 (June 1979), 90–104.

22. Cézanne, in Rewald, *Biography*, 1948, 170.

23. Johns, in Walter Hopps, "An Interview with Jasper Johns," *Artforum* 3, no. 6 (March 1965); reprinted in Varnedoe, *Writings*, 1996, 106.

24. Johns, in the Bourdon interview, 1977, in Varnedoe, *Writings*, 1996, 157. Anonymous, "Cézanne at the Met," *The Art Digest* 26 (April 1, 1952), 18.

25. After the Museum of Modern Art's seminal "Cézanne, Gauguin, Seurat, van Gogh" show of 1929, most opportunities to see Cézanne's work were to be found at a variety of New York galleries: Knoedler Galleries in 1933; Marie Harriman Gallery in 1936; Bignou Gallery in 1936; Durand-Ruel in 1938; a few very small shows in 1939 and 1940; and Paul Rosenberg in 1942. For obvious reasons, there was a dry spell during the war years. No Cézanne show was presented again until one at Wildenstein Galleries in 1947. This was followed by another major dearth of opportunities until the spring show at the Met in 1952.

26. Helen Comstock, "Cézanne in a Loan Exhibition," *The Connoisseur* 130 (September 1952), 80. Public attendance was far greater than had been anticipated and equaled the Van Gogh exhibition of two years earlier, which until 1952 had been the most popular show ever presented at the Met.

27. James Fitzsimmons, "A Cézanne Exhibition, A Definition of Greatness," *The Art Digest* 26 (February 15, 1952), 7.

28. Erle Loran, "Cézanne in 1952," *The Art Institute of Chicago Quarterly* 46 (February, 1952), 2.

29. Max Kozloff, "Art and the New York Avant-Garde," *Partisan Review* 34 (Fall 1964), 535.

30. See Barbara Rose, who comments on Johns' "increasingly introverted, reclusive personality." Rose, "Decoys and Doubles: Jasper Johns and the Modernist Mind," *Arts Magazine* 50 (May 1976), 69.

31. Johns also later makes reference to Cézanne's early and lesser-known work, *Four Seasons* of 1860–1861. See Barbara Rose, "Jasper Johns: This is Not a Drawing," *The Journal of Art* (April 1991), 16. Bernstein points out that until Johns' tracing of 1977, the artist had made no direct reference to a specific work by Cézanne. None appeared again until a series of six tracings by Johns in 1994. For more on Johns' tracings after Cézanne, see Bernstein, " 'Seeing a Thing,' " in Varnedoe, *Retrospective*, 1996, 62–64.

32. In 1952 at a record-breaking auction in Paris, $110,031 was paid for Cézanne's *Apples and Biscuits* (1879–1880), now in the collection of the Musée de l'Orangerie, Paris. See *ARTnews* 51 (June 1952), 112.

33. See Theodore Rousseau, Jr., *Cézanne: Paintings, Watercolors and Drawings* [exh. cat., The Metropolitan Museum of Art] (New York, 1952). Rousseau's essay primarily seeks to establish Cézanne's rightful place in a canon of old master painters. As a scholarly project, this is perhaps less revelatory of the essential interest of Cézanne's art than of other treatments of Cézanne at the time.

34. See Meyer Schapiro, *Cézanne* (New York, 1952).

35. I wish to thank Theodore Reff for discussing with me his experience of working on Cézanne in the context of the 1950s and for his insights into the particular nature of Cézanne studies during that decade.

36. See *Art and Literature* 4 (Spring 1964) for Maurice Merleau-Ponty, "Cézanne's Doubt," 106–124; Jasper Johns, "Sketchbook Notes," 185–192; and Clement Greenberg, "Modernist Painting," 193–201.

37. Johns, artist's statement for *Sixteen Americans*, in Varnedoe, *Writings*, 1996, 20.

38. Clement Greenberg, "Modernist Painting" (1960); reprinted in John O'Brian, ed., *Clement Greenberg: The Collected Essays and Criticism*, vol. 4, *Modernism with a Vengeance, 1957–1969* (Chicago, 1993), 85.

39. Greenberg, "Modernist Painting," in O'Brian, *Vengeance*, 1993, 4:86.

40. Theodore Rousseau, Jr., "Cézanne as an Old Master," *ARTnews* 51 (March 1952), 29.

41. Clement Greenberg, "After Abstract Expressionism" (1962); reprinted in O'Brian, *Vengeance*, 1993, 4:126. Italics in citation.

42. Johns, in a 1963 interview with Billy Klüver; reprinted in Varnedoe, *Writings*, 1966, 87–88.

43. Rose, "The Graphic Work, Part I," 1970, 39.

44. Cézanne, letter to Émile Bernard, May 26, 1904, in Rewald, *Correspondance*, 1978, 302.

45. Cézanne, letter to his son, September 8, 1906, in Rewald, *Correspondance*, 1978, 324.

46. Johns, artist's statement, for *Sixteen Americans*, in Varnedoe, *Writings*, 1996, 20.

47. See, for instance, Erle Loran, *Cézanne's Composition* (Berkeley, 1943), 8, for a discussion of the idea of the rotating point of view in Cézanne's work.

48. Rewald's biography of 1948 had recently displaced Gerstle Mack's of 1935. Rewald's translation of Cézanne's letters had already been published in 1941. See John Rewald, ed., *Paul Cézanne: Letters* (London, 1941).

49. R. P. Rivière and Jacques Felix Schnerb, "L'Atelier de Cézanne," *La Grande revue* 46 (1907); reprinted in *Conversations avec Cézanne*, P. M. Doran, ed. (Paris, 1976), 88.

50. Johns, from a sketchbook page reproduced in Varnedoe, *Writings*, 1996, 37.

51. Wrongly, Marjorie Perloff connects this passage to Stein: "The reference is probably to Gertrude Stein's observation that 'Cézanne conceived the idea that in composition one thing was as important as another thing. Each part is as important as the whole.'" Perloff, "Watchman, Spy, and Dead Man: Jasper Johns, Frank O'Hara, John Cage and the 'Aesthetic of Indifference,'" *Modernism/Modernity* 8 (2001), 199.

52. Rewald, *Biography*, 1948, 96.

53. Johns, in Sylvester, "Jasper Johns 1965," *Interviews*, 2001, 165.

54. Johns, in an interview with Gene R. Swenson, "What is Pop Art? Part II," *ARTnews* 62, no. 10 (February 1964); reprinted in Varnedoe, *Writings*, 1996, 93.

55. *Art Now: New York* 1, no. 4 (April 1969), unpaginated: "One of the functions of art is to make the viewer rediscover the visual world. Johns makes us look with renewed vision at things we never noticed before. His work grows out of the interaction of the object and the image."

56. Johns, in Sylvester, "Jasper Johns 1965," *Interviews*, 2001, 155.

57. Fairfield Porter, "Jasper Johns," *ARTnews* 56 (January 1958), 20.

58. Alan Solomon, "The New American Art," *Art International* 8 (March 1964), 51.

59. Cézanne, letter to Émile Bernard, October 23, 1905, in Rewald, *Correspondance*, 1978, 314–315.

60. Lionello Venturi, *Cézanne, son art, son oeuvre*, vol. 1 (Paris, 1936), 53.

61. Johns, quoted in Michael Crichton, *Jasper Johns* (New York, 1977), 28.

62. Johns, in "His Heart Belongs to Dada," *Time* 73 (May 4, 1959); reprinted in abbreviated form in Varnedoe, *Writings*, 1996, 82.

63. Johns, in Sylvester, "Jasper Johns 1965," *Interviews*, 2001, 152.

64. Rewald, *Biography*, 1948, 202.

65. Johns, in "His Heart Belongs to Dada," 1959; reprinted in Varnedoe, *Writings*, 1996, 82.

66. This is Johns' own assessment of the work. See Hopps, "An Interview with Jasper Johns"; reprinted in Varnedoe, *Writings*, 1996, 110.

67. Rose, "The Graphic Work, Part II," 1970, 74. Johns, in the 1963 interview with Klüver; reprinted in Varnedoe, *Writings*, 1996, 85.

68. Jasper Johns, "Thoughts on Duchamp," *Art in America* 57 (July–August 1969); reprinted in Varnedoe, *Writings*, 1996, 23.

69. Rose, "The Graphic Work, Part II," 1970, 70.

70. I mean to evoke some of the language characteristic of Clement Greenberg's seminal essay on Cézanne. See Greenberg, "Cézanne," *Art and Culture: Critical Essays* (Boston, 1961), 55.

71. Kozloff, "Art and the New York Avant-Garde," 1964, 537.

72. Cézanne, letter to Émile Bernard, May 12, 1904, in Rewald, *Correspondance*, 1978, 302.

73. Maurice Denis, "Cézanne," *L'Occident* (September 1907), 118–133; reprinted in Maurice Denis, *Theories, 1890–1910*, 4th ed. (Paris, 1920), 253.

74. Please see my "Cézanne and Lucretius at the Red Rock," *Representations* 78 (Spring 2002), 56–85.

75. Johns, in Roberta J. M. Olson, "Jasper Johns: Getting Rid of Ideas," *SoHo Weekly News* 5, no. 5 (November 3, 1977); reprinted in Varnedoe, *Writings*, 1996, 166.

76. Johns, in the 1963 interview with Klüver; reprinted in Varnedoe, *Writings*, 1996, 85.

77. Johns, in Olson, "Getting Rid of Ideas," 1977, 166.

78. Johns, in the 1963 interview with Klüver; reprinted in Varnedoe, *Writings*, 1996, 85.

79. Stevens, journal entry, June 6, 1907, in Stevens, *Letters*, 1996, 104.

80. David Sylvester, "Johns" (1964), in *About Modern Art: Critical Essays, 1948–1996* (New York, 1996), 228.

81. Sylvester, *About Modern Art*, 1996, 226.

82. Cézanne, letter to Charles Camoin, February 22, 1903, in Rewald, *Correspondance*, 1978, 293. This comment comes up in other testimonials of Cézanne in his later years. It is also noted in Rewald, *Biography*, 1948, 201.

83. Rainer Maria Rilke, letter to his wife, October 12, 1907, in *Letters of Rainer Maria Rilke, 1892–1910*, Jane Bannard Greene and M. D. Herter Norton, trans. (New York, 1945), 309. Rilke attributes the commentary to his companion of that day, but the language is distinctly Rilke's.

84. Rose, "The Graphic Work, Part II," 1970, 74.

85. Cézanne, letter to Joachim Gasquet, April 30, 1896, in Rewald, *Correspondance*, 1978, 249–250.

86. Cézanne, letter to Émile Bernard, October 23, 1905, in Rewald, *Correspondance*, 1978, 315.

87. Joachim Gasquet, *Cézanne* (Paris, 1926), 168.

88. Geelhaar, "The Right Eyes," in *The Bathers*, 1990, 299.

89. Theodore Reff, "Cézanne's Bather with Outstretched Arms," *Gazette des Beaux-Arts* 59 (1962), 174.

90. Reff, "Bather," 1962, 173.

91. Bernstein, "'Seeing a Thing,'" in Varnedoe, *Retrospective*, 1996, 42.

92. Geelhaar, "The Right Eyes," in *The Bathers*, 1990, 298.

93. Alan Solomon, *USA: XXXII International Biennial of Art Venice, 1964* (New York, 1964).

94. Max Kozloff, "Johns and Duchamp," *Art International* (Lugano) 8, no. 2 (March 20, 1964), 43.

95. Venturi, *Cézanne*, 1936, 239.

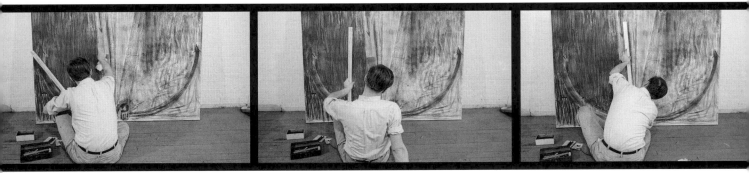

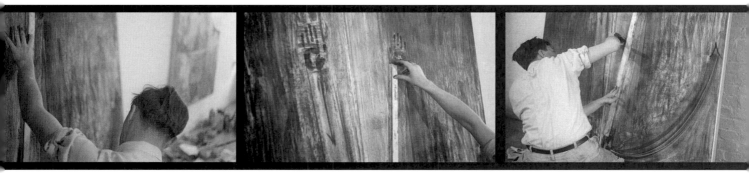

Diver: A Delay

John Elderfield

The self attempts balance, descends.[1] *Jasper Johns*

A delay is a suspenseful time in a narrative that postpones a conclusion. It is an interval, empty of new initiatives. And it is a stoppage, during which a project already launched is able autonomously to unfold. Hence, Marcel Duchamp's *3 Stoppages Étalon (3 Standard Stoppages)* (fig. 1) supposedly records the shapes assumed by three threads of a standard length after the delay of their falling to the ground.[2] A stoppage means stopping and taking a chance. A dive is that kind of a delay: a planned fall into the unknown. Edouard Manet likened his manner of improvising directly on the canvas to learning to swim by plunging headfirst into the water.[3] He likened himself to a diver. Perhaps Jasper Johns does.

This essay combines, expands, and eliminates thoughts on Jasper Johns' *Diver* (fig. 2) recorded on three different occasions, over about a decade, so it is itself a sort of delay.[4] It is a close reading of *Diver* because *Diver* brings you close to it. And it is also like its subject in seeking to build a unity in its response to an experience, but not one constructed from a unifying principle. For *Diver* itself is a work that, while complete, does not support such an imaginary completeness, made from afar, but requires an accretion in understanding of its dissolving and reforming oppositions, its reversals and its inversions. A dive is also a plunge, carrying the diver deep under the surface of the water, and a delay is also a deferment of understanding, of certainty.

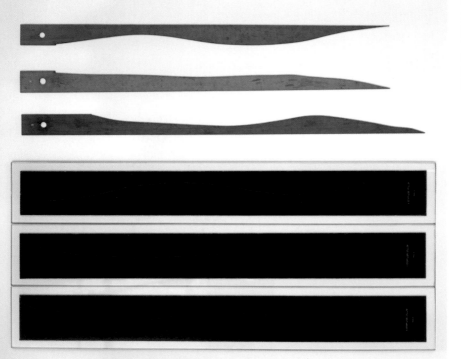

1. Marcel Duchamp, *3 Stoppages Étalon (3 Standard Stoppages),* 1913–1914, The Museum of Modern Art, New York, Katherine S. Dreier Bequest

A Full Contradiction

The artist has said that *Diver* shows "the idea of a swan dive."[5] The idea should be: leaving the diving board, keep the legs straight together, back arched, and arms stretched out from the sides, then arms back together as you enter the water.[6]

He was asked: "Do you think of the drawing as a diagram of a swan dive?" He answered, "I did, but now it would take me a while to recover the original thought."[7] The original thought is recoverable, perhaps, by remembering the conditions of making. And *Diver,* he recalled, "started as a way to figure out a diagram for the painting [also called *Diver*], but then it was finished later as a kind of drawing."[8]

I take this to mean: Preparing the five-panel, 1962 painting *Diver* (fig. 3), his largest work to date and marking a new direction in his art,[9] Johns felt the need to work out a section of it in advance, the section that occupied two panels to the right of the gray scale panel. The single panels to the left of the gray scale and the right of the Diver image were also, to different degrees, worked out in advance, by replicating (repeating and altering) them from other paintings; the left part from *Device* (cat. 53) and the right part from *False Start* (cat. 30).[10] But there wasn't a painting with the Diver image, so Johns had to create an image to scale, which required two large sheets of paper put together, in order "to figure out a diagram [of a diver] for the painting," and to make the new painting fully an assemblage of borrowings, as well as anticipations — the wall of a Jasper Johns museum of some of his absent works.[11] Later, the two-part drawing having served its purpose as a cartoon, the artist had the two pieces of paper mounted on two canvases, as if it were a painting — which made a drawing now a *kind* of drawing. Setting the panels together, he continued to work on them in 1963, combining the panels as he had combined images in the painting *Diver*. That is to say, he built them into a unity while showing the separation that could again pull them apart.

Then he was asked: "Is this a sort of diving board, the rectangular area toward the top?"[12] (referring, presumably, to the two abutted bands, one on each panel, that reach up the center of the composition to the very top). Turning the question, he offered encouragingly: "Well, it suggests it, doesn't it?" The lure was set, and the interviewer obligingly answered, "It did to me." After a pause, perhaps, came the laconic: "I would say that is probably a little short of logic and requires an imaginative leap." I take this to mean: *that* interpretation is not a logical construction or *that* area of the drawing is not; either way, it requires a leap of the imagination to understand.

If *Diver* can be said to show the thought of, or to diagram, a swan dive, "the rectangular area toward the top" cannot securely be said to suggest a diving board (this is a common reading), at least not if the diver is thought to descend within the picture plane, for the footprints next to the top edge would, then, be pointing the wrong way. Of course, when the footprints were put there, it was a different matter. The work had to be on the ground, so it could have seemed to the artist, standing there, that he was about to dive out of the composition as if off a diving board. Did he make these footprints in the way that divers are told to prepare

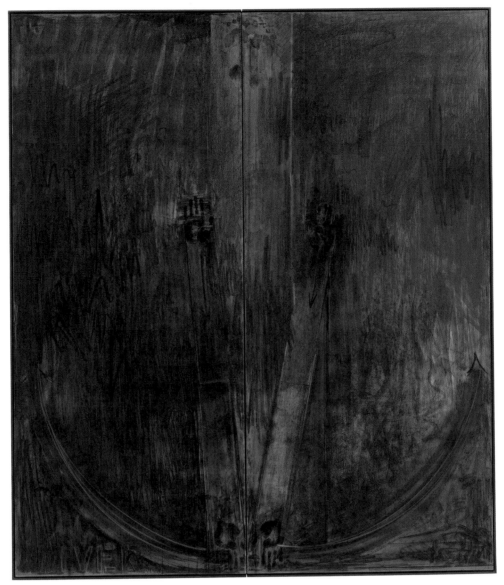

2. *Diver* (cat. 66)

for the dive? ("Take a few steps and, as you approach the end of the board, lift one knee up and push off the other leg, then land on two feet at the end of the board. When you land, your body should be perfectly vertical."[13] Then dive.) Or did he step backward onto the drawing, looking down and behind, presumably, to enter the fictive plane? We are allowed, even encouraged, to imagine both options — for the memories of these possible postures cling to the blurred shapes of the soles of the feet — and then we have to dismiss them, now that the drawing is a vertical wall of paper. This is to say, one of these options achieved representation in the making of the drawing and was denied representation in its completion, where both are now remembered because we cannot know with certainty which movement of the body marked the surface.

In any event, the footprints may be said to represent, indexically, the physical effect of someone (whom we identify, by default, as the artist) stepping onto the surface of the composition. And they reveal, by extension, that the surface had originally been in, and has moved from, a horizontal position. Neither of these propositions may plausibly be said to apply to the handprints that represent the physical effect of someone, the artist, having placed his hands two-thirds of the way up and at the bottom edge of the composition. Both sets could have been and presumably were made while the work was vertical: those at the bottom edge, by the artist turning his back to the work and bending down, as if reaching into the water — reaching for something? I shall return to this analogy. Therefore, from neither set may we infer that the

artist entered the pictorial space to make the prints; this may have as much to do with our understanding of how hand- rather than footprints are made as with our reading of this composition, but it still counts in our reading. What is very particular to this composition is that its handprints do not allow us to infer that the orientation of the surface was once horizontal. Indeed, they shut out that option by allowing, again even encouraging, us to imagine ourselves reaching up against the wall of paper to make the upper set of prints,[14] and turning to reach down and touch its bottom edge to make the lower set. The former (upper set) extends a stretch that points to, and the latter (lower set) seems clamped against the place in the composition farthest from, the footprints, which gain in distance precisely because they could hardly have been made by someone placing their feet up there, at the top edge of the composition.[15]

This accounts, I think, for the curious effect of the bottom edge of the work seeming to pull forward and the top edge (along with it, the pictorial space in the upper area) seeming to recede. This effect is tempered by the flattening central verticals when the work is seen from a distance. Close-up, however, the pictorial surface is tangibly present and the pictorial space shades backward as it rises, in the same sort of way as it does in — an obvious example — Claude Monet's Nymphéas compositions.

But let us leave aside the "Symbolism" of the work and stay with what it may be thought to represent, and how. If the footprints do reject our reading them as standing on a diving board, because they point the wrong way to dive into the composition, what plausible narrative can include them? One possible narrative unfolds if we notice that they display the soles of the feet. Then, we might imagine the body of the diver, seen from the back, gliding down before us, moving fairly fast. If so, we will need to surrender our reading of the hand- and footprints as depicting the physical effects of the artist's fabrication, if we can, and see the blur of the footprints as representing the actual appearance of the moving subject, our loss of focus on the diver. In contrast, the greater density of the handprints should represent moments of fixity. But this would only make sense if these hands were thought to be not in movement but somehow arrested in (or before or after) the dive.

In fact, to read the elements of the drawing as representational of the fictive subject is to see that Johns represents its movement in more than one way.[16] In addition to representing the appearance of movement (the pale, blurred, divided column — "legs straight together" — that drops down the composition), he also represents the physical effects of movement (the darker water, parted by the body, streaming down each side of it). And he does offer something akin to the arrested, exemplary moment recommended by

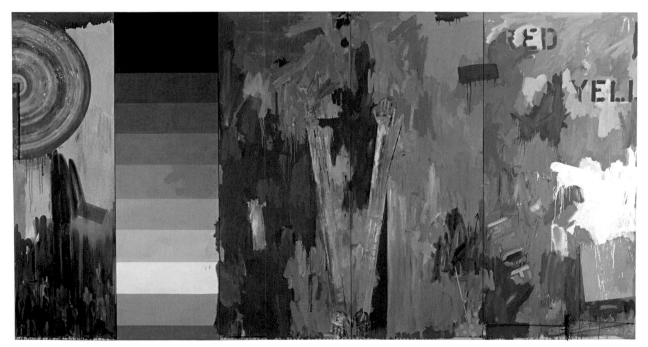

3. *Diver* (cat. 65)

Gotthold Ephraim Lessing, in the large, V-shaped image of body and arms with densely stamped hands, whether we read the latter as pointing down or up.[17] Traditionally, we were meant to infer the preceding and following moments from such an image and, hence, the larger narrative to which it belongs. We do so here; we read in a frozen image the movements of the dive.

As we do so, though, we cannot prevent ourselves from also reading the movements of the artist's fabrication.[18] And just as there is more than one way of representing fictive movement in the drawing, there is also more than one way of representing the movement of fabrication in it.

The hand- and footprints self-evidently represent the artist, placing him before or above the picture plane — and through the perceptual illusion of these forms being above, on, and within the space,[19] somehow sinking within it, too. Conversely, there seem to be some truly nonsemiotic marks in the drawing, among them the red drips at the bottom, which Johns says are "from some other activity in the studio,"[20] presumably from painting *Periscope (Hart Crane)* (cat. 67), which we see next to *Diver* in a photograph of these works in progress (fig. 4). Some of the marks in the bottom right corner of *Diver* may also be nonsemiotic, for they look as if they were done just to test the charcoal and get things going. It is impossible to be certain about them; nonetheless, the presence of what looks like atavistic scratching is important to the drawing in establishing a primitivism of the mark around and over which an extremely sophisticated draftsmanship is displayed.

We can identify securely some marks that do carry a signifying function in telling of the artist's moving hand, yet float, seemingly independent, on the surface of the drawing, as if refusing to partake in its semantic functions. A good example is the self-sufficient patch of vertical scribbles about two-thirds up the right-hand side. It challenges the viewer to mistake it for something aqueous, even to read it as part of the representation. The warning is reinforced by a patch of finer vertical scribbles to its lower left, doubly semantic in shaping a beautiful visual pun of representing movements of the artist's hand and the physical effects of movement through the water of a depicted hand. A larger pun marks the center of the composition, for the vertical bands that represent the appearance of the movement of the dive also assume a nonrepresentational function in offering an internal reference to the literal shape of the work itself. Noticing the latter reference, David Sylvester observed: "It's as if Rembrandt had been at work on a Barnett Newman."[21] Noticing that association, we may be reminded of Newman's remark, "The self, terrible and constant, is for me the subject matter of painting,"[22] and wonder whether this feature is representational of the artist in the drawing as well as of the diver zipping down. But one set of marks in the drawing unquestionably is nonrepresentational, although semantic, namely, the nonresemblant, stenciled sign in the bottom left corner that reads DIVER.

These few examples offer but a meager sense of the semiotic and sensible wonders of the drawing. To follow its narrative of representation is constantly to be interrupted by the means of the representation, and vice versa. Earlier, focus on a flag of the United States was interrupted by the object's identity as a painting, and vice versa. Now, not only does Johns give us alternatives to look at, but each alternative is unfolded in complex ways, and they, therefore, interrupt each other in multiple, complex ways. All seems in flux. The surface, as Sylvester said broadly of Johns' painting, "composes an objective correlative for change."[23]

The artist has said that he is concerned "with any moment in which one identifies a thing precisely and with the slipping away of that moment."[24] He is interested in the subject of transitional states as they are disclosed in the visual and mnemonic processes of perception and identification. *Diver* may be thought to allegorize that subject. If, each side of the body, the double-handed arms point downward, then they do so ready to be stretched sideways during the dive — in the directions marked by the arching arrows. In this interpretation, the dive has just been launched; the diver is not entering the water, ready to deliver a breaststroke (another common reading); he is shown poised in the air, visually delayed just as he is beginning to fall. But, even in this interpretation, the breaststroke (in the water the diver will enter) and the

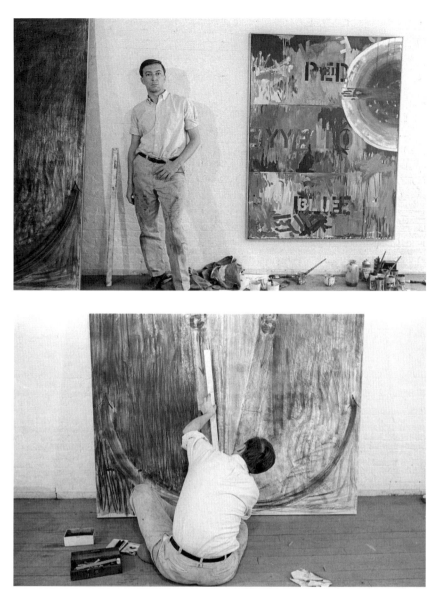

4. Johns with *Diver* and *Periscope (Hart Crane)*, 1963, Photograph by Paul Katz

5. Johns working on *Diver,* 1963, Photograph by Paul Katz

diving board (the ground from which the diver has launched) cannot be thought incorrect readings, since the drawing allows them. They must be thought of as subsidiary ones, descriptive of features that are potential to, anterior and posterior to, the dive through the air itself. All readings belong to that *imaginative leap* the artist has said that his drawing requires.

This is true, certainly, of the reading that has the double-handed arms pointing upward, as if stretched backward during the dive. However, this interpretation is truly a little short of logic if this is a swan dive, during which the arms are stretched out from the sides until they are brought together as the diver enters the water. They are never stretched backward. Nonetheless, the drawing again allows this subsidiary reading. It helps the figure to plunge down, and its reversal of the initiatory posture of the dive suggests an opposite movement; even as he launches, the diver anticipates that he will eventually thrust his arms out of the water. Let us now notice that each arm is divided in two, precisely halfway along its length; that each half is of a different tonal value, the lower half lighter, as if the paper there had been covered; and that arrows point down from the palms of the hands at the top. The inescapable suggestions are, first, that the arms are represented as if made of wood: indeed, a photograph shows the artist drawing them with the aid of a wooden slat (fig. 5), as Duchamp did with one of his standard stoppages.[25] The second is that the arms are hinged in such a way that if one were to pull in the direction of the arrows, the upper halves would cover the lower.

The artist was asked about his having worked with the poetry of Frank O'Hara. Replying, he spoke, among other things, of *Memory Piece* (fig. 6), a sculpture "in which a rubber cast of his left foot is attached to the underside of the lid of a wooden box. There are three drawers in the box filled with sand. When the lid is pressed down and lifted, it leaves a footprint in the sand. There are also references to Hart Crane in a painting I made called *Periscope*, and in *Diver*."[26]

Three drawers; three more standard stoppages? These hinged lids that leave the footprints of a contiguous template are like the hinged arms that can be imagined to stamp handprints in *Diver*. In fact, while the illusion of hinged wooden slats in *Diver* goes back to the literal hinging in early works like *Target with Four Faces* of 1955 (cat. 3), it was surely reinforced when (in 1959 or 1960) Johns saw Duchamp's early note in the *Green Box:* "Perhaps make a *hinge picture.* (folding yardstick, book...) develop the *principle of the hinge.*"[27] Arms drawn with a yardsticklike slat illustrate the principle of the hinge. The principle has a disturbing connotation. The automatism of these folding arms, once recognized, is a shock in this picture of a motivated movement; their repetitive, mechanical, enforced form of mimesis, a chilly reminder of the uncanny that attaches to such doubling.[28] Imagine the slats of the arms folded down in a closed position: what would the backs of the hands look like? This potential of the picture is unknowable, but the known withholding of the representation leaves its mark.

The exposed, open position reveals one of the most ambiguous of all symbolic gestures. Arms thus raised, now usually understood to mean exultation, long served as the principal symbol of lamentation upon death.[29] The downward-pointing arrows beneath the outstretched hands, which tell us how the arms might fold down, thereby suggest that the figure finally will sink. This reinforces the older meaning, giving credence to the proposal — deriving from the artist's remark that *Diver* makes reference to the poet Hart Crane — that *Diver* refers to the suicide of Crane by drowning. ("Some claim they saw an arm raised from above the water.")[30] But the gesture itself does not allow the one choice. Although exultation hardly seems consonant with lamentation, it is a poor understanding of tragic fiction that will not recognize them for a double. Johns' replication of the right arm in his contemporaneous *Land's End* (cat. 70) is a very desperate gesture. But the complete diving-and-rising form in *Diver* constitutes an ambiguity that is a full contradiction, which marks, as William Empson tells us, a division in the artist's mind.[31] The artist acknowledges this when he says that the image has an ambiguous quality that can suggest either life or death.[32]

6. Jasper Johns, *Memory Piece (Frank O'Hara)*, 1961–1970, Collection of the artist

A Partial Concealment

In 1962, when Johns began work on *Diver*, Fernand Léger's *Divers* of 1941–1942 could be seen on exhibition at the Guggenheim museum in New York. A typical composition (fig. 7) displays a wonderful jumble of limbs shaped into a new composite figure that floats, centered, amidst colorful shapes that reach almost to the edges of the canvas. Gravity-free diving.[33] At that same time, Johns also could have seen Paul Cézanne's *Bather* of about 1885 (fig. 8) hanging at the Museum of Modern Art — another centered image, but of a grave, introspective figure, just putting his toe into the water.[34]

Perception of the body as a whole has always been fostered by distance: by means of theater, ballet, games; by diving, even. The body as a whole is, therefore, always another's body even if an image of one's own.[35] But how can an image of the body be conceived except in relationship to one's own, which is in a relationship of experienced parts rather than as a perceived whole. So there is the experience of proximity as well as of distance, of touching as well as of looking, to record. The artist was referring, perhaps, to this two-foldedness of a great human representation when he said of Cézanne's *Bather:* "It makes looking equivalent to touching."

With *Diver*, too, there is a distant experience and a proximate experience and they are brought into equivalence. Of course, the viewer's distant visual experience will differ from his proximate visual experience. But the distant visual experience represents a proximate experience; it does so because the whole representation is made to feel proximate, as it is in the Cézanne. (As it is in a Barnett Newman.) The subject shape, lengthened, is pulled stiffly to attention; centralized, it describes the vertical axis of the pictorial shape; drawn near, it occupies the frontal plane. More precisely, the subject shape is surrendered to

the shape of the plane, so that a particular kind of image can be extracted from the subject, an image that is seen to have been pulled, placed, and exposed. This is to say, the shape of the body — whether circumscribed, as in the Cézanne, or not, as in the Johns — is seen to have been shaped, and this shaping is seen to have been done to gain in proximity, to make looking equivalent to touching.

The image in Cézanne's *Bather* looks down to see his hands touching each side of his body. So was Johns speaking not of the viewer's but the bather's experience of looking, when he said it was equivalent to touching? And, when he made *Diver,* was he thinking of those hands resting above the pleat at the top of the bather's shorts when he clamped his own diver's hands onto the big, pleated arch at the bottom of his composition? (The comparison makes his work seem fierce.) Their touch, however, is blind. In *Diver,* looking down is invited but unrepresented. Rosalind Krauss has written of the "blindness of this dive, the sense of a gesture that is nothing but touch, the body's yield to vertigo, the blackness and obscurity closing over its horizonless fall."[36] While this is unconditional hyperbole, it does align the representation of touch by the image and by the artifact containing the image — too definitively, though — inviting us to remember that Johns is not saying that looking is touching. Rather, he attributes to looking a force or effect equal to that of touching.

Touching is represented in *Diver* but looking is not. If looking is like touching, touching can be like looking. Looking at *Diver* may invoke the sense of touch and looking at the touching represented in Diver requires, and therefore refers to, the sense of sight. The drawing makes equivalents of looking and touching by presenting them in an alternation. It does so by relying upon the reflexive switches in our perceptual mechanism, which will replace, for example, a color or a directional movement by its opposite when fixed attention on it causes the eyes to tire. The darkness of this work has become exaggerated over time,[37] but in-process photographs suggest that it could always have been used, as Michael Podro observes of analytic cubist paintings (to which it makes reference), to represent to ourselves the efforts of perception in obscure circumstances and, therefore, "makes our perceptual adjusting a comprehensive theme within the [work]."[38] As, looking, we no longer can see, we may become more receptive to the invocation of touch and experience the blindness of the dive. At least, we may experience a fading of attentiveness and, with it, something disentangling itself from the inertia of visual identification and falling.

A dive is a representation of the delay between a cause and an effect, between a wish and its realization. It represents the delaying of a wish. Freud called an indefinitely, permanently delayed wish a "repression," and a wish that has been represented, in order to escape repression, a "sublimation," which meant that the delay in its passage toward at least its partial fulfillment was coming to an end.[39] Diving, in the drawing, may be thought of as an exercise in imagining that coming-to-an-end, in imagining the perils and pleasures on the way, and, perhaps, in suspending the possibility of the end. (Works of this period, the artist told Richard Field, are about having "nowhere to stand.")[40] While the body does fall (especially when the eyes tire), to look back at it is to see, of course, that it is suspended in place yet again.

The element of wishfulness in this drawing had opened it to some speculative dives into the artist's personal and social history, notably on the part of Jonathan Katz, who has suggested that images of swimming and diving in Johns' works of 1954 to 1961 refer to his partnership with and then separation from Robert Rauschenberg.[41] Sylvester brusquely responded to a similar suggestion: "However, there is nothing in the pictures themselves that conveys the personal significance of such material."[42] And it is absolutely true that there is nothing in *Diver* to allow such an inference — except one thing, the manner in which it is titled. I just mentioned that the drawing makes reference to analytic cubist paintings, and earlier drew attention to the nonrepresentational, but semantic, image in the lower left corner: the stenciled sign that reads DIVER. Not far from Cézanne's *Bather* in the galleries of the Museum of Modern Art, a similar stenciled sign could be found, reading "Ma Jolie" (fig. 9), which Picasso said that he wrote in this painting as a declaration of his love.[43]

9. Pablo Picasso, *Ma Jolie,* 1911–1912, The Museum of Modern Art, New York, Acquired through the Lillie P. Bliss Bequest

As the paper on which *Diver* is made has darkened over time, both its reference to analytic cubism and its elegiac tone indubitably have become more apparent. Nonetheless, if its sense of chiaroscuro would have been less when it was made, its organizing architecture would, therefore, have been even clearer. This, too, bears comparison to works like *Ma Jolie.*

The possibility that we may use a fixed image to represent movement in our perception of it is called forth the more strongly by images placed in confining tracks. Johns discovered this when he made *Device Circle* in 1959 (cat. 28), an anthropomorphic version of which composed a part of *Periscope (Hart Crane),* made alongside *Diver.* And the more prescriptive these tracks the better. In this respect, the ultimate model for both *Device Circle* and *Diver* is, as often remarked, Leonardo da Vinci's *The Proportions of the Human*

10. Leonardo da Vinci, *The Proportions of the Human Body According to Vitruvius* (*The Vitruvian Man*), c. 1492, Gallerie dell'Accademia, Venice

Body According to Vitruvius (fig. 10), done about 1492. However Leonardo's drawing is a representation not of movement but of the coterminousness of the human body and two basic geometric forms.[44] As such, it demonstrated that the paradigm for the unity of a work of art was the whole body and, unwittingly, allowed that the pose of the body not only designs but is also designed by the work of art.

Diver accepts that allowance. The diver may be imagined to govern the space into which he dives, but also to be governed by the coordinates of that space as he falls within it — only here, while the unity of the drawing is given by the whole body, insofar as that unity gives way, and it does, so does that wholeness. It is in this respect that *Diver* makes reference to the architectural construction of analytic cubist paintings. Its big, converging diagonals offer a reminder that the bodily gestures that composed Picasso's pre-cubist paintings were the ultimate sources of the abstracted, linear scaffolds that organized his compositions of around 1911–1912. This internalization of a represented subject matter within the form of the execution, which effectively reallocates the narrative component of a painting to its representation in the perception of the beholder, persists half a century later. Only, Johns elicits ever more from the beholder when he holds us by the intricate power of a narratable content deep within the enacted form of the image as if within the privacy of a thought.

Diver may be so affective precisely because it holds us by an action as if by a thought. Which is to say not only that Johns asks us to think the drawing through, but also that he asks us to treat our thoughts as actions, subject to enquiry about their motivations. So my claiming, pressing this further, that the unseen figure in the drawing is lost in action as an absorbed figure might be lost in thought, catches me performing

in this drawing the memory of somebody diving, then rising, then falling, then lost in action to me. Just how lost becomes painfully clear when I see that the drawing's two panels are closed like a door, and that the hands sealing the base of the drawing have become a skull on the ocean floor.[45]

In 1959, Johns wrote of his art as containing "possibilities for the changing focus of the eye." He seemed to have been thinking (among other things) of complementary after-images, for he referred to Larry Rivers' having pointed to "a black rectangle two or three feet away from where he had been looking in a painting, and said 'like there's something happening over here too.'"[46] And, about a decade later, he did make a color lithograph (fig. 11), which invites an attentional shift by implicitly posing the question: "Which nation does this strange (green, black, and orange) flag represent?" If, after fixating that flag, the gaze is swiftly transferred to the monochrome flag below it, the eye will produce a complementary after-image to answer the question. A changing focus of the eye, but within a demarcated area, is similarly required to create the so-called Gestalt switch that allows multistable images like the hands-skull image to switch identity. Johns has made extensive use of borrowed multistable images, for example, the famous, so-called wife-and-mother-in-law figure (fig. 12),[47] so it is not unreasonable to ask if he constructed one for himself in *Diver*.

The artist has nothing to say in reply, neither approving nor rejecting this reading. However, Sylvester had compared *Diver* to a crucifixion (again, the artist neither approving nor rejecting) and thought a skull on the hill at Golgotha made sense.[48] But if this image is to be compared to a crucifixion — the greatest of all themes of a body constrained by the plane that it occupies — then it must be an upside-down crucifixion. Therefore, it must refer not to Christ's Crucifixion but to Saint Peter's. And Saint Peter, to continue the association, was the Galilean fisherman who was famously called by Christ to become a "fisher of men." Johns allowed that *Diver* had something to do with Hart Crane, who died by drowning. And Johns, a lover

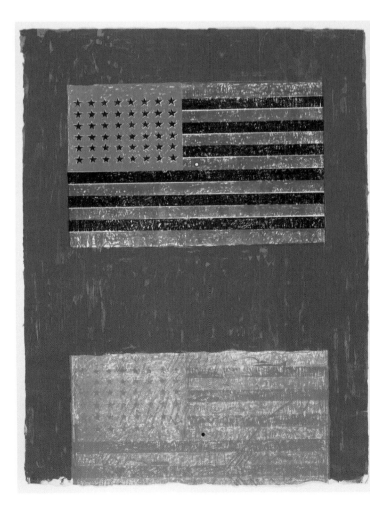

11. Jasper Johns, *Flags*, 1968, The Museum of Modern Art, New York, Gift of the Celeste and Armand Bartos Foundation

12. W. E. Hill, *My Wife and My Mother-in-Law*, 1915, as used by Jasper Johns in *Untitled* (see detail), 1986, The Museum of Modern Art, New York, Fractional gift of Agnes Gund

13. Raphael, *The Miracu-lous Draft of Fishes,* 1516, from a nine-piece tapestry *Acts of the Apostles,* Soprintendenza per Il Patrimonio Storico, Artistico ed Etnoantro-pologico di Mantova, Su Concessione del Ministero per I Beni e le Attività Culturali

of puns, once remarked that the earliest paintings he saw as a child, made by his grandmother who died before he was born, included one of a crane standing in water. Of these paintings, he said: "I have the suspicion that they were copied, but I don't know. Those were the only paintings I ever saw, real paintings, as a child."[49] But copied from what? The most famous of all images of a crane standing in water, Kate Ganz reminded me,[50] is in Raphael's great tapestry *The Miraculous Draft of Fishes* (fig. 13). And this, of course, is an image of the calling of Saint Peter. And there, the crane — often a symbol of vigilance, an appropriate symbol for the painter of *Watchman* — stands below the V-shaped arms that reach down into the water to draw in the miraculous draft. And, finally, to return to where these associations started, when this lover of puns drew the V-shaped arms of *Diver* reaching into the water, did he think not only of Crane and crane but also of *crâne,* the skull on the ocean floor?

However, to follow Sylvester again, there is nothing in *Diver* itself that conveys the personal significance of such material. Have we reason, then, to allow that *Diver* dives into Johns' past and beyond, to tap into an atavistic image-bank for illustrations of death and suffering, conversion and redemption, and discovery of the miraculous beneath the surface?[51] The artist, we know, has become very impatient with critics who want to look under the surface. His impatience is with those who build narratives around imagery that "I didn't believe they could see until after they were told to see it."[52] So he is not talking about intimations of the sort that I am discussing. Nonetheless, I believe that he would not wish to constrain his work by the preceding narrative, and of course he would be right. For what matters, to borrow a statement from Christopher Ricks on one of Johns' greatest contemporaries, is that he "is doing the imagining, not that he be fully, deliberately conscious of the countless intimations that are in his art."[53] Of course, he himself created "an audience that had grown accustomed to teasing out obscure points of reference."[54] But, having declared that he was an artist of conscious mystification by telling people how to decipher his cryptic images, he decided to stop telling — but not, of course, to stop painting enigmatic pictures. Indeed, he then revealed that he was an artist of mystification by creating a new cryptic image, a "green angel," and "wasn't going to say what it was or where it had come from."[55]

It is touching to note that, when talking about his early memories of his grandmother's paintings, he also spoke of being very happily mystified by something else green, namely, the shoots coming up in his grandfather's fields: "I was completely mystified how he would know what this green stuff was. He would be very excited about the cotton or melons or rye just coming up, and I couldn't understand how he could tell one thing from another."[56] So he happily places the viewer in the same position of mystification that he himself remembered. Freud and Proust both thought that the knowledge of art and the appreciation of art cannot be separated. Johns thinks that the puzzle is part of the pleasure.

Having painted iconic symbols as if they no longer symbolized, he began with *Diver* to describe significant actions shorn of obvious significance, picturing those privileged shapes of the body by which human emotion and personality explain themselves — then withholding the explanations, which only stimulates the desire to find explanations or, more precisely, to remember and rewrite the stories that the gestures used to tell. However, we also need to remember the means of delivery that routes the message we imagine the delivery will bring. This has been the subject of this essay, the delay in the delivery, which keeps the diver in suspense — and, therefore, the viewer, kept waiting, as well.[57]

As for the message, Johns has stated that he would like to keep his work "in a state of shunning statement,"[58] and that "I have attempted to develop my thinking in such a way that the work I have done is not me."[59] Therefore, Johns is just being himself when he says: "The self attempts balance, descends. Perfume — the air was to stink of artists' egos. Himself, quickly torn to pieces. His tongue in his cheek."[60]

Notes

1. Jasper Johns, "Marcel Duchamp (1887–1968)," *Artforum* 7, no. 3 (November 1968), 6.

2. It is now broadly accepted that Duchamp could not have made this work in such a manner: see Rhonda Roland Shearer and Stephen Jay Gould, "Hidden in Plain Sight: Duchamp's *Three Standard Stoppages,* More Truly a 'Stoppage' (An Invisible Mending) Than We Ever Realized," *Tout-Fait: The Marcel Duchamp Studies Online Journal* 1, no. 1 (December 1999). However, this was not acknowledged when Johns made *Diver.* Duchamp wrote on the subject of delay in his notes in the *Green Box,* and Johns reviewed the typographic version (*The Bride Stripped Bare by Her Bachelors, Even: A Typographic Version by Richard Hamilton of Marcel Duchamp's Green Box,* George Heard Hamilton, trans. [London and New York, 1960] unpaginated) in his "Duchamp," *Scrap* 2 (December 23, 1960), 4. Johns would appear to have had access to one, at least, of the notes in translation prior to its publication, for he quotes it in an untitled statement in Dorothy C. Miller, ed., *Sixteen Americans* [exh. cat., The Museum of Modern Art] (New York, 1959), 22, on which more later. In any event, he would surely have read all the notes by the time that *Diver* was begun. Duchamp's notion of delay is twofold: 1. Principally, it was a term to use as "merely a way of succeeding in no longer thinking that the thing in question is a picture... a delay in glass as you would say a poem in prose or a spittoon in silver." 2. Insofar as a delay is a stoppage, it is intimately related to Duchamp's fascination with gravity (shared by Johns in *Diver* and through to the recent catenary paintings), which produces, in the *Green Box,* a 1914 note on how the 3 *Standard Stoppages* ostensibly were made, and the note on the "bottle of Benedictine" for *The Bride Stripped Bare by Her Bachelors, Even* (Philadelphia Museum of Art), a feature that is relevant to *Diver,* since it "lets itself be raised by the hook C; it falls asleep as it goes up; the dead point wakes it up suddenly and with its head down. It pirouettes and falls vertically according to the laws of gravity."

3. Phillipe Verdier, "Stéphane Mallarmé, Les Impressionistes et Edouard Manet," *Gazette des Beaux-Arts* (November 1975), 149, reprinting Mallarmé's report of his conversation with Manet from *The Art Monthly* (London) (September 30, 1876). It has also been said of Manet that "the work is spread out in time, *deferred,* as though to encourage productive discrepancies." See Jean Clay, "Ointment, Makeup, Pollen," John Shepley, trans., *October* 27 (Winter 1983), 27–28.

4. They are 1. Jasper Johns, "Diver," *Artforum* 36, no. 5 (January 1998), 81; 2. An unpublished transcription of my presentation of *Diver* to the Committee on Painting and Sculpture, The Museum of Modern Art, on December 8, 2003 (clusters of residual sentences from both 1 and 2 appear here); and 3. Additional thoughts developed in the creation of this text, which I have to thank Jeffrey Weiss for inviting, indeed encouraging, me to produce; and The American Academy in Rome, through the generosity of Sid and Mercedes Bass, for providing me with the opportunity to write, in an extraordinary setting and, for the first time on this subject, from across an ocean. I thank also Joachim Pissarro for recommending articles on *Diver* that I had not come across, and Jeanne Collins for offering, as usual, most useful suggestions on an almost completed text. And I want to acknowledge the conversations that I had about *Diver* with the late David Sylvester and Kirk Varnedoe; it is hard to believe that this exhibition is taking place without them.

5. Stated in Roberta Bernstein, *Jasper Johns' Paintings and Sculptures, 1954–1974: "The Changing Focus of the Eye"* (Ann Arbor, 1985; PhD diss., Columbia University, 1975), 108, from her conversation with the artist, spring 1968. This reference is made of the painting *Diver,* but since the drawing diagrammed the image for the painting, it obviously applies to it, too.

6. See "Dive Like a Swan. NYU diving coach Scott Donie, who won silver in the ten-meter platform dive at the '92 Olympics, explains how to hit the water with flair and precision," *New York Magazine,* Summer guide, July 4, 2005.

7. Ruth E. Fine and Nan Rosenthal, "Interview with Jasper Johns," in Nan Rosenthal and Ruth E. Fine, *The Drawings of Jasper Johns* [exh. cat., National Gallery of Art] (Washington, 1990), 74.

8. Paul Taylor, "Jasper Johns," *Interview* (July 1990), 100.

9. See David Sylvester, "Shots at a Moving Target," *Art in America* 85 (April 1997), 94.

10. Jeffrey Weiss points out that, while the right-hand side of *Diver* has the prototype of *False Start,* as do all works with the naming of colors and "abstract expressionist" brushstrokes, it is not a specific prototype in the way that *Device* is for the left side.

11. Philip Fisher makes this point generally of Johns' multipanel compositions in *Making and Effacing Art: Modern Art in a Culture of Museums* (New York, 1991), 62–64.

12. Fine and Rosenthal, "Interview," 1990, 74.

13. "The big mistake most people make is keeping their head down as they jump—if you do that, you'll tumble forward and hit the water with your back, making an embarrassing cracking sound." Donie, "Dive," 2005.

14. Sylvester, "Shots," 1997, 95, suggests that these upper hands "look like tribal ritual objects," which gives them a volume as well as a density that they would not otherwise possess.

15. The artist could have been in the drawing—or, perhaps, between it, before the parts were combined—in order to make the palm prints. And he could have made the footprints from a vertical position by using casts of feet. But neither option alters our expected understanding of how they were made.

16. On the four ways of representing movement (the fourth, not used in *Diver,* is by depicting its side effects, say, sweat on a body after exercise), see John Hyman, *The Objective Eye; Color, Form, and Reality in the Theory of Art* (Chicago, 2006), 203–204.

17. Gotthold Ephraim Lessing, *Laocoön: An Essay on the Limits of Painting and Poetry,* Edward Allen McCormick, trans. (Baltimore, 1984).

18. Of course, all the marks in *Diver* may be thought of as representations of fabrication in addition to whatever else they may be thought to represent. However, not all may be thought (I argue, below) of as representations of the fabrication of *Diver,* and not all do represent something apart from their fabricating function.

19. Rosalind Krauss has observed that Johns' arm-and-palm device of semicircular smearing (referring, presumably, to works like *Periscope [Hart Crane]*), "has the uncanny effect of seeming to appear from underneath the surface as well," adding, "It is in this ambiguity that it images forth the experience of a body touching itself." She properly compares this to the "Study for Skin I–IV" set of drawings of 1962. See Rosalind Krauss, "Split Decision: Jasper Johns in Retrospect. Whole in Two," *Artforum* 35, no. 1 (September 1996), 81 (78–85). In the drawing *Diver,* the feet seem to stand on the sheet (and, besides, hands matter much more than feet in what Krauss asks us to consider), but her suggestion that hands seem to appear from underneath the surface may be inferred from the lower hands, but not from the upper ones, owing to their volumetric illusion (see note 14), which cause them (most evidently, the left one) to appear even on top of the surface. This may seem strange, yet it is important in helping to urge the interpretation that, when we imagine the arms folding in half downward, they do emboss the sheet at the base—rather in the way that *Memory Piece* (fig. 6) can literally emboss footprints in sand.

20. Notes by Karl Buchberg, paper conservator at the Museum of Modern Art, recording a conversation with the artist, Buchberg, John Elderfield, Gary Garrels, and Peter Perez in December 2003 on the materials, techniques, and desired framing of *Diver.* "Not an exact quote," Buchberg says, adding: "JJ seems amused that the red drips are considered part of the medium."

21. Sylvester, "Shots," 1997, 95.

22. Quoted in Harold Rosenberg, *Barnett Newman* (New York, 1994), 21. This quotation was adopted by Joachim Pissarro as the headnote of the section of his discussion of John's catenary paintings entitled, "The self as an (empty) center of the universe." See "Jasper Johns's Bridge Paintings under Construction," in *Jasper Johns: New Paintings and Works on Paper* [exh. cat., San Francisco Museum of Modern Art] (San Francisco, 2000), 52. This description applies to *Diver.*

23. Sylvester, "Shots," 1997, 92.

24. Johns has been extremely eloquent on this subject: "I am concerned with a thing's not being what it was, with its becoming something other than what it is, with any moment in which one identifies a thing precisely, and with the slipping away of that moment, with at any moment seeing or saying and letting it go at that." Jasper Johns, interview with Gene R. Swenson, "What Is Pop Art? Part II," *ARTnews* 62, no. 10 (February 1964), 43.

25. Duchamp, of course, is said to have used the standard stoppages to create the painting *Network of Stoppages* of 1914 and then *The Bride Stripped Bare by Her Bachelors, Even,* 1915–1923.

26. Bryan Robertson and Tim Marlow, "The Private World of Jasper Johns," *Tate: The Art Magazine* 1 (Winter 1993), 47.

27. Hamilton, *Duchamp's Green Box*, 1960. In the same year that he completed *Diver,* Johns used a similar imprinting device using letters in his *Field Painting* (1963–1964, collection of the artist); he had done so earlier with *Liar* (1961, Gail and Tony Ganz), on which, see Leo Steinberg, "Jasper Johns: The First Seven Years of His Art," in his *Other Criteria* (New York, 1972), 17–19.

28. Sigmund Freud, "The 'Uncanny,'" in *Art and Literature: The Penguin Freud Library,* vol. 14 (Harmondsworth, 1990), 336–376, being a corrected reprint of the Standard Edition translation by Alix Strachey of "Das Unheimliche" of 1919.

29. The older symbol persisted, famously, in Pablo Picasso's *Guernica,* which Johns would have had to walk past in 1962 when we went to look at Cézanne's *Bather* (The Museum of Modern Art).

30. I quote this after Bernstein, *Johns,* 1985, 109. Extended discussions of Johns and Hart Crane appear in Fred Orton, *Figuring Jasper Johns* (Cambridge, Mass., 1994), 73–77, and Pissarro, "The self," in *New Paintings,* 2000, 41–46.

31. William Empson, *Seven Types of Ambiguity* (1930; repr., New York, 1955), 217.

32. Paul Clements, "The Artist Speaks," *Museum and Arts* (May–June 1990), 81. So is "Diver" a pun (someone who dies as well as dives), in addition to offering an anagram that connotes energy?

33. These works are mentioned as a possible inspiration by Bernstein, *Johns,* 1985, 108. I agree, but as something to avoid doing, for the reason mentioned in the text.

34. The artist apparently thought of copying this work in gray at some time during the 1960s but abandoned the idea. Roberta Bernstein offers the provocative suggestion that the creation of *Diver* possibly replaced this unfulfilled project. See Roberta Bernstein, "Seeing a Thing Can Sometimes Trigger the Mind to Make Another Thing," in Kirk Varnedoe, *Jasper Johns: A Retrospective* [exh. cat., The Museum of Modern Art] (New York, 1996), 42 and notes 18–20.

35. See Lawrence Gowing, ed., *The Critical Writings of Adrian Stokes* (London, 1978), 3:303–342, especially 303–305. In this and later paragraphs, I also drawn upon the discussion of figural representation in my *The Language of the Body: Drawings by Pierre-Paul Prud'hon* (New York, 1996).

35. Krauss, "Split Decision," 1996, 80.

37. "JJ notes that the paper was once white and has discolored." Buchberg, Notes, 2003. Johns has speculated that the browning of the support may have been caused by nicotine (the work was unglazed in the many years it was in the collection of Victor and Sally Ganz); however, this cause seems less likely than that of discoloring fixative.

38. Michael Podro, "Depiction and the Golden Calf," in Norman Bryson, Michael Ann Holly, Kieth Moxley, eds., *Visual Theory: Painting and Interpretation* (Cambridge, 1991), 175, 188.

39. See the more detailed, and therefore precise, discussion of these issues in Whitney Davis, "Erotic Revision in Thomas Eakins's Narratives of Male Nudity," *Art History* 17, no. 3 (September 1994), 301–302; this account of another diving (but mainly swimming) painting, Eakins' great *The Swimming Hole,* c. 1883–1885 (Amon Carter Museum, Fort Worth), argues against approaches similar to mine for "not going back any distance in a subject's personal and social history" (page 304).

40. See Richard Field, "Chains of Meaning: Jasper Johns's Bridge Paintings," in *New Paintings,* 2000, 23. There, Field speaks of Johns' 1963 paintings as "very possibly" alluding to the artist's break with Robert Rauschenberg (on which subject, see note 40) and, categorically, that "what had begun as a formal device four years earlier [the "device" of *Device Circle*] became a carrier for ideas about suicide." This is a too constraining interpretation of both *Device Circle* and *Diver.*

41. Jonathan Katz, "Lovers and Divers: Interpictorial Dialog in the Work of Jasper Johns and Robert Rauschenberg," in *Frauen, Kunst, Wissenschaft* 25 (June 1998), 16–31.

42. Sylvester, "Shots," 1997, 93.

43. Picasso wrote this in a letter to Daniel Kahnweiler of spring 1912; see William Rubin, *Picasso and Portraiture* [exh. cat., The Museum of Modern Art] (New York, 1996), 35. That "Ma Jolie" is a personal term of affection may be inferred from the painting, unlike the fact that the phrase came from a popular song, on which, see Jeffrey Weiss, "Picasso, Collage, and the Music Hall," in Kirk Varnedoe and Adam Gopnik, eds., *High and Low: Modern Art and Popular Culture* [exh. cat., The Museum of Modern Art] (New York, 1990), 83.

44. *Diver* and its contemporaneous paintings of supposedly aqueous subjects have frequently been compared to other of Leonardo's works, his Deluge drawings, most extensively in Bernstein, "Seeing a Thing," in Varnedoe, *Retrospective,* 1996, 41–42 and notes 16 and 17. Bernstein points out that Johns had spoken of "Leonardo's idea ('Therefore, O painter, do not surround your body with lines…') that the boundary of a body is neither a part of the enclosed body nor a part of the surrounding atmosphere," in his *Sixteen Americans* statement of 1959 (see note 2). This is generally persuasive of the figural method of *Diver.* She additionally notes that the word "Deluge" appears in a sketchbook note of the early 1960s and that in 1967 a reproduction of one of the Deluge drawings was on his studio wall. Neither fact is conclusive, and when she points out that Johns actually saw the Deluge drawings in Windsor Castle in 1964, one suspects that the relationship to *Diver* of this particular admiration was as a consequence rather than a cause. In any event, it would be pressing a point to claim that it was a relationship of resemblance.

45. One of Johns' notebook remarks of the 1960s reads: "A Dead man. Take a Skull. Cover it with paint, Rub it against canvas. Skull against canvas." Bernstein, *Johns,* 1985, 111, following John Cage, "Jasper Johns: Stories and Ideas," in *A Year from Monday: New Lectures and Writings* (Middletown, Conn., 1969), 74.

46. Johns, Statement, in *Sixteen Americans,* 1959, 22.

47. Johns' use of this image and its precise source are discussed in Bernstein, "Seeing a Thing," in Varnedoe, *Retrospective,* 1996, 55 and note 87.

48. Sylvester, "Shots," 1997, 95; Sylvester, conversation with the author, 1998.

49. Varnedoe, *Retrospective,* 1996, 119.

50. Ganz, conversation with the author, 2003.

51. The artist does allow that "because works of painting tend to share many aspects, working itself may initiate memories of other works. Naming or painting these ghosts sometimes seems a way to stop their nagging." Quoted in Richard Francis, *Jasper Johns* (New York, 1984), 98.

52. See Scott Rothkopf, "Suspended Animation," in *Jasper Johns Catenary* [exh. cat., Matthew Marks Gallery] (New York, 2005), 6 and note 9.

53. Christopher Ricks, *Dylan's Vision of Sin* (New York, 2004), 7–8. Like Johns, Bob Dylan assembles fragments, disconnected from an immense pool of existing verses, into new, strange combinations, expressive of displacement.

54. Rothkopf, "Suspended Animation," in *Catenary,* 2005, 6.

55. Rothkopf, "Suspended Animation," in *Catenary,* 2005, 6 and note 9.

56. Varnedoe, *Retrospective,* 1996, 119.

57. Steinberg wrote in 1962 that "all of Johns's early pictures, in the passivity of their subjects and their slow lasting through time, imply a perpetual waiting…But it is a waiting for nothing, since the objects, as Johns presents them, acknowledge no living presence." See Steinberg, *Other Criteria,* 1972, 54. From the year after he wrote, the proposition remained true but the rider did not.

58. Sylvester, "Shots," 1997, 92, quoting a 1965 interview with the artist.

59. Vivien Raynor, "Jasper Johns: 'I have attempted to develop my thinking in such a way that the work I've done is not me,'" *ARTnews* 72, no. 3 (March 1973), 22.

60. Johns, "Duchamp," 1968, 6. See John Coplans' interview with Jasper Johns, "Fragments According to Johns," *Print Collector's Newsletter* (May–June 1972), 30–31, for Johns' recycling of the works by Duchamp referred to in the last two sentences of his statement.

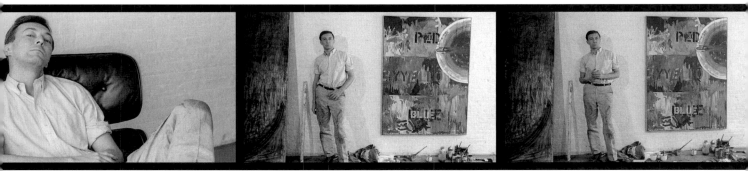

Jasper Johns: The First Decade

Robert Morris

Half a century ago a recently discharged, young army veteran began his cultural assaults. In a decade-long campaign he raised the *Flag*, dared them to fire at his *Target, Numbered* the prisoners taken o *through 9*, *Mapped* out a strategy, and *Dived* from a height heretofore not attempted.

Much has changed since Johns produced these works just after midcentury. America was then not only a guaranteed safe place with a middle class, but also lender to the world. Recently we have become unsafe, debt ridden, and absent a middle class. Since 9/11 we have become an unapologetically imperialistic and militaristic nation squandering its treasure on war while waiting for the next disaster to be played and replayed as the spectacle of entertainment on TV. America is anxious, insecure, self-righteous, and dangerous, with an ever shorter fuse and attention span.

America's large museums have also changed by becoming virtually unrecognizable from the introverted, mostly empty, silent places they were at midcentury. Those somber spaces that sat halfway between church and bank have given way to new architectural pleasure palaces — recalling the movie palace extravaganzas of the 1920s — in which "gee whiz" art of the spectacle replaces sober masterpieces. But the museums only reflect the culture at large, which is a culture of spectacle. Fun is serious business, and no museum can ignore serving up the entertainment that will pull in a paying crowd.

We have always wanted art to intrigue us with its physical achievements and tell us about itself. We want to be seduced by its wiles and graces. But we also look to art to tell us about our culture and ourselves. The better art always tells us about those aspects that are not apparent or easy to accept. Lesser art speaks to what we already know.

Modernism, with its claims of autonomy, valorization of the heroic, and utopian sentiments, seemed to want to deny Elizabeth Bishop's remark that the twentieth was "the worst century so far."[1] Likewise, modernism wanted to prove wrong Max Weber's idea that modernity had disenchanted the world. By midcentury modernism was dead (largely euthanized by Johns in the plastic arts) and the disaster of the twentieth century could no longer be denied. But neither could it be easily accepted. That culture has turned toward the distractions of spectacle is proof enough of this denial. Anything not to face a failure so vast as to be unthinkable. Today demographic, political, economic, social, and ecological areas are out of control and there are no answers available to rescue the world for us. After the cold war was won, the market and technology were deified by the West. It is now clear that these were false gods. The demand for the right to entertainment, perhaps the patron saint of this dual divinity, drives toward ever larger, more relentless, and ubiquitous stagings of spectacles of distraction from the coming disasters. Large museum shows have for some time very often been in the service of the hysteria of the spectacular. What then can this exhibition of quiet, unspectacular paintings just this side of the grim deliver to museumgoers today?

I want to argue that some of these works from 1955 to 1959 held a proleptic edge, and today we can see in them a beacon from the horizon of the past. Perhaps these works were more profoundly pessimistic than they seemed at the time they appeared. Targets, numbers, flags, maps: icons always hoisted amid the clank and grind of gearing up for the enemy, anticipating the coming shock and awe. Whether red stars

or crescents fly on the flags above the trenches, the targeting of the other was always a targeting of just numbers. Trying hopelessly and absurdly to make the edges of our homeland map safe in the face of the imagined threat — all this was better than facing what could not be solved. Johns' works of 1955 to 1961 stand as a painful reminder of what we have done and have not done in the half century that followed their creation. How better to be reminded of our collective failure than by such gracious signs? And if we can take this, then there is also — as might be expected from work that is also always something else — that breathtaking ride of complexity, intricate thought, and aesthetic glory that the works deliver.

An overarching allegory of art as of and from the body haunts all the work, regardless of its formal or structural dispositions, or apparent subject matter. And the subtheme is, in my opinion, the self-confined body's endurance of oppression or suffering. The obliqueness of the handling of this reference gives the work the subtle sense of the tragic that rises from it. If there are many European affinities in the work it is in the nature of this "tragic" aura that the artist is revealed as quintessentially American. The suffering of which the art speaks arises from isolation and loneliness. Only a massive, hermitic solipsism of the defended, vulnerable self could generate this kind of flat, gorgeous, airless space, where, generally, only icons of the already represented are permitted entry. A voluntary inner exile has been the fate of many American poets and artists, driving a number to the depths of not only their art. Herman Melville, Edgar Allan Poe, Albert Ryder, Delmore Schwartz, and Hart Crane were but a few.

The world and its disturbing evils has for Johns always been *Out the Window,* and that window is never raised. If Johns sensed what was outside in his early exposure to the military, the window was closed tightly by the end of the 1950s, and the *Shade* lowered. Knowing even indirectly about the European slaughter is enough to make most want to draw the shade. And no artist has better illuminated the somber pleasures of our isolated confinement in our innermost rooms, where we wait with and on the body, where flesh numbers its losses, where skin wears its memories, and where every mark is a solemn, careful counting toward our mortality.

Tell me who your enemy is and I'll tell you who you are.[2] *Carl Schmitt*

On May 25, 1951 Jasper Johns was drafted into the army. He was stationed for a year and a half at Fort Jackson, South Carolina, where he developed an art exhibition program for the soldiers. From December 1952 until May 1953, Johns was sent to Sendai, Japan. The military environment is characterized by the impersonal, the anonymous, and the insistently repetitious. Targets, flags, numbers, and maps form a ubiquitous set of iconic signs within the closed military environment. These icons constitute the subjects

of the paintings Johns made, beginning two years after his discharge from the army in May 1953. I don't think it is too much of a stretch to regard these works as allegories of revenge. Military life is at best regimented, demeaning, repetitive, stupefying, and alienating. Outside the chaos of battle the military environment is characterized by the rigidly hierarchic and symmetrical. The U. S. flag is seldom out of sight. Every button on the soldier's uniform must be fastened to maintain bilateral symmetry. The soldier is first and last a number. And military life is completely regulated by numbers. On the rifle range the target is raised, the soldier fires, and his score is denoted by a number that is hoisted in the place of the target. The soldier marches within a squad of bodies dressed in identical uniforms and rigidly aligned. Life in the barracks is strictly supervised and disciplined. Personal freedom of choice does not exist. Standing at rigid attention in a symmetrical field of unmoving bodies, the soldier shouts the anonymous "Yo!" in response to the roll call of his name. Sometimes he is required to shout his enlistment number as well. Johns' particular experience in the army — whether difficult or easy — is irrelevant. The culture of the military could not have been avoided. No, it is not too much of a stretch to see the depiction of the early Targets, Flags, Maps, and Numbers as allegories of revenge and, perhaps, redemption. It is doubtful that these works sprang from a conscious intention. But the intention of the artist is irrelevant. Art of any weight and significance rises from unconscious compulsions.

Zero through Ten

A single death is a tragedy, a million deaths is a statistic.[3] *Joseph Stalin*

Under organized power. Subject to tremendous controls. In a condition caused by mechanization…In a society that was no community and devalued the person. Owing to the multiplied power of numbers which made the self negligible.[4]
Saul Bellow, Herzog

1. Figures, 1955

In 1955 Johns painted some Figures. Each canvas limned a number from zero to nine (fig. 1). Each is roughly 17 by 14 inches. Each depicted figure is more or less the same size, fills most of the rectangle, and is of the same, standard serif typeface. A thin black outline distinguishes each number, or figure, from its field or ground. Collaged newspaper is visible beneath the brushy encaustic white paint. The entire surface from edge to edge, as well as running beneath the outlined figure, is rendered in collage and white wax. Let us read this family of signs — these standardized and anonymous icons of quantity, these crisp yet somehow shabby figures, each so lovingly rendered in a wistful haze of unreadable, mute text and sensuous, translucent white wax — as punning metaphors for the human figure. Figures as figure. Each so alike, yet different. Allegorical portraits of the anonymous dogface soldier. Maybe. But the "messy" beauty of the brushwork and diaphanous collage of surface does more than undermine the spit and polish of the compulsive, oppressive, minimal military aesthetic.

1. Jasper Johns,
Figure 5, 1955, Collection
of the artist

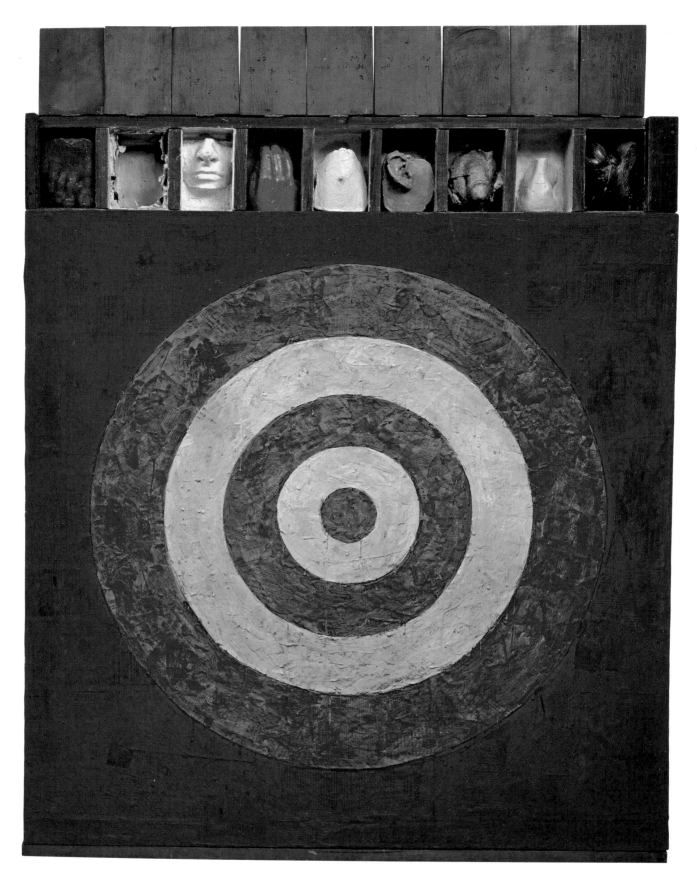

2. *Target with Plaster Casts* (cat. 1)

Nothing is ever simple, immediate, singular, straightforward, innocent, undisguised, or undisplaced in Johns' early work. Logic is always burdened with contradiction, language and image remain adversarial, puns abound, origins are hidden, ambivalence reigns, and the allegorical is seldom out of sight. Simplicity of image never equates with simplicity of experience. Revenge lies locked in an embrace with redemption. If one were to search for a law governing these early works it might be this: "Everything is really something else."[5] The art in the Figures displaces the image from its origin in revenge. Redemption of the bloodless, singular "figure" is achieved by the *aufhebung* of converting revenge into pathos. The thick, waxy, clotted, translucent white paint running down the surface of these works is of course encaustic. But what are we to make of the resemblance here to semen running down a newspaper? The aestheticized surface functions as a decoy, a disguising delay that ever so slowly refocuses itself as an act of witnessing on the part of the artist. Eventually it dawns on us that the artist has seen for us, felt for us, redeemed for us, the dehumanizing of human numbering. But the cost of the original dehumanizing is never forgotten in the work of Johns — where, if there is pathos, there is never sympathy — and it haunts all the early works based on the diagrammatic icons of flag, target, number, and map.

Existence is terrifying[6] *Paul Cézanne*

2. Target with Plaster Casts, 1955

To reiterate the place that the early works of Johns hold in that narrative of the collapse of modernism is to trivialize and officialize them, allowing their contradictions, complexities, and origins to slip away. The more familiar the works are allowed to become, the less we need to face the morality that underlies them. If the dehumanized saturates the military emblems of the flag and target, the diagrammaticism of the numbers and the maps extends further Johns' investigation into the field of alienated signs, which forms the dehumanizing language of the military.

Heraclites was right, war is the father of everything. All I know I learned in the army.[7] *Joseph Beuys*

Shoot the foot, the face, the breast, the ear, the genitals, the heel, or the bull's-eye: the large Target (fig. 2) of 1955 offered a choice (even the bull himself was offered metonymically via a beef bone in the last box on the right). Looking is conflated with a .30-caliber weapon. Military life flattens and confines the body, controls it and puts the body in boxes. Desire is objectified, regimented, fragmented, compartmentalized. Get drunk on payday, fuck on Saturday, shoot a Gook on Monday. Everything in its box. And if you failed inspection on Tuesday, you got to sleep with your M1 rifle for the rest of the week.

But out there in civilian life the abstract expressionists were dripping paint, throwing paint, screaming paint, and Clem Greenberg was telling them they were macho geniuses. Out there in civilian life subjectivities were untucked and it was hard to tell who had the biggest one. A kind of American adolescent male athleticism was in place, and only the really big sweat-soaked canvas counted. Of all the twentieth-century American artists, Johns has been the least American (the flag notwithstanding). Here was an aesthetic subversive who would temper his innate suspicious mistrust and a grim, arrogant, detached derisiveness with redemptive loving care. Here was a skeptic who took back any large gesture and covered it with an embroidery of doubt. Here was a sensibility with an itch for mockery that would not be denied.

Here was the predatory, remorseless aesthetic of a compassionless, dead-eyed art sniper who "targeted" the cant in big-time American art. But a deeper, more subtle revenge is delivered by the Target paintings. They stand as a mockery of the notion of focus itself. The kind of vision the target invites, focused and conscious, will always deliver the fragmented, the partial thing in its box. The targets impugn conscious thought itself insofar as the "targeted," what one consciously focuses on, is a kind of tunnel vision condemned to miss the whole.

The Targets speak to a deep given in the culture — that sacred tenet of capitalism — competition. Winning, the best score, hitting the bull's-eye, getting the prize, defeating the other, being the best, etc., etc. And for the consequences of this first rule of American freedom, open the boxes above the target.

3. White Flag, 1955

Why so large? Almost 7 by 10 feet. The size of the Old Glories I remember tacked up in the mess halls. A ballsy, intimidating, military size, and "bigger than you, soldier." It was up there watching you and demanded a salute. But cut one in two places and let the blood colors of red and blue drain out. Make it a big cut. Not exactly that "Y" cut of the autopsy. Not exactly. Dead flag. Cut and drained and stuck back together with the scar showing. A big, anemic, dead sign. A bloodless sign. Yet a sign resurrected as flesh. Dead flesh perhaps. An embalmed flesh of the sign. A white, waxy necrophilia for the autopsied remains. A murderous aesthetic act and a caressing mummification of the corpse wrapped in white, waxed strips, or stripes. Revenge taken. Resurrection delivered. The redeemed corpse as a trinity of dissected and reassembled parts. Transfiguration of the oppressive, dominating sign by transgressive encaustic bleaching. Encaustic, the medium of second-century tomb décor. Nothing but the finest funerary accouterments for that patriotic shroud which has wrapped so many public scoundrels. The large *White Flag*, ghost banner of countless, officially sanctioned criminal acts. But flattened, bled white by Johns, and filed away as flat forensic evidence. No wonder Johns kept this work (fig. 3) so long for himself.

4. 0 through 9, 1960

The outline of one number on top of the next, superimposed (confined?) in a space 29 by 23 inches. Drawn in charcoal on white paper (fig. 4). A few smudges, but on the whole fairly neatly executed. Each number skillfully drawn freehand. At first glance the "3" snaps into focus, then the "4." The rest take longer to extract. A collapsing of quantitative signs, an implosion of the numerical, counting compressed to a single point in time and space. An endless, repetitive rush of the act of dividing done at warp speed. Zeno's paradox. In some ways this can be seen as a pendant to Marcel Duchamp's *3 Stoppages Étalon* (see page 190, fig. 1) of 1913–1914. Duchamp's use of chance to point up the absurdity of standards of measurement is echoed by Johns (whose early works are almost all "assisted readymades") in *0 through 9*, when he applies a vacuum to suck out the space that is assumed to be needed to enumerate anything. But the pessimism that lies below *0 through 9* goes much deeper. The suggestion that numbers imply an infinite sublime is inverted and canceled in this work. The very process of enumerating the series shuts down the action. At a deeper level *0 through 9* is an allegory of foreclosure, stasis, ending — a counting toward death.

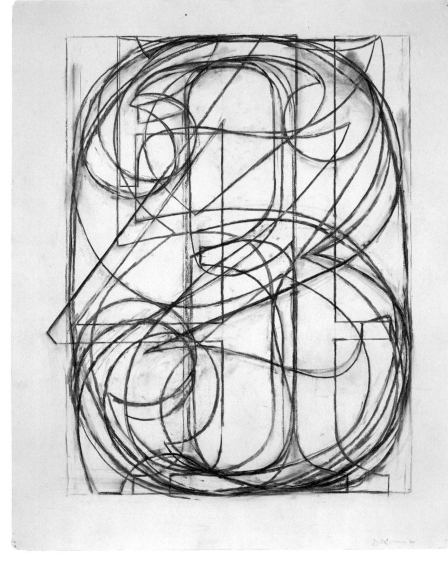

3. Jasper Johns, *White Flag,* 1955, The Metropolitan Museum of Art, New York, Purchase, Gift, and Funds from various donors (see page 273)

4. Jasper Johns, *0 through 9,* 1960, Collection of the artist

5. Jasper Johns,
Gray Alphabets, 1956,
The Menil Collection,
Houston

6. Jasper Johns,
White Numbers, 1958,
Museum Ludwig,
Cologne

7. Jasper Johns,
Map, 1961, The Museum
of Modern Art, New
York, Gift of Mr. and Mrs.
Robert C. Scull

But how can a rule show me what I have to do at *this* point? Whatever I do is, on some interpretation, in accord with the rule.[8]

Is what I call "obeying a rule" something that would be possible for only *one* man to do, and only *once* in his life?[9]

Ludwig Wittgenstein

After some thought he [Albert Speer] hit on the idea of covering the distance from Berlin to Heidelberg by walking around the garden—four hundred miles as he calculated. As he had no tape-measure, he marked out the path by shoe-lengths. It came to 870 units, which he multiplied by the twelve inches of a shoe, concluding that one circuit would equal roughly 295 yards. Then he fixed an approximate daily route, and after four weeks recorded that he had covered 149 miles.[10] *Joachim Fest*

5. Gray Alphabets, 1956

6. White Numbers, 1958

These paintings (figs. 5, 6) allow for a lateral, two-dimensional space that is denied in the later *0 through 9*. Once the units — whether running across a two-dimensional space (*Gray Alphabets, White Numbers*) or collapsed into a temporal superimposition (*0 through 9*) — are run through, the work finishes itself by exhausting the sequence. What the three works share is a logical structural device, which might be described one way as an entropic rule for exhaustion. Another way to describe it is as a self-enclosed and self-completing mechanism, or as an a priori, spring-loaded algorithm or rule for sequences, which nullifies the freedom for certain aesthetic decisions. Part of the pathos of these works issues from that march of patient, encaustic marks across and within the imprisonment of the device.[11] Johns' focus on the ordinary iconic signs of numbers, flags, targets, and maps as subjects for art carries more than aesthetic significance. A morality of resistance is implied in taking on these signs, which, if so apparently ordinary, are also freighted with connotations of domination. For in mass society numbers are not innocent. Neither is the nationalism implicitly signified by flag and map. And targets are of course in the service of weaponry. The de-familiarization of these signs through the frame of art can be read as an oblique rhetoric of resistance that is also a form of redemption.

7. Map, 1961 (with a note on Device Circle, 1959)

The gestalt singularity of flags, targets, and numbers is missing in the map imagery (fig. 7). Space in the sense of an implied figure/ground opposition, and the arbitrary designations of state boundaries in the U. S. map don't hold the image. There seems to be a special anxiety evident in the somewhat hysterical brushwork that delineates and obliterates the boundaries in these works.

Johns' work is especially powerful when he employs the mnemonic, public, gestalt image that he can then haunt with a brushwork that never violates the inner divisions. The earlier *Device Circle* (cat. 28), 1959, which literalizes the inscribing compass and hints at the coming of indexical signs, is attacked with a riot of paint, the excesses of which never endanger the loss of the gestalt. Perhaps because of this security, as well as the lack of a "public" tension-making sign to work against, *Device Circle* seems too self-consciously devicelike and finally too didactic. The Flag, Numbers, and Target works are powerfully mnemonic signs against which the pathos of the art can press.

There is something of the folk-art sampler in those works in which the image coincides with the physical limit of the painted object. Patchwork quilts that respect the interior divisions of stripes and bands, stars and numbers, are distant relatives of that family of a priori images that Johns embroidered with the wistful delicacy of newspaper and collage. That and the use of the mechanical instruments of ruler, compass, and stencil, which eschew the "creative" mark and lend a further pathos to this family of early works in which the artist abdicates the skill of drawing to merely "copy" given public signs. And this cool, insouciant reticence is of course the strategic Trojan horse with which Johns invades and decimates the fervid existential pretentiousness of originality in American art in the 1950s.

8. Tennyson, 1958

Be near me when my faith is dry,

 And men the flies of latter spring,

 That lay their eggs, and sting and sing

And weave their pretty cells and die.[12]

Monochrome gray, about 6 by 4 feet (fig. 8). Two vertical panels covered with an unstretched piece of canvas starting about one-fifth of the way down and ending before the bottom edge, where it terminates just above the name TENNYSON. This large, loosely attached patch of canvas does not quite reach the edges. It is like a cover, or a shade drawn (the use of an actual window shade would appear a year later). This seems to be an early instance of a word interrupting the image of a painting in Johns' work. *Diver* comes five years later, citing the second poet, Hart Crane, in dedication rather than the label, which names the act rather than the man. A faint vertical line appears on the left side of this "shade" in *Tennyson* and runs across the bottom edge. Part of a canvas ripped from its stretcher bars? Second thoughts about what is under this shade? This seems to be one of the first works Johns made that abandoned the a priori given of both internal divisions and external limits. It is not a work that copies a given scheme as do the maps, flags, targets, and numbers. Yet *Tennyson* maintains a strict bilateral symmetry. The expected newspaper collage beneath the wax is abandoned and the embroidery of gray encaustic is laid on in a subdued, almost mechanical way. We could be looking at a badly painted wall, except for clues that emerge from the bottom edge where a few inches of nearly bare canvas show spatters of color, which lend credibility to the speculation that the large shade covers and suppresses a previous, more colorful effort. We seem to be looking not so much at a salvaged mistake as at a subdued and suppressed first impulse. Tennyson always said too much in too heated and lyrical a way. But those overheated, romantic scenes of Camelot, where the Lady of Shalott is confined and condemned to see the world through a mirror on pain of death, must be set aside for now, covered over. Her corpse and mirror will not be forgotten. Johns will revisit them a couple of decades later. But here, in this work, naming for the first time not only asserts itself as invasive equivalent of the image, but becomes image itself. The slightly earlier *Tango* (fig. 9) of 1955 does of course place the name clearly in the upper left corner of this monochrome blue picture, which also contains a music box hidden behind the canvas and a key located near the lower right side to do the winding. Duchamp's object entitled *Hidden Noise* (fig. 10) is the obvious reference. But neither word nor implied sound seems to come together here to rescue this work from a rather inert monochrome image. (The convention of looking at paintings rather than touching them would seem to override Johns' stated intention that went something like this: the invitation to turn the key

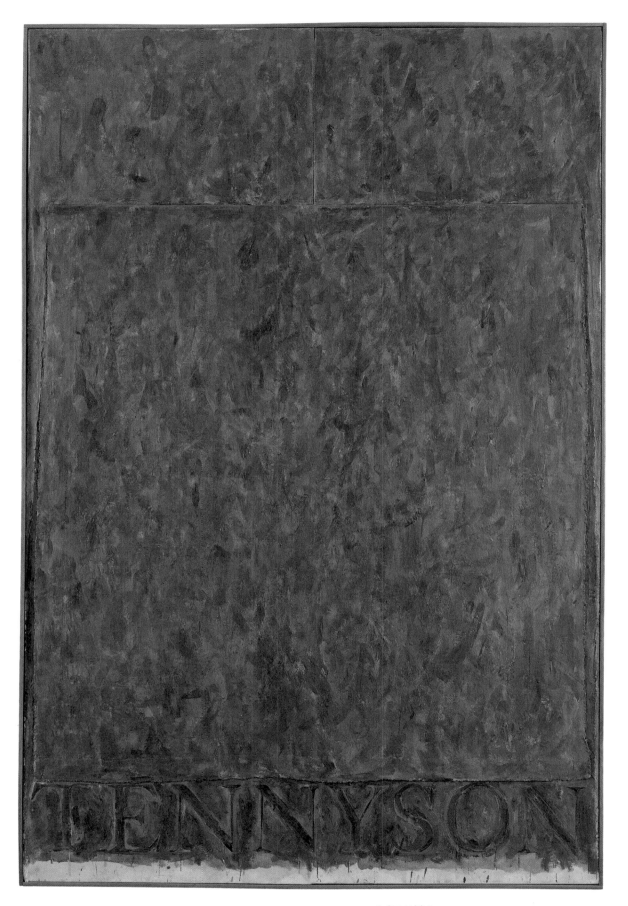

8. Jasper Johns, *Tennyson,* 1958, Des Moines Art Center, Nathan Emory Coffin Collection, Purchased with funds from the Coffin Fine Arts Trust

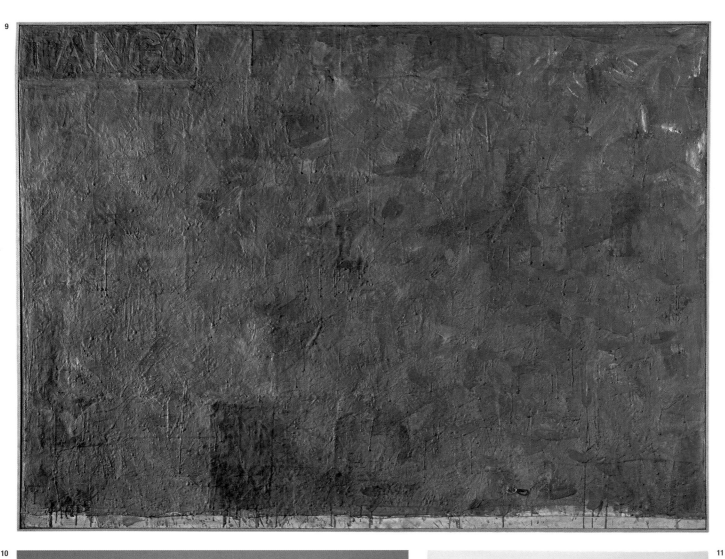

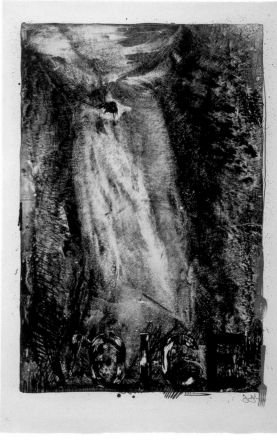

9. Jasper Johns, *Tango,* 1955, Museum Ludwig, Cologne

10. Marcel Duchamp, *With Hidden Noise,* 1916, Philadelphia Museum of Art, The Louise and Walter Arensberg Collection, 1950

11. Jasper Johns, *Voice,* 1966–1967, National Gallery of Art, Washington, Gift of Lionel C. and Elizabeth P.S. Epstein

protruding from the surface would induce a kind of close-up looking into the surface or field of the work and then the limiting edges of the picture would disappear).[13] In *Tennyson* the linguistic sign supports the entire weight of a visual mass above it. The large letters can put an edge on a painted space, as well as lend tension to the word itself, which it otherwise would not possess as modest script.[14] But what does "Tennyson" name in this work? The poet? the poetry? or both? If we follow the American philosopher Saul Kripke's argument that, contrary to Bertrand Russell's claim, proper names are not descriptions but "rigid designators" that hold true in "all possible worlds," and trace back through time to their original referent, then perhaps Tennyson sleeps somewhere beneath the shroud of gray shade in this work. We might theorize this, but bearing in mind again Kripke when he said he had no theories, because if he did they would be like all theories, wrong.[15]

9. Voice, 1966–1967

This is one of the most mysterious and un-device-like of all of Johns' early works. Actually it slips just beyond the wire of the first decade, which runs from 1955 to 1965. I refer not to the painting (cat. 91) of 1964–1967 but to the 48 ¼ by 31 ¼ inch black-and-white lithograph (fig. 11) of 1966–1967. As in the earlier *Tennyson,* the word of the title runs prominently across the bottom of the image. The surface seems smudged or scraped with the swath of a lighter form cascading down and across the darker areas. But the entire surface is mottled and there are no distinct linear divisions in the work, except for the letters of the word VOICE at the bottom edge. No representation of an image seems to emerge from what appears to be an abstract design in black and white — until one stares for a while at the work. Then I begin to see an endless assembling, dissolving, and reassembling of monstrous faces, not unlike what emerges from staring at the surfaces of Goya's Black Paintings. I would not argue that this imagery was intentional, anymore than I would argue that the swath of a lighter form was a kind of synesthetic visual equivalent of the interior of the throat, but it feels like a throat/voice. It is not a representation but a kind of subjective mapping of the body's interior, as if the imagery of the Skin works, in which the body, pressing and distorting against the surface of the page as though it were a sheet of glass, has given way and we now have access to what is within the epidermis of the body, and have passed into the interior passages of the vocal chamber itself, where we find ourselves within the very stream and origin of the linguistic. Although it may not be language we feel rushing around us, for we may be within the voicing of the artist himself, hearing what we have always heard from him — a quiet melancholy humming. *Voice* does and does not sing the song the abandoned child sings to keep up his courage in the face of the monstrous that hovers nearby. Along with *Diver* and *Tennyson,* the work looks inward and to the past, turning its back on the exterior, public themes of flags, maps, targets, and numbers.

10. Diver, 1962–1963

An object that tells of the loss, destruction, disappearance of objects. Does it speak of itself. Tells of others. Will it include them?[16] *Jasper Johns*

This work has its roots in the earlier *0 through 9*, 1960. These roots are not imagistic but temporal. Roots in time that have collapsed, in the dense moment when an action is run through in a flash of time, leaving an indexical sign of good-by. The "figures/figure" of *0 through 9* has transited to an elsewhere in *Diver* (cat. 66). But that quintet composed of Target, Flag, Numbers, 0 through 9, Diver forms a family of related signs. Of the five, Target vibrates with a threatening imminence awaiting the violence of an impending impact. But Diver exists in the space of the immediately past instant, after an irreversible action has left its indexical trace. Nevertheless this family of signs, related at some deep, irrepressible genetic level by the innate trait of revenge — which can be admitted into the light only with the promise of redemption — bears the family resemblance of the disenfranchised and the alienated, surrounded by a hovering absence of either before or after.

Diver is the only work in which Johns maps the extension of the fully unfurled body. Johns is himself a large man, and the reach and movement indicated by the indexical signs of hands and feet seem to loom enormous here. The traces of a body just unfurled are all the more emphasized by the boardlike tracks and radial marks of feet and hands, which are laid out in bilateral symmetry and seem to indicate the terminations of the extended body. Yet in spite of the sense of a body having just previously occupied the space — where it paused to address the void and make a sweeping gesture before disappearing into oblivion — we cannot resolve these indexical tracks into any prior logical bodily coherence. Some extended set of symmetrical bodily motions does seem to have just occurred and the indications of limits made by the radial swing of arms and hands resonate with Leonardo's *Vitruvian Man* (see page 200, fig. 10).

Diver — the one time the artist permits the full gesture of the expanded body suggesting wholeness — is dedicated to the suicide of Hart Crane. Pessimism and the self-punitive will cancel any moment of bodily joy, and the artist will never again allow the implication of a full bodily presence through an indexical sign.[17]

In other works of 1963, an arm and hand swing through an arc in imitation of the mechanical *Device Circle*,[18] and in still other works we can look through the invisible glass into the face and hands as in the Skin works of 1962,[19] but the whole body perishes in the dive with Hart Crane.

A diver stands poised between earth and water. If Johns appeared to be standing on the firm ground of hard public signs in the first years of his production, his skepticism and mockery of this public space was apparent from the beginning. And as early as 1955 the liquid blue depths of *Tango* announces the nearness of the shoreline of the subjective. *Diver*, 1962–1963, limns the pivot from the former to the latter as an allegory of farewell to the public, external world. The drawing generates a wake formed by the plunge into the terrors of the self. If the world is as hard as targets, flags, numbers, and maps picture it, the risk of a downward voyage into a shaded interior is the other perilous option. Up above, the public space is a vicious, implacable, unforgiving, intolerant, self-righteous, hypocritical, fickle space, lit by a shadowless, accusatory glare. Take the plunge downward out of the light. Take the risk, death wish and all.

Or was this work based on military calisthenics, say the "side straddle hop," and just later given the sexy dedication linking it to the poet? It would not be too much of a stretch to posit both, given the artist's perverse and hidden humor. There are many decoys in Johns' work set up to shunt us away from his profound vulnerability, which will reveal itself only at the last minute, by which time he has fled. For *Diver* also says, "You are too late. I have gone before you had the chance to fail me."

Seven of the works examined in some detail here are informed by and preoccupied with the structuring "device." Such devices as the public signs of flag, target, and map constrain the image and deliver a limit as whole images more or less coincident with the limit of the painting.[20] The repetitive use of the numbers one to nine, as well as the alphabet paintings, forecloses the works in slightly different ways. *Diver, Tennyson,* and *Voice,* while unconstrained by the limiting device, nevertheless seem to be even more deeply introverted works of melancholy and mourning. Never was a body of work further from modernist utopian impulses to "re-enchant the world." What redemption this art achieves is wrenched from its losses, losses made bearable in the ten works we have lingered over here by a mourning that forgets and forgives nothing.

Seven of the works discussed above remain today as the proleptic and admonitory conundrums they were half a century ago. They alluded then, among many other things, to a chilling spiritual, moral, and political bleakness hovering on the horizon. Standing as we do now in the midst of such an achieved bleakness, do we see these works differently? Certainly we read these early works from a much darker place, and we should be aware of how our present condition shades our outlook.

Counting Marks

The early Johns is to marking as Descartes was to thinking. Descartes' doubt brought him to the undeniable idea of himself thinking and therefore existing. Johns' skepticism brings him to confront the repetitive stroke of marking as the digitized body. Ten fingers connect us to the world. The numbers 0 through 9 are not only metaphors for the "figure." They are in the hands of Johns the recursive affirmation of hands counting and being in the world, but at the same time they are displaced from the anthropomorphic image. Later, in 1963, Johns makes a lithograph of his two hands in which all ten fingers are clearly readable. Perhaps he does this to mark the ground with a clue? I count therefore I am. We are digitized beings incapable of not dividing the world with our fingers. Johns' reduction of the body moving as a digital marker delivers simultaneously the pathos and accusation of how we inescapably divide and reduce the world by counting it. But as Johns knew, numbers count. And in his hands, hands count with a vengeance. That the first few, special Figures of 1955, which resisted serial completion, become the Numbers of the serial sequences beginning two years later is already a narrative of pathos.

Johns' early meditation on Figures and then Numbers recalls us to Edmund Husserl's early phenomenological thought in which "the concept of plurality, for example, was explained in terms of our mental act of combining different contents of consciousness into one representation, of, for example, seeing distinct people as a single group."[21] Johns inverts and deconstructs this plurality in the Figures, reinvesting the plural name of the counted (a "3," "5," "7," etc.) as metaphor for a single "figure" that, in all of its physical particularity, still remains anonymous.

In the early Figure works Johns' skepticism finally delivers that ecstatic leap from doubt to the "Eureka!" of insight, undeniable newness, and a fresh beginning. His rejection of what counted in the past as art demanded a radical deflationary stripping and discarding of certain premises deemed necessary for art to occur at all. Johns delivers the coup de grace to the already tottering dragon of modernism and its fire-breathing, transcendent attempts at enchantment. On this lumpy, still febrile corpse, Johns raises his flat *Flag* and begins *Numbering* the dragon's last breaths. When the smoke starts to clear, one looks down to see the world of the ordinary, so sinister and so intimate, looking back from his art.

Johns' phenomenological meditation bridges thought and the body. The Figures show a necessary connection between the body and thought, anchoring thought to the counting body. And here it is the body that counts in both senses. This digital, Cartesian meditation is first embodied in the sensuous metaphor of figure as figural "4" or "7" or "5," etc., but not in sequence or completed as a 0 through 9 series. There is something of the vulnerability of lament or mourning, as well as defiance, in preserving the intense particularity of only a few Figures in the face of that generality personified by the mathematical infinity of numbers. But it is characteristic of Johns' sensibility that he will not allow this element of pathos without soon mocking it by letting the series go, submerging the Figures of 1955 into the march of sequential, anonymous Numbers, which begin in 1957. "Count off!" shouts the drill sergeant and the ranked soldiers yell out their numbers in sequence (excepting zero).

Thought is not colored. Color adds nothing to thought. Thought is black, white, and gray. Infinity may be gray. Why add color to numbers? Color in Johns, one might think, is not so much a weakness as an irrelevance. Then why is it there? It is not immediately apparent. Perhaps it is an additional form of enumeration. Red, yellow, blue are often named in the early works, such as *False Start* (cat. 30), 1959, as well as applied to the surface. But as someone remarked about the movies, the old black and whites are more powerful and even more realistic than the later Technicolor. The white encaustic Figures and *Flag* have, like every instance of white, all the colors already. In his early works, Johns is essentially a graphic artist of thought. (Color in the first Targets and Flags is simply a given that arrives with the image.) And throughout his long, subsequent meditation on figures and numbers, the black and white work remains the more arresting. And this is partly because light, as well as dark, opens to the world of thought by allegorical implication — the penumbra of black and gray opening to the white light of illumination. Color is given to the lower world as compensation for the absence of the light of illumination.

The large black-and-white drawing *0 through 9* (fig. 12) of 1961 conveys a pathos through its majestic modulation of dark and light, line and shadow, rubbed and incised surfaces, multiple and contrapuntal edges that move from crisp to soft to the glint of the erased white line. All this stands mocked in the heavy-handed, clotted, colored Figures of 1959. But this illustrates the second rule in Johns' work: for every instance of the exquisite flight of the aesthetic, there is an equal and opposite instance of the mocking and self-consciously crude. The corollary is to let color do the grunt work of self-mockery. *Figure 0* (fig. 13), 1959, is a perfect example of the way color, and its heavy-handed application, is a hostile pendant to the graphic instances of the same subjects. Although in this particular case, *Figure 0*, 1959, predates the large graphic *0 through 9* of 1961. Here the dynamic of exquisite/crude runs the other way, in which case we could invoke the notion of the redemptive. Here strategic color in a "loaded" brush is used to "execute" these Figures. It is a weapon, as well as a shield, against the vulnerability of the intimate, exquisite, undefended, black-and-white thought-mark. Or maybe John Locke was right after all: color is only a secondary quality. It is not until gray is called in to subdue color in a work like *By the Sea* (cat. 40), 1961, that color is allowed to speak with any sensibility in the work. In works he completed in his first phase Johns often set color loose like a pit bull to maul his ideas, which like Minerva's Owl — to mix the metaphors and invoke Hegel's mascot of philosophical thought — takes flight only in the grayed, colorless dusk of black, white, and especially gray, after the colorful tumult of the day has died down. This brings us to the third Johnsian law, and to its corollary: everything springs from the penumbra of the hidden, and all tracks and origins will be covered — almost.

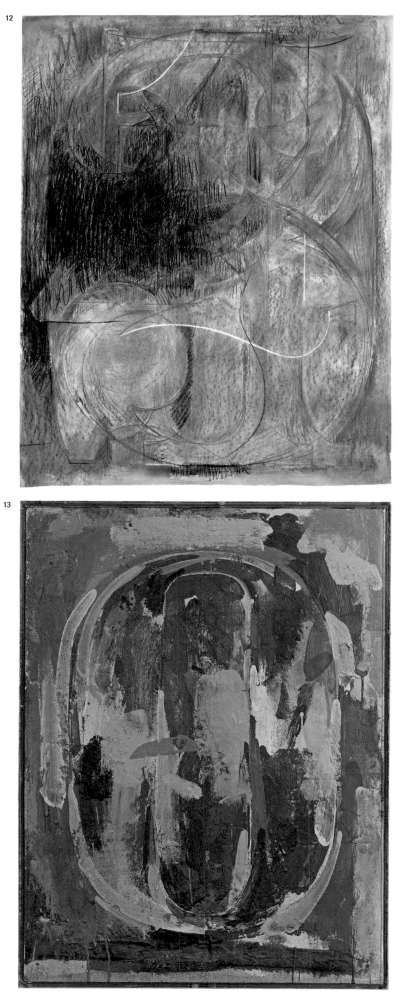

12. Jasper Johns, *0 through 9*, 1961, Private collection

13. Jasper Johns, *Figure 0*, 1959, Ludwig Museum in Deutschherren-haus, Koblenz

Signs and Icons

The American philosopher Charles Sanders Peirce believed that nothing escapes its destiny of appearing as a sign. Every percept is destined to precipitate into a propositional sign. Underlying his famous semiotic classification of types of signs as index, icon, and symbol was a tripart system of categories derived from the logic of relations. The predicate "This painting is red" is a one-place predicate. "No red painting respects the law" is dyadic, or two-place. And "The policeman gives the law to the red painting" is a three-place relation. Underlying this was a corresponding triadic phenomenological metaphysics of oneness or firstness as mere presence; secondness as brute actuality; and thirdness as a mediation and intelligibility to which Peirce assigned chance, law, and habit-taking.[22] Signs themselves are inescapably interactive. As Peirce put it:

> The whole purpose of a sign is that it should be interpreted in another sign and its whole purpose lies in the special character which it imparts to its interpretant. When a sign determines an interpretant of itself in another sign, it produces an effect external to itself.[23]

What was essentially new in Johns' early works in which the readymade signs of flags, targets, and numbers functioned as subjects for the art was the compression into triadic relations of "apparent" one-place predicates. "That is a flag" is a one-place predicate that is destabilized beneath the dyadic "is/is not a flag, but is also a painting," which is compressed into the triadic "This flag, which is/is not a flag, is also a painting and this changes our art expectations" — not to mention the multiple references these predications bring in their wake. The precedent here is Duchamp's readymades, which deflate art by means of utilitarian, apparently one-place predicate signs (snow shovels, urinal, bottle racks, etc.) forced into three-part predication of "is manufactured object/is also art/changes art." There may be more signs of this type that could have been adapted to painting than those "flat" ones of flags, numbers, and targets (the defect of the maps is that this sign was already inherently dyadic before its designation as art), but Johns found no others and was *forced* (I think the term is not too strong) rather quickly into beginning with the tertiary predication of "is a painting/is art/does not change art," which is already occurring in such works as *Jubilee* (cat. 35) and *Out the Window* (cat. 39), both of 1960. The bilateral symmetry of the early works (which closely follow the one-place signage of flags, targets, and figures) was probably an unconscious attempt to hold on to this compressive tension (here I refer to such works as *Tennyson, Shade, Thermometer, Painting with Two Balls*, and a number of others that conform to symmetrical layouts). Is there a diminution in those nonsymmetrical works that begin with the triadic predication of "this object/is (clearly) a painting/is like many others"? I think the answer is yes. It was as if some powerful muse (half Cartesian skeptic and half relentless, Hannibalesque warrior-general) disciplined and sustained the earliest work — work that issued out of doubt and was transmuted into the impersonal attack mode of revenge for about five years during which the compressive density of the work was at an almost unsustainable level.

The iconic sign is said to represent its object by resemblance or similarity. The definition is problematic. Some similarity can always be found between any two objects. On the other hand one identical twin does not represent the other.[24] Flags, targets, and maps fall under the problematic heading of iconic signs. Are such signs looked at but not really seen, perceived but not experienced? Johns forces his iconic signs to become flesh. Such embodied icons are eroded of their iconic status in Johns' oeuvre where seeing is always both reading and experiencing, and sometimes even identified with eating.

But what do we mean by the term "experience," and what do we mean by the term "perception"? And are some percepts experienced and others "read"? Does every act of perception imply a propositional attitude? Are signs read and not experienced? Or should all awareness fall under the term experience? The answers to these questions will vary depending on whether an empiricist or a rationalist is being asked. Pragmatist empiricism has long been identified with an American outlook. Postmodernism, first theorized in France, was dedicated to textualizing experience by a reduction to "reading." Experience then becomes an empty signifier, a mere effect of language and power. But on the other side, from the empiricism of Locke and Hume down to American pragmatism, experience is claimed to be all there is.[25]

Four plaster casts of faces cut just below the eyes are placed side by side and above the painted surface in *Target with Four Faces* (cat. 3). Here blindness is presented as both sign and metaphor of nonexperience — vision denied and experience foreclosed. The iconic target below the faces is subdued and slowed, wrested from its transparency as unseen sign and made flesh by the sensuously painted surface on the one hand, and by the nominalism of calling a target art on the other. This art-icon-nonicon reverberates against the dead, sightless faces above. The work is suspended between the sign made flesh and the representation of a blindness incapable of experiencing the flesh of sight. Johns does not unify our experience but mocks it, stretches it between two irreconcilable polarities, metaphorizing and displacing the iconic sign as sensuous flesh while desiccating the body as a wounded sign. The simple gestalt imagery resolves nothing. In the Johnsian world, flesh (experience) is always tortured by the connotations of the sign — via manipulations of blindness, the oppressions of patriotism, the numbing of repetitive counting, and myriad other ways. No other artist of the twentieth century delivered so much pain and pleasure in such simple packages. But the density of the irony informing this work deflates any foothold for the sublime. The aesthetic gorgeousness of these early works would caress our bodies only for an opening through which the mind could be seared. Redemption and torture were never cinched more closely together.

The Inward Turn

No artist of the last half of the twentieth century carried more weight than Johns. No other possessed the necessary cruelty, resentment, arrogance, and thirst for revenge, which would enable him to drive himself so far into dismantling the presuppositions of existing art while at the same time redeeming the ground he had laid waste. No other changed the course of art as much as he. No other could wield an arsenal of grim, ordinary object-signs with such fearlessness, yet without ever losing his self-possession, restraint, and reticence. And no other possessed so many mirrors with which to reflect back and forth across his oeuvre his aggression and his vulnerability, his complexity and simplicity. Finally, no other moved so relentlessly toward hermetic self-sufficiency, which, as the years passed, turned from an increasingly grim external world toward an increasingly melancholy inner one.

Never before had the command for flatness in painting been so enforced and obeyed, while being presented with such sly mockery. But there is a flickering between mockery and pathos here. From the very beginning Johns presents his flags, targets, numbers, and maps with a pathos that redeems their tawdry, alienated status. And yet, these ordinary public signs are freighted with accusation and boil up with aesthetic *pharmakon*. Holding in balance his ambivalent feelings, he transmutes the aesthetic into the critical and the moral. But when Johns leaves the public, militaristic arena of flags, maps, targets, and numbers for the darker inner worlds of *Diver, Tennyson,* and *Voice,* the work turns melancholy. After *Land's End* (cat. 70), his more conventionally "composed" pictures (*In Memory of My Feelings — Frank O'Hara,* 1961, *Fool's House,* cat. 54, 1962, and others) are somber inner meditations.

Johns was not a cold-blooded, impersonal, cynical, and depressive personality, as was Duchamp, who sustained the aggressive tension of compressed predicate signs for much of his career. His strategy of the readymade involved overloading the one-place sign (for example, "is urinal") into a triadic predication: "is manufactured object" ("urinal/is art/changes art"). But such expansion does not obliterate from the obstinate, existential, one-place predicate "is urinal" its hardness as a nonart thing. This hard, cold-bloodedness of the readymade was not softened by any added aesthetic touch. As we have argued, Johns sought redemption through his art and it follows that he would turn toward (inward?) iconologies of *need* rather than Duchampian ones of *desire.* Duchamp would never have conflated seeing with eating as Johns does in the iconography of tableware found in so many works. There is at times a coyness, a beseeching of the "hidden" that pervades Johns' work — especially after the early symmetrical phase that suggests a profound insecurity (a vulnerability?) and the need to be "found out" (understood, loved?). Johns quickly turned from works that struck out at the world through public signs to those of the inward gesture that might save his own *Skin.*

On one level the works of the first decade can be described as moving from resentment to mourning. Johns' military experience may have been no more than a catalyst precipitating the first works — the military environment of repression, regimentation, and conformity stirring earlier, more deeply seated resentments. The aesthetic realizations of Flags, Targets, and Numbers then gave way to an unlocking of, and permission for, a confrontation with feelings rising from the deepest sense of personal loss and suffering. And this second space, opening after 1960, is illuminated by a pathos of mourning that increasingly suffuses all the work.

But how different it is, after 1960, to try to find Johns than to be confronted with his accusatory signs of the first five years. Both *False Start* and *Jubilee* (cats. 30, 34), both from 1959, say what we see before we see it. And on first acquaintance, they seem to be two of the worst paintings Johns ever produced. Red, yellow, and blue are splashed over the surface in crude, mocking imitation of abstract expressionist brushwork. The words "red," "yellow," and "blue" are stenciled over the surface in colors that correspond neither to the colors of the named word nor to the splotches of color on which they appear. The irony here seems tedious. Although the treatment of the surfaces resembles that of *Shade* of the same year, both *False Start* and *Jubilee* are absent any attached object or a priori, readymade image, multiple panels, or division of the canvas surface that are found earlier — see *Canvas* (page 180, fig. 8), 1956, *Gray Rectangles, Drawer* (page 171, fig. 2), and *Newspaper,* all of 1957. One of the connotations of the word "jubilee" is emancipation. And perhaps the artist felt certain jubilation in being rid of these things. But the uniform density of an allover surface uninflected by physical division or attached objects was a "false start" in that these previous aids would quickly reappear to structure his pictures. But the title *False Start* is also ironic and mocking in view of the fact that the play of the linguistic red, yellow, and blue across the surfaces of both works announces a theme that would be relentlessly repeated. The linguistic nominalism also announces Johns' confrontation with color, which must have held much trepidation for an artist who showed no facility for it. The irony of the nominalistic would have been a way to ease into this new world of color. The play of word against thing,

name against color, is explored in a number of canvases divided horizontally into three and four panels —
a format that runs from *Out the Window* (cat. 38) of 1959 to *Land's End*, 1963, and beyond.

The 1955 work of the early Figures, Targets, and Flags may be as close as Johns ever comes to looking
directly at the world. By allegorizing counting and the quantitative as our pathetic and manipulative grip
on the world, we could read the earliest Johns as a kind of proto-Goyaesque artist pointing out our tenden-
cies toward the pathetic and the monstrous. But for whatever reasons, by 1959 his work had turned inward.
If *Tennyson* announces this, *Device Circle, Jubilee, False Start* were by 1959 all following a change of course.
In this sense one of the other ironies of *False Start* is that it was one of the earliest works to hint at the
coming inward turn.

What accounts for the work having turned so resolutely inward at such an early stage? Had that
dragon of modernism bitten Johns as he stood atop its dying body? Did recognition come too early, fast, and
furious? How much guilt does revenge bring with it? And after success can it be sustained as a motive force?
Does redemption feel hollow in the face of success? Did a point come around 1961, when he knew and felt
these things — and expressed them in the bleak and knowing *No* (cat. 47)? Had these burdens pushed him
to an edge, to an unstable *Land's End* by 1963? I think it took ten years for the artist to recover his balance,
density of structure, exuberance of high mental concentration, and purpose, when in the early 1970s he
again caught the *Scent* (1973–1974) of his muse.

The cry a peacock makes in the early morning after it has had its first drink of water at some forest pool: a raucous, tearing

cry that should have spoken of a world refreshed and re-made but seemed after the long bad night to speak only of everything

lost, man, bird, forest, world … later it was possible to work out the stages by which he had moved from what he would have

considered the real world to all the subsequent areas of unreality: moving as it were from one sealed chamber of the spirit to

another.[26] *V. S. Naipaul*

Johns' work has been seen largely in the context of what it did to art: what it closed off and what it opened
up. That and its aesthetic gorgeousness seem to have preoccupied past commentaries, and much of this
one. But as art recedes into the past, even this aesthetically complex work, the question begins to be asked:
what does it tell us about ourselves and the world? I started by asking about affect in the work. But how
in the end can the overarching question about the epistemic be avoided? The question always arises at the
end, when we try to sort out our feelings. Just as there is no ontology without epistemology, there are no
aesthetic judgments without assumptions of the epistemic. Affects arise from effects. Art exists in a world
that impinges on us. Art is part of a world that presses against us. And we respond by asking what is the
nature of this weight we feel against us. The epistemic reverberations from both Kant and Hegel have
still not faded completely. Heroic notions about art, how it mediates even a little freedom in the causal,
downward crush that surrounds, can still be heard. Not to mention that narrative of how History proceeds
and increases the consciousness of art, both ours and its. Today wisps of this epistemic fog bank still
rise from much so-called critical writing. But in clearer, bleaker air questions of minuscule increments of
liberation, asked within the gritty walls of the market (questions still smelling of K & H & Co.), are the
wrong questions.

And that bleakness I spoke of seems at this point to be less and less ascribable to a set of totalized
effects of the world. Or to say it differently, what we know of the world through art is always mirrored by a
glass smudged by our desires. Subjectivity, which already threatened Descartes, will always be part of the

equation. And its consequences are never innocent. That affect which focuses our vision does not just passively receive the world; it changes it. The twentieth century was a lesson in how our defective vision lost our world. Johns' first five years of work started to speak of how certain failures of feeling account for the grimness accompanying the loss of our world. His first five years of production arose from epistemic meditations that allegorically targeted, numbered, flagged, and mapped the affects of a ruthless vision (or a vision of ruthless affects). He kept a precarious balance on this exposed and threatening site by beating time with aesthetic flourishes, but after half a decade he turned inward toward a more personal melancholia.

Reasons

There is far more in the works of Jasper Johns than reason can enumerate. And we have no doubt that Johns, always so full of apparent reasons, has operated on another side of those reasons and according to mysterious impulses we will never fully grasp or name. We are prompted to recall here Wittgenstein's question, " 'Have I reasons?' the answer is: my reasons will soon give out. And then I shall act, without reasons."[27] Nothing is more important than acting without reasons in art, unless it is acting with so many that they never quite come to rest. And here we arrive at a cultural turning point over "reasons" in art in the mid-1960s:

Recent cognitive science pictures a modular brain in which visual perception is broken down into a number of separate tasks such as recognition of shape, movement, edges, constancy of form through rotation, etc. Language is a different system, and the study of its innate features, as Chomsky has noted, "neither provides a useful model for other parts of the study of mind, nor draws from them significantly." (Noam Chomsky, *Language and Thought* [Wakefield, Rhode Island, and London, 1993], 35) ... What may never be made clear by cognitive science is how the interface between the visual and verbal operates, in terms of not only the seamless connection that facilitates the interchange between what is seen and said, but the complex and endless conflict between the one and the other.[28]

Not being a rational enterprise, the kinds of meanings, or problems, expected of art are not those expected of linguistic discourse. At least this was the case up until the 1960s when a new rationalization of art was set in motion. First came minimalism, followed by conceptualism, then the rise of the photograph as an art object, and finally, now, the democratization of art as spectacle. We look back at forty years of a progressive simplification, a reduction of ambiguity of meaning, and a thinning of art as cultural engagement.

If Johns initiated this with his rationalizing methodology of the a priori device — that final, fatal arrow in the Saint Sebastian of modernism — the rising market's demand for nominally simple and distinct commodities completed the emptying out of art. (Johns himself moved toward mannerism after the 1970s and mocked the rational/a priori aspects of his art in the self-parody of self-quotation.) The "plurality" that was said to characterize the art market of the 1980s and 1990s nominalized art by demanding style-star recognition to negotiate the exponential increase in gallery activity. The expanding market demanded ever more artists to supply it with that contradictory demand for commodities both new and name-recognizable. Thus art progressed, over the last four decades, toward a kind of stupefying of expectation that had more to do with labels and commodity identification and ever less with the experience of ambiguous, shifting, multiple, and relative meanings. Nominalization in itself does not militate against rich experience. Johns' use of his readymade icons of target, flag, numbers, and maps demonstrated that. But the very success of this combination of simple images, which belied their potency for experience in the form of a kind of

delayed detonation, did not travel. Nothing demonstrated this more clearly than minimalism's supreme easiness. Anybody could get it, because there was very little to get. As Stella remarked, "What you see is what you see." Of course nothing was more American than that kind of flat-footed empiricism. And minimalism was nothing if not an all-American, anti-European art practice — the term "practice" slipping so easily into the jargon of the day. Minimalism was that performative art unwaveringly stamped out from a few blunt premises. There was not much to experience or to "get" here, but you knew what it was from a mile away. And of course what little there was to get beyond the inherent, simple decorativeness were the *reasons* for minimal art, its dogma of justifications. It was minimalism (though coming out of Johns) that so resoundingly set art on that course of dumbing down that permeates all "art practices" today. Practices justified by reasons (euphemized as "ideas" in conceptual art) that guide us through the extensive bleakness that now surrounds us.

The Liveried Life

Artists are the elite of the servant class.[29] *Jasper Johns*

Art has always been dependent upon and served one set of forces or another with little regard for the morality of

those people or forces it served (pharaoh, pope, nobilities, capitalism).[30] *Robert Morris*

In the Museum of Modern Art a woman said to him, "Jasper, you must be from the Southern Aristocracy."

He said, "No, Jean. I'm just trash."[31] *Max Kozloff*

The people who own the country ought to govern it.[32] *John Jay, first chief justice of the United States*

For one artist to think about another is to think about other "possible worlds." Could Kripke aid me here? Or are those other "possible" worlds Kripke imagined as bleak as ours? Could there be another possible world similar to ours, but more advanced in its historical cycle? What might we see in such a world that had come to the end of its history? Perhaps it would be this: The two last men fighting to the death. Inevitably one gained the advantage in the struggle. As the vanquished felt the blade against his throat, he pleaded, "Spare me and I will be your slave." The victor, curious as to whether being a master would give him more satisfaction than the murder he loved, relented. Thus began a relation between the two in which the master lived in idle luxury while the slave worked (in the beginning out of fear of death) to provide the master with food and shelter. One day the master called his slave and said, "This is not enough, I want more than necessities." The slave returned to his labors and invented art and brought it to his master. "Ah," said the master, "this is what I have always wanted. It is magnificent. And although I get no prestige from recognizing you, slave, who I regard as trash, perhaps owning this art will bring me prestige." The slave smiled a hidden smile and thought to himself, "Through my work I have found my freedom, and though I am still a slave I have achieved my prestige through the recognition of my master — not to mention a kind of quiet revenge, allegorical though it may be."[33] Of course such a story (a nightmare, actually) could only be about another world. Here in our world we already have art. Part of this art is the magnificent works Jasper Johns made between 1955 and 1965.

After speculating on the sources of the works, and after tracing the arc of their development, enumerating the motifs, innovations, devices, ironies, and contradictions — after all the explanations — much of the work, like all great art, remains elusive, unexhausted by analysis. In the end we stand before these icons, which have become part of the memory images of our time, and listen to their silences. On the other side of all the complexities a kind of majestic grief rises from such works as *Target with Four Faces* (cat. 3), 1955, *Tennyson* (fig. 8), 1958, *0 through 9* (fig. 4), 1960, *Diver* (cat. 66), 1962–1963. Whatever else these works may be about, they loom as monuments of melancholy and mourning. Their dark origins in Johns' personal suffering become irrelevant when we realize that these works seem to resonate to an indelible darkness at the bottom of our own being. We are held, stilled by these icons of loss and perseverance, these images so saturated with pathos, yet so understated by having been handmade from that grit and grain of the ordinary, which forms the very texture of our lives.

The underlying tragic edge of much of Johns' work may be alien to the irrepressible optimism of the American pragmatist outlook. Johns' work speaks of exhaustion and paralysis, the termination of options, and often displays a blatant mockery of action. The work is founded on an implicit pessimism and critique of enthusiasm, immediacy of experience, and the assumption of the transparency of signs. Its doubt approaches Humean dimensions. The skeptical thought at the bottom of the work, beneath its aesthetic splendors, has in the past perhaps been misidentified as mere Johnsian irony. The depth of negativity in the work should be acknowledged. That this is disguised by the exquisite aesthetic touch of the artist as he skates over the surface of the abyss — with one innovation after the other appearing in the first decade of production — can lead us astray. The strategy of an exquisite formal presence sliding over and shading the abyssal has been practiced by few. Goya and Edward Hopper come to mind.

Perhaps the redemptive capacity of these early works, these icons of melancholy that now feel somehow ancient, lies in how they confront us and open us to accept the darker shadows within ourselves and to meditate on that fallen world into which we have been cast.

Notes

The half circle described by a pinioned ruler appears as early as 1961 in *Good Time Charley* (cat. 46), and is doubled in *Device* (cat. 50), 1961–1962, where two stretcher bars appear to screed paint beneath double arcs — a thematic repeated in the lithographs of 1962. Again the ruler performs this motion in *Passage* (cat. 63) and *Out the Window Number 2* (cat. 64), both of 1962, the same year that a broom in *Fool's House* (cat. 54) does double duty as a swinging paintbrush. The following year a hand and forearm, apparently pinioned at the elbow, indicate the indexical, windshield-wiper-like mark of swiped half circle. If this anthropomorphic version of the image, so obsessively repeated in works of the early 1960s, conveys a note of temporal motion through the indexical sign, the waving gesture also seems to convey a signal for help — or perhaps futility, or worse, since it is anatomically impossible for the forearm to rotate a full 180 degrees palm down while pinioned at the elbow.

This essay was written in summer 2005.

1. Elizabeth Bishop, review of *Selected Poems*, by Robert Lowell (New York, 1977), http://www.holtzbrinckpublishers.com/academic/book/BookDisplay.asp?BookKey=512142, June 2006.

2. Carl Schmitt, *Glossarium: Aufzeichnungen der Jahre 1947–1951*, Eberhard Freiherr von Medem, ed. (Berlin, 1991), 243.

3. This maxim is widely attributed to Stalin (though not by Stalin scholars), and has also been attributed to Lenin and Hitler; see Ralph Keyes, *The Quote Verifier: Who Said What, Where, and When* (New York, 2006), 41–42.

4. Saul Bellow, *Herzog*, introduction by Philip Roth (New York, 1992), 219.

5. Palle Yourgrau, *A World Without Time* (New York, 2005), 146.

6. "C'est effrayant, la vie!" Joachim Gasquet, *Cézanne*, 2d ed. (Paris, 1926), 208.

7. Joseph Beuys, private conversation with the author, Düsseldorf, 1964.

8. Ludwig Wittgenstein, *Philosophical Investigations*, G. E. M. Anscombe, trans. (New York, 1953), #198, 80e.

9. Wittgenstein, *Investigations*, 1953, #199, 80e.

10. Joachim Fest describing one of the strategies Albert Speer employed to deal with his long confinement in Spandau Prison. See Fest's *Speer: The Final Verdict*, Ewald Osers and Alexandra Dring, trans. (New York, 1999), 316.

11. I use the term "device" to refer to three aspects of the works: (1) the indexical mark made by stretcher bar, ruler, or hand rotated through 180 degrees and appearing to leave a screeded track of wet paint, (2) the readymade image that is more or less coincident with the edges of the canvas, and (3) a sequential rule that when followed completes the work. If titles are any indication, Johns himself uses the term only in the first sense, that is, in reference to works generating circular or semicircular marks. See not only *Device Circle* (cat. 28), 1959, but the paintings and lithographs from 1961–1962 entitled *Device*.

12. Alfred Lord Tennyson, "In Memoriam," in *Tennyson's Verse* (London, 1971), 16.

13. "I wanted to suggest a physical relationship to the pictures that was active. In the targets one could step back or one might go up very close and lift the lids and shut them. In TANGO, to wind the key and hear the sound, you had to stand relatively close to the painting, too close to see the outside shape of the picture." Quoted by Michael Crichton, *Jasper Johns* [exh. cat., Whitney Museum of American Art] (New York, 1977), 30.

14. A lesson not lost on Ed Ruscha. Although I do not think we can hold Johns responsible for what now amounts to a kind of conceptual folk art: that tedious practice of writing large on walls.

15. See Saul A. Kripke's *Naming and Necessity* (Cambridge, Mass., 1972).

16. Quoted by John Cage in "Jasper Johns: Stories and Ideas," in Alan Solomon, *Jasper Johns* [exh. cat., The Jewish Museum] (New York, 1964), 22.

17. Of course in the later 1987 paintings The Seasons, the silhouette of a nearly complete bodily shadow appears Presumably this is that of the artist and as such a kind of indexical sign. But rather than implying the recent presence of an active body springing to its death, which in *Diver* (cat. 66) is associated with Hart Crane, the shadow in The Seasons pictures seems to refer to the future absence of the artist and a death arrived at by a process of decay.

18. The half circle described by a pinioned ruler appears as early as 1961 in *Good Time Charley* (cat. 46), and is doubled in *Device* (cat. 50), 1961–1962, where two stretcher bars appear to screed paint beneath double arcs — a thematic repeated in the lithographs of 1962. Again the ruler performs this motion in *Passage* (cat. 63) and *Out the Window Number 2* (cat. 64), both of 1962, the same year that a broom in *Fool's House* (cat. 54) does double duty as a swinging paintbrush. The following year a hand and forearm, apparently pinioned at the elbow, indicate the indexical, windshield-wiper-like mark of swiped half circle. If this anthropomorphic version of the image, so obsessively repeated in works of the early 1960s, conveys a note of temporal motion through the indexical sign, the waving gesture also seems to convey a signal for help — or perhaps futility, or worse, since it is anatomically impossible for the forearm to rotate a full 180 degrees palm down while pinioned at the elbow.

19. The 1960 *Anthropometries* of Yves Klein, while precedents for using the surface of the rotating body to generate indexical marks, are decorative and detached, not to mention absurdly sexist in their use of the female body as paintbrush. Johns' use of the device seems to reek of airless confinement and compression of the body in two dimensions.

20. Of course the margins between the outer ring of the target and the four edges of the painting in the Target works vary from one Target painting to another; as early as 1955 a flag floats above a lower field of arbitrary dimension; in 1957 a flag is painted floating in an orange field; in 1958 three flags of diminishing sizes are stacked one on the other. Clearly the found image did not obviate every compositional decision Johns made in the "device" works. The sizes of the Numbers and Alphabet works are in no way given by the series run-out of 0–9 or A–Z. And colors are not suggested by any prior logical decisions. But this caveat does not weaken the general argument about the importance of the device or found object in Johns, or for those who came after him.

21. *The Oxford Companion to Philosophy*, Ted Honderich, ed. (Oxford, 1995), 382.

22. See Joseph Brent, *Charles Sanders Peirce, A Life* (Bloomington, 1998), for Peirce's notions about perception and logic, as well as the triadic nature of his systems.

23. *The Collected Papers of Charles Sanders Peirce*, Arthur Burks, ed. (Cambridge, Mass., 1958), 8:191. On the other hand Wittgenstein thought that the practice of interpreting every sign — those for rules, for example — could only lead to skepticism, for whatever one might do would be, "on some interpretation, in accord with the rule" (Wittgenstein, *Investigations*, 1953, #198, 80e). Not interpreting rules saves us from skepticism. Or, as Wittgenstein put it, "When I obey a rule, I do not choose. I obey a rule *blindly*" (#219, 85e). But such salvation from skepticism only delivers us to ethical questions.

24. See Nelson Goodman's *Languages of Art* (Indianapolis, 1976), for a discussion of the difficulty encountered by semiotics in attempting to define the icon, and how resemblance is neither a necessary nor sufficient condition for representation.

25. Abstract art of the 1960s and beyond, especially minimal sculpture, was American modernism's last gasping attempt to protect an aestheticized zone of phenomenological "experience." Increasing scale was the main tactic utilized in this conservative operation. Gigantic objects impinging on the body in environmental spaces sought to restrict art to pure perception. Johns belonged neither to the abstract camp of empiricist-modernist "experience," nor to the rationalist, deflationary signage camp of postmodern conceptual art. Yet he heavily influenced both.

26. From the prologue of V. S. Naipaul's *Magic Seeds* (London, 2004).

27. Wittgenstein, *Investigations*, 1953, #212, 84e.

28. Robert Morris, "Toward an Ophthalmology of the Aesthetic and an Orthopedics of Seeing," in *Re-Discovering Aesthetics* (New York, forthcoming).

29. Crichton, *Johns*, 1977, 17.

30. Robert Morris, "Notes on Art as/and Land Reclamation," *October* 12 (Spring 1980), 102.

31. Max Kozloff, *Jasper Johns* (New York, 1969), 15.

32. This maxim is attributed to John Jay in Frank Monaghan, *John Jay, Defender of Liberty against Kings and Peoples* (Indianapolis, 1935), 323.

33. Hegel tells the story slightly differently, leaving out the art. See G. W. F. Hegel, *Phenomenology of Spirit*, A. V. Miller, trans. (Oxford, 1977), and especially Alexander Kojeve, *Introduction to the Reading of Hegel*, Alan Bloom, ed., James H. Nichols Jr., trans. (Ithaca, 1969), 48–49.

1 2

A Sum of Corrections

Carol Mancusi-Ungaro

The following notes are from a conservator's journal. They are offered along with a suggestion that the close scrutiny of the facture of works of art has a value beyond indicating possible conservation options. "I know more than anybody else. I know how I made it," quipped Jasper Johns in response to a question about the nature of a painting.[1] The quote reminds us that the meaning of art and its material form are inextricably linked. Editors of artists' interviews tend to skip over information about the minutiae of studio practice, such discussions trailing off into notations [...] indicating omitted text. But these details contribute, often substantially, to the work's meaning. As shown here, they also reveal and confirm intentions.

Target with Plaster Casts (cat. 1, 1955)

My use of objects comes out of, originally, thinking of the painting as an object and considering the materialistic aspect of painting: seeing that painting was paint on canvas, and then by extension seeing that it occupied a space and sat on the wall, and all that, and then, if those elements seemed to be necessary to what I was doing.[2]

The canvas and stretcher are incorporated into an elaborate system of three-dimensional parts that transforms the relatively narrow strainer (¾ inch deep) into an object with a depth exceeding 3 inches. Although the source of the stretcher is unknown, it recalls the cheap, commercially available ANCO stretchers, produced in Glendale, New York, that Johns used to make *Target with Four Faces* (cat. 3, 1955), *Thermometer* (1959), and *Device* (cat. 50, 1961–1962).[3]

After assembling the stretcher, Johns attached a fine weave canvas, primed with a white ground that is clearly visible on the bottom edge. Johns did not always prepare his canvases with a ground; sometimes he chose to paint directly on the canvas, as in *White Target* (cat. 8, 1957) and *Out the Window* (cat. 38, 1959). The canvas was attached to the stretcher bars with flat-head tacks that are visible on the bottom tacking margin but not on the lateral edges where newspaper and paint obscure what is beneath.

One piece of wood functions as a platform (¾ inch high) upon which the stretcher rests while two other pieces of wood, nailed to the reverse edges of the stretcher, extend its depth another 3 inches (fig. 1). Two additional pieces of wood, measuring 6 ¾ inches high, are attached to the top of the deepened stretcher at either side to form the boundaries for the nine cubicles that are created between them (fig. 2). Hinged to the top of each cubicle is a door fashioned from a piece of found wood. Extraneous holes and nicks throughout the wooden members attest to their former use.

Judging from the flow of the paint into the connective crevices, the elements of the construction were apparently assembled before Johns began to paint. The flat taut canvas with minimal breadth lost its identity to the dominance of the ensemble.

Johns tended to assemble the parts of his works before he applied paint (fig. 3). In *Out the Window* (1959), he allowed the medium to flow between the attached stretchers and then carefully sliced the pooled paint to free the parts, only to join them again with drips from the final campaign of painting. He separated them visually to insist upon their independence but ultimately treated the parts as a whole.

I think the wood that I framed things with was, for a time, three to five inches deep. Paintings were brought out from the wall, giving them a depth similar to that of TARGET WITH PLASTER CASTS. Various paintings had such framing but none, that I can remember, was ever shown in that way outside my studio.[4]

The attached pieces of wood in *Target with Plaster Casts* act as a framing device separating it from the wall. Johns confirmed this order of thinking in a 1963 interview by explaining that since a painting must project from the wall anyway, he would exaggerate the distinction not only by attaching deep frames but also "by including cabinets and doors that could be opened. Later on, all the flat things I took off, because I could see it anyway. It didn't seem important to stress it."[5]

By contrast, in a painting like *Gray Alphabets* (1956) extraneous holes in the tacking margins resulted, as Johns explained, from the attachment of narrow strips of wood lath. They, rather than deep pieces of wood, served as the original framing device.[6] The lath may have conformed to the depth of the stretcher bars, providing clean edges but not adding breadth.

In an earlier painting, *Star* (1954, The Menil Collection, Houston), Johns explored the space between the wall and picture plane even further by placing three small triangles of painted canvas directly against the wall and a larger dominant triangle spaced 1 ⅞ inches away (detail, fig. 4).

One of the more interesting aspects is that the painting covers the surface, so that there is nothing that is not the object in one way or another. In any case, one does become very much aware of the physical size of the object and its corners. In some early pictures I painted beyond the edge, farther than necessary.[7]

Johns applied papers and paint to all the lateral pieces of the wood assemblage, visually connecting it to the target and accentuating their combined depth (fig. 5). Orange paint and papers seen on the edges became an underlayer of the target. Subsequent campaigns of layering ensued on all surfaces. Drips of red paint onto the sides indicate that it was the last layer applied to the canvas, including its tacking edges, as it lay flat. Aside from the structural divisions that create the compartments, the lids that close them, and the wood strip at the bottom, every surface was covered with paint.

One approaches to lift the lids of the cubicles; one steps back to assume a respectful distance from the imposing target.

In other cases, I developed a kind of mannerism in the relationship between painting and canvas, by leaving a corner of the canvas blank. At first this happened by chance, while I was working on a large painting; as I usually do, I painted the upper part first, because I have to bend down to work on the lower part. I became aware of it and decided to leave it that way, because I liked it that much.[8]

In numerous instances, Johns left the bottom edge of a painting unpainted or relatively unfinished compared to the rest of the work — *White Target* (cat. 9, 1958), *Device Circle* (cat. 28, 1959), *False Start* (cat. 30, 1959), *By the Sea* (cat. 40, 1961), *Device* (cat. 53, 1962), and *Periscope (Hart Crane)* (cat. 67, 1963).

In *White Target,* such a reveal is emphasized by the exposure of a blue thread, woven at the factory into the unpainted cotton-duck fabric to mark the selvage of the cloth (fig. 6). The same broken blue line, characteristic of cotton-duck fabric sold by John Boyle and Company in New York City in the 1940s and 1950s, often appears on tacking edges of paintings by Jackson Pollock and Barnett Newman. Pollock occasionally included it on the painting surface as part of the design. The blue thread in *White Target* is more prominent, for it is essentially a white painting.

These unfinished areas seem analogous to the ¾ inch strip of unpainted wood at the bottom of *Target with Plaster Casts.*

In *Periscope (Hart Crane),* Johns actively engineered the bottom reveal rather than letting it occur spontaneously (fig. 7). With a white preprimed canvas placed upright, Johns apparently positioned masking tape (perhaps from the roll seen on the floor in a studio photograph, see fig. 21) along the bottom ½ inch of the canvas and then applied thin black paint. The paint collected along the edge to form a clear dark line. Black paint, used in the process, dripped into the protected reveal through inevitable skips in the adhered masking tape. Johns removed the tape before finishing the painting.

Johns' method is discursive. He moves from one step to another in a logical progression. "Once he does something," John Cage wrote, "it doesn't just exist: it replies, calling from him another action." As Johns himself explained, "If one takes delight in that kind of changing process one moves toward new recognitions (?), names, images."[9] A bottom edge catches his attention. He continues to think about it in his work. He paints it; he doesn't paint it. He lets primed canvas show; he lets a colored selvage thread show. He uses a found wood strip; he carefully crafts an edge. He continues to engage with it. He thinks of it in one way and then he turns it another. "Working is therefore a way of getting rid of an idea. The manner in which I work constantly involves a feedback. I paint out parts, change others, and add and subtract as I go along. I don't think about chance. One's initial ideas may have to do with chance, but as one continues, one watches and controls the effects."[10]

My studio had in it various plaster casts that I had done for people: hands and feet and faces and things. So I simply thought of these wooden sections…as being able to lift up and see something rather than hear something. Then I saw these things I had, and I decided to put them in it. So I did.[11]

I don't want to say that I didn't understand thoughts that could be triggered by casts of body parts, but I hoped to neutralize, at least for myself, their more obvious psychological impact. Earlier, the casts were of unpainted white plaster and seemed clinically or photographically morbid. I decided to paint each a different color to counter that impression.[12]

The casts sit tightly within their alcoves. Each has been colored with encaustic paint, a mixture of beeswax and tube oil paint, used elsewhere in the work. Johns first attached the casts to the structure and then slathered the paint not only on the forms but onto the inner walls of the cubicles as well, sometimes with one continuous brushstroke.

8

9

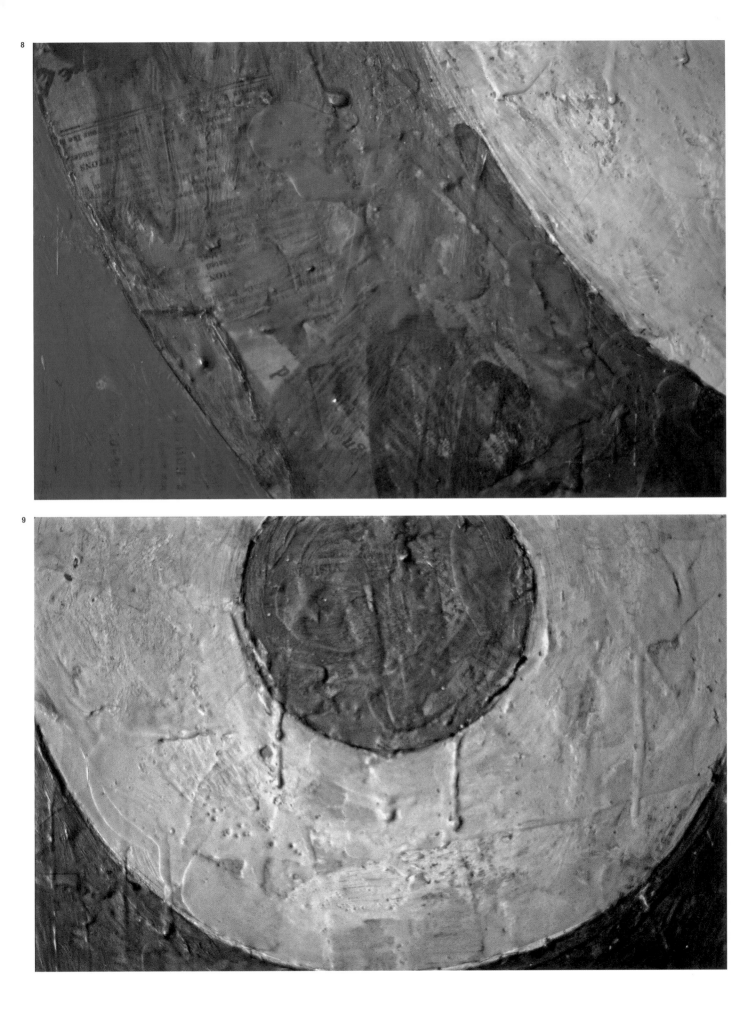

He treated the empty blue box by first attaching fragmented material to its sides and then covering it all in paint. The effect is not unlike that seen in Joseph Cornell boxes.

The plaster cast of Rachel Rosenthal's face, incorporated in *Untitled* (1954), seems unpainted. However, close inspection indicates that it has been painted — white — to look like plaster.[13] The object carries as much paint as the painting above the head.

Whatever printing shows has no significance to me. Sometimes I looked at the paper for different kinds of color, different sizes of type, of course, and perhaps some of the words went into my mind; I was not conscious of it.[14]

John Cage described these carefully placed collage newspaper elements as the "thick presence all at once of a naked self-obscuring body of history."[15]

Each concentric circle of the target in *Target with Plaster Casts* was constructed separately. Circles were drawn on the canvas. Johns then held bits of paper against the circles and cut or tore small segments of arcs to conform to the circular outline. The fragments, intentionally small so as to avoid continuous lettering, were dipped in the colored encaustic medium and placed within the predetermined lines of the target. The concentric bands abut but do not overlap.

Johns used newspaper because it was "cheap and easy" and because it "had a different kind of information on it, an information that was contrary, had nothing to do with the activity…I like the fact that the newspaper introduced an intellectually different focus. It also gives a three-dimensional sense to the work."[16] The papers definitely contribute to the topography by immediately differentiating the surface from the flat plane of an actual target and thus insisting upon its presence as an object.

Disparate printed papers affect the tone of each band (fig. 8). The largest blue band consists of encaustic paint over newsprint without images. The paper of the adjoining yellow band consists of newspaper headlines and advertisements. The next blue band incorporates papers with printed words of small type, and the smaller yellow band incorporates print of bold type. The variegated font of the printing affects the tonality of the colors and asserts the accuracy and discreteness of the forms.

Oil was purely conventional, and encaustic was for me an escape from the slow drying of the oil. I was impatient with that and began to work with wax, which could dry very rapidly and keep the quality of the overlapping brushstrokes without confusing the sense of time.[17]

What it did was immediately record what you did. I liked that quality. It drips so far and stops. Each discrete movement remains discrete. The combination of this new material and this new idea about imagery made things very lively for me at that time and started my mind working and my arm.[18]

Johns' use of encaustic augmented the three-dimensional nature of the newspaper.[19] The mixture of tube oil paint and beeswax dried very quickly, enabling the artist to paint without interruption, to freeze each brushstroke as it was applied, and to layer in a manner that did not smudge the underlying color.[20]

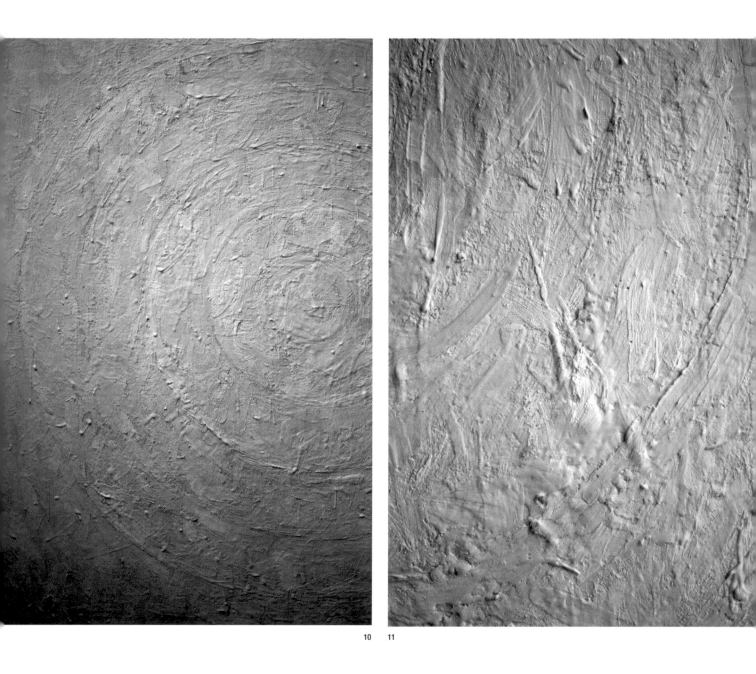

10 11

The intricate and interdependent layers of papers disguise where the process began (fig. 9). The presence of certain drips and Johns' subsequent overpaintings suggest the order in which he finished the painting. The final application of paint began at the bull's-eye and blue encaustic dripped onto the adjoining yellow band. Johns painted over this drip with yellow paint and then corrected analogous drips from the yellow band to the larger blue. He followed this procedure until he reached the outer perimeter of the target, where he used red paint to hide drips from the largest blue band. Given his attention to these details, all remaining drips on the painting, including the vertical green drip at the right and the orange one at the top, were intentionally left.

White Target (cat. 9, 1958)

The early paintings of mine seem to me to have been about, partly,...accuracy, and questioning whether there are such things, so that the paintings tended to be a sum of corrections in terms of painting, in terms of strokes. So that there are many, many strokes and everything is built up on a very simple frame but there is a great deal of work in it, and the work tends to correct what lies underneath constantly until finally you quit and say "It's this one."

The earlier paintings refer to specific designs or lines or whatever, which had to be dealt with, and the liveliness of the painting tends to be what I called earlier, corrections, very complex set of corrections, in relationship to these lines.[21]

Johns delineated the white target by corralling an underlying array of multidirectional strokes with short curved strokes, posited by a ½ inch brush, that assert the outline of the form (fig. 10). Independent matte white strokes and ridges of impasto further emphasize, create, and accentuate the circumference of the target. "My marks in the early pictures were shorter and more discrete."[22]

The paint is so thick and chalky that in the upper left quadrant, for example, the pasty medium looks like a piece of fabric collage: Paint itself as collage. There is no newspaper. The paint consists of beeswax, gum dammar, linseed oil, and pigment.[23] Orangelike blobs of poorly dissolved dammar resin are caught in the white paint.

Judging from the drips in the off-white paint, the target was painted in an upright position.

However, if I paint a flag [or target] in white only, using various brushstrokes and tone variations, or many painterly elements, then people would tend to regard it as a picture and not as a flag. It is the gray zone between these two extremes that I'm interested in—the area [where it] is neither a flag nor a painting. It can be both and still be neither.[24]

Multiple layers of mediums applied with different, seemingly chaotic strokes embody the form. A more yellow, waxier white is smoother and shinier than a seemingly purer white paint that holds the tracks of brush hairs and appears consistently more matte.

Drips abound (fig. 11). Vertical drips are everywhere and other drips actually follow the circumference of the target. Johns often paints over hardened drips — a meticulous gesture that evokes the sense of a highly

246

worked surface. Time is implicit; it is not a sudden application. Johns may have chosen to use wax because it dries quickly, but that attribute of the medium does not reduce the time he spends building up the surface. If anything, the immediate consolidation encourages more reworking that ultimately enables the activity to be finalized as one creative gesture.

"I recall seeing a white flag that was no longer very white," interjects David Bourdon. "That's not only from newsprint, that's from the lead, which, unless it's in sunlight, becomes yellow," replies Johns. "Do you welcome this kind of morphological change in color? Does it seem agreeable?" asks Bourdon. "Not especially. I think certain materials changing very quickly add a kind of fake time to the thing that I don't really like, a patina, and give it a nostalgic quality that it doesn't have originally. But I don't think my work suffers really very badly from that," concludes Johns.[25]

The work is remarkably well preserved.

False Start (cat. 30, 1959)

The early things to me were very strongly objects. Then it occurs that, well, any painting is an object, but there was…I don't know how to describe the sense alterations that I went through in doing this in thinking and in seeing. But I thought how then to make an object which is not so easily defined as an object, and how to add space and still keep it an object painting. And I think in, say, False Start and those paintings, the object is put in even greater doubt and I think you question whether it's an object or whether it's not.[26]

False Start is a commanding painting. The impressive size of its canvas (roughly 67 by 54 inches) supported by a relatively narrow stretcher (¾ inch deep) reduces its "object-quality."

Its bottom and top tacking edges are fully primed white, unlike the rest, and marked with colored drips that indicate Johns shortened the painting — understretched it — at some point in its genesis.

Johns provided glimpses of primed canvas at the bottom. Additionally, at the central bottom edge, with viscous orange-yellow paint, he slathered over and partially hid a series of red letters, perhaps a truncated word (fig. 12). Directly above, near the top, are blue letters whose formation of the word "red" has been interrupted by another slathering of paint — this time a briskly applied white (fig. 13). Seemingly similar in size to their counterparts below, these letters sit directly on the bare or lightly primed canvas, whereas the lower letters sit on an isolating white ground. They clearly occupy different levels of space. Where earlier the intentional exposure of a fabric or ground served to identify the work as a painting, in False Start the position of similar lettering on different layers of the exposed structure achieves the opposite effect: it reminds us that the painting is an object with a discernible depth.

Johns stenciled the words and word fragments onto a color, painted over them, stenciled them again onto another layer of paint, painted over them, and so on. The effect is one of continuous and energetic activity that upon close examination has a distinct bottom, middle, and top.

14

15

As Cage described: "Then with a change of tempo he began painting quickly, all at once as it were, here and there with the same brush, changing brushes and colors, and working everywhere at the same time rather than starting at one point, finishing it and going on to another. It seemed that he was going over the whole canvas accomplishing nothing, and having done that, going over it again, and again incompletely...Every now and then using stencils he put in the name of a state or the abbreviation for it, but having done this represented in no sense an achievement, for as he continued working he often had to do again what he had already done. Something had happened which is to say something had not happened. And this necessitated the repetitions, Colorado, Colorado, Colorado, which were not the same being different colors in different places. I asked how many processes he was involved in. He concentrated to reply and speaking sincerely said: It is all one process."[27]

"The explorations with colors and words: were they investigations of color for yourself because you knew this was a weakness of yours?" asks Peter Fuller. "You are thinking about *False Start?*" Johns replies. "Well, no. For me, that was more an attempt to get rid of predetermined boundaries which had existed in the images which preceded those pictures; painting within lines, basically."[28]

In *False Start*, Johns used oil paint to explore the pure colors of his earlier palette in a more fluid medium. Gone are the lines. In their stead are squiggly, seemingly uncontrolled starlike bursts of color that conform to no image or object. Like a signature, or at least a personal gesture, these colored forms became a recurring motif in Johns' work.

He seems to be freely exploring paint for the first time.

The first layers are thinly painted compared to the later, more viscous applications of oil paint. He used the handle of the brush or another sharp tool to make scratches in the upper central quadrant that x out nothing but the thin layer of paint beneath (fig. 14).

Along the right upper edge, he applied red paint in a manner that differs completely from its manipulation elsewhere in the painting — no impasto, minimal brushwork, simply opaque. This red is rosier and flatter than other reds in the painting. Similarly, in *Device* (cat. 50, 1961–1962) a flat undifferentiated green in the bottom right corner stands insistently against the other highly brush-marked greens in the painting — still green but definitely different.

Well, you and I agree that there is red, but once there is an agreement then you use it in that way in terms of that convention. If we disagreed as to what red was, you said it was red and I said it was yellow, then what we have is a situation to which we would both respond differently. And I think that's frequently the case in painting.[29]

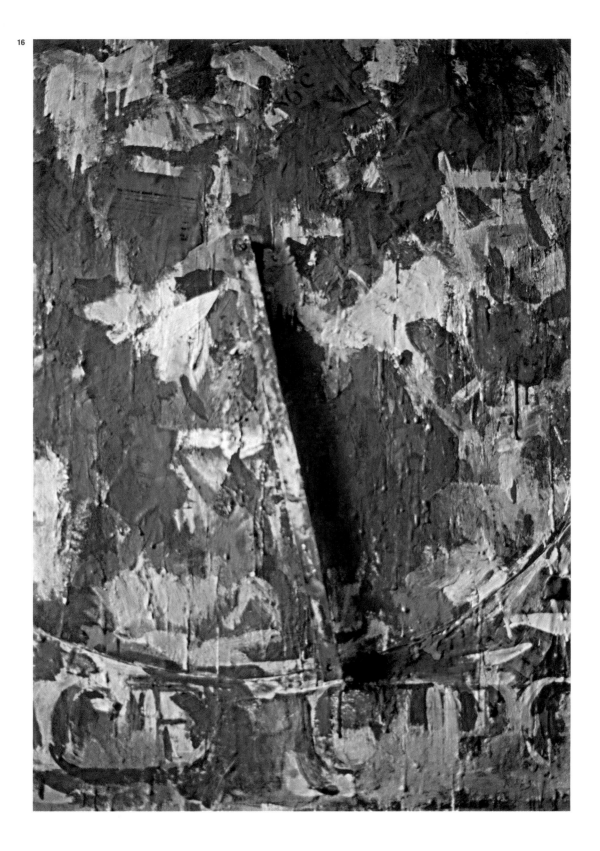

Out the Window (cat. 38, 1959)

In *Out the Window* Johns conjoined three stretched canvases, roughly 18 ¼ by 40 ¼ by 1 inches each, into a vertical stack. The tripartite division reads visually despite being irregularly overpainted.

The painting has an objectlike quality, which is enhanced by the use of encaustic and randomly placed bits of paper.

There is not that much paper, and what is there is seemingly not positioned with the precision of the collage elements of *Target with Plaster Casts*. Nor does it form the primary support for the paint, as it did in the earlier work. Rather, the encaustic is drippier, apparently more fluid. Perhaps Johns used proportionately more oil paint in this mixture, causing it to appear lighter in weight and less opaque than the medium used to form the Targets.

In order to read the words, one must step back. When viewed up close, the letters become lost in the vigorous brushwork, dripping paint, and vivid colors (fig. 15).

Devices (cats. 28, 29, 50–53, 1959–1962)

The more recent work of mine seems to be involved with the nature of various technical devices, not questioning them in terms of their relation to the concept of accuracy…You know what is painting and you know what the objects are that are involved, and you may or may not know what the sense of it is. That's your own business. They are also less arbitrary… they have no references outside of the actions which were made.[30]

The technical devices perform actions. In *Device Circle* (cat. 28, 1959) a stick is attached to the center of the canvas (fig. 16). It has an additional hole in its opposite end. A nail, screw, or pencil was presumably placed in that hole, and as it spun around it scored the circumference of a circle into the paint. At present without a sharp point, the device is no longer an operative tool but rather a design element. Its colors match the painted surface. The scored circumference in the encaustic paint is reinforced with brushwork that follows the form.

In *Device* (cat. 50, 1961–1962), two extraneous and highly visible stretcher bars (measuring 18 inches each, as indicated on the right one) are attached to an invisible underlying stretcher with wing nuts and bolts. The evidence suggests that the stretcher bars swung around to make two smeared semicircles in the oil paint.

In *Device* (cat. 53, 1962), two ends of a yardstick (each measuring 12 ¾ inches and secured to the underlying stretcher through proprietary grommets) similarly create two semicircles in the oil paint.

The measured stretcher bars in *Device* (1961–1962) and the shards of a yardstick in *Device* (1962) carry enough residual oil paint to assert their use in the making of the work. However, brush hairs found in both semicircles of *Device* (1961–1962) attest to a later embellishment of the forms, as does the overpainting of an underlayer's impasto. Although a drippy application of the thin medium in this work suggests speed, the conscious reworking of dried ridges of oil paint suggests Johns took his time.

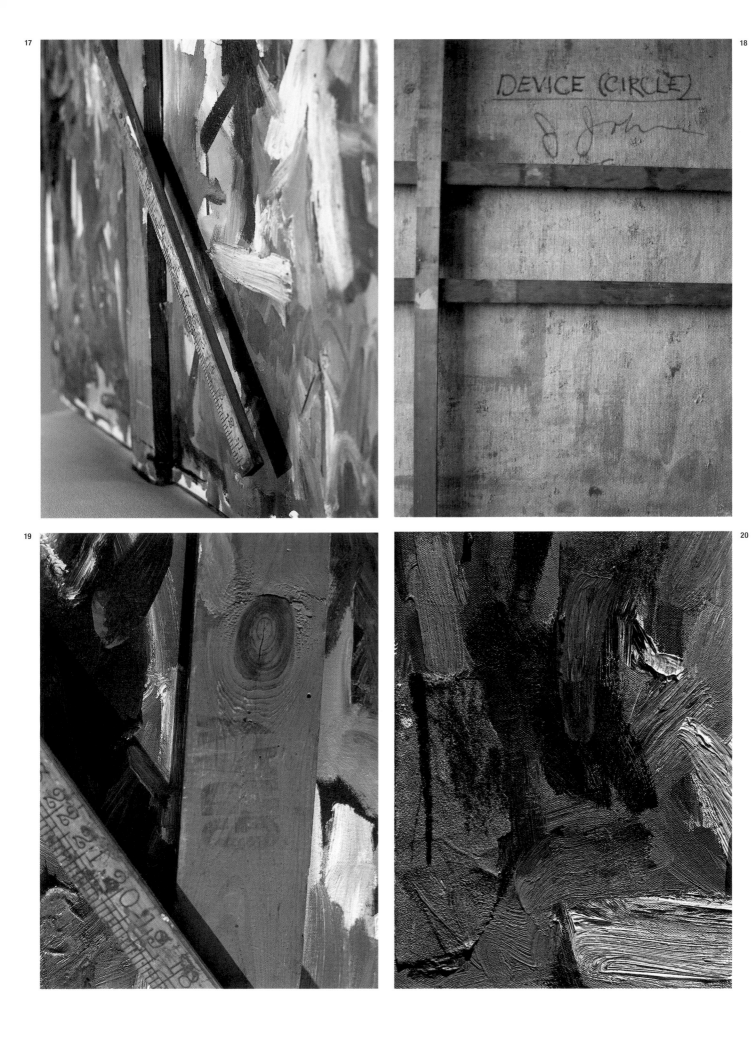

In *Painting with Ruler and "Gray"* (cat. 44, 1960) a larger fragment of a yardstick (approximately 32 inches) positioned on top of a found piece of wood swings freely above the canvas, not actually creating a circle in the paint but certainly suggesting one as it moves around its axis.

Suppose there are two portions, and one is external and the other is internal. Let's try to consider the reverse case too. Now even if you take up the external portion and draw it into a picture, the internal position continues to exist all the while. I think this fact should be kept in mind… I'm interested in seeing a thing through as many approaches as possible.[31]

The exposed fabric at the bottom of *Device Circle* confirms that it is painted on canvas. Yet, there must be a solid structure behind the canvas to support the defining stick, even though it is not visible, and indeed there is: "the internal position continues to exist."

In *Painting with Ruler and "Gray,"* Johns centered a piece of wood on the front, where it is readily visible, rather than on the reverse, where a central stretcher bar would normally reside. The numbers on the inverted yardstick, reading backward from right to left until they are obliterated by oil paint, echo this back to front repositioning.[32]

In *Device* (1962) the central piece of wood sits where a bar should be (but is not) on the back of the stretcher. Yet, the position of the two yardstick shards reminds us that other stretcher bars lie behind, to which the shards are necessarily attached. The duplication of the title in large and small print at the bottom right corner reasserts that the fragments are indeed two devices.

"Where would you focus to determine subject matter?" Johns queries. "What a thing is. In your Device paintings it would be the ruler," Gene Swenson answers. "Why," Johns asks, "do you pick ruler rather than wood or varnish or any other element?"[33]

The tacking edges of *Painting with Ruler and "Gray"* confirm that Johns initially painted the canvas with bright colors, some of which peek through the painting's predominantly gray, black, and white brushstrokes (fig. 17). Johns started the colorful *Device Circle* with a gray paint that has bled through to the reverse (fig. 18). Similarly, in constructing *Three Flags* (1958) with encaustic, he painted the hidden stripes of the largest flag with gray paint, as seen on the reverse of the canvas.

In the predominantly gray *Reconstruction* (cat. 36, 1959), Johns provided a hint of color not through paint but with the colored threads of fabric fragments that animate a sea of gray.[34]

I used gray encaustic to avoid the color situation…The gray encaustic paintings seemed to me to allow the literal qualities of the painting to predominate over any of the others.[35]

In *Painting with Ruler and "Gray"* and in *Device* (1962), the word "gray," painted in gray, is barely visible as it blends into the worn strips of wood that carry the letters (fig. 19). In *False Start*, Johns overtly used stencils to posit the names of the primary colors in primary-colored paints that do not always correspond (for instance, the word "blue" sitting atop an area of orange paint or the word "red" stenciled in yellow). Technique is obvious; meaning is questioned. In these gray device paintings, the meaning of the word is clear; technique is not.

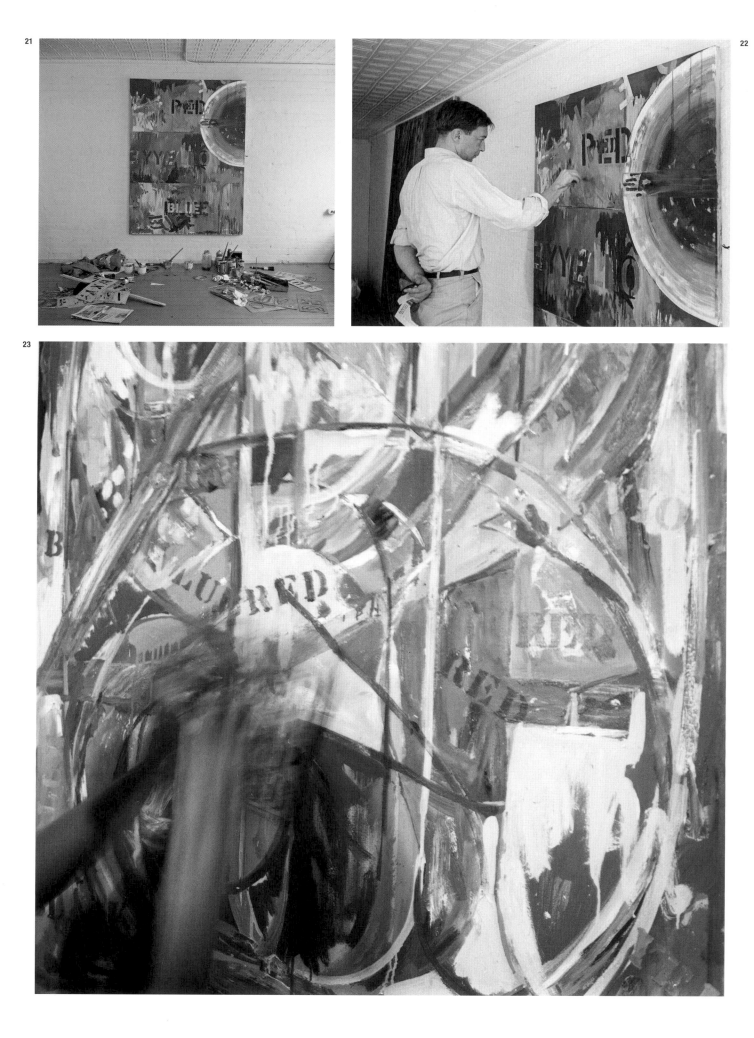

I've always been interested in exploring the quality of various materials.[36]

In *Painting with Ruler and "Gray," Device Circle,* and *Device* (1962), attention is drawn to the instrument mentioned in the title. What about the other materials incorporated in the paint layers that are equally engaging? In *Painting with Ruler and "Gray,"* the artist inserted sandpaper (fig. 20) into the paint and then, presumably focusing on fabric, added pieces of silk and linen near exposed areas of primed canvas in the left half of the painting. In *Reconstruction,* Johns had similarly explored the use of fabric as both a collage element and a primary support. A second canvas, folded in thirds, is adhered to the stretched one along with extraneous fragments of colored fabric and newsprint. Analogous bits appear in *Device Circle,* and *Device* (1962) includes a scrap of batting at the top of the wooden bar that recalls furniture stuffing.[37]

Periscope (Hart Crane) (cat. 67, 1963)

"It's called *Periscope (For Hart Crane).* Do you know him? He is an American poet," Johns asks. Billy Klüver replies, "There is an arrow." "There are all kinds of things." Johns returns. "What's the physicality like?" Klüver asks. "This is the least physical painting of any work I've done recently. At least, I hope so. Physicality is purely illusionistic, or tends to be illusionistic. One might or might not think that circle has been made by that hand," Johns explains. "Isn't that using physicality in the true sense?" Klüver asserts. "It's what I call questioning it," Johns responds.[38]

Paul Katz photographed Johns as he worked on *Periscope* in his Front Street studio. These photographs reveal a full array of material gathered in front of the painting: stencils of letters in three sizes, masking tape, Winsor and Newton oil paints, paint thinner, dammar resin spray, palettes fashioned from a chunk of wood or paint-can lid, paper towels, a stray stretcher bar, and miscellaneous cans and cups containing diluted paint (fig. 21). Each of these materials contributed to the making of *Periscope,* and yet when looking at the painting, materiality is the last thing that comes to mind.

Although the tripartite division of the painting recalls that of *Out the Window, Periscope* is a single canvas attached to a relatively narrow (1 inch wide) stretcher.

In contrast to the palpable mediums of *Out the Window, Periscope*'s diluted oil paint runs freely, creating barely a wash under the charcoal-drawn arrow. In transmitted light, the thin paint layers become ethereal. In these terms, it is "the least physical painting."

Katz recorded Johns working on *Diver* (cat. 65, 1962) at the same time and noted "piles of different stuff" in front of each painting. "He was most interested in the art of making them," observes Katz.[39] The photographs show Johns crouching down to assess the paint layers and then going back into *Periscope* with freshly mixed gray paint to reinforce the brushwork around the inverted and upright "Rs" at the top (fig. 22). Not surprisingly, many factors confirm the artist's attention to detail despite the beguiling immediacy of the work: the charcoal reinforcement between the top and middle divisions; the stencils pushed into and lifted from the brush-marked paint beneath; the taped edges of some registers; the ordered alternation between sizes of the stencils to create "red" and "blue"; and of course the particular attention paid to the reveal at the bottom edge, as noted earlier. In the photograph, Johns approaches the painting with a rag and

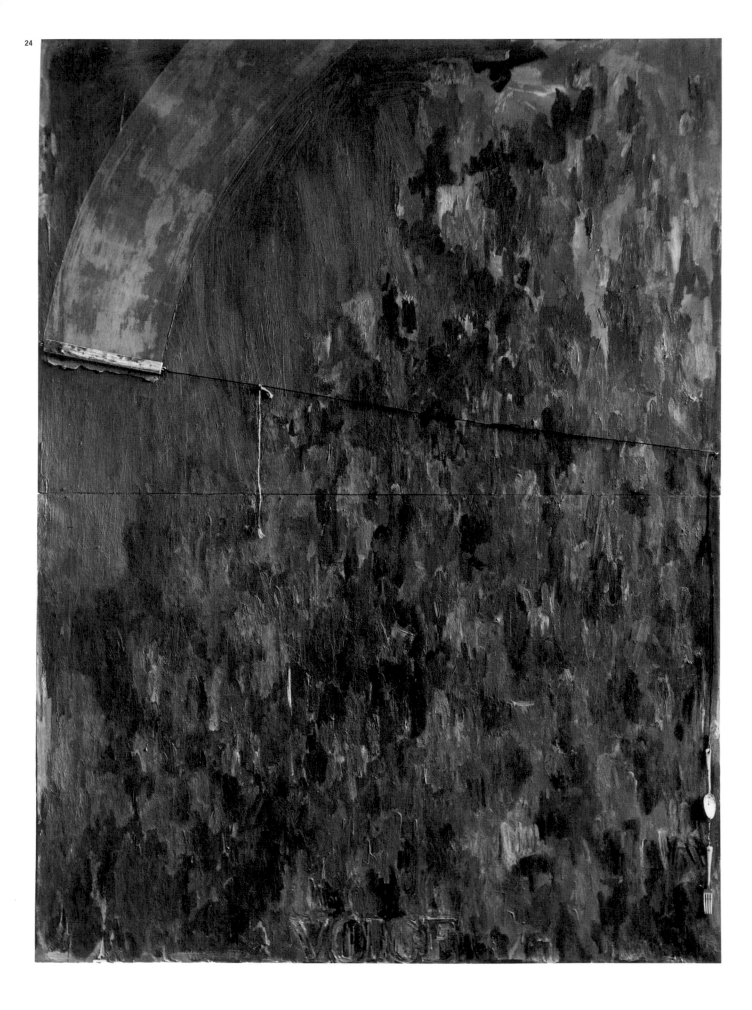

a stencil or guide crafted from stiff paper, such as magazine stock, in his free left hand. Presumably this cut-out was used to mask forms during the process just as the lengthy stretcher bar on the floor undoubtedly factored in the making of the semicircle.

The image of the arm in *Periscope* and particularly in *Land's End* (cat. 70, 1963) recalls a photograph (fig. 23) taken by Robert Rauschenberg of Johns while he was making *0 through 9* (1961).[40] Johns most likely saw the image.

Whether the upturned palm in *Periscope* actually participated in the heavily worked paint of the semicircle seems less important than the lasting impression of an activity.

Voice (cat. 91, 1964–1967)

I like what I see to be real, or to be my idea of what is real. And I think I have a kind of resentment against illusion when I can recognize it. Also, a large part of my work has been involved with the painting as object, as a real thing in itself. And in the face of that "tragedy," so far my general development, it seems to me, has moved in the direction of using real things as painting. That is to say I find it more interesting to use a real fork as painting than it is to use painting as a real fork.[41]

Recently I've been using such objects and traces of action in order to diversify the way to see things.[42]

Johns painted *Voice* in his Edisto Beach, South Carolina, studio on two stretched canvases that were stacked and conjoined in a manner reminiscent of *Out the Window*. In preparation for their shipment to New York, the stretchers were separated, assembled face to face with spacers, and given to a packer. Instead of making a crate, the man "used the painting itself as the sides of the box and simply nailed two pieces of plywood to either side. The painting was surrounded by an interior frame of nail holes when it got to New York. There was a nail hole through the painting about every three inches."[43] Johns repaired the damage by painting over the holes but made no other changes at that time.[44] Before its shipment to the Ferus Gallery in Los Angeles in April 1965, Rudolph Burckhardt photographed the painting in this state (fig. 24).

Two years later, in April / May 1967, Johns decided to "alter the composition by changing the position of the word VOICE and [by] painting over much of the entire surface."[45] It was, in the artist's words, "a very strong change."[46]

What remained were the two attached canvases; the trace of action by a device — a curved swath of paint created by a scrap of wood; straightened coat hangers attached to the wood and running diagonally across the painting, through a screw eye, and down the right side; a spoon and fork dangling from the end; a piece of string, and the word "VOICE" in a completely different place. Johns significantly reworked the painting with additional viscous oil paint, and with charcoal he noted the separation of the horizontal registers and created a strong diagonal line in the bottom left quadrant that mimics the angle of the coat hangers above (fig. 25).

25

26

27

258

In the first version, the horizontal division of the two canvases, complemented by the position of the title along the bottom edge, dominates the structure. In the final version, the diagonal line in charcoal strengthens the slant of the coat hangers and heightens the vertical thrust of the string and hanging utensils. The horizontal order is lessened. There are lots of lines — diagonal, vertical, horizontal — in soft and hard materials — wood, wire, string, metallic flatware (fig. 26). Johns questioned the nature of a line in part by varying its materiality. Beyond the design changes, he thoroughly reworked the paint layers. Yet, a ghost of the original "VOICE" is still visible, not totally erased but left as a reminder of process, of an earlier campaign.[47]

While *Voice* was exhibited at the Sidney Janis Gallery in 1970, the spoon (fig. 27) and fork disappeared. Johns replaced the set with another and then at the close of the show, the original utensils reappeared. Johns disclaimed as his own a later replacement set — fabricated by the owner for extra security — because of the way the wire was made, but ultimately stated that "anything is a reasonable replacement."[48] Johns seems more interested in the incorporation of a *real* fork than a *particular* real fork.

"He is able," Cage remarks, "even anxious, to repair a painting once it is damaged. A change in the painting or even someone looking at it reopens the conversation."[49]

As with *Voice*, Johns has occasionally reopened conversations with other paintings as well — for instance, *Map (Based on Buckminster Fuller's Dymaxion Air Ocean World)* (1967–1971).[50] Once, while repairing an early map that had been damaged, he thought casually that it might be easier to repaint it than to restore it. He then remembered that Ad Reinhardt had wanted to repaint rather than repair one of his paintings but the owner refused. "I thought that was an interesting idea."[51] Johns continued, admitting that when he repaints a work, it "has a different quality, of course, because the way I apply paint changes over time."

The most interesting judgment about a painting that I make is the way I proceed after it. Not always. But one of the possibilities is that you do something which allows you to do something the next time that you would not have been able to have done the last time."[52]

The physical facts of painting are very important to me.[53]

Notes

1. Interview I-7, Billy Klüver (March 1963), in Kirk Varnedoe, ed., *Jasper Johns: Writings, Sketchbook Notes, Interviews* (New York, 1996), 87. Close examination of works of art requires the cooperation of colleagues in museums and in private collections. For their cooperation and support of my research, I would like to thank Geraldine Aramanda, Corey D'Augustine, Thomas Buehler, Jim Coddington, Heather Cox, Michael Duffy, Anita Duquette, Inge-Lise Eckmann, Brad Epley, David Geffen, Christa Haiml, Judith Hastings, Mary Kadish, Susan Lake, Maura Lynch, Susan and Francois de Menil, Billie Milam, Julianne Nelson, Christina Rosenberger, Carol Rusk, Denise Saul, Mary Sebera, Marcia Steele, Serena Tremayne, and David White. Paul Katz generously provided important images from his photographic archive, and Yve-Alain Bois, Mark Flood, and William Steen offered insightful comments about the text. My thanks go to Sarah Taggert for facilitating communication with the artist, and finally I remain grateful to Jasper Johns for attentively and astutely answering detailed questions about the materials and method of his art.

2. Interview I-7, Klüver, in Varnedoe, *Writings,* 1996, 87–88

3. ANCO stretchers were also favored by Jackson Pollock and Barnett Newman during the 1940s.

4. Johns, private communication with the author, March 13, 2006.

5. Interview I-7, Klüver, in Varnedoe, *Writings,* 1996, 88. Johns, private communication with the author, May 25, 2006: Johns recalls putting deep frames on only *White Flag* (1955) and two small white flags.

6. Johns, unpublished interview with the author, February 15, 1996. When John and Dominique de Menil purchased the painting from Ben Heller in 1968, it had a reverse L aluminum frame with a painted black inset. Later, Johns confirmed that Heller had put that frame on the painting and recalled Heller boasting that he had paid more for the frame than for the painting itself. As a restorative measure, wood lath strips now frame the painting.

7. Interview I-35, Annelie Pohlen (May–June 1978), in Varnedoe, *Writings,* 1996, 172.

8. Interview I-35, Pohlen, in Varnedoe, *Writings,* 1996, 172.

9. John Cage, "Jasper Johns: Stories and Ideas," in Alan Solomon, *Jasper Johns* [exh. cat., The Jewish Museum] (New York, 1964), 23.

10. Interview I-34, Roberta J. M. Olson (November 3, 1977), in Varnedoe, *Writings,* 1996, 168.

11. Emile de Antonio and Mitch Tuchman, *Painters Painting* (New York, 1984), 100.

12. Interview I-39, Roberta Bernstein (1980), in Varnedoe, *Writings,* 1996, 202.

13. The author thanks Susan Lake at the Hirshhorn Museum for confirming this observation.

14. Interview I-13, Walter Hopps (March 1965), in Varnedoe, *Writings,* 1996, 106.

15. Cage, "Stories," in Solomon, *Johns,* 1964, 23.

16. Interview I-30, David Bourdon (October 11, 1977), in Varnedoe, *Writings,* 1996, 161.

17. Ann Hindry, "Conversation with Jasper Johns/Conversation avec Jasper Johns," *Artstudio* (Spring 1989), 13. Omitted from Interview I-49, in Varnedoe, *Writings,* 1996, 231.

18. De Antonio and Tuchman 1984, 97.

19. In an artist's questionnaire for *Target with Four Faces,* Johns corrected the medium to read "Plaster casts, encaustic 'with' (as opposed to 'on') newspaper over canvas." The author thanks Michael Duffy of the Museum of Modern Art for providing a copy of the questionnaire.

20. Johns, private communication with the author, March 13, 2006. "When I first began using beeswax, I used oil paint from tubes to color it. Later (I don't know when), I began to use dry pigments. I continue to use them." Other comments about technique result from the author's direct observation.

21. Interview I-7, Klüver, in Varnedoe, *Writings,* 1996, 85.

22. Interview I-34, Olson, in Varnedoe, *Writings,* 1996, 166.

23. From a questionnaire that Johns completed when the Whitney Museum purchased the work in 1971. Archives, Whitney Museum of American Art, New York.

24. Interview I-10, Yoshiaki Tono (August 1964), in Varnedoe, *Writings,* 1996, 98. Brackets around "where it" are in the original.

25. Interview I-30, Bourdon, in Varnedoe, *Writings,* 1996, 161. Johns, private communication with the author, May 25, 2006: Occasionally, as in *White Flag,* Johns employed both tube oil paint and encaustic.

26. Interview I-13, Hopps, in Varnedoe, *Writings,* 1996, 109–110.

27. Cage, "Stories," in Solomon, *Johns,* 1964, 22.

28. Interview I-36, Peter Fuller (August 1978–September 1978), in Varnedoe, *Writings,* 1996, 185.

29. Interview I-7, Klüver, in Varnedoe, *Writings,* 1996, 87.

30. Interview I-7, Klüver, in Varnedoe, *Writings,* 1996, 85.

31. Interview I-10, Tono, in Varnedoe, *Writings,* 1996, 98.

32. The author thanks Billie Milam and Julianne Nelson of the Frederick R. Weisman Art Foundation for confirming technical observations.

33. Interview I-9, Gene R. Swenson (February 1964), in Varnedoe, *Writings,* 1996, 93.

34. The author thanks Marcia Steele at the Cleveland Art Museum for providing this information.

35. Interview I-20, Joseph E. Young (September 1969), in Varnedoe, *Writings,* 1996, 129.

36. Interview I-35, Pohlen, in Varnedoe, *Writings,* 1996, 172.

37. The author thanks Mary Sebera of the Baltimore Museum of Art for this observation.

38. Interview I-7, Klüver, in Varnedoe, *Writings,* 1996, 91.

39. Paul Katz, conversation with the author, February 27, 2006.

40. The author thanks the Robert Rauschenberg Studio for access to photographs of Johns' work.

41. Interview I-14, David Sylvester (June 1965), in Varnedoe, *Writings,* 1996, 119–120.

42. Interview I-11, Tono (August 1964), in Varnedoe, *Writings,* 1996, 104.

43. Interview I-65, Milton Esterow (Summer 1993), in Varnedoe, *Writings,* 1996, 284. Johns identified this painting as *Voice,* correspondence with the author, March 13, 2006.

44. Johns, correspondence with the author, March 13, 2006.

45. Johns, correspondence with the author, March 13, 2006. Roberta Bernstein noted the date of the reworking in her "Journal." See Roberta Bernstein, *Jasper Johns' Paintings and Sculptures: 1954–74. "The Changing Focus of the Eye"* (Ann Arbor, Mich., 1985), 236, note 17.

46. Johns, interview with the author, February 15, 1996.

47. The author thanks Brad Epley at The Menil Collection for confirming this observation.

48. Johns, interview with the author, February 15, 1996.

49. Cage, "Stories," in Solomon, *Johns,* 1964, 23.

50. Interview I-65, Esterow, in Varnedoe, *Writings,* 1996, 284.

51. Interview I-55, Paul Taylor (July 1990), in Varnedoe, *Writings,* 1996, 249.

52. Interview I-14, Sylvester, in Varnedoe, *Writings,* 1996, 116.

53. Interview I-36, Fuller, in Varnedoe, *Writings,* 1996, 185.

Chronology

This chronology relies heavily upon Lilian Tone's extensive chronology in Kirk Varnedoe, *Jasper Johns: A Retrospective* [exh. cat., The Museum of Modern Art] (New York, 1996), now the standard source. I have also consulted *Jasper Johns: Writings, Sketchbook Notes, Interviews,* compiled by Christel Hollevoet and edited by Kirk Varnedoe (New York, 1996).

Events listed at the beginning of each period take place sometime during that time frame. A more precise date is either unknown or has been deemed unnecessary. Each season corresponds to three consecutive months, beginning with December as the start of winter. Titles of artworks refer to paintings unless another medium is specified.

Jennifer Roberts

1930–1948

Born in Augusta, Georgia, on May 15, 1930, the only child of William Jasper Johns (1901–1957), a farmer and graduate of Wake Forest University Law School, and Jean Riley Johns (1905–1992, born Meta Jeanette Riley). Raised by his grandparents in a house on Main Street in Allendale, South Carolina, following his parents' divorce in 1932 or 1933. Starts to draw at age three, and from age five wants to be an artist. Has little exposure to art beyond paintings done by a grandmother he had never known. After his grandfather, a farmer, dies in 1939, stays with his mother and stepfamily in Columbia, South Carolina, for a year. From the fourth or fifth grade through his junior year of high school, lives with his aunt Gladys in a rural community on Lake Murray, west of Columbia. Attends a two-room school there until entering high school in Batesburg in 1942. Spends his last year of high school in Sumter, while living with his mother. Takes classes in mechanical drawing and art and graduates as high school valedictorian in 1947. Enrolls at the University of South Carolina, Columbia, for three semesters and completes the school's course offerings in art. His art instructors there encourage him to move to New York, which he does in December of 1948.

1949–1950

Enrolls at Parsons School of Design. Faces financial difficulties after two semesters; withdraws after he is offered a scholarship based on need, not merit. Works as a messenger and shipping clerk. Attends exhibitions at the Whitney Museum of American Art and sees the work of Jackson Pollock, Isamu Noguchi, and Hans Hofmann for the first time. Attends exhibitions of the work of Edvard Munch at the Museum of Modern Art (MoMA); of Jacob Lawrence at the Downtown Gallery; and of Pollock at Betty Parsons Gallery.

1951–1953

Drafted into the army on May 25, 1951. Stationed in Fort Jackson, South Carolina, where he runs an art gallery for soldiers. Sees exhibitions at Gibbs Art Gallery in Charleston and the Columbia Museum of Art. Spends leave time in New York, where he sees a Barnett Newman exhibition at Betty Parsons Gallery (April 23–May 12, 1951) and a Cézanne retrospective at the Metropolitan Museum of Art (April 4–May 18, 1952). While stationed in Sendai, Japan, during his final six months of service, visits an exhibition of Japanese dada- and surrealist-inspired work in Tokyo. Discharged from the army in May 1953.

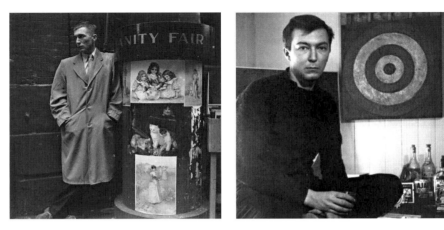

1955. Johns in New York, Photograph by Robert Rauschenberg

1955. Johns in his Pearl Street studio, with *Target with Four Faces*, Photograph by Robert Rauschenberg

Returns to New York that summer and rents an apartment on East 83rd Street in Manhattan. Enrolls at Hunter College, then in the Bronx, for a day but does not continue. Works as a night-shift clerk at Marboro Books in midtown Manhattan. In late fall 1953 (or early January 1954), is introduced to Robert Rauschenberg by his friend the writer Suzi Gablik.

1954

Winter / Moves from East 83rd Street to East 8th Street and Avenue C. Attends parties at the artist Sari Dienes' studio, where he meets John Cage and Morton Feldman. Also meets Merce Cunningham. First uses a body cast, a mask of a face (Cunningham's student Rachel Rosenthal) in *Untitled*.

Winter–spring / First sees works by René Magritte in *Magritte: Word vs. Image* at the Sidney Janis Gallery and by Joseph Cornell, possibly at the Whitney Museum of American Art or at Stable Gallery.

Summer / Moves with Rosenthal to 278 Pearl Street, where they each rent a loft, just a block from Rauschenberg's loft on Fulton Street. Quits bookstore job in order to paint; does window-display work with Rauschenberg.

Fall / Destroys all of his own work. Prompted by a dream, begins to paint a large American flag.

November / Helps Rauschenberg build a stage set for the first performance of Cunningham's *Minutiae,* with music by Cage. (Will design stage sets and costumes for contemporary dance performances in subsequent years.)

Late December–January / His first group exhibition in New York, at the Tanager Gallery, comprises works by eighty-one artists. Johns' assemblage *Construction with Toy Piano,* 1954, is mentioned and reproduced in Fairfield Porter's review in *ARTnews*.

Mid-1950s

Visits the home and studio of Jack Tworkov, who has solo exhibitions at Charles Egan Gallery and, later, Stable Gallery.

1955

Participates in two group exhibitions, one at Stable Gallery and one at Poindexter.

Winter–spring / Makes his first target painting, *Target with Plaster Casts* (cat. 1).

Summer / Rauschenberg moves from Fulton Street into the loft above Johns' on Pearl Street. Paints *Target with Four Faces* (cat. 3), attaching casts of his friend, the poet and potter Fance Stevenson.

After summer / Johns and Rauschenberg start a window-display business, the pseudonymous Matson Jones—Custom Display.

Fall / Paints *Green Target* (cat. 5). Johns and Rauschenberg become friends with Cage and Cunningham. The four meet regularly at downtown bars, such as the Cedar Tavern in Greenwich Village.

October 15 / Meets Lois Long and producer Emile de Antonio for the first time at performances of the Merce Cunningham Dance Company, Cage, Harold Coletta, and David Tudor.

1956

Creates his first alphabet painting, *Gray Alphabets.* Gene Moore, the display director for Bonwit Teller and Tiffany & Co., hires Matson Jones to build props for his department store window displays (Johns continues this work in 1957 and 1958).

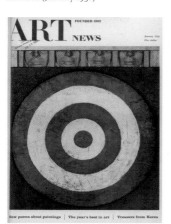

1958. *Target with Four Faces*, cover, *ARTnews* (January 1958)

1958. Cunningham, Rauschenberg, Cage, M. C. Richards, and Johns, Photograph by Bob Cato, Courtesy George Avakian

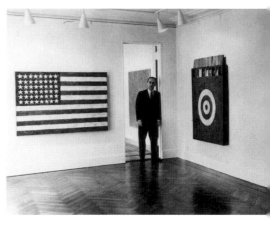

1958. Castelli at the Johns exhibition, Leo Castelli Gallery, Photograph by Rudolph Burckhardt

February–March / Sees the exhibition *Recent Paintings of Philip Guston* at the Sidney Janis Gallery, on view from February 6–March 4.

1957

Makes *White Numbers,* his first painting of a series of numbers. Meets the poet Frank O'Hara. Invites the dealer Betty Parsons to visit his studio; she declines.

Winter / The artist Allan Kaprow initiates Johns' inclusion in an upcoming Jewish Museum exhibition by bringing Horace Richter, a member of the museum's administrative committee, to visit the Pearl Street studios. Sends *Target with Plaster Casts, White Flag,* and possibly *Tango,* all from 1955, to the exhibition. Withdraws *Target with Plaster Casts* when organizers request that cast of male genitalia be concealed behind closed lid. (This consideration will partly motivate Alfred Barr to acquire *Target with Four Faces,* instead, for MoMA.) *Print* magazine reproduces *Target with Four Faces* in its February–March issue.

March 7 / Leo Castelli (who had opened a new gallery in February) attends the preview for Johns' first museum exhibition,

Artists of the New York School: Second Generation at the Jewish Museum (March 10–April 28). *Green Target* (cat. 5) is exhibited rather than the three works he initially sent.

March 8 / Castelli and his wife Ileana (later Ileana Sonnabend) visit Rauschenberg's studio to look at new work. While there, Castelli learns that Johns, whose name and *Green Target* Castelli remembers from the Jewish Museum exhibition, is living downstairs. Castelli expresses interest in meeting Johns, and the couple sees the full range of the artist's work, including *Target with Plaster Casts* and *Target with Four Faces.* Castelli proposes a solo exhibition and Ileana purchases a painting, *Figure 1,* 1955.

May 6–25 / Exhibits *Flag,* 1954–1955, in a group exhibition at Castelli's gallery. Critic Robert Rosenblum reviews the exhibition, referring to the readymades of Marcel Duchamp and coining the term neo-dada in his discussion of Johns. Later in 1957 (or in 1958), Johns reads the artist Robert Motherwell's *The Dada Painters and Poets: An Anthology* and visits the Philadelphia Museum of Art with Rauschenberg to see Duchamp's work in the Arensberg Collection.

1958

Receives a copy of Duchamp's *Box in a Valise.* Makes his first painted sculptures of everyday objects using Sculp-metal, an aluminum plastic compound that can be applied with a brush and solidifies into a rigid metallic surface.

January / *Target with Four Faces* is reproduced on the cover of *ARTnews,* edited by Thomas Hess. Makes a drawing by tracing the cover.

January 20–February 8 / First solo exhibition, at Leo Castelli Gallery, receives extensive press coverage. Alfred Barr and Dorothy Miller select *Green Target* (cat. 5), *White Numbers,* 1957, and *Target with Four Faces* for acquisition by MoMA, and *Flag,* 1954–1955, for Philip Johnson. All works sell except for *Target with Plaster Casts,* which Castelli acquires, and *White Flag,* 1955, which Johns keeps. Willem de Kooning sees the exhibition and meets Johns.

March / When the Pearl Street building is slated for demolition, Rauschenberg and Johns move their studios to 128 Front Street.

Summer and fall / Exhibits works in Europe for the first time: at the XXIX Venice Biennale (June 14–September 30) and in *Le Dessin dans l'art magique* at Galerie Rive Droite, Paris (October 21–November 20).

December / Receives a $500 award from the Carnegie Institute, Pittsburgh, in conjunction with its Bicentennial International Exhibition. Duchamp is among the eight jurors.

1959

Paints first work with a device, *Device Circle* (cat. 28), and first works with stenciled names of colors: *False Start* (cat. 30), *Jubilee* (cat. 34), and *Out the Window* (cat. 38). (Will later say that *False Start* and related paintings represent "an attempt to get rid of predetermined boundaries" that had distinguished the imagery in previous works.)

January / Critic Nicolas Calas brings Duchamp to visit Johns and Rauschenberg. Johns reads Robert Lebel's 1959 monograph *Marcel Duchamp*. Alfred Barr includes *Green Target* (cat. 5), *White Numbers,* 1957, and *Target with Four Faces* in the exhibition *Recent Acquisitions* at MoMA, January 30–April 19.

March / *Arts* publishes Johns' letter to the editor responding to Hilton Kramer's "Month in Review" piece (published in February). Has solo exhibition at the Galleria d'Arte del Naviglio in Milan.

May / Castelli introduces the Japanese critic Yoshiaki Tono to Johns and Rauschenberg.

Summer / The artist Larry Rivers introduces Johns to Tatyana Grosman, founder of the lithography workshop Universal Limited Art Editions (ULAE) on Long Island.

June / Rosenblum introduces Johns and Rauschenberg to Frank Stella.

July 15 / In a letter to Johns, O'Hara recommends the following writers: Gary Snyder, Philip Whalen, Michael McClure, Gregory Corso, Jack Kerouac, William S. Burroughs, Alain Robbe-Grillet, Nathalie Sarraute, Peter Orlovsky, John Ashbery, William Carlos Williams, Laura Riding, and Jane Bowles. He further remarks: "I think everyone should read all of Samuel Beckett." (Johns will meet Beckett in 1972 and collaborate on a book, *Foirades/Fizzles,* published in 1976.)

Fall–winter / Participates in group exhibitions in New York at Leo Castelli Gallery, Stable Gallery, D'Arcy Galleries, and the Whitney Museum of American Art, and in Houston at the Contemporary Art Museum.

September / *Target with Plaster Casts* appears on the first page of the first issue of the Milan art magazine *Azimuth.*

October 4, 6–10 / Participates with Rauschenberg in Kaprow's *18 Happenings in 6 Parts.*

Mid-December–mid-February 1960 / Lends *Target with Plaster Casts* to an exhibition in Paris organized by Duchamp and André Breton, *L'Exposition Internationale du Surréalisme, 1959–1960.* Participates in the exhibition *Sixteen Americans* at MoMA, and cites Paul Cézanne, Marcel Duchamp, and Leonardo da Vinci as three conceptual sources for his work.

December 25 / Duchamp and his wife Teeny have dinner with Johns and Rauschenberg.

1960

Meets Jim Dine.

February 15–March 5 / Second solo exhibition at Leo Castelli Gallery includes paintings from the preceding year. (Castelli will later recall that Barr expressed disappointment with the new work.)

Spring / At Front Street, makes *Painting with Ruler and "Gray"* (cat. 44).

April 21 / Participates in the symposium *Art 1960* at New York University, along with other artists included in the *Sixteen Americans* exhibition.

Summer–fall / Invited by Grosman to make a print at ULAE. Visits the workshop and subsequently begins work on *Target* (cat. 27, his first published print). Group exhibitions include *Jasper Johns — Kurt Schwitters* at Ferus Gallery, Los Angeles, and *New Forms — New Media* at the Martha Jackson Gallery, New York.

Late October–late November / Visits Rauschenberg in Treasure Island, Florida.

December / The magazine *Scrap* publishes Johns' review of the book *The Bride Stripped Bare by Her Bachelors, Even, A Typographic Version by Richard Hamilton*

of Marcel Duchamp's *Green Box,* translated by George Heard Hamilton and published by Wittenborn. Buys a copy of the 1934 edition of the *Green Box* from Duchamp, who delivers it personally and inscribes it with the pun, "To Jasper Johns, Sybille des cibles, Affectueusement, Marcel 1960." (Will design a stage set for Cunningham's *Walkabout Time* based on Duchamp's *The Bride Stripped Bare,* also known as the *Large Glass,* in 1968.)

December 7–29 / The exhibition *Jasper Johns 1955–1960* at the Columbia Museum of Art comprises eighteen paintings and five lithographs.

1961

Begins reading the work of Ludwig Wittgenstein (1889–1951) concerning the philosophy of language.

Winter / Rauschenberg moves from Front Street to Broadway.

January / Buys a house in Edisto Beach, South Carolina (over the next few years, lives and works primarily in Edisto Beach, returning to New York during winter).

January 31–February 18 / Solo exhibition at Leo Castelli Gallery includes forty-five drawings, sculptures, and lithographs. Meets Andy Warhol at Leo Castelli Gallery.

March 3 / A fire at the governor's mansion in Albany, New York, destroys *Black Target* (cat. 24), in the collection of Governor and Mrs. Nelson A. Rockefeller.

June / Makes his first trip abroad, accompanied by Leo Castelli, to install his second solo exhibition at Galerie Rive Droite, Paris. Probably during this trip, purchases a bronze sculpture by Duchamp titled *Female Fig Leaf,* which the gallery has just issued in an edition of eight (later, heats the base of the sculpture and presses it into the surface of the paintings *No,* cat. 47; *Field Painting,* cat. 77; and *Arrive/Depart,* cat. 78).

June 19–July 8 / Participates in the group exhibition *American Vanguard Painting,* organized by the United States Information Agency. The exhibition travels to Austria, Yugoslavia, England, and West Germany.

June 20 / Contributes the sign/painting *Entr'acte* and a large target made of flowers to pianist Tudor's performance of Cage's *Variation II* at the theater of the American Embassy in Paris. Niki de Saint Phalle, Rauschenberg, and Jean Tinguely also participate.

1962. Johns working at ULAE, Photograph by Hans Namuth, National Portrait Gallery, Smithsonian Institution, Washington, Gift from the Estate of Hans Namuth

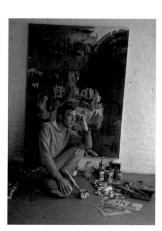

1963. Johns in his Front Street studio, with *Land's End*, Photograph by Alexander Liberman, Alexander Liberman Photographic Collection and Archive, Research Library, The Getty Research Institute, Los Angeles

July / Exhibits lithographs at the Hyannis Festival on Cape Cod.

Late July–September / In Edisto Beach, makes *Map,* his first of several versions, and also paints *By the Sea* (cat. 40) and *Target* (cat. 43).

Late summer / Johns' and Rauschenberg's relationship ends.

September 29–November 5 / Exhibits in the American section of *Deuxième Biennale de Paris: Manifestation Biennale et Internationale des Jeunes Artistes* at the Musée d'Art Moderne de la Ville de Paris.

Fall / At Front Street, completes six paintings, including *No* and *Good Time Charley* (cat. 46), mostly in grays and blues with objects attached. Also makes *Painting Bitten by a Man* (cat. 48).

October–December / Discusses his work with the critic Leo Steinberg, who in writing an essay on the artist visits his studio several times.

Fall–winter / Participates in many group exhibitions, including *The Art of Assemblage,* at MoMA; *American Abstract Expressionists and Imagists, 1961*, at the Solomon R. Guggenheim Museum, New York; *The*

1961 Pittsburgh International Exhibition of Contemporary Painting and Sculpture, at the Carnegie Institute, Pittsburgh; and an exhibition at the Leo Castelli Gallery.

1962

Begins using plastic supports in drawings, *Disappearance II* and *Device* (cat. 51). Visits Madame Tussaud's Wax Museum in London. Lends three drawings to Dore Ashton's *Abstract Drawings and Watercolors* exhibition, which the International Program of MoMA circulates to seven South American countries over the course of the year.

March 17–September 2 / *4 Amerikanare: Jasper Johns, Alfred Leslie, Robert Rauschenberg, Richard Stankiewicz* opens at the Moderna Museet, Stockholm, and then travels to the Netherlands and Switzerland. (Billy Klüver invents a portable neon sign for Johns to use in *Zone*, cat. 55).

May / The Milan magazine *Metro* publishes Steinberg's article on Johns.

May 5–27 / *Slow Field* (cat. 76), is exhibited in the *XVIIIᵉ Salon de Mai* at the Musée d'Art Moderne de la Ville de Paris.

May 6 / In Edisto Beach, makes a series of preparatory drawings (cats. 56–59) for an unrealized work titled *Skin* by pressing his face, rubbed in oil, against paper and applying charcoal over the greasy impression. (He later abandons *Skin* after a failed attempt to cast a "flattened, maplike rubber mask" of his model Jim Dine's head.)

Summer / Visits Dine and his wife in East Hampton.

Early November–December / At Front Street, makes *Diver* (cat. 65), a fourteen-foot painting spanning five panels.

November / Joins Metropolitan Museum of Art curator Henry Geldzahler in a visit to Warhol's studio. Johns is quiet, Andy thrilled.

November 5–January 6, 1963 / Participates in the MoMA exhibition *Lettering by Hand,* which later travels in South America.

November 15–December 31 / His solo exhibition marks the opening of Ileana Sonnabend's gallery in Paris. Castelli sends paintings made between 1955 and 1962, including *Target* (cat. 17), *Jubilee, Painting with Ruler and "Gray," Good Time Charley,* and *Device* (cat. 53).

1963. Installation view, Leo Castelli Gallery,
Photograph by Rudolph Burckhardt

1964. Johns at Riverside Drive, August, working on *According to What*,
Photographs by Mark Lancaster

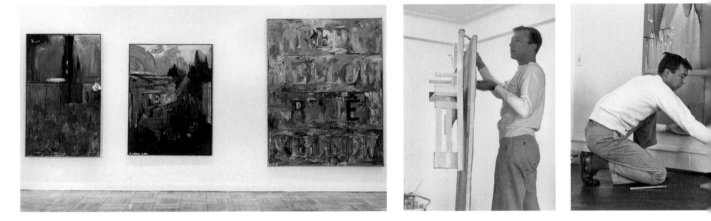

November 19–December 15 / *Jasper Johns: Retrospective Exhibition* is shown at Everett Ellin Gallery in Los Angeles.

December 12–February 3, 1963 / Exhibits *Folly Beach* (cat. 41) in *Annual Exhibition 1962: Contemporary Sculpture and Drawings* at the Whitney Museum of American Art.

1963

The first monograph on the artist, Steinberg's *Jasper Johns*, is published by Alec Tiranti, London. The book is a revised edition of Steinberg's article on Johns published in *Metro* in 1962. Serves as a founding director of the Foundation for Contemporary Performance Arts.

January 12–February 7 / *Jasper Johns* at Leo Castelli Gallery includes paintings *By the Sea, Zone, Fool's House* (cat. 54), *Out the Window Number 2* (cat. 64), *Passage* (cat. 63), and *Diver*.

March 14–June 12 / Participates in *Six Painters and the Object* at the Solomon R. Guggenheim Museum, New York: curated by Lawrence Alloway; selected works by Dine, Roy Lichtenstein, Rauschenberg, James Rosenquist, Warhol, and Johns, including his *Green Target* (cat. 5) and *False Start* (cat. 30).

March 29 / Attends the preview of the exhibition *Robert Rauschenberg* at the Jewish Museum.

April 3–June 2 / Exhibits *Reconstruction, 1959,* in *Ascendancy of American Painting* at the Columbia Museum of Art.

Summer / Accepts a commission from Philip Johnson to create a 108 by 82 inch painting for the New York State Theater at Lincoln Center, Manhattan. Makes a version of the painting *Numbers* in Sculpmetal on canvas. (The theater will open on April 23, 1964.)

June / Passages from his sketchbook notes are printed in the Japanese magazine *Mizue.*

June 14 / At the White House, on Flag Day, Castelli presents President John F. Kennedy with Johns' bronze *Flag,* one of three cast in 1960. (Cage tells a disgruntled Johns to consider it a pun on his work.)

End of August–September / Moves from his Front Street loft to a penthouse at 340 Riverside Drive (at 106th Street).

October 29–November 23 / Sees an exhibition of Florine Stettheimer's works at the Durlacher Brothers Gallery, New York.

December 12–February 5, 1964 / Exhibits *Reconstruction in Black and White* at the Jewish Museum.

1964

At Riverside Drive, finishes *Arrive/Depart,* his first painting incorporating screen printing (as well as a screen given to him by Warhol).

February 13–April 12 / The Jewish Museum gives Johns his first museum retrospective, organized by Alan Solomon and accompanied by a catalogue with essays by Solomon and Cage. (Other venues are the Whitechapel Gallery, London, in December 1964, and the Pasadena Art Museum, California, in January 1965.)

Late March / Embarks on a month-long trip to San Francisco and Hawaii with Long and Cage. In an interview with Tono, says of Duchamp, "in ordinary works there is a process of making them; in his case he has assimilated that process itself into his work. This is the point I am attracted to."

April 22–June 28 / Exhibits *Target with Plaster Casts* and *Passage,* among other paintings, in *1954–64: Painting and Sculpture of a Decade* at the Tate Gallery, London.

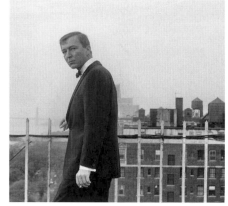

1964. Johns at Riverside Drive, September, Photograph by Mark Lancaster

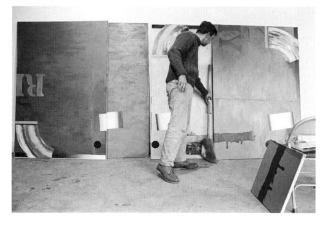

1965. Johns working on *Untitled*, Photograph by Ugo Mulas, Archivio Ugo Mulas, Milan

April 30 / Flies to Tokyo with Japanese composer Toru Takemitsu.

Late spring–early summer / With the help of the Minami Gallery, finds a studio at the Artists' Hall on the Ginza in May. While there, makes the paintings *Watchman* (cat. 86), *Souvenir* (cat. 79), and *Souvenir 2* (cat. 82), as well as the drawings *Souvenir* (cats. 80, 81), *Handprint* (cat. 75), *Watchman* (cats. 87, 88), *Untitled (Cut, Tear, Scrape, Erase)* (cat. 83), and *No* (cats. 84, 85). Has cheap souvenir saucers with a photograph of himself and the words "red yellow blue" made for use in the paintings *Souvenir* and *Souvenir 2.* Writing to Castelli, mentions that he has begun work on a new painting (probably *Watchman*) that he may title *Watchman — Ginza Light.*

June 15 / Accompanies Takemitsu to Kyoto.

June 20–October 18 / Exhibits seventeen paintings and three sculptures in the American section of the XXXII Venice Biennale.

June 27–October 5 / Exhibits three paintings, including *Periscope (Hart Crane)* (cat. 67), in Documenta III, Kassel.

Early July / Flies back to New York from Japan. Meets the artist Mark Lancaster.

August 21–23 / Travels to London with Long for the start of Cunningham's world tour. Also visits Windsor Castle to see Leonardo da Vinci's drawing *Deluge.*

Fall / In Edisto Beach, paints *Untitled* (cat. 90) and *Voice* (cat. 91).

October 7–November 1 / *Premio Nacional e Internacional, Instituto Torcuato di Tella 1964,* Buenos Aires, includes *Fool's House* and *Arrive/Depart.*

December / In London, attends the openings of his retrospective at the Whitechapel Gallery and an exhibition of his lithographs at the American Embassy.

1965

Spends most of the year in Edisto Beach. Acquires Magritte's *Interpretation of Dreams.*

January / Attends the openings of two exhibitions: his retrospective at the Pasadena Art Museum and Duchamp's exhibition *Not Seen and/or Less Seen of/by Marcel Duchamp/Rrose Sélavy 1904–1964,* organized by Richard Hamilton, at the Cordier & Ekstrom Gallery, New York.

March / In performing *Site* with Carolee Schneemann, Robert Morris wears a rubber mask Johns had cast from Morris' face.

March 31–April 24 / Participates in the exhibition *Critic's Choice: Art since World War II* at the Providence Art Club, Rhode Island (critics Thomas B. Hess, Hilton Kramer, and Harold Rosenberg had selected the artists).

April / Interviewed by the BBC at Edisto Beach.

May / Visited at Edisto Beach by Cage, who gives him a collector's edition of Arnold Schoenberg's letters.

June / Wins an award at the *VI International Exhibition of Graphic Art,* Ljubljana, Yugoslavia, for his lithograph *Skin with O'Hara Poem* (cat. 60).

June 1–25 / Exhibits thirty-three works in *Jasper Johns,* at the Minami Gallery, Tokyo (catalogue essay by Tono).

December / Participates in the exhibition *Word and Image* at the Solomon R. Guggenheim Museum (catalogue introduction by Alloway).

December 8–January 30, 1966 / Participates in the *1965 Annual Exhibition: Contemporary American Painting* at the Whitney Museum of American Art.

Acknowledgments

Jeffrey Weiss

My first and most grateful thanks go to Jasper Johns. He has been immensely supportive throughout the process of preparing the exhibition and is also generously lending paintings and works on paper from his own holdings. Needless to say, the exhibition would have been impossible without his interest, and I cannot overstate my appreciation. In his studio, Sarah Taggart has been a patient and tireless source of information and has juggled many queries and other issues relating to loans and catalogue production with her usual grace.

Four distinguished authors join me in contributing essays to this catalogue: John Elderfield, Carol Mancusi-Ungaro, Robert Morris, and Kathryn Tuma. Separately and together, their work marks a truly original contribution to the field of Johns literature. Special thanks go to Robert Morris for agreeing to write what is a historically important document due to his role as a close artistic and critical observer of Johns' work during the 1960s.

As ever, preparation of the exhibition and catalogue has been supported by the generosity of many people. The lenders, who are separately named, all deserve our deepest thanks for sharing works by Johns in their care. Other individuals have contributed precious time and effort in various ways. Photographers Paul Katz and Mark Lancaster, who recorded Johns at work during the 1960s, were willing to share previously unpublished images; I also thank George and Carole Silver and Irene Casali for their help with published and unpublished photographs by, respectively, Walt Silver and Ugo Mulas. Such photographs, which we reproduce in great number in this book, deepen our representation of the process of Johns' work. Jim Coddington, head of conservation at the Museum of Modern Art, conducted invaluable examinations of works in the collection of MoMA on behalf of the exhibition. Both Jim and Carol Mancusi-Ungaro, along with Jay Krueger, conservator of twentieth-century art at the National Gallery, have contributed their superb expertise to the project. Ruth Fine, curator of special projects at the National Gallery, has been an invaluable counsel to me. Bob Monk and Laura Paulson generously assisted us with various loans. For further support in ways too numerous to itemize here, I also express my sincerest thanks to Darsie Alexander, Roberta Bernstein, Mel Bochner, Lynn Davis, Kathy Fuld, Larry Gagosian, Tony Ganz, Susan Hirschfeld, Antonio Homem, Eric R. Johnson, Susan Lorence, Robert Mnuchin, Iris Müller-Westermann, Barbara Rose, Richard Serra, and Jennifer Tobias.

The effort here at the National Gallery has been a collective one. Director Rusty Powell has been enthusiastically supportive at every stage of the project. In my own department of modern and contemporary art, Jennifer Roberts, exhibition specialist, has been assiduous in conducting research for the project, including searching and securing archival photographs of the artist's studio as well as composing an important chronology. Marcie Hocking, exhibitions assistant, has been an indispensable and supremely gracious manager of myriad details relating to every aspect of the show. In the department of the registrar, Michelle Fondas coordinated the complicated packing and shipping process. In the department of installation and design, Jamé Anderson, architect, working under Mark Leithauser, chief of design, created the spaces for the show. The show was lit by Gordon Anson; Lisa Farrell produced the silkscreens and related design

elements. In the department of exhibitions headed by Dodge Thompson, chief of exhibitions, Jennifer Cipriano, exhibition officer, and assistant Kristina Giasi worked closely with lenders and insurers throughout the process. In the publishing office, Judy Metro, editor in chief, coordinated our collaboration with Yale University Press and oversaw the editing and design process. Julie Warnement was our attentive, thoughtful editor; Margaret Bauer designed this catalogue with typical sensitivity to the nature of the art and the content of the text. Sara Sanders-Buell and Ira Bartfield served as permissions coordinators for photography in the catalogue. In the department of imaging and visual services, digital specialists John Schwartz and Christina Moore, working under Alan Newman, chief, scanned images for the exhibition. In loans and exhibitions conservation, Hugh Phibbs and Jenny Ritchie were the experts for matting and framing. In the press and public information office, Deborah Ziska, chief, and Anabeth Guthrie, publicist, handled the promotion of the exhibition. And in the corporate relations department, Christine Myers, chief development and corporate relations officer, and Jeanette Beers, program specialist, worked closely with Target, the exhibition's generous sponsor.

At the Kunstmuseum Basel, Bernhard Mendes Bürgi, director, has been our enthusiastic partner, devoting much time and effort to bringing the exhibition to Basel. His assistant Janine Guntern has managed many details of logistics and communication with dedication and good humor. It has been our pleasure to share this exhibition with the Kunstmuseum, which has its own longstanding, distinguished relationship with the artist and his work.

Display Images

Photographic credits

Index

Note: Page numbers in italic type indicate illustrations.

275

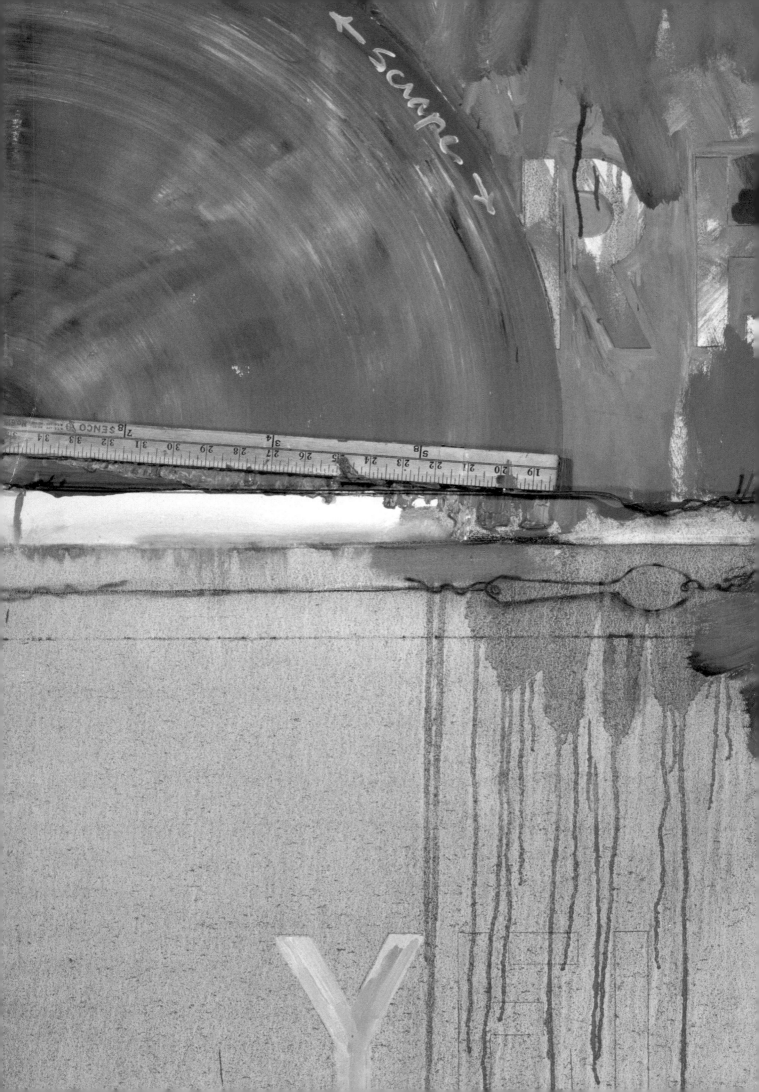